PICTURING SCIENCE AND ENGINEERING

PICTURING SCIENCE AND ENGINEERING

Felice C. Frankel

The MIT Press Cambridge, Massachusetts London, England

© 2018 Felice C. Frankel

All rights reserved. No part of this book may be reproduced in any form by any electronic or mechanical means (including photocopying, recording, or information storage and retrieval) without permission in writing from the publisher.

This book was set in Neue Haas Grotesk by the MIT Press. Printed and bound in China.

Library of Congress Cataloging-in-Publication Data

Names: Frankel, Felice C., author.

Title: Picturing science and engineering / Felice C. Frankel.

Description: Cambridge, MA : The MIT Press, [2018] | Includes index.

Identifiers: LCCN 2018007484 | ISBN 9780262038553 (hardcover : alk. paper)

Subjects: LCSH: Photography--Scientific applications. | Photography--Digital techniques. | Science--Graphic methods. | Engineering--Graphic methods.

Classification: LCC TR692 .F735 2018 | DDC 770--dc23 LC record available at https://lccn.loc.gov/2018007484

10 9 8 7 6 5 4 3 2 1

For Yosi and Ellie

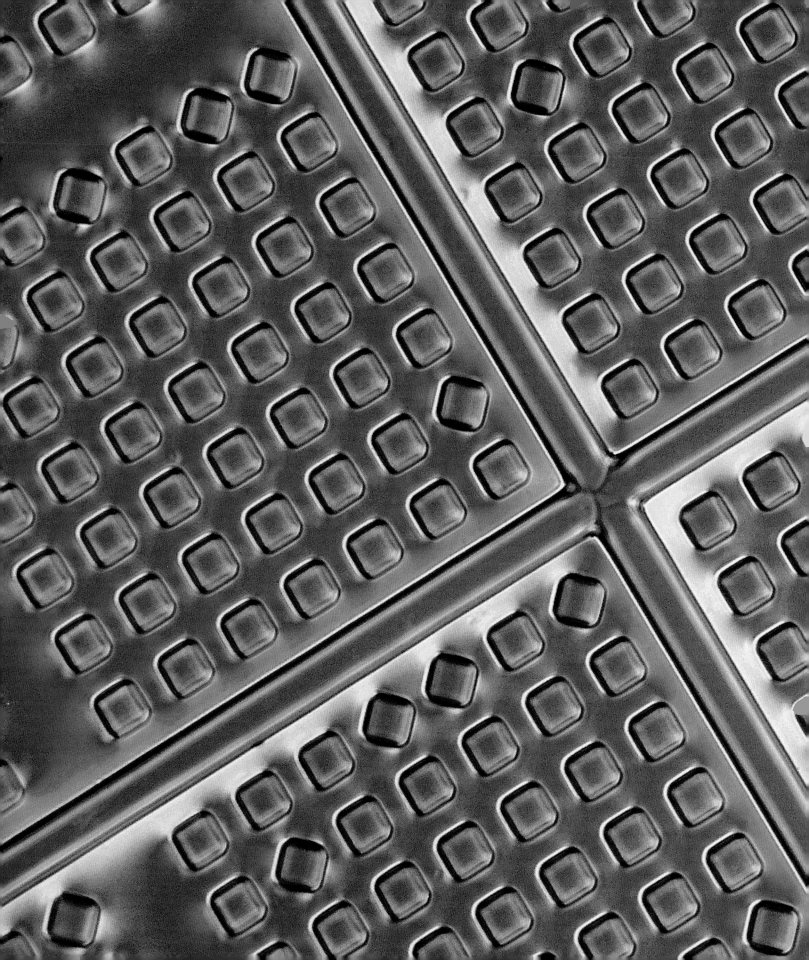

CONTENTS

INTRODUCTION XI

1 FLATBED SCANNER 1

2 CAMERA BASICS 45

3 LIGHT 101

4 PHONE CAMERAS 145

5 MICROSCOPY 203

6 PRESENTING YOUR WORK 249

7 IMAGE ADJUSTMENT AND ENHANCEMENT 315

8 CASE STUDIES 345

VISUAL INDEX 409

INDEX 449

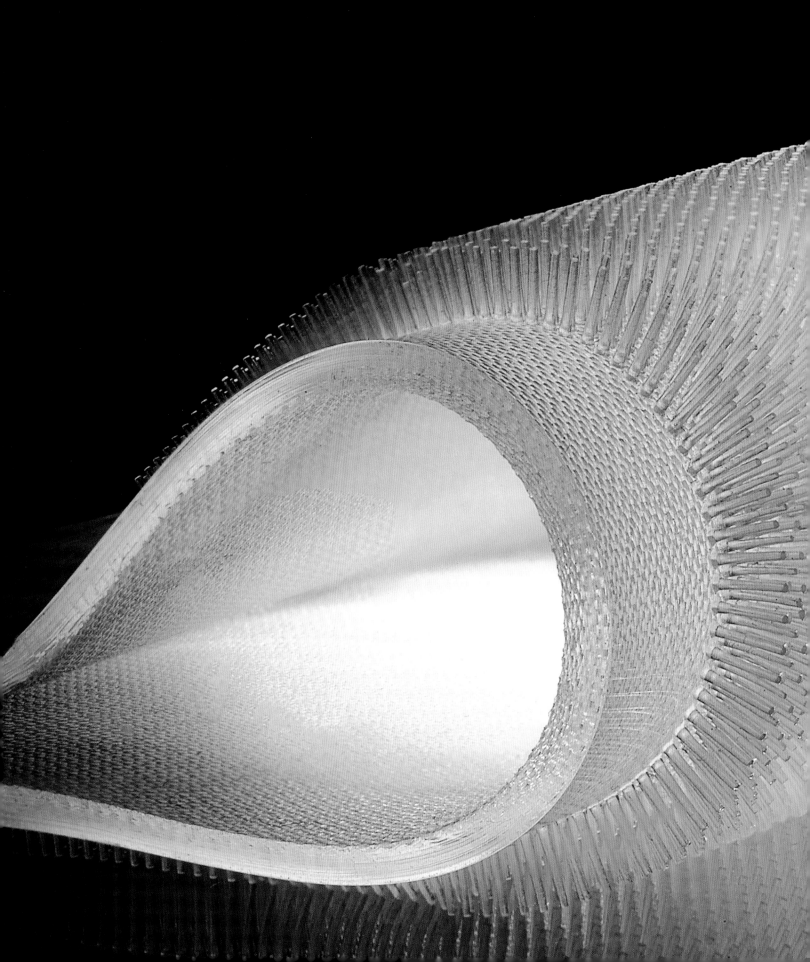

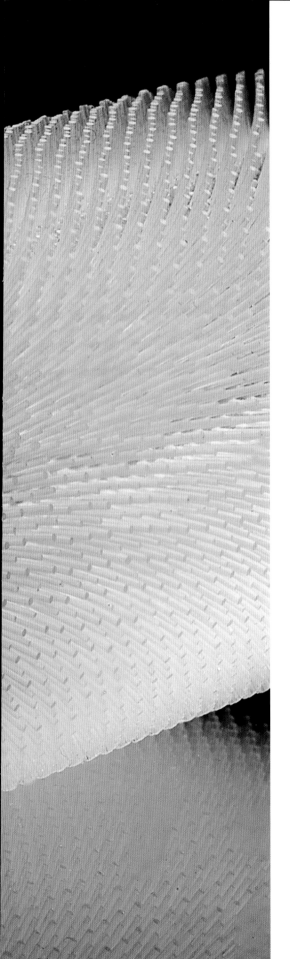

INTRODUCTION

Finally.

I no longer have to argue the point. You, researchers of the present and future, are visually documenting and explaining your work, not just in words and equations. And so I write this book for you—the women and men in science, engineering, and medicine who are solving the most challenging problems of our planet. I know you are interested because you tell me you are.

This book covers 25 years of my efforts to capture remarkable research visually. Most of the examples are from my home base at MIT, but the principles are universal. My purpose is to show you how I do what I do. It is satisfying to see a researcher's eyes light up when she sees her work on the cover of a journal or when she realizes that she has let a complicated set of data tell its own story through a figure. It is just as rewarding to introduce the broader public to the marvels of science and engineering—to communicate research that is important, but often difficult to understand when it's in the form of collections of data and analyses.

These pages will tell you pretty much everything I know. This book is different from my other books because I have much more to tell. With this information, I hope you will not only see your work with a fresh eye but will open the door for others to look.

In 2015, when we uploaded the 32 tutorials for an edX online course, "Making Science and Engineering Pictures: A Practical Guide to Presenting Your Work," and then placed them on MIT's Open CourseWare (OCW) platform, I knew that someday there would be some sort of printed version.

There had to be. I was and am convinced there is a place, in our digitally packed lives, for a book filled with (I hope) beautiful photographs of science and engineering over which to linger, to learn, be inspired, and reflect.

HOW IT ALL STARTED

In 1991–1992, I was given a gift — a Loeb Fellowship in the Graduate School of Design at Harvard University. I was privileged to receive this mid-career fellowship for my work in photographing the built landscape and architecture. While my colleagues audited classes in government or design, I returned to my roots in science and *lived* at Harvard's Science Center. I was in heaven listening to E. O. Wilson, Stephen J. Gould, Robert Nozick, and other remarkable thinkers and scientists. One of my colleagues suggested that I try auditing yet another class, offered by this chemist who she thought was extraordinary in his communicative skills. I did attend and marveled at, among other things, his ability to draw a perfectly round five-foot circle on the chalkboard. After that lecture, I walked to the front of the lecture hall, introduced myself, and asked if I could visit his lab to see, perhaps, if I could help photograph his work. Clearly wanting to get away from this strange person, while walking quickly out the door he threw out a "why not," and on that day I found myself searching the halls of Mallinckrodt (one of Harvard's chemistry buildings) for his lab.

What started as a whim became a serious turn in my professional life. I began working with Nick Abbott, who was at the time a postdoc in the lab. I took a look at their images and decided that I might, in fact, be able to come up with something, shall we say, more respectable (see page 448).

We got the cover of *Science*.

Life is all about timing and luck. George Whitesides, that lecturer and communicative chemist, turned out to be a renowned scientist in many areas of research. I had no idea who he was when I had the audacity to invite myself to his lab. Later, after the cover was accepted by *Science* and more of my images appeared in other journals, George said to me, "Stay with this, Felice, you are doing something that no one else is doing." I listened.

Getting the cover was mostly about the importance of the science in Nick and George's journal article — that's the thing to keep foremost in mind as you pursue your own careers and covers. But the "stay with this" part became a life-changer for me, and I will forever be grateful.

After the one-year Harvard fellowship my luck continued with invitations from other researchers to work with them. I was an artist in residence at the Edgerton Center at MIT in 1994, thanks to Director Kim Vandiver. A few years later Bob Silbey, Dean of Science, carved out a more permanent place for me, and there I remained for most of my tenure at MIT. At this writing, I am a research scientist in the Department of Chemical Engineering. That's the thing about MIT. If you have something to offer, even without formal credentials (I don't have a graduate degree), MIT will support you.

If you think about it, there isn't a formal "discipline" for what I do, and there should be. I average about two emails a week from young researchers or graphics types who want to do what I do. I do not know why there are so few programs teaching science photography and graphics. Perhaps with this book and the online course, those of us who love science and the challenges of visually depicting research will find a way.

THE VALUE OF VISUAL DEPICTION AND OUR RESPONSIBILITY TO THE PUBLIC

Developing the right visual or metaphor to express a concept or to communicate the unseen is a powerful exercise for two reasons. First, in the process of conjuring up new and communicative visuals, you are clarifying your science in your own mind. Think about it. When putting the pieces together in your slide presentation, or your figure or cover, you are telling a visual story—one that has to be ordered and clear. For that to happen, your thinking has to be ordered and clear. You have to help us see and understand. Benoit Mandelbrot told me how first seeing the picture of a fractal informed the mathematics. The physicist Lene Hau wrote to me, "I am a firm believer in the absolute importance of using visuals in teaching and science communication—it is essential for conveying information." My dear friend Michael Berry suggested in a lecture, "Pictures bring mathematics to life. It remains true that an equation is a more economical representation, summarizing infinitely many pictures. But economy and worth are not the same, and with the extreme compactness of equations can come a loss of immediate understanding and communication, and pictures can remedy that."

As for the second reason, I am convinced that smart, accessible, and compelling representations of science can be doors through which others can enter. It is no longer enough to communicate only within the research community. It is critical to engage those outside of research, so that we can welcome the nonexpert to observe how science advances knowledge and how critical thinking informs important decision making, *based on fact*. There is no question that part of a researcher's education should be to develop ways to entice the public to *look*, and then to understand.

I encourage you to take a step back when preparing your visuals. Just because various published graphs and figures are designed around styles perpetuated in your particular discipline, because "That's the way we have always done it," does *not* mean you shouldn't consider finding new approaches. Study your colleagues' work and question whether "the way we have always done it" is the most effective in telling a story. I often see these sorts of representations in our workshops and wonder why advisors insist on graphics that don't communicate.

I remember, years ago, asking a chemist why I saw so many representations of molecules with reflections of windowpanes on each shining,

spherical atom. Not only was it silly-looking, it was wrong. The contradiction in scale is not helpful to those of us involved with communicating science to the public. These days, I am delighted that we rarely see those windowpanes. However, the software has now replaced them with the more subtle light "reflection," which still makes no sense. The notion of light leaving a reflection on an atomic "ball" is preposterous and once again hardly helpful when teaching science.

ONLINE RESOURCES

I urge you to see this book as a sort of workbook. At the web resources page associated with this book (https://mitpress.mit.edu/frankel) you will find the following:

- All the tutorials from our online course "Making Science and Engineering Pictures," including the "how-to-do it" videos;
- Conversations with Kelly Krause, creative director for *Nature*; Brian Hayes, writer and photographer; Christine Daniloff, creative director at MIT; and J. Kim Vandiver, director of the MIT Edgerton Center;
- Articles from my column "Sightings" published in *American Scientist*;
- A short bibliography;
- Some of my MIT homepage snapshots;
- Additional links to exemplary videos by other image-makers, and other helpful videos from outside resources.

A NOTE ABOUT THE IMAGES

Most of the pictures have been sharpened so they will reproduce properly. In addition, I digitally cleaned some of the images so that your eye won't be distracted by dust particles and scratches.

WITH GRATITUDE

Finding a spot on the MIT campus could only have happened with the support of those previously mentioned and all the others who understood the value of the work. I was privileged to know former MIT Presidents Paul Gray and Chuck Vest who, I am sure, quietly made a case for my positions. Phil Sharp, Michael Rubner, Klavs Jensen, and Paula Hammond also supported me over many years. Mary Boyce (now Dean of Engineering at Columbia University), Gang Chen, Chris Schuh, Evelyn Wang, and Marty Schmidt continue to be important advocates and colleagues, to whom I remain lastingly grateful.

Professor Anette (Peko) Hosoi and Christine Daniloff remain critical to my intellectual and personal well-being on campus. Most important, both make me laugh. As for this book, I am grateful to Amy Brand, Director

of the MIT Press, whose vision of the future of publishing played a critical role in my decision to work with the Press. Gita Manaktala, Editorial Director, has kept me on track and sane. Yasuyo Iguchi, Design Manager, has done her magic in bringing the book to life and generously listened to my opinions and preferences. Editor Matthew Abbate helped keep my voice while fixing my sometimes uninspired writing. Janet Rossi patiently listened to my thoughts on production. I am also grateful to Kyle Gipson for his organizational skills, and outside of the Press I thank Gregory Sellei for his help in initial editing. My thanks also go to my online course team who helped make the tutorials, student interactions, and interactive tools the successes they turned out to be: Robin Heyden, Natasha Collette, Ben Mandeberg, Joanne Larrabee, and Gina Franzetta.

And finally my love and gratitude go to my remarkable family: Matthew and Michael, my sons; Laura, my amazing daughter-in-law; and the joys of my life, Yosi and Ellie Frankel, my grandchildren. Ken would have adored them.

1

FLATBED SCANNER

You might wonder why I chose to begin the book with a flatbed scanner – a tool you probably wouldn't think of using. We start with the scanner for two reasons: First, to offer you a *quick* way to experience the fun of creating images. Second, to begin with something *easy* – well, relatively easy – without having to worry too much about technical issues that, believe me, will come later.

Using a flatbed scanner, one that offers you the ability to control image resolution (discussed later), will help you create some very fine images of three-dimensional objects, like microfluidic devices, petri dishes, and other sorts of material you might fabricate or work with in the lab. You'll be surprised by some of the wonderful images you can create with a scanner and the detail you will capture.

But, in fact, the scanner isn't just a beginner's tool.

It affords you the opportunity to create some stunning images without getting into the more complicated setups of, say, a camera. You'll be able to immediately share your observations with colleagues almost on the spur of the moment – to quickly send an image of what you're currently observing in your lab or to show evidence that you've made something new; or just to show a small component of a larger structure.

Look at this image of three vials of material. **1.1a** As we zoom in to the image on screen, we see remarkable detail. **1.1b**

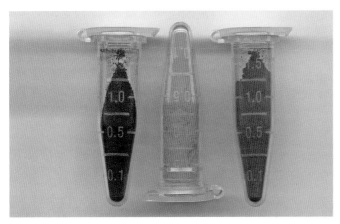

1.1a

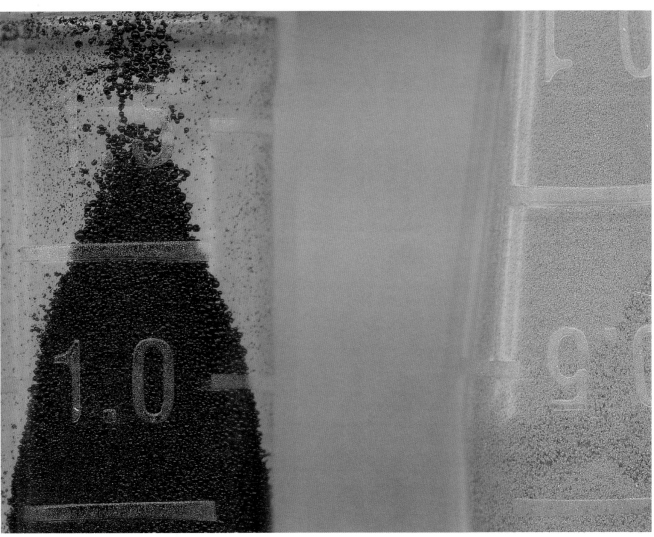

1.1b

And the same for the device in the chapter opener. Here is a zoomed-in image. **1.2**

1.2

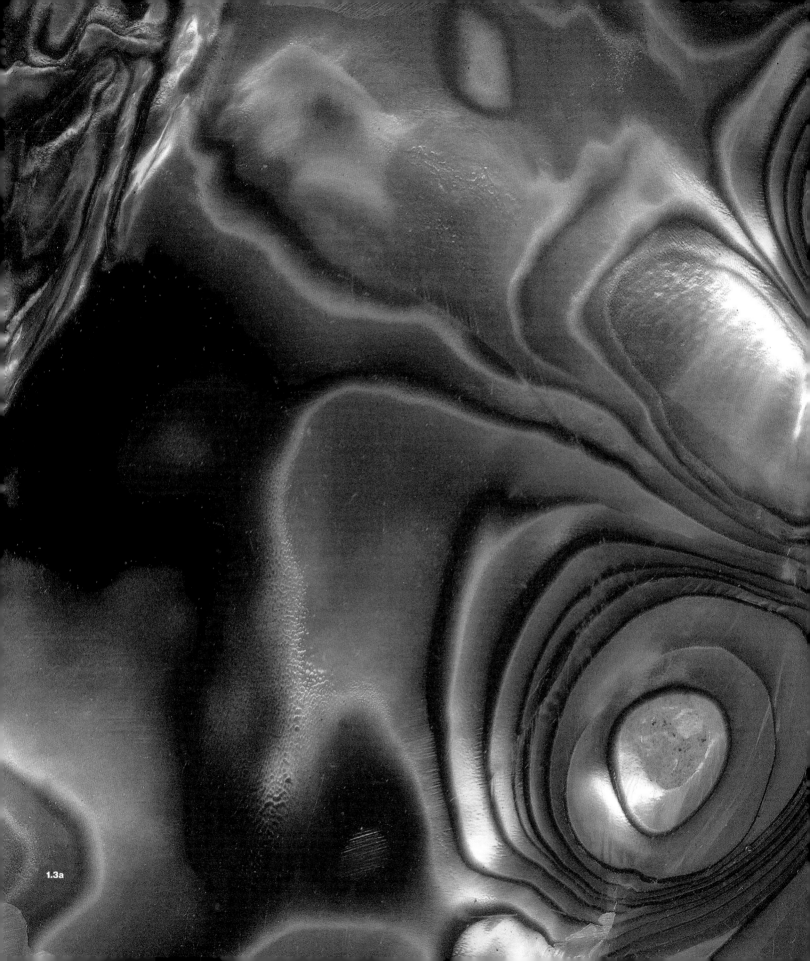
1.3a

1.3b

For these images of abalone as well. **1.3a,b**

 You can also use these images as drafts of higher-quality images that you will eventually use for journal articles or even patent submissions. The ease and simplicity of the scanner lend it to all of these uses. **1.4, 1.5**

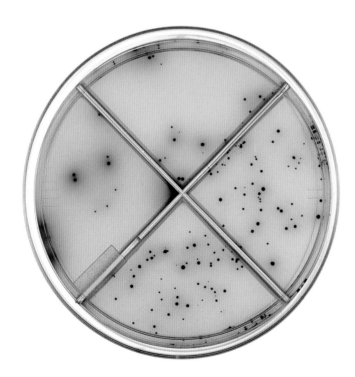

1.4

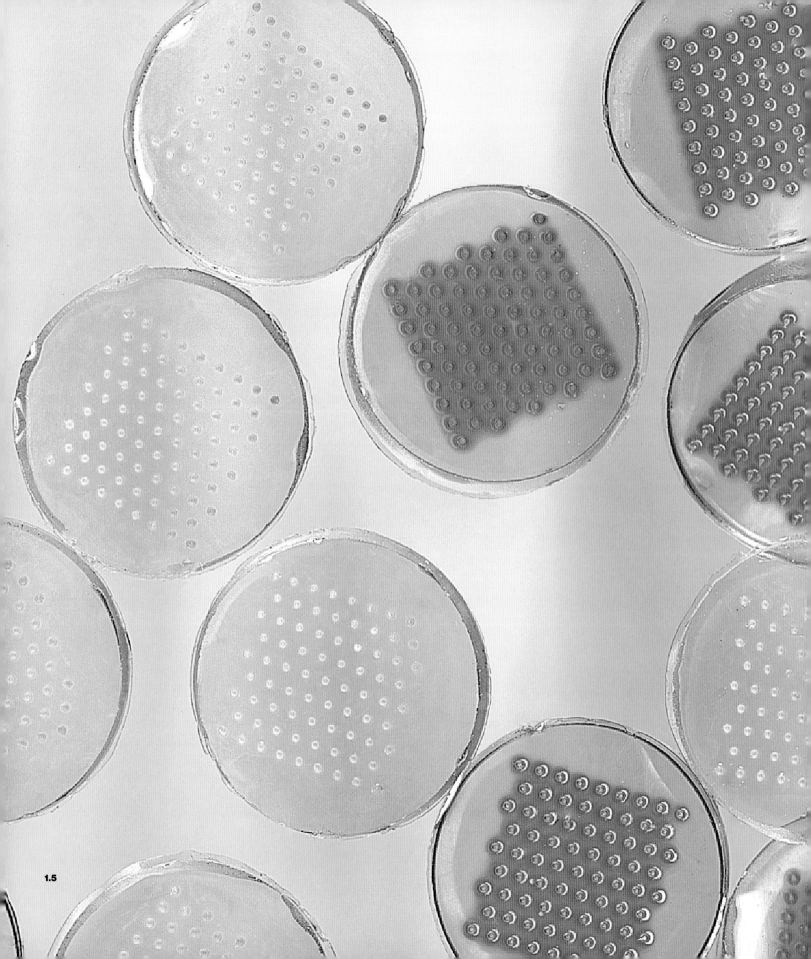

1.5

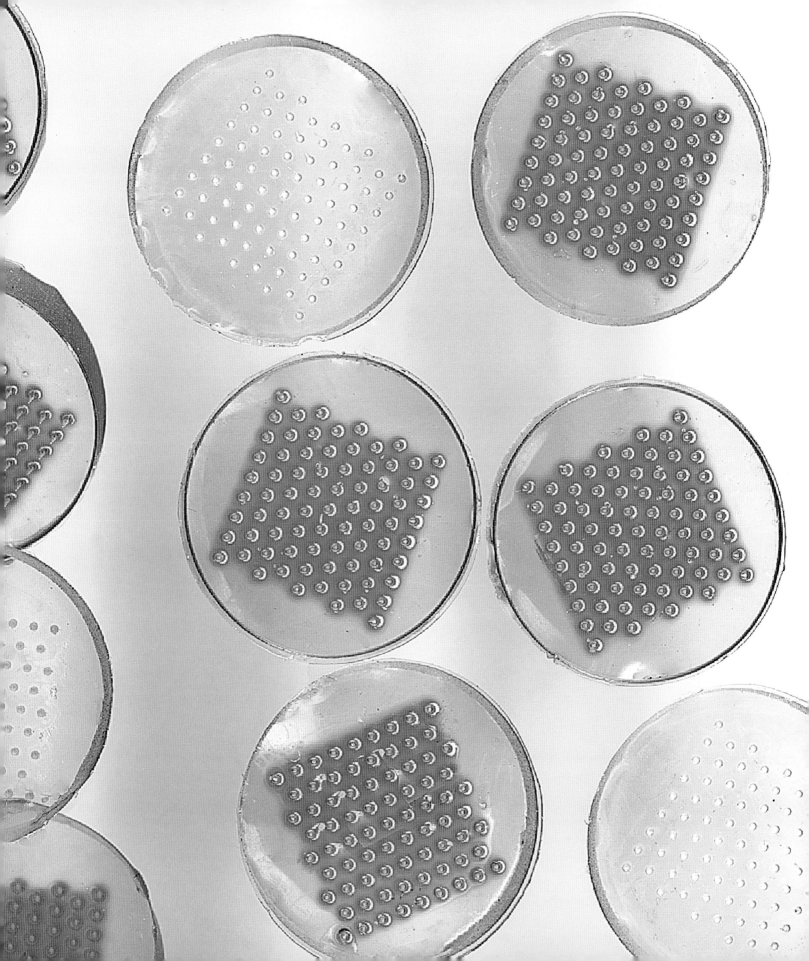

1.6

The wonderful surprise is that you can put a three-dimensional object on the scanner and create images that suggest its three-dimensionality.
1.6–8

1.7

1.8

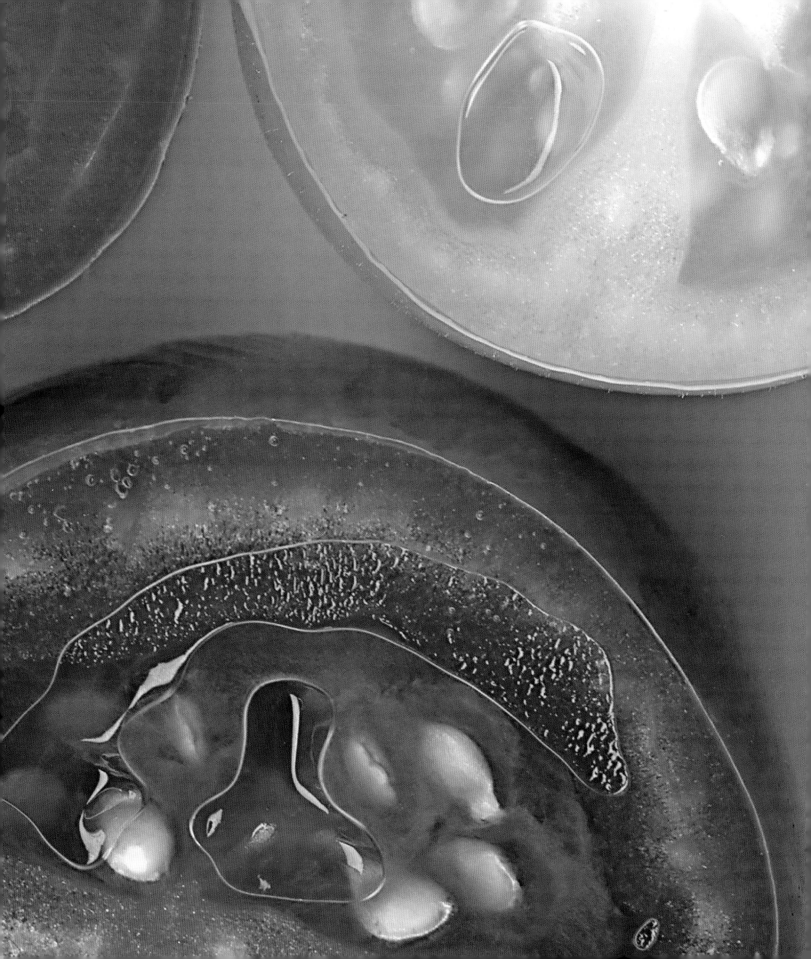

Yes, you will lose depth of field, which we'll discuss in the next chapter on cameras and lenses. But you can still create some pretty amazing images with a scanner.

In general, this book is meant to encourage you to capture your material in a variety of ways. Most importantly, in the process you will learn to *see*. The flatbed scanner plays a key role in this. It won't take long to try new approaches and ideas when you use it. Your own investigations will become, I hope, an active process of discovery, just as mine did for me when I made the images throughout this book. **1.9–11**

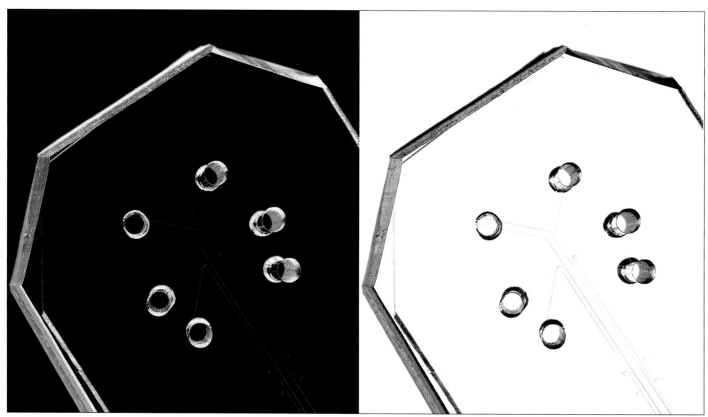

1.9

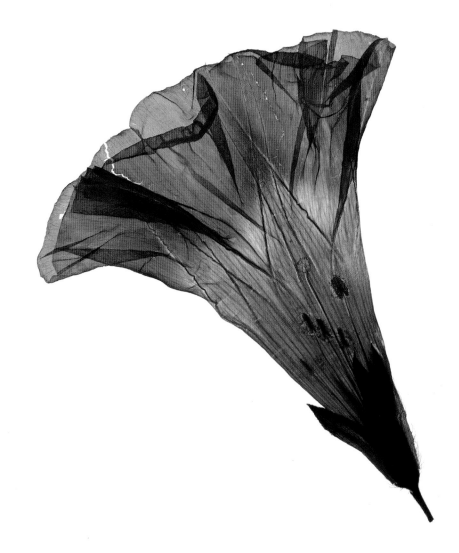

1.10

1.11

IMAGE SIZE, RESOLUTION, AND DPI

In deciding whether or not to use a flatbed scanner, you might want to think first about the size of your object or material. If you're planning to see details from a few millimeters up to a few centimeters, the scanner is a safe bet—and, as you see here, **1.12a,b** you'll be able to capture detail in the 30- to 50-micron range. Later in this chapter, I'll show you how

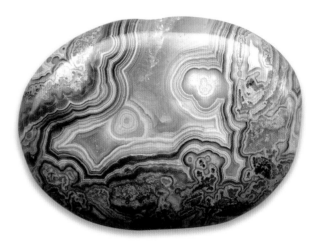

1.12a

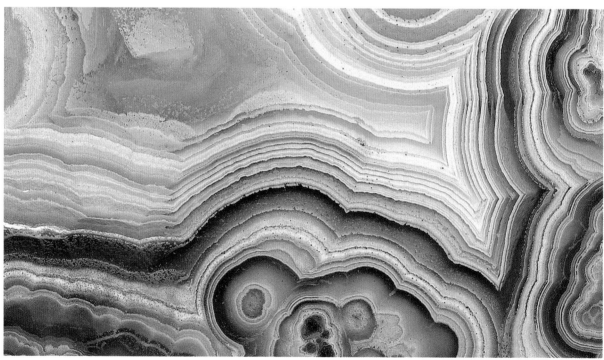

1.12b

using a scanner can come close to imaging with a microscope. If you capture your image at a high enough resolution, you can zoom in on your image on your computer screen and see things that you could not have seen with your unaided eyes (or perhaps things you would prefer *not* to see?). **1.13a,b**

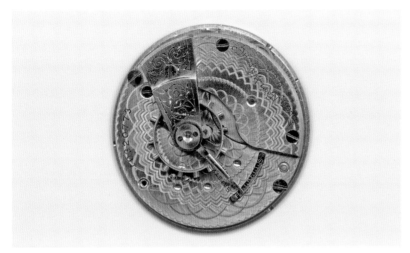

1.13a

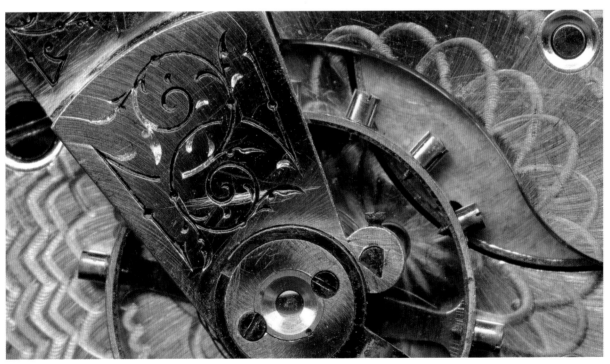

1.13b

What you'll see and show in your images will therefore depend on how you set the scanner's resolution. For the time being, just think about it this way: the higher your dpi setting (that is, dots per inch), the more information you're sending to the sensor. The more information you're sending, the more detail you'll capture and see. Changing the dpi settings, as in these three images, has a direct effect on capturing details. **1.14**

You'll learn more about setting dpi in the how-to-do-it videos on the book's web resources page.

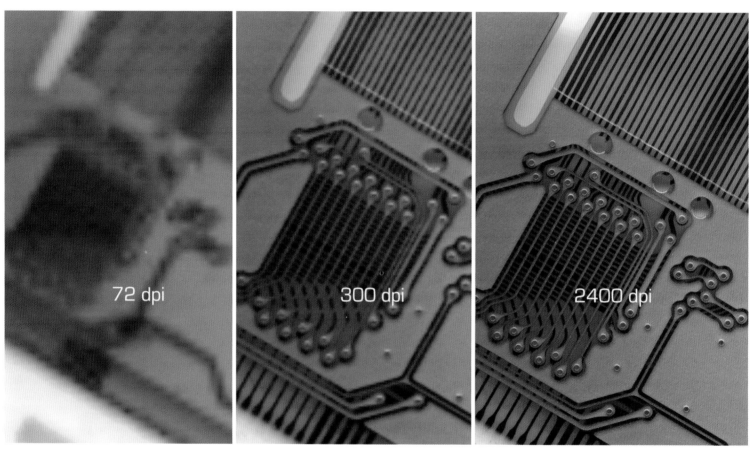

1.14

COMPOSITION, ORIENTATION, AND LIGHTING

You can adjust the little you have control over when using the scanner. When you read about the specific examples below, think about their relevance to your own work.

When I first scanned this music box, **1.15** the image seemed pretty good. **1.16**

1.15

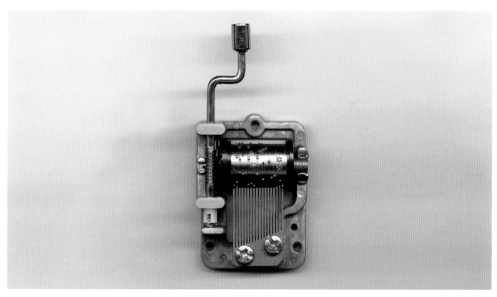

1.16

But as I looked more carefully, I saw a couple of things that bothered me. First appeared some writing on the barrel. **1.17** Looking closer, I gathered these were numbers and letters, and they were an unnecessary distraction.

The other problem was the positioning of the turning stem of the mechanism. **1.18**

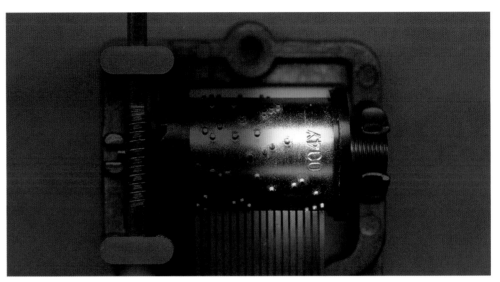

1.17

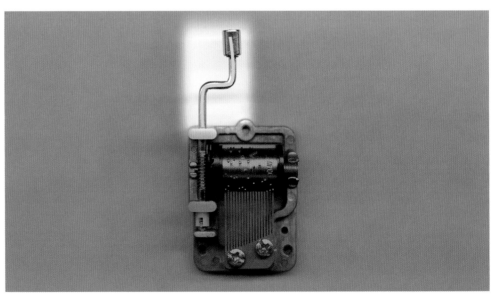

1.18

Somehow, it didn't feel properly composed. To fix these issues, I played the music box (turning the stem) which moved the barrel so that I no longer saw the writing, **1.19** and at the same time repositioned the stem for a better-composed image. **1.20**

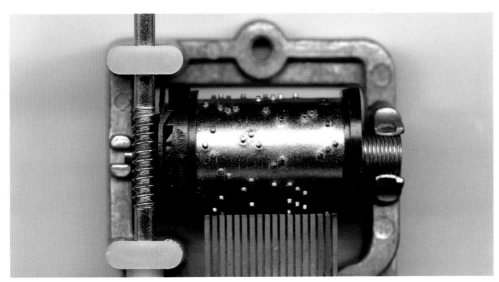

1.19

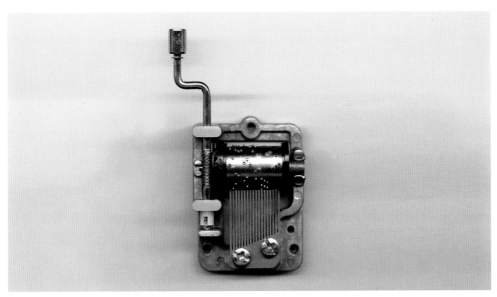

1.20

At first you might consider these adjustments to be somewhat trivial, but I urge you to trust trying small changes like this. You will find that making a series of small adjustments will improve your images more than you can imagine.

Next, I wondered what difference it would make if we changed the orientation of the device on the scanner. Remember, the scanner's light source and sensor travel only in one direction. We have no control over that.

In the images made thus far, the barrel of the music box was parallel to the light source. **1.21a,b**

1.21a

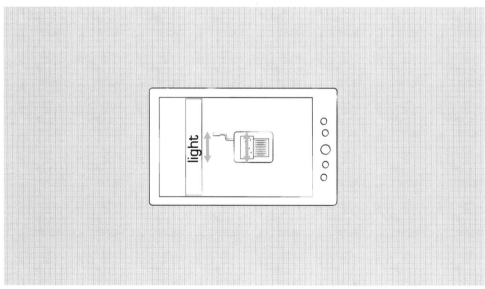
1.21b

For the next image, I rotated the music box 90 degrees — that is, putting the barrel perpendicular to the light source. **1.22a**

Here's the resulting image. **1.22b**

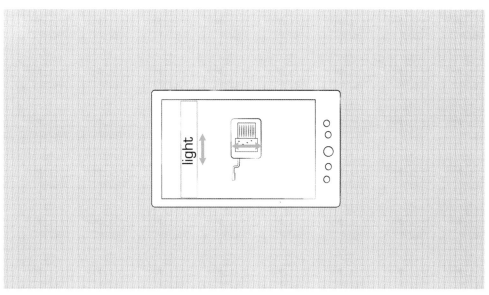

1.22a

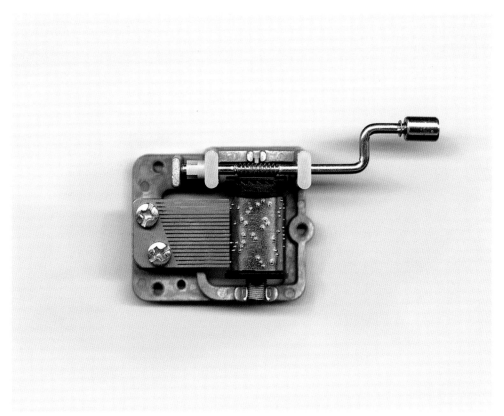

1.22b

Take a look at the two images side by side and observe the differences. **1.23**

You can see that the left one, made with the barrel oriented parallel to the light source, has a significant highlight. The one captured perpendicular to the light source has no highlight.

If I tried to anticipate all these results by drawing arrows from light sources and reflections and so on, I might have been able to anticipate what the differences would be in advance; but I prefer simply to discover the results by experimenting – as I hope you will do with your own material.

1.23

CAPTURING VERY FINE DETAILS

Seeing fine detail of your work becomes possible only if you capture your images at a high enough dpi setting. (See the how-to-do-it folder, on the book's web resources page, for a video to show you how to set your dpi.)

Here you see the beautiful sea animal *Euplectella aspergillum* in a dry state also known as Venus' flower basket. I put the 8-inch-long three-dimensional structure on the flatbed scanner, covered it with black velvet, and created a very-high-resolution scan – about a 1 GB file. Keep in mind the placement of the various objects – the black velvet becomes the background of the image. **1.24a**

As a side note, with a careful look you can see that two shrimp are living within this skeleton in a symbiotic relationship. **1.24b**

As we zoom in on the image, we begin to see the silica fibers, which measure about 50 microns wide. **1.24c**

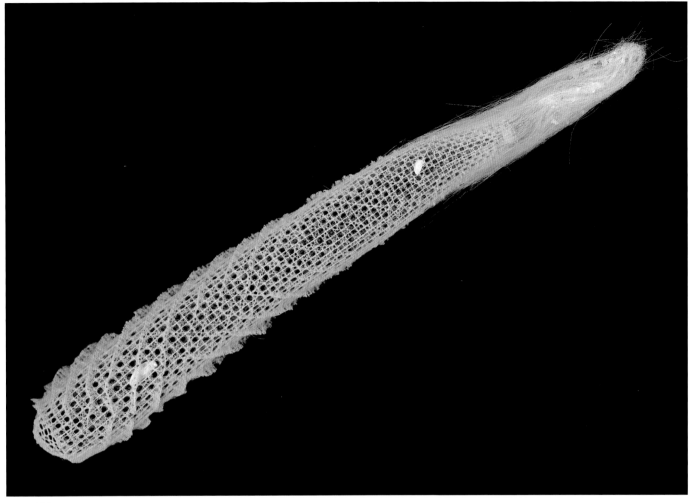

1.24a

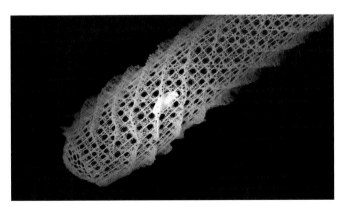

1.24b

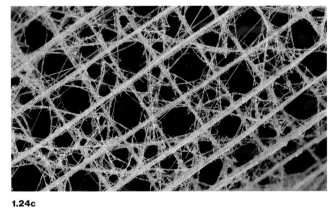

1.24c

Here's another attempt. This device is roughly 2.5 centimeters across. Again, I simply placed it on the scanner. **1.25a**

In the tutorial video on using a flatbed scanner, you will see how some of these devices come to me in the mail. As I observed the device closely from all angles, an idea came into focus on how to capture the image. It's critical to look carefully at your own object or material from all angles — to consider all the different points of view.

Try to look as if you are observing for the first time. The left image below was a scan of the "top" of the device and the right image was the scan of the reverse side. **1.25b**

This "naïve" look is not easy to achieve since you've been working with your material for some time, but that's the trick — taking a step back

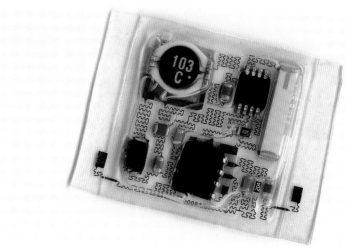

1.25a

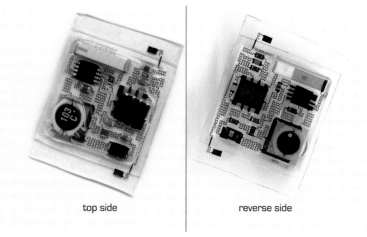

top side | reverse side

1.25b

and trying to see it with fresh eyes. For this particular exercise, John Rogers and I were aiming for a journal cover.

I decided to work with the "reverse" side of the device and scanned it to a large enough file that when I zoomed in, we could see the fascinating detail. **1.25c**

Once again, when you capture your image at a high enough resolution on your scanner, you *can* see these details. The image will be well resolved and ready to submit for a cover. If you decide to do so, consider cropping and formatting specifically for that journal cover, i.e., leaving space for a logo and other text. (See the case studies in chapter 8.)

By the way, in the end, we didn't get the cover, but that's another story.

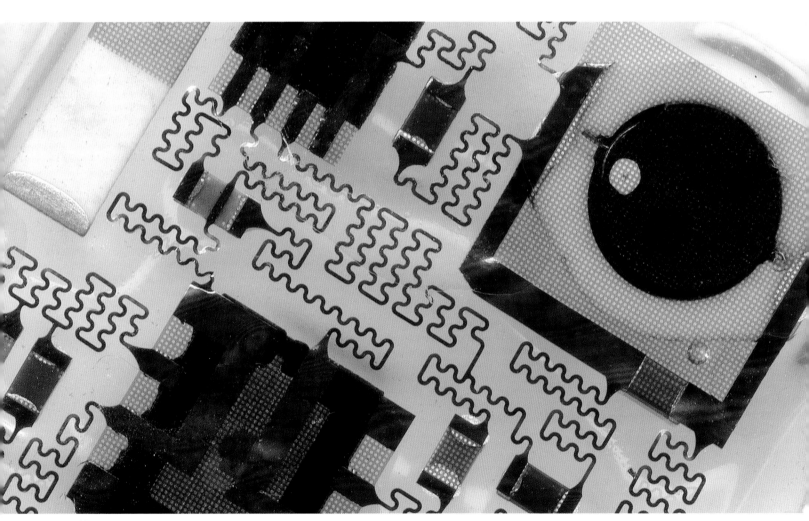

1.25c

LIGHT FROM ABOVE

A good scanner will offer you a choice of transmitted light (light from above in the cover) or reflected light (from beneath the glass). To compare scanned images using both, we'll start with these five devices **1.26** — three on the right and two on the left. (I encourage you to see who the researchers are in the visual index at the back of the book.) Notice the composition — not boringly lined up in a row. This image was taken, along with most of the others in this chapter, in what is usually considered the scanner's default mode: *reflected light* used for scanning documents, coming from below the glass.

The light scans (travels) along beneath the device, bounces off, and is read by the sensor beneath the glass. **1.27**

Just for fun, I played around with my setup. Here, for example, I simply opened the cover of the scanner. **1.28**

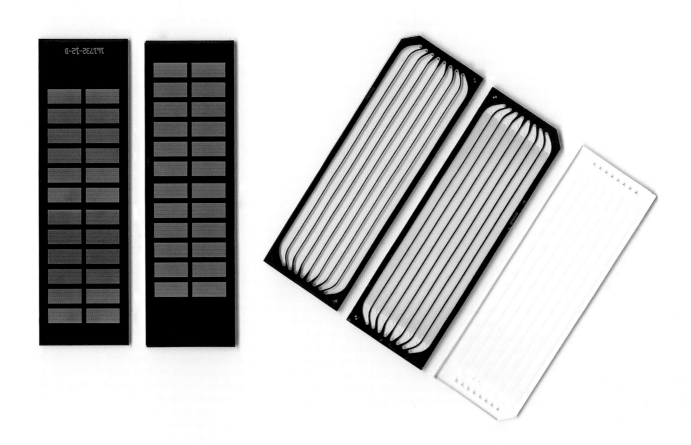

1.26

1.27

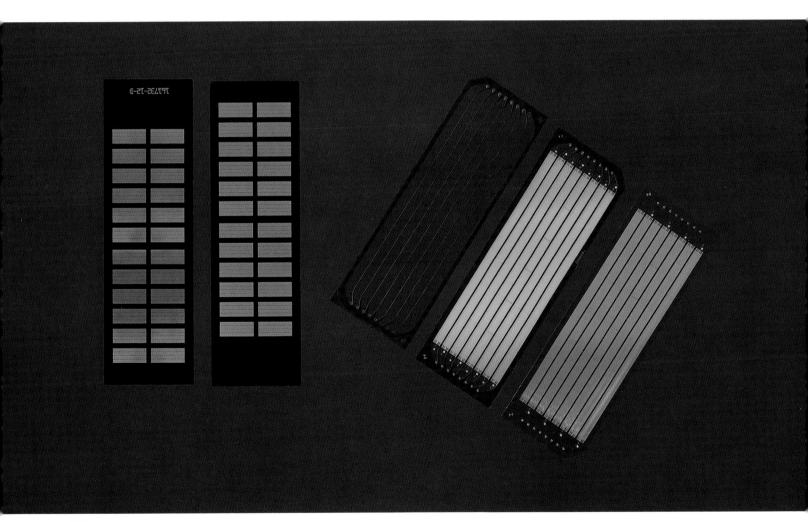
1.28

Again, the setting in the scanner was for reflected light. This is one of those examples where experimenting can give an unusual result – something new and possibly useful.

Now look what happened when I used transmitted light, that is, light from above. **1.29**

1.29

Remember, the scanner's sensor is still capturing the image from beneath the glass. This light source is considered to be *transmitted* – traveling *through* the samples.

Here you see the result. **1.30** The two devices on the left appear as black rectangles.

1.30

That's because the light from above is blocked from being transmitted by the solid silicon material, so that no light reaches the sensor below – the slide appears black. In comparison, the devices on the right show some detail since they are transparent.

As we zoom in to the image, the material on the right shows an interesting detail **1.31** – a detail that we would not see with reflected light. You can compare these details here. **1.32**

The luxury here is having the ability to transmit light through the sample with a scanner that offers transmitted light from the cover. I simply set my scanner in its settings window to the *transmitted* light mode, as if we were scanning film or other transparent material.

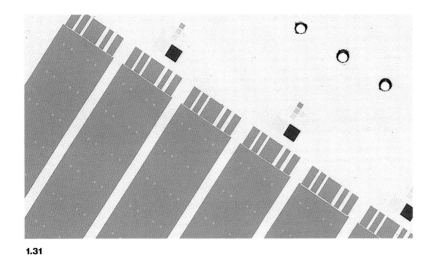

1.31

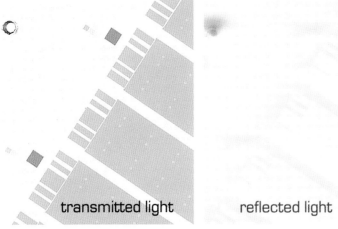

1.32

Here's another dramatic example of the differences between reflected light **1.33** and transmitted light, **1.34** scanning the same device in two modes.

1.33

1.34

MORE ON LIGHT AND RESOLUTION

Let's take a look at biological growth in a petri dish using the reflected light setting. **1.35a**

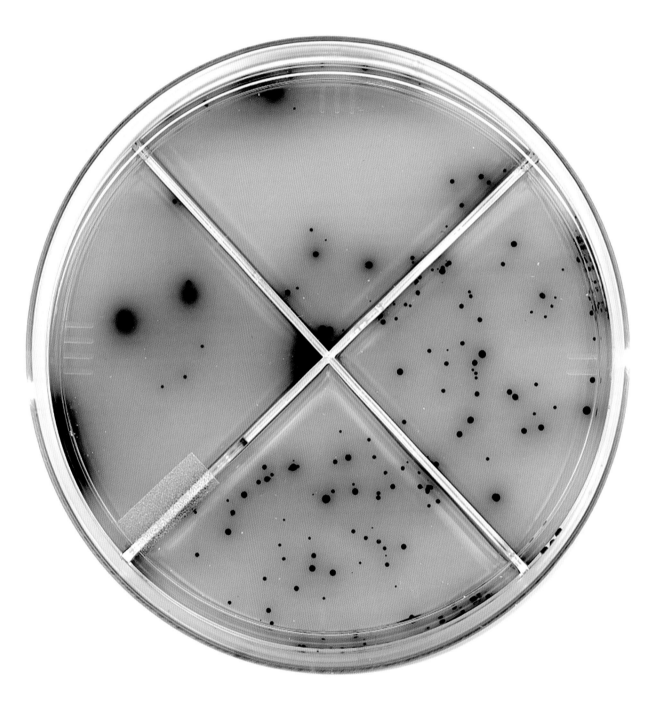

1.35a

Here we see *E. coli* growing under four conditions. I placed the petri dish on the scanner and once again used the default setting for reflected light. The resulting high-resolution file is around 400 MB, which superficially looks fine. But as we zoom in, we see some dust and scratches on the surface of the dish. **1.35b**

So I decided to try transmitted light from above, using my scanner's light source in its cover. **1.36**

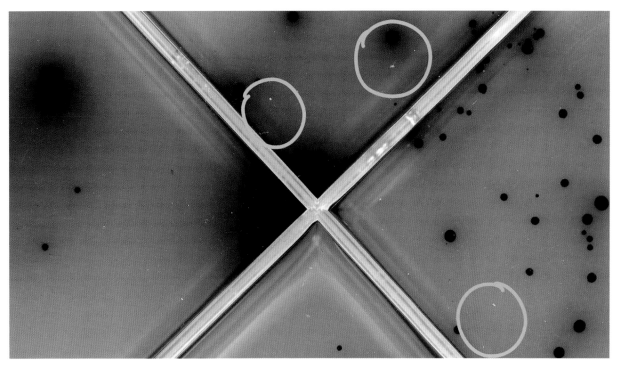

1.35b

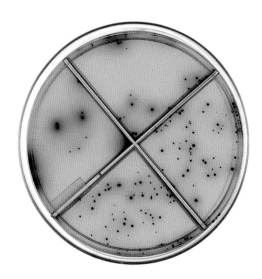

1.36

Using this transmitted light approach makes sense for bacterial and biological growth in petri dishes and is more precise. If you don't have a scanner that has a light in its cover, you still might have some luck with reflected light if your material is pristine.

I want to make a particular point before we move forward. You'll see in chapter 4 how I have changed my mind about using phone cameras. The technology is moving quickly and it's exciting to see the potential of these built-in cameras. However, the problem still is in the file size – it simply is not large enough for most of our purposes. Here I used a mobile phone camera, making a picture that is adequate for quickly showing what's going on in the petri dish. **1.37**

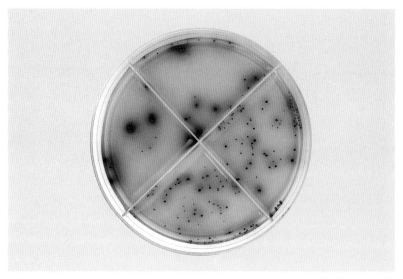

1.37

But the high-resolution scanned image using transmitted light is a whole different world. Layering the phone image over the image made with transmitted light in the scanner drives home this important point. **1.38**

The phone image is considerably smaller in terms of its file size, giving us less resolution and information. When we zoom in closely to each image on the computer screen, we see significant differences in the clarity of the images. In the 400 MB scanned image, we can see remarkable detail. Compare that to the image made on the phone. **1.39**

Your decisions about all of these variables will depend on your purpose. In the end, I encourage you to get the very best image you can *from the very beginning*.

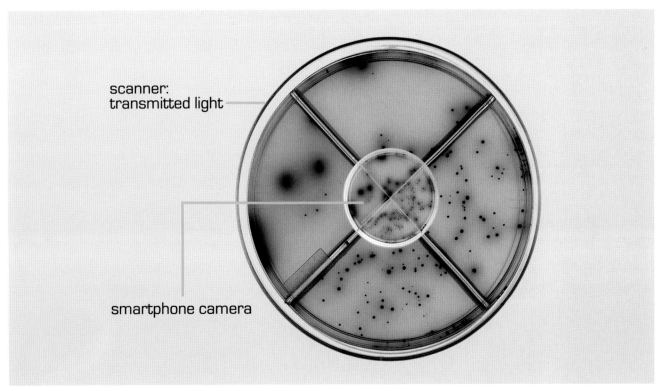

1.38

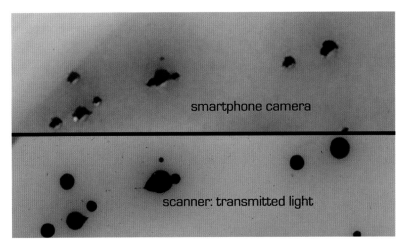

1.39

A NOTE ABOUT BACKGROUNDS

As you will see throughout this book, I am a bit of a background collector.

Whenever some interesting envelope or card arrives in my mailbox, I keep it because it might help with an image one day for my scanner. The same goes for platters, wired thingies, or anything else that might be appropriate for a background placed *over* the small objects and devices for reflected light scans. **1.40**

And besides, it's fun to think about.

You might become a collector as well. Seeing all sorts of material throughout your day as potential background material helps you to imagine your images, even while you are not actively working on them. **1.41a-c**

1.40

1.41a

1.41b

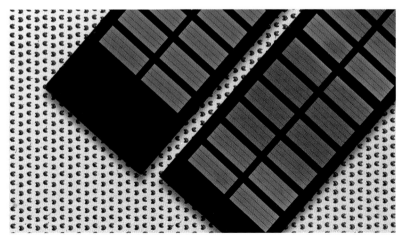

1.41c

Deciding on what background to use for the scanner can have a considerable effect on your final images. I used simple graph paper as a background for this diagnostic device. **1.42a**

Next, I tried some bubble wrap, of all things. **1.42b** This attempt is definitely over the top and doesn't work. There is no visual connection or meaning between this device and the background.

In the end, I landed on using simple green paper. **1.42c**

And because the image was captured at a high resolution – roughly 400 MB – I was able to zoom in, crop, and finalize the image. **1.42d**

Both the simple colored background and the composition work well for this image.

See the how-to-do-it folder on the book's web resources page for a video on how to digitally add a background color.

1.42a

1.42b

1.42c

SUMMING UP

Why use a scanner?

- It's a quick, inexpensive, high-quality camera alternative.

- You can experiment with image capture and share familiar visual content in new ways.

- It's great for drafts, placeholders, patent submissions.

Consider:

- Is your subject appropriate for a scanner?

- Will interesting details be seen? Do they measure somewhere from a few millimeters to a few centimeters in size?

- Depth of field for 3D objects is limited, but shouldn't deter exploration.

- How will the image be used? (cover art? presentation? figure in a journal?)

- The background; make sure your choice is not distracting.

Experiment with:

- Position and placement on the scanner.

- Direction of light.

Check the scanner settings

- Uncheck all image processing.

- More dots per inch provides more resolution and finer detail.

- Capture as a TIFF.

Keep a record

- of your process.

2

CAMERA BASICS

In this chapter we address the basics of using a camera and lens to capture images of your work in the lab, with a focus on camera equipment.

Because this book is mostly about photographing specific types of materials with a particular range of scale within the optical range, I'm going to be very specific in my suggestions for a camera and lens and for other equipment. The photographs you make will be staged. *You* will have control over the look of the image, as opposed to, let's say, photographers who shoot portraits or sports. You are not going to wonder what the images will look like – you will see how your final image will appear as you set it up, light it, and compose it.

I will assume you already have a basic knowledge of your camera (please read your manual!). For clarity, I will review the process of getting the right exposure for our specific requirements. If you are brand-new to all of this, you will find useful websites on the book's web resources page.

CAMERA

You don't need a camera with all sorts of bells and whistles. You just need one that will take various lenses and one that will allow you to manually change your ISO, aperture, and shutter settings. Most importantly, you will need one that can capture an image large enough – measured in file size – to be submitted, say, for a journal article or perhaps a cover. For the latter, for example, you will generally need around a 24 MB file. This works out to approximately 300 dpi for an 8.5 × 11 inch cover. Make sure to choose a camera whose sensor will give you an image of that file size.

LENS

I will be concentrating on using a 105 macro lens. With this particular lens, you will be able to get close to your material or device using macrophotographic techniques. Do not use enlarging filters on a normal lens. The quality of the optics doesn't compare to the optics of a fine macro lens.

OTHER EQUIPMENT

You'll also need a tripod. I suggest getting one with a quick release mechanism that allows you to take your camera on and off the tripod easily. **2.1**

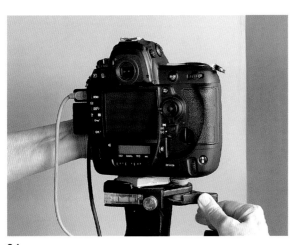

2.1

I want to discourage you from using a copy stand, which I see in many labs. Using a copy stand – where the camera is placed only in one position – limits your point of view. You'll see in the "Point of View" section that having the ability to move the camera around on a tripod not only slows you down, which is a *good* thing, but teaches you to see and to look carefully at your material.

Finally, I strongly recommend that you use your camera in conjunction with your computer. This means using software to (1) make the various exposure settings and (2) store images directly onto your computer, rather than on a card in your camera. Make sure you get the right software for your camera. If you decide not to use software, you'll have to learn how to make your exposure and aperture settings within your camera.

TECHNICAL ISSUES: EQUIPMENT SETUP

The best way to learn to use your equipment is to make pictures. Our first subject will be a device you've already seen – the internal mechanism of a music box.

Let's start with getting the right exposure; that is, capturing the right amount of light from the subject on the camera's sensor. Keep in mind that I am using a 105 mm lens along with the previously installed camera-specific software on my computer. The first step is to open the software and find the window that permits you to set the ISO number. ISO stands for

International Standards Organization, industry's standard unit for measuring light sensitivity.

My software window looks like this. **2.2** Set the ISO number to the lowest possible number so that you can get the finest picture possible. For my particular camera, the lowest setting is 200. That number "tells" the sensor how sensitive it should be while "reading" the light from the subject. The higher the ISO number – for example, 6400 – the more sensitive the sensor becomes. In low-light conditions, a higher (a more sensitive) ISO setting could be the way to go. But remember, in our situations, we have control over our setup. In principle, we should be able to add as much light as we need. More importantly, the problem with setting your camera with a high ISO number is that as the sensor becomes more and more sensitive, it picks up "noise" – electronic signals from the circuitry in the camera. The noise appears as graininess. It is not digital information from the subject, so it is not what we want.

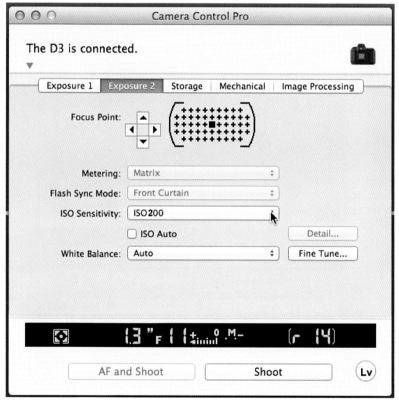

2.2

To see what I mean, take a look at the difference between these two images. **2.3a,b**

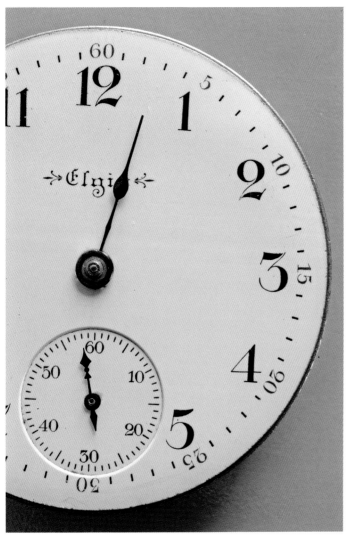

2.3 a

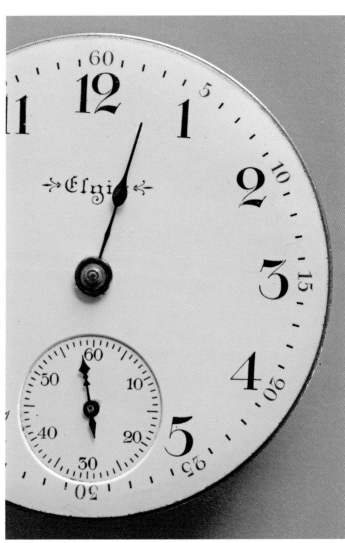

2.3 b

The image on the left was taken with the ISO number set at 200. The right image was taken with a setting of 6400. You might not see the difference in the noise levels at full frame. But now look at the zoomed-in images. **2.3c,d** The graininess of the 6400 ISO image is not what we want.

2.3c

2.3d

Next, locate the window that offers the ability to change exposure settings by adjusting the shutter speed and aperture. **2.4** I generally set the aperture at F/32. For my purposes, I want as much as possible in focus. Notice that "F/32" is indicated in the readout at the bottom of the software window as well.

Next, set the shutter speed, which you choose while looking at the exposure readout. **2.5** Most of the time, we're aiming for the readout to indicate 0, smack in the middle shown in this readout: it's neither underexposed nor overexposed.

The exposure readout is very similar to what you would see in your viewfinder. I find it easier to use the computer screen.

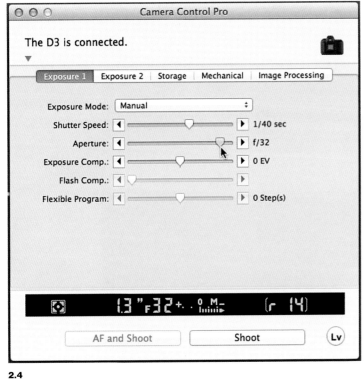

2.4

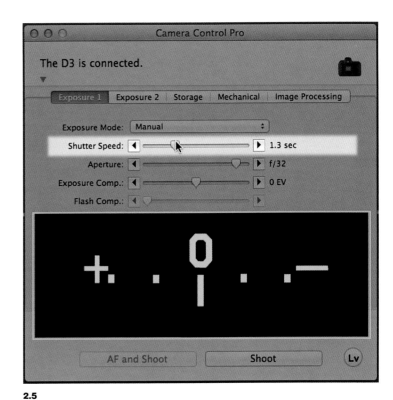

2.5

Here is where the tripod comes in. To get the correct exposure, we might have to set the shutter speed at, say, a half a second. I don't know about you, but if I hand-hold a camera with that very slow shutter speed, the image will not be sharp when enlarged. Look at the next two images. **2.6a,b** The first was taken hand-held and the second with the camera securely mounted on the tripod.

The difference is considerable. Shooting with a tripod offers the luxury of using slow shutter speeds without the worry of an unstable, quivering camera.

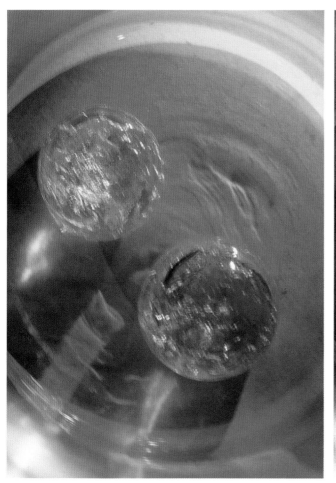

2.6a

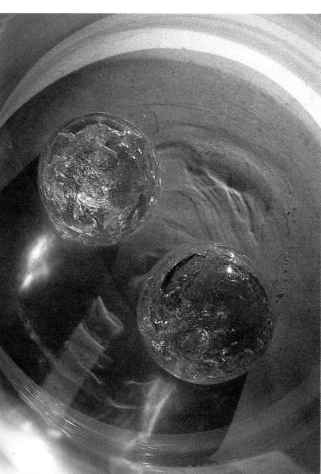

2.6b

Now that you've set the ISO, the aperture, and the shutter speed, you can click on "Live View," which is another great feature of the software. **2.7** This allows you to see two things. First, you can decide whether you have to make adjustments in composition, for example if the subject is not properly aligned. Second, you can see the image at the aperture setting you've chosen – noting what is in focus.

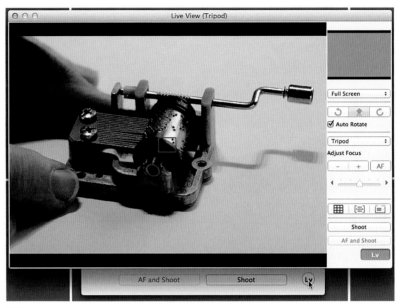

2.7

When you're ready to take the picture, simply click on "Shoot." **2.8**

The image is captured in the camera and immediately downloads onto the computer. It does this quite quickly. And here, too, even with the small thumbnail you see on the computer screen, you can tell if the exposure is on target and if your composition is right. **2.9**

If the image seems crooked, you can go back and forth and fix it in "Live View."

Reviewing the reasons for using software to adjust your exposure setting:

1. Settings are easily seen on your computer screen,

2. You can immediately judge whether those settings are correct,

3. You can adjust your composition in real time (using "Live View"),

4. With the aperture you've set, you can see what is and what is not in focus on the screen, and

5. You can store the image directly onto your computer without worrying about storage space on a camera card.

If you still choose not to use software, all of these exposure settings can be made in your camera. Just read your manual.

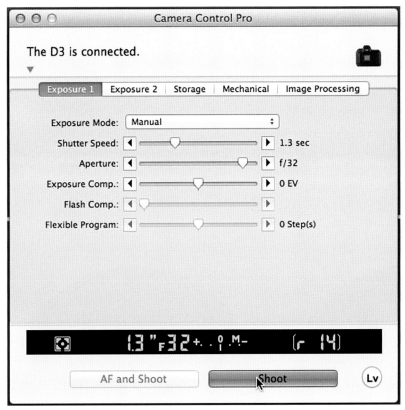
2.8

2.9

APERTURE "IN DEPTH"

Let's look more closely at aperture settings and what is referred to as "depth of field." Depth of field describes what is in focus (and what is *not* in focus) in a picture. Changing the aperture setting adjusts the size of the opening of the lens. **2.10**

The size of the aperture determines how much of your image will be in focus. You can view the chosen setting – called the f-stop – in your camera's viewfinder and in the appropriate window in your software. For my 105 mm lens, the aperture settings can be adjusted by hand with the barrel and with the software. With some newer lenses, the aperture can only be adjusted electronically. Take note when purchasing your equipment.

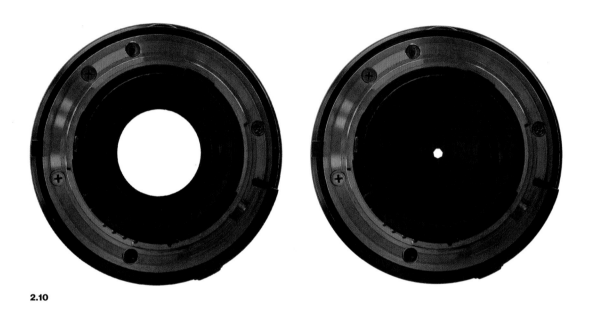

2.10

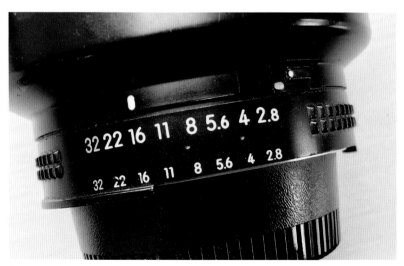

2.11

If you want to see what will be in focus through your camera's viewfinder, you will have to press the "Preview" button. When you do so, the aperture will close down to your chosen f-stop. You then will see the image with the specific focus created by that particular f-stop. But keep in mind that because the preview makes the aperture smaller, the image will become dark and be difficult to see. This is another reason why I like using software, since there is no need to press a "Preview" button. In the software's "Live View," you will see the image with the chosen aperture on the screen without any darkening, making it much easier to *see* what is in focus.

When you choose the largest aperture that your lens offers, we say that the lens is "wide open." For my particular 105 mm lens, the largest aperture is f-stop 2.8. When spoken, we simply say "f2.8," but when written we indicate f/2.8. Notice that the number is actually written as f *over* 2.8. The various numbers written on the lens barrel represent fractions. **2.11** For that reason, f/2.8 ("f over 2.8") gives a larger opening – a larger aperture – than f/4 ("f over 4"). Similarly, f/4 is larger than f/5.6, and so on. This can be a little confusing, but if you think in terms of fractions, it will make sense.

Here is an image I made of the watch we saw before, taken at f/4, **2.12a** and the associated lens aperture. **2.12b**

2.12a

2.12b

Take a look and see what is in focus and what is not. Not very much in either the foreground or background is in focus. Therefore, we say this image has a narrow depth of field. Only a relatively narrow area is in focus.

Here is that same image compared to another, the latter captured at f/11, **2.12c** and the two apertures together. **2.12d** For this comparison I skipped a couple of stops, since it's sometimes difficult to see differences in print.

2.12c

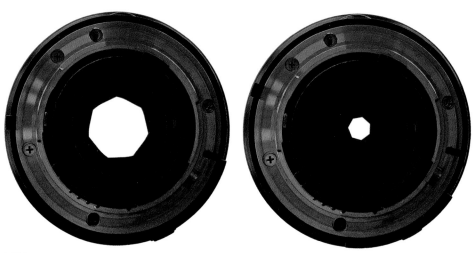

2.12d

Let's compare the two. We see a change in focus. I encourage you to go to the interactive tool on the book's web resources page to see how, as you change the aperture stop by stop, more and more of the watch comes into focus.

For our purposes here, if we skip again to f/32 and compare that image to the first image, f/4, we see a marked difference in focus. **2.12e** Also note the difference in apertures. **2.12f**

But remember, as you close down the aperture to smaller settings like f/32, you will also decrease the amount of light you let into the camera. You

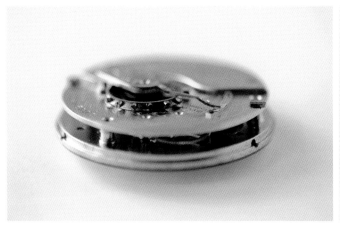

2.12e

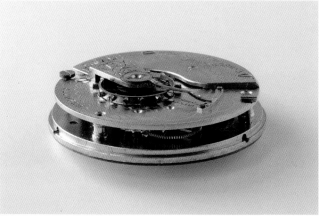

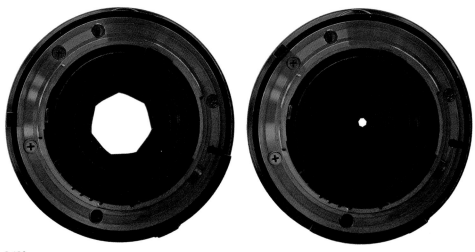

2.12f

will have to compensate by increasing the amount of time the shutter is open when you take your shot. For example, when you change the shutter speed from one second to two seconds, you are keeping the shutter open twice as long, allowing more light into the camera. The longer the shutter is open, the longer you permit light to enter the camera and to be read by the sensor, thereby compensating for the smaller aperture setting.

Special case. There will be times when you will not be able to get all you want in focus, even when you are stopped down. In that situation, you may want to use a technique called focus stacking. For this you create a series of images (five or six) *at different focal planes*. Each image is taken from the identical point of view with the identical exposure. The only difference among them is that you have focused first at the foreground and worked yourself to the back of the material, basically making slices of images. Using software (I use Photoshop), the images are then stacked into one final image that has the depth of field you will want. Just ensure that you don't move the camera. **2.13**

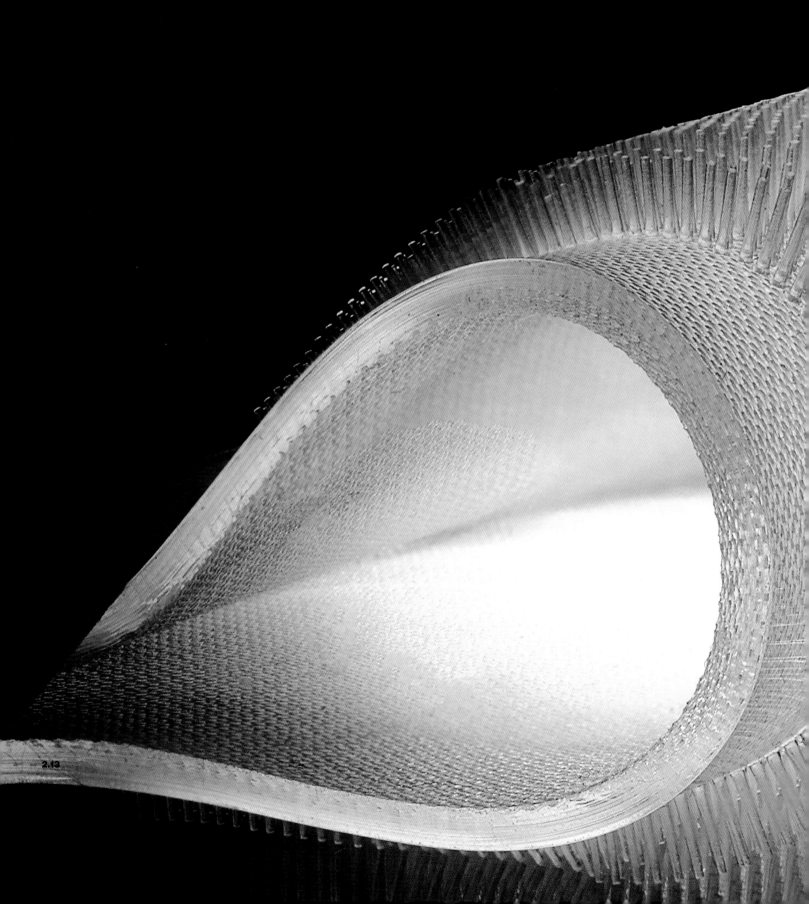
2.13

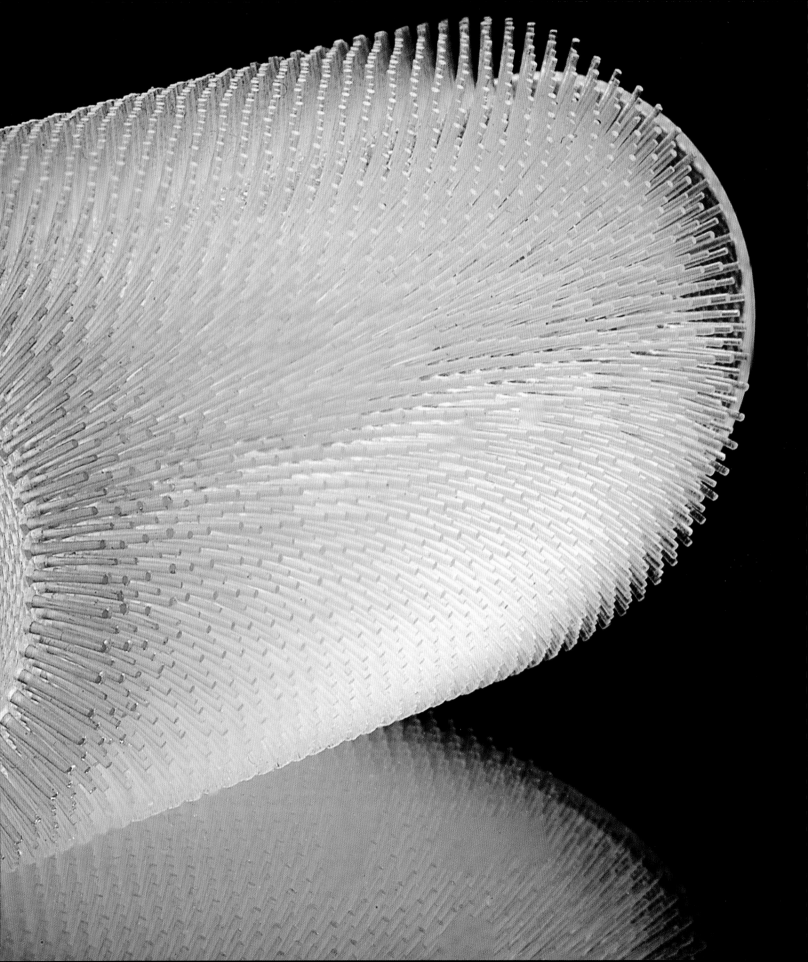

COMPOSITION, POINT OF VIEW, BACKGROUND, AND LIGHTING

It's difficult to separate the concepts of composition, point of view, background, and lighting. They all are determined in tandem. For example, when you adjust your light you're going to get a different kind of shadow, and that shadow becomes part of the composition. So, while we have separated these into separate categories, it is important to keep in mind that they are closely connected.

Let's start with this image of autumn leaves placed on a light box. **2.14**

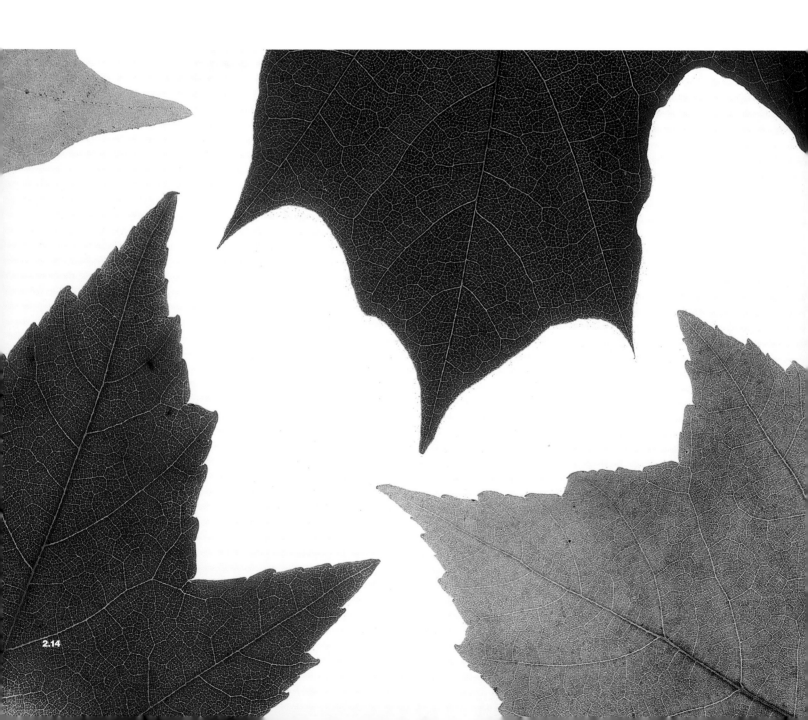

I'll address this piece of equipment in the discussion about light in chapter 3. For this discussion, the light box itself becomes an important compositional element in the image – the light creates strong negative spaces or forms between the leaves. You might find it interesting to play around using a background as a compositional element.

Now take a look at these crystals, randomly placed on a background. **2.15** Notice how the crystals' shadows become part of the composition. You'll see other examples in chapter 3.

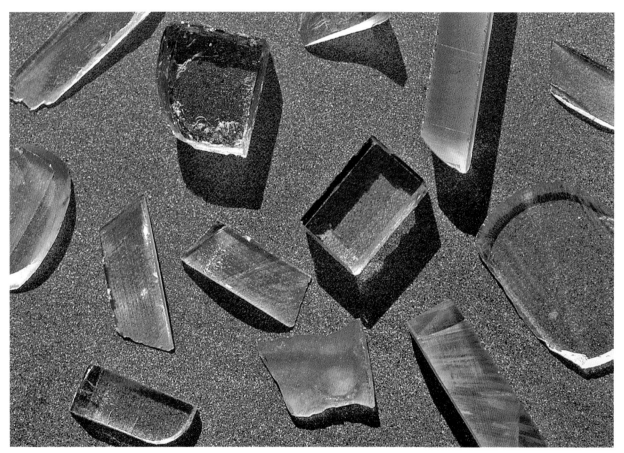

2.15

TAKE TWO ON COMPOSITION

I'd like to suggest that an image is more interesting if you show your subject in pairs, i.e., *two* of something rather than just one.

Here is an example in which I photographed two devices. **2.16a** As well as being compositionally interesting, this approach also demonstrates the researcher's capability of fabricating more than one such device. I photographed the devices in my studio with a skylight above. Notice that there is a problem with depth of field. The device at the top is not as sharp as it should be.

So I stopped down, making the aperture smaller and creating better depth of field, i.e., I got more in focus. **2.16b**

However, note the unintended consequence. So much of the image was now in focus that I could see the reflection of the frame of the skylight above the setup, along with the exterior environment. So once again, all the components of picture-making are connected. In this case, changing the aperture added a new unwanted element to the image. How often have you seen in your photographs a tree growing out of your friend's head? That's because more than you wanted came into focus with your aperture setting. You have to pay close attention and *learn to see* what it is you're including in your image.

Here's another example of shooting "in twos." **2.17** I find it so much easier to compose this way. And once again, the image suggests the ability to fabricate more than a one-off.

2.16a

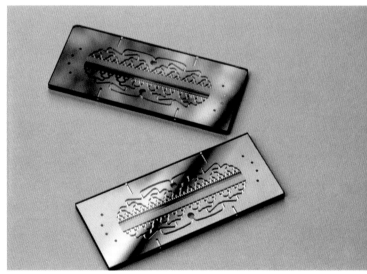

2.16b

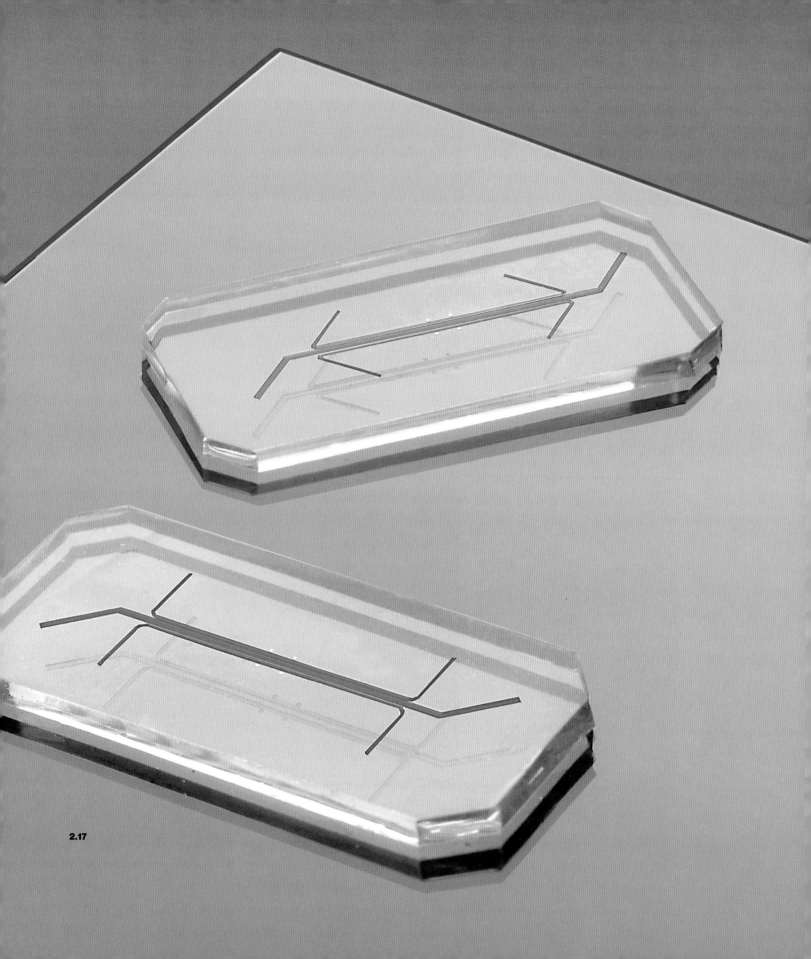
2.17

And here are two acrylic balls that have such small imprinted patterns that light is refracting from the surface. **2.18**

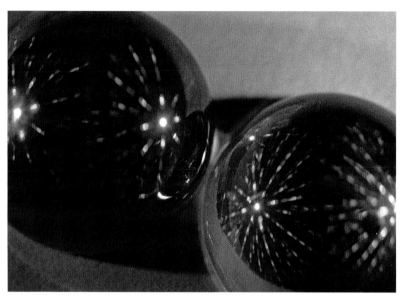

2.18

Next are two silicon chips whose surfaces are also responding to light. **2.19**

2.19

2.20

Here's another duet: two petri dishes of *E. coli*. **2.20** Notice the composition. The two are not placed perfectly in the middle. A little more of one is showing.

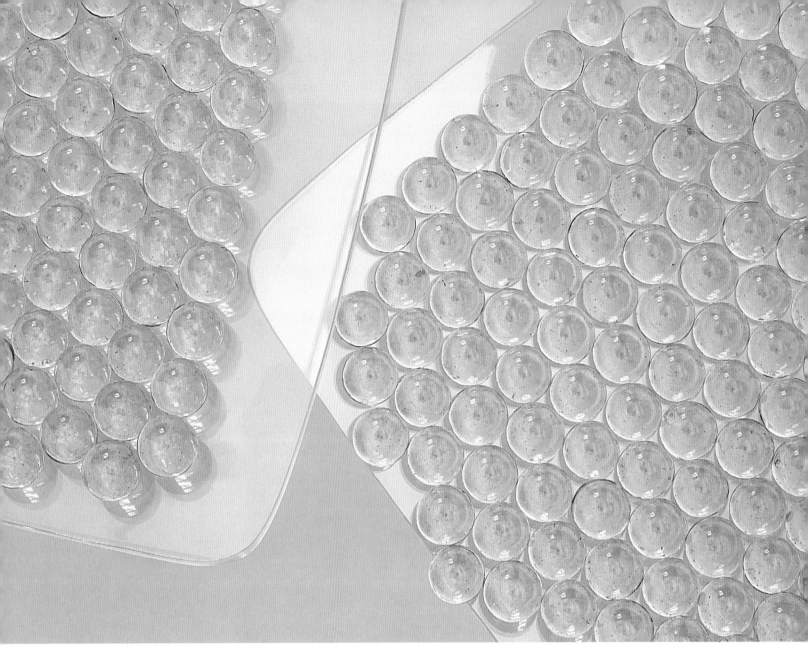

2.21

For our book *No Small Matter*, we wanted to discuss the phenomenon called self-assembly. These are two acrylic dishes with acrylic balls that literally lined themselves up, in perfect order, as I "poured" them into the dishes. **2.21**

And finally, for a journal cover, I overlapped two samples of the fabricated material. **2.22**

It's simply easier to create a nice composition with two rather than one, and an idea I encourage you to try.

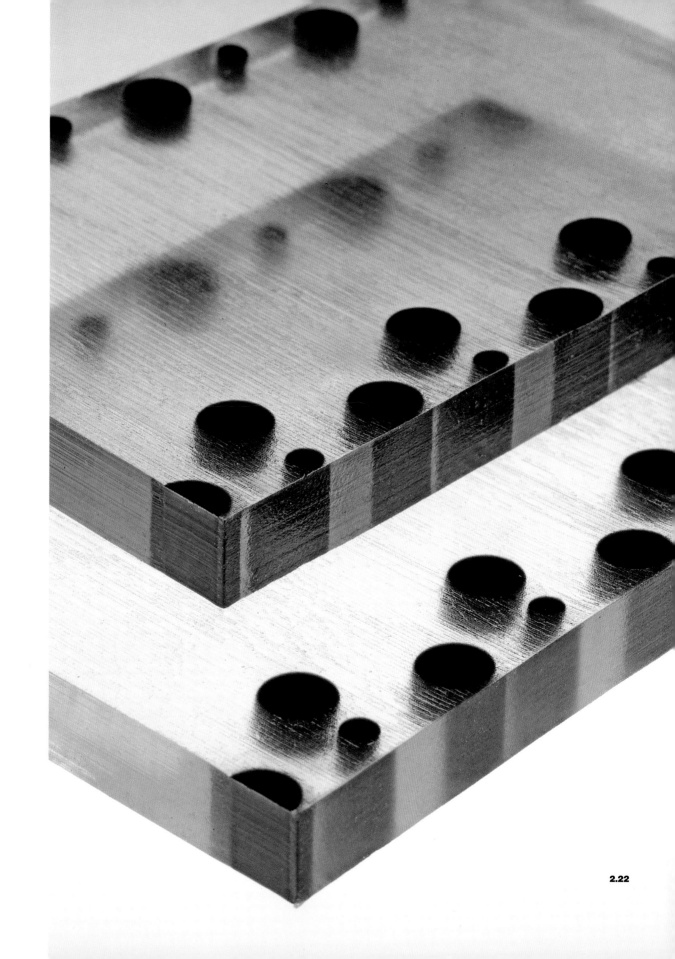

2.22

WATCH YOUR BACKGROUNDS

An important part of making good photographs, especially of small devices, is choosing what to use for the background. Interesting images can be made even more interesting by using a background that works with, or is relevant to, the subject. The selection of the right background can really change an image. But it's important that the background doesn't detract from what you want to say.

Take, for example, this image of our music box. **2.23a**

The issue is the horizontal line where the table meets the wall. Take the extra step and place a piece of paper curving up from the table to the wall (without creasing the paper). You'll give yourself a nice background without that distracting horizontal line. **2.23b**

2.23a

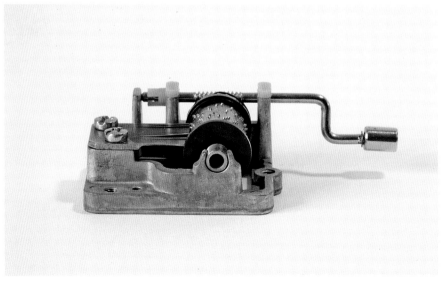

2.23b

These are the kinds of small adjustments I strongly suggest you begin to think about. This particular idea of adding paper to the background is very easy to use with small devices.

Here's another image of a device that was taken in the lab. **2.24a** As is usually the case, the researcher knows exactly what the image is meant to show, but we cannot expect the first-time viewer to home in on what we want them to see. The viewer will generally see all of the mess behind it. Simply take that piece of paper mentioned before, put the device on it, and curve the paper up against the background like before, but this time covering up all the distractions. **2.24b**

2.24a

2.24b

All that extraneous and unnecessary material in the back is hidden, and the viewer can see the device far more clearly.

Sometimes, having the background echo what we're looking at can add an interesting compositional element. I was asked to take some pictures of copper sulfate crystals. So I found two pieces of copper and used them as a background, as a way to suggest the presence of copper in this material. **2.25**

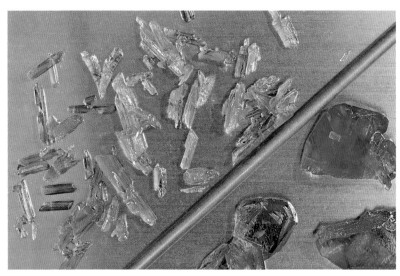

2.25

In these next three images, I attempted to visually offer information within each image about this highly flexible sensor. The first image shows how the sensor was packaged. The next two suggest an important property of the device, its flexibility. **2.26a,b,c**

2.26a

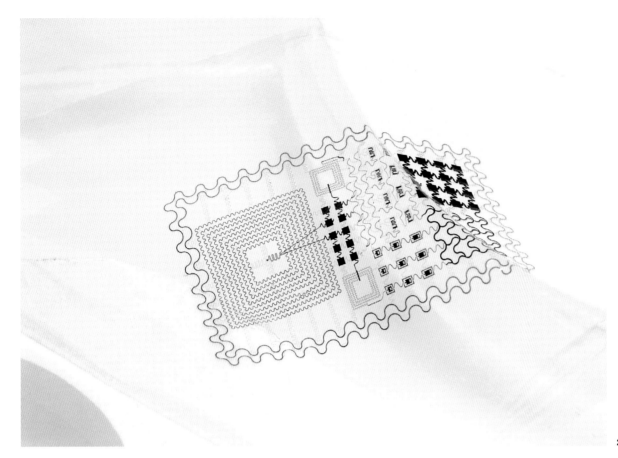

2.26b

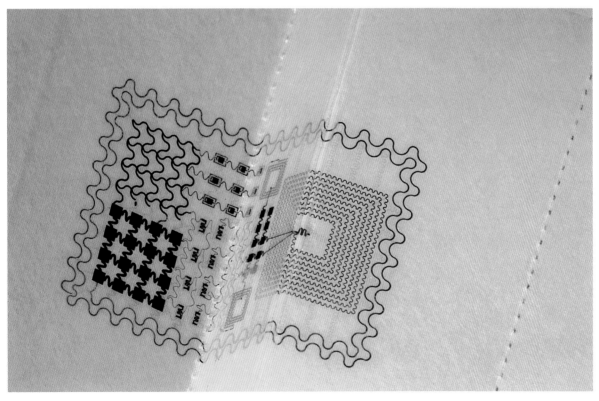

2.26c

Here's an image referring to the phenomenon of how water drops are formed. **2.27a**

2.27a

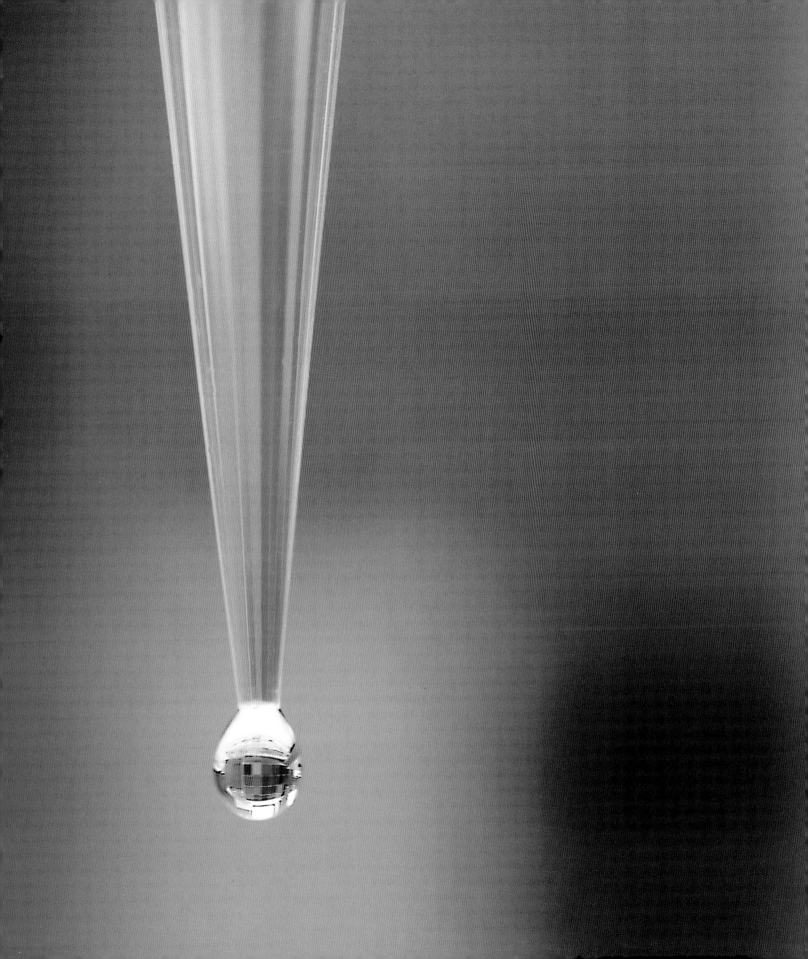

Remember, I'm using a 105 lens. Taking advantage of its narrow depth of field, I used this grid of pastel paints as a background, knowing that the grid would appear out of focus. **2.27b**

2.27b

Incidentally, if you look closely at the drop, and you'll see that it acts as a lens, focusing the background.

For this next image of *B. subtilis* growing in a petri dish, I decided to layer a couple of backgrounds. I first placed the petri dish on blue plastic and then I put the blue over orange plastic. Also note the composition. **2.28**

2.28

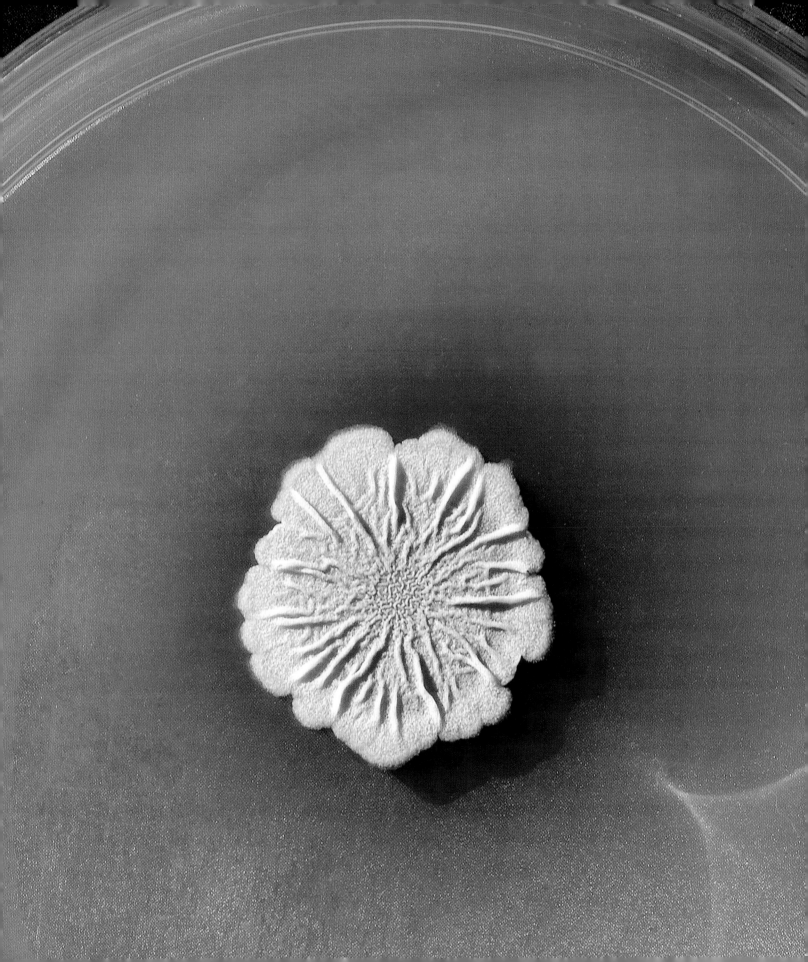

Here's another example of layering backgrounds. I first put the device on a blue Post-It note and then both onto a black surface. I think this works. **2.29**

In this next layered idea, I used a crazily patterned background. This one doesn't work. The background only gets in the way and adds nothing to the image. **2.30**

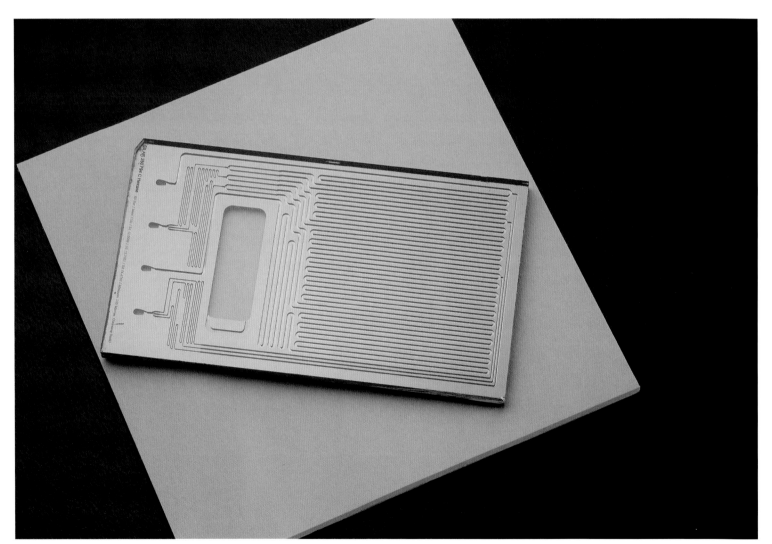

2.29

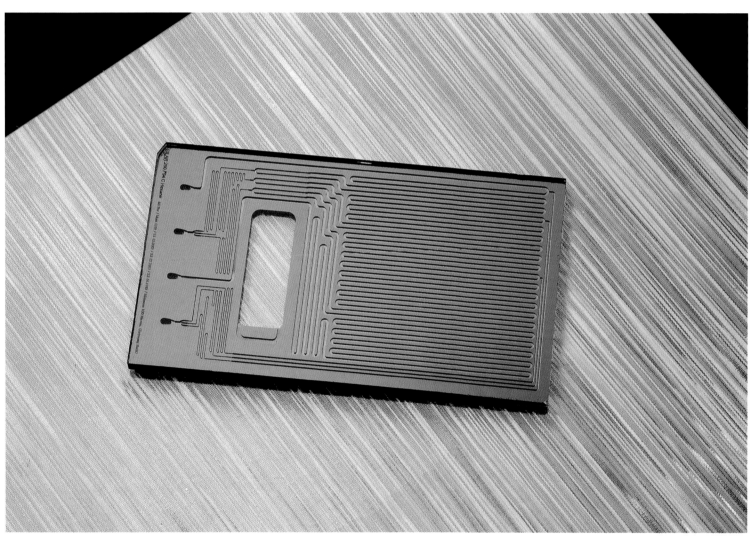

2.30

2.31

In this image, I used sketches of the CAD drawing used for the design of the device. **2.31** I like the idea of showing the human element in the fabrication of high technology.

Below is an electronic chip, shot with two backgrounds. **2.32** Note how a subtle change in camera angle (point of view) between the last two images shifts the colors.

This is an example of how composition, point of view, and background are all connected. A change in any one of them results in a change in the image.

For the image on the next page, returning to an attempt to show the ability to make various crystals, I used some weighing paper on top of my desk. Notice also how I incorporated the daylight and shadows from the window for compositional elements. **2.33**

 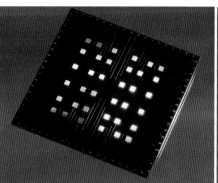 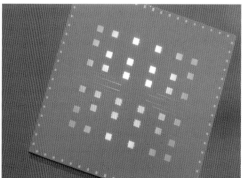

2.32

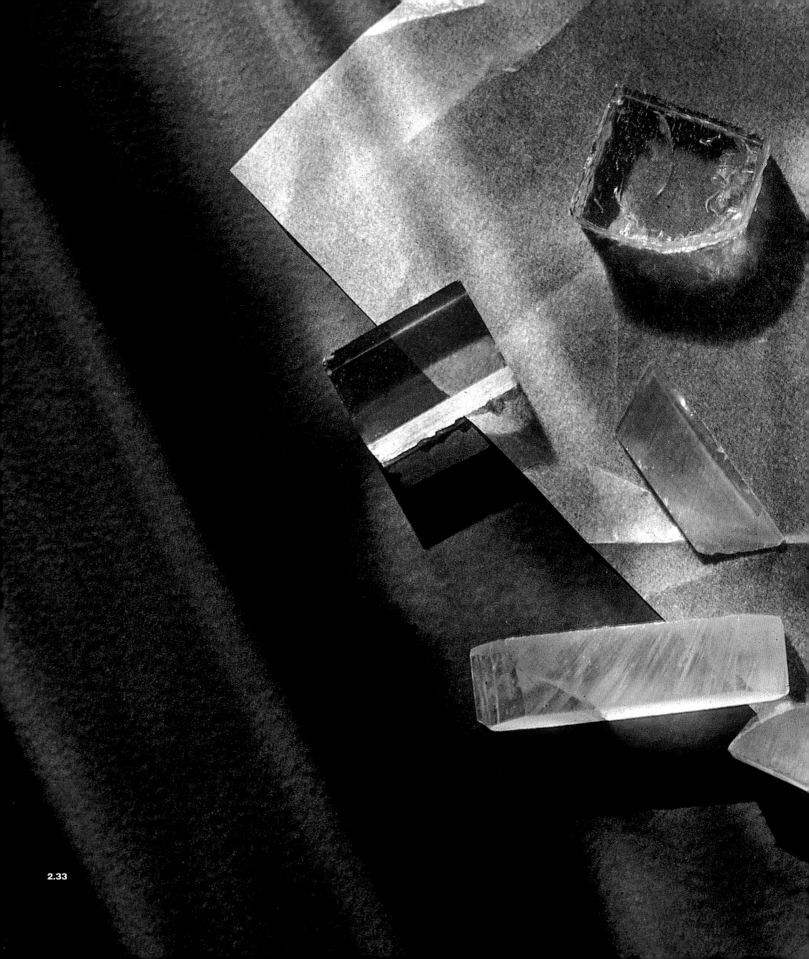
2.33

And here, we see similar weighing paper as overlays of shapes, creating a simple background for some powdered material from a lab. **2.34**

For this next image, I made use of the reflective quality of a large piece of glass as a background under glass slides. **2.35** The surfaces of the slides were hydrophobic. I then placed drops of water on each slide. The idea was to emphasize the hydrophobic quality of the surface. In this case the reflections of the drops beneath the slides might be more distracting than useful. I'm not sure.

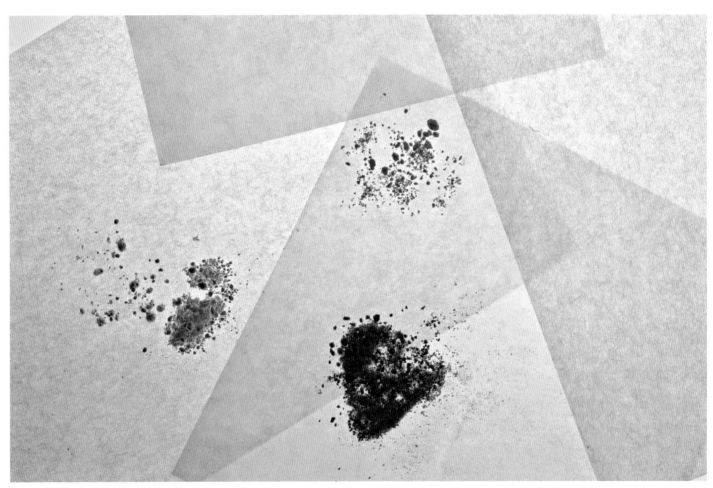

2.34

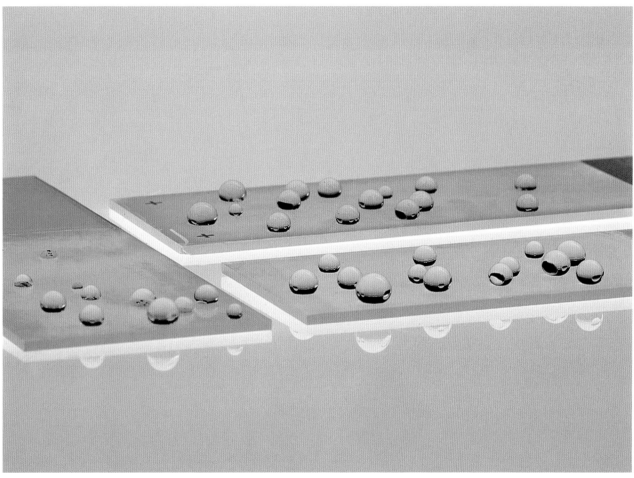

2.35

And for the image on the next page I used a yellow round table as a background, echoing the shape of this particular metallic material. **2.36**

2.36

Below is a photograph of a small flying robot, measuring about one centimeter long. **2.37** I used the plastic box and cover in which it arrived as part of the image composition. They add interesting compositional elements.

The one on the right was a very quick test image that I made just to see what kind of depth of field I would get with these one-centimeter-wide devices. **2.38**

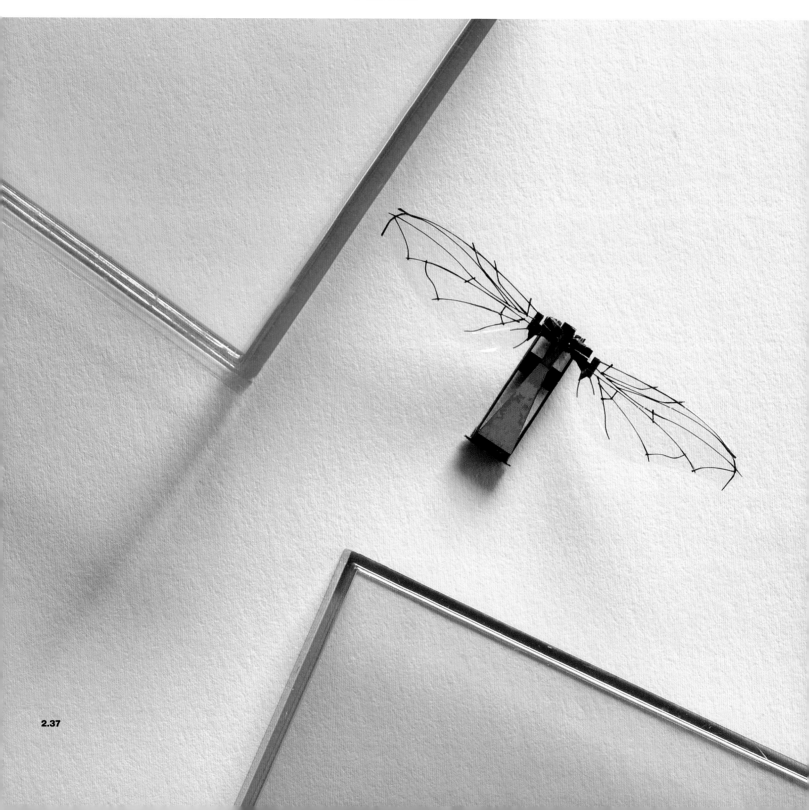

2.37

2.38

It turned out that I liked the haphazardness of the image. The background was accidental, and for me it works. I go into more detail on how I made the final image in chapter 8, case study 9.

POINT OF VIEW

Deciding on the right point of view is not as straightforward as one might think.

Sticking with your first approach might not be the best choice. I encourage you to move the camera and your materials around to various points of view. Not only will you land on what might be the best choice, but you will also broaden your thinking. All of these images are of the same material, taken from different points of view. **2.39** The backgrounds have also been slightly changed; but for the most part I simply moved either the sample or the camera to a different angle for four of the images. One was made on the flatbed scanner. Which one is "right?" Or is there no such thing?

2.39

I took this next mage of a microrotor from above, using a new stereo microscope. **2.40a** Your choice of equipment could enforce a particular point of view since the placement of the camera may be rigid, as it was in this case.

Unfortunately, from this point of view, we see all kinds of dust particles. Returning to make the image with my camera and 105 lens where my equipment offered me a different point of view, I captured a much cleaner image. **2.40b**

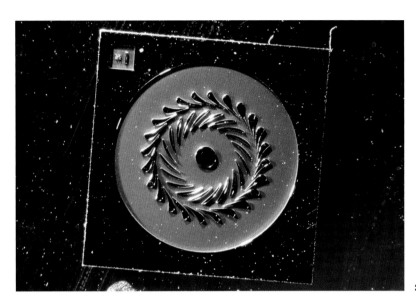

2.40a

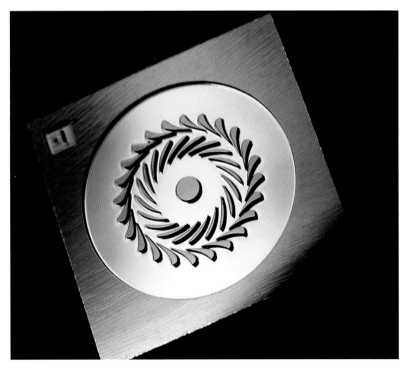

2.40b

Getting stuck with a particular approach – such as placing the camera directly above in this case – doesn't necessarily give the best image.

Here is a glass wafer that's been etched to create channels on the surface. This image is from one point of view, showing the full wafer. **2.41a**

But here is another point of view, showing only part of the wafer. **2.41b**

Sometimes, showing the sample in a more compositionally interesting way, with a different point of view, works best.

2.41a

2.41b

Here is John Rogers's point of view when he decided to show the flexibility of this material. He included his hands to suggest scale. It works well.
2.42a

I decided to play around more with the flexibility of the material and to include some reflections and shadows in the image to emphasize the various shapes (next page). **2.42b**

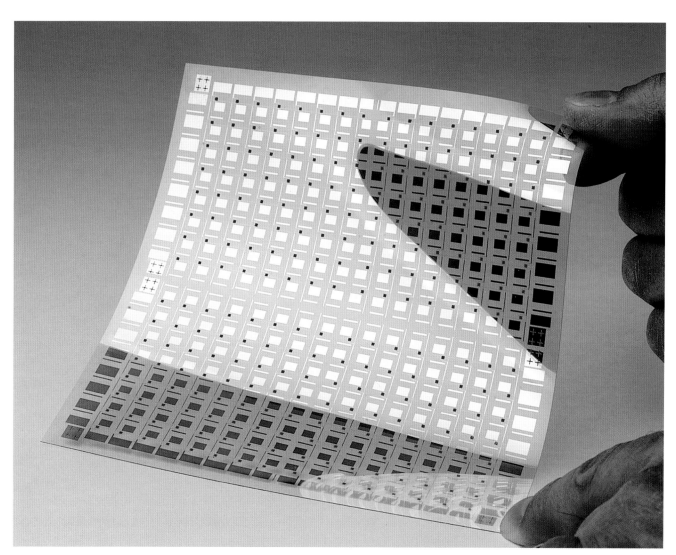

2.42a

2.42b

In that case, we got a journal cover, which is always nice. The image I made is a completely different point of view of the same material. Both are good; it is not clear that one is necessarily better than the other.

And here are two more points of view — of 3D-printed material. This is a good time to remind you that making images is, in fact, creating a 2D view out of three dimensions. Your view becomes a flatland. When I first held this object in my hand, I anticipated making the image from the side view. **2.43a** However, after moving around the sample, I changed my mind. I decided that the overhead view is easier to read *as an image*. **2.43b** Think about it.

2.43a

2.43b

This image is of a device from the researcher's point of view. **2.44a**

And below is my point of view. **2.44b** I simply shifted the device to a slant, changing the camera's point of view, and placed it on a white background. I think this one is a more successful picture.

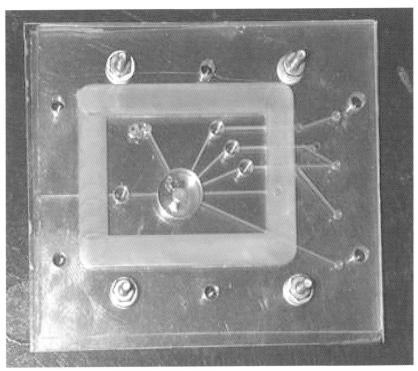

2.44a

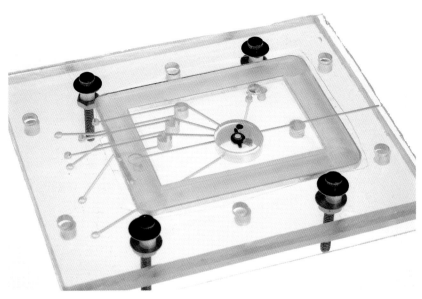

2.44b

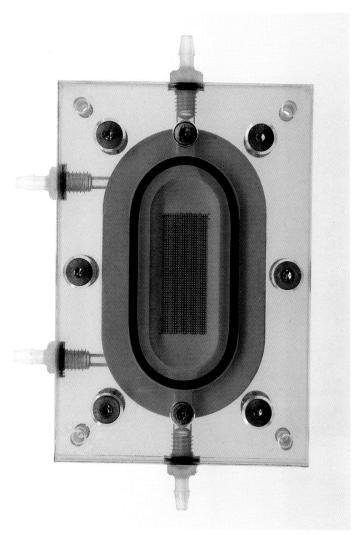

2.45a

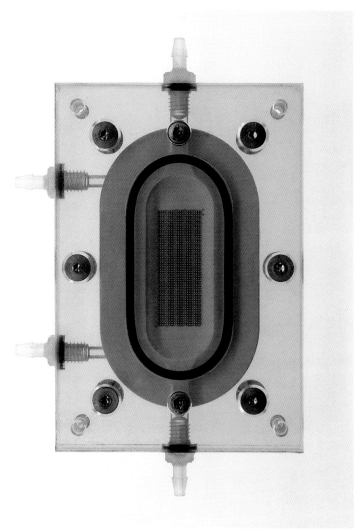

2.45b

Finally, when you have a device that is more or less symmetrical, and if you are going to take a photograph from above, you had better make sure that you make the image precisely symmetrical, i.e., perfectly aligned. Take a look at this first image. **2.45a** There's nothing worse than an *almost* symmetrical image. Get it right. **2.45b** It matters.

SUMMING UP

Use the right tools

- Camera, macro lens, tripod with quick release.
- Use software to control exposure settings for ISO, aperture, shutter speed.

Exposure

- Set the ISO number to the lowest possible setting (higher setting is more light-sensitive).
- Set the aperture to the highest possible setting (f/32).
- Adjust the shutter speed to match 0 on exposure readout.

Aperture

- This opening determines depth of field, i.e., what's in focus.
- Aperture is written as f/ number.
- The larger the number, the smaller the aperture and the more is in focus (greater depth of field).
- A smaller opening delivers less light to the sensor, so the shutter must be open longer.

Composition

- Be aware of negative space and shadows.
- Simplify a busy image.
- Try two or more of the same object to contrast orientation, scale, or color.

Backgrounds

- Watch for seams and horizons; use a sheet of paper or container to remove seams.
- Narrow the depth of field to soften edges or distracting backgrounds.

Point of view

- Distance and angle (and resulting shadow) affect the final image.
- You can provide context for size or location, or to convey dimensionality.

Keep a record

- of your process

3

LIGHT

Any book on photography – by definition: drawing with light – *has* to include more than just a reference to light. Light is *the* essential component in the photographic process. One could easily take up all the pages in this book and only scratch the surface of the subject. Here we are going to provide something of an overview, showing various characteristics that some light sources offer. We can't address every conceivable possibility. What we can do is pique your curiosity – to urge you to pay close attention to what you see and how these light sources affect the image-making process. For example, as you look at the shadows, discern how they, and the highlights, change as the light source moves. **3.1** In this chapter, as in all the rest, I will encourage you always to observe exactly what is going on – even when small changes are made. I am not going to encourage using a prefabricated tentlike lighting setup, such as you will often find in other books on macrophotography. For one thing, using the same setup for all your work would get formulaic and boring. But most important, as the ongoing mission of this book is to encourage you to learn to *see*, the idea is to closely look while photographing your subject with different light setups. I am convinced that coming up with your own unique approach to lighting will affect your scientific thinking.

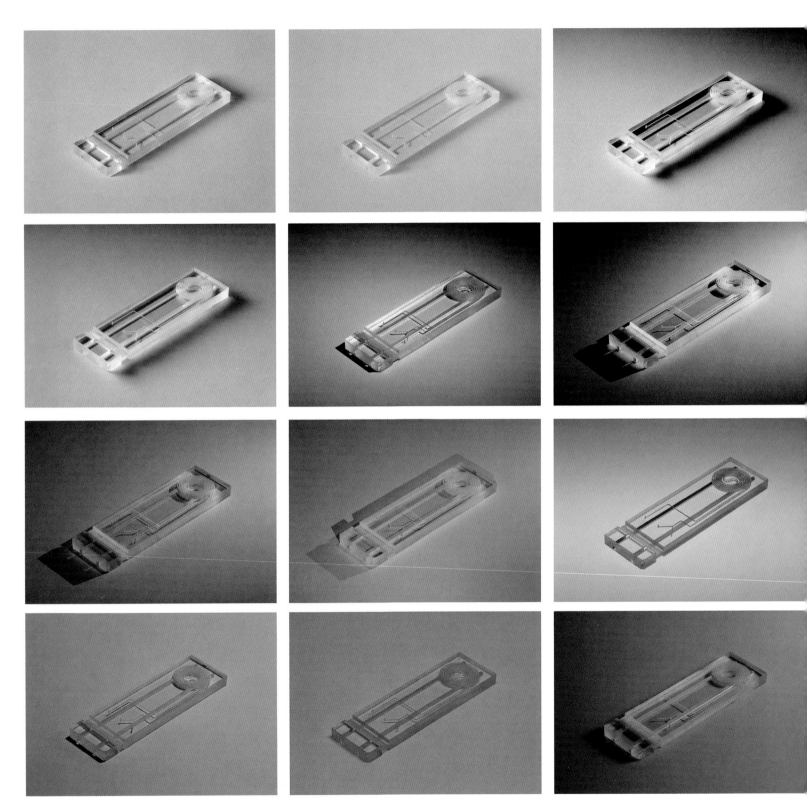

3.1

We'll start with a very simple piece of equipment, a lightbox. **3.2**

It's a good and uncomplicated light source when working with transparent material. Simply placing the object you are working with directly on the lightbox, like this petri dish, works easily. **3.3**

(We will see later that this simple lightbox can also be used as another general light source.)

In the previous chapter we saw an image that works quite well with the lightbox – two petri dishes growing *E. coli*. **3.4**

3.2

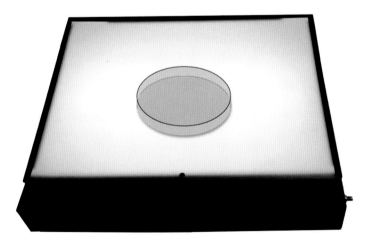

3.3

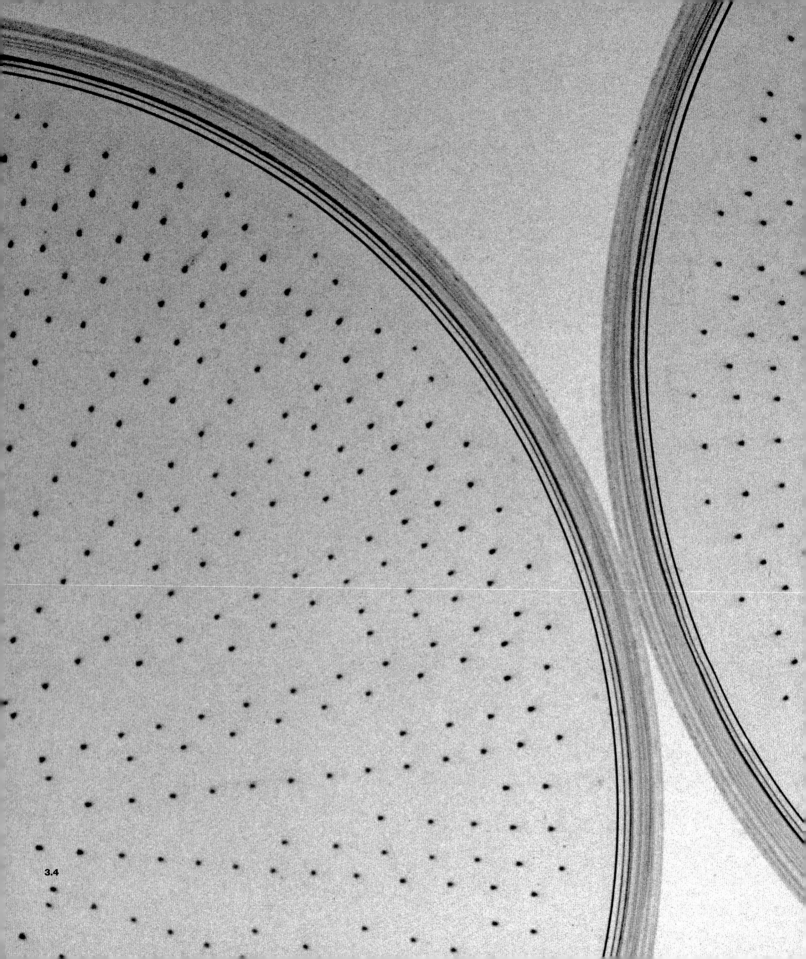

3.4

In the next image, we see small, geometric pieces of colored plastic, about 3 millimeters across, that are organizing, or self-assembling, at the interface between two solutions. They're becoming a flat assemblage at that interface. **3.5**

Once again, I simply placed the glass container holding all the material on the lightbox and shot the phenomenon without showing the container.

Next are images of sugar crystals nucleating on wooden sticks (a gimmick that some coffee shops offer). **3.6a**

By digitally inverting the image, a process we have also seen before, we get another iteration. **3.6b**

In the image on the next page — whose subject is hopefully recognizable by now — we see a kind of lighting that is different from what we've seen in the previous images of the music box. **3.7**

3.5

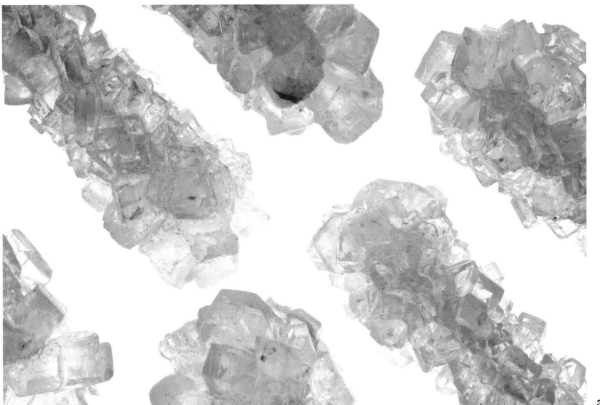
3.6a

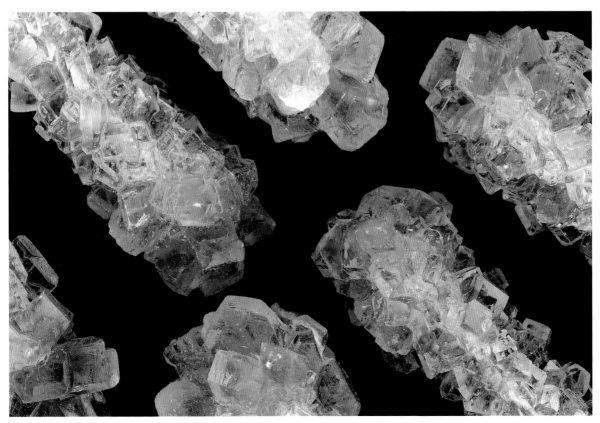
3.6b

3.7

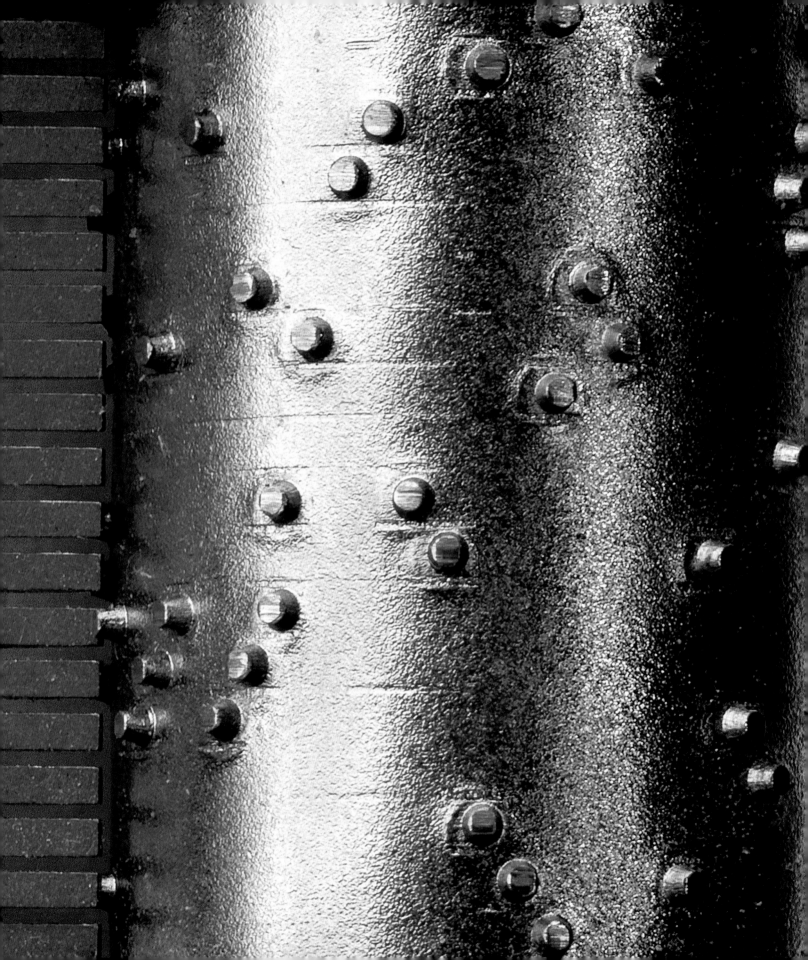

I shot from directly above using mostly daylight from a window, with some added light from four tungsten bulbs from a lamp above. Here's the setup. **3.8**

This was specific to this situation, but you might find it helpful in one of yours.

Take a look at what happens to the picture on the right **3.9a** when you simply add a small additional light source. **3.9 b**

Notice how the image is changed dramatically just by an additional lamp above this fishing reel. (Yes, that's what this is – a fishing reel placed in a green garbage can!)

For that image, I thought it would be fun to see what quality of light I could get by shooting into a plastic, translucent garbage can, with ambient light filtering through. **3.10** We'll address the idea of using your imagination to conjure up some unusual lighting techniques at the end of this chapter.

3.8

3.9a

3.9b

3.10

And again, just by adding one more light – this time inside a chamber producing silicon wafers – we see this image **3.11a** become this. **3.11b**

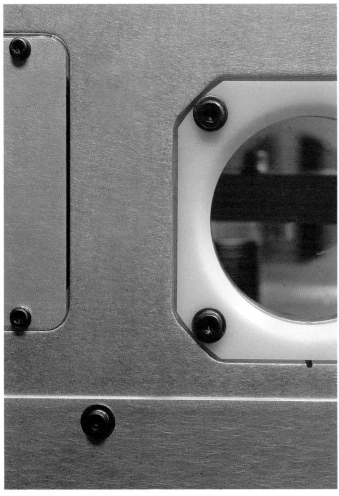

3.11a

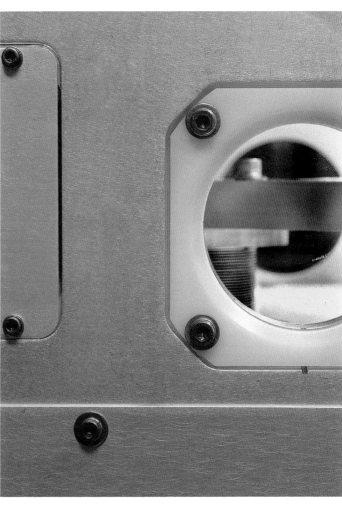

3.11b

In this image of a triangular water drop, about 1 centimeter long, we can see the reflection of the lamp. In this case, I simply directed the lamp onto the drop. This is considered direct lighting. **3.12a**

With *bounced light,* I first directed the lamp onto a gold card and bounced the light back onto the water drop, giving a completely different quality of lighting. **3.12b**

I used a gold card because the water was on a gold surface. The bounce gives a diffuse quality to the light.

You can think of other material you could use to bounce light with (for example, a mirror or white card) to create a fill, which does exactly what the word implies. It doesn't offer a main source of light but fills in with a small amount of additional light.

3.12a

direct lighting

3.12b

diffuse lighting

In these next three photographs of the familiar watch from before, I used different fills. The main source of light was daylight from a window.

This first image is with daylight alone, on an overcast day with no shadows. **3.13a**

Here I added a white card placed on the side of the watch for a fill. **3.13b**

And here, a mirror reflecting daylight back onto the watch, again as a fill. **3.13c**

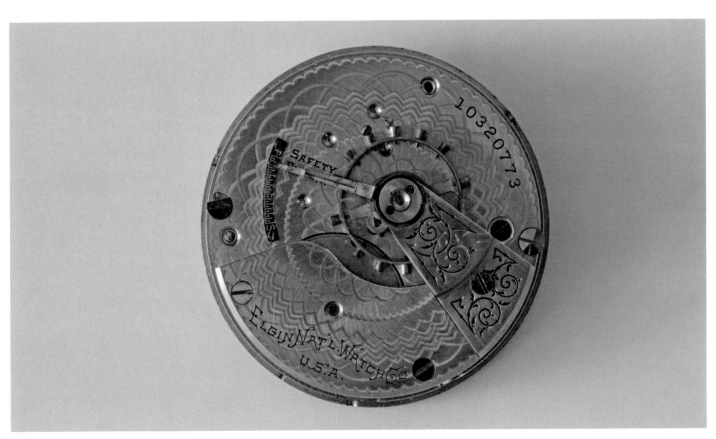

3.13a

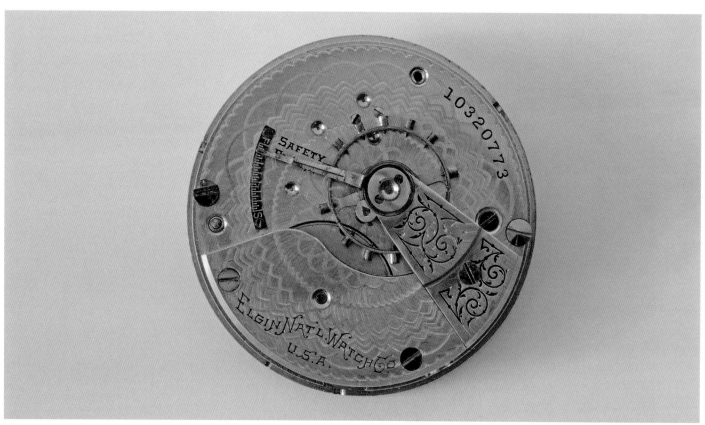

3.13b

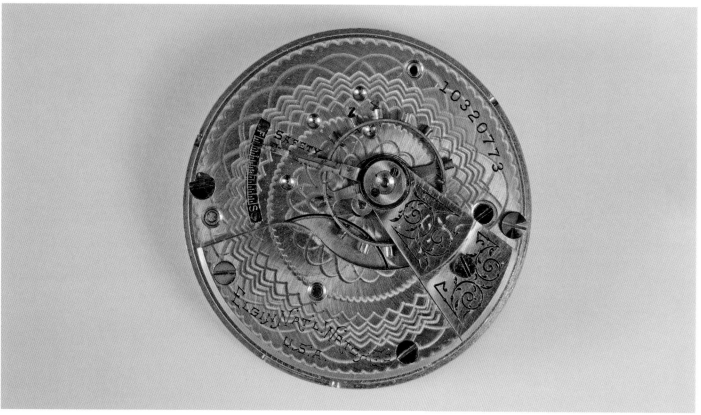

3.13c

If we zoom in, we can see the subtle differences among them. **3.13d**

Depending on your material, you might see more dramatic changes. I encourage you to experiment with these ideas.

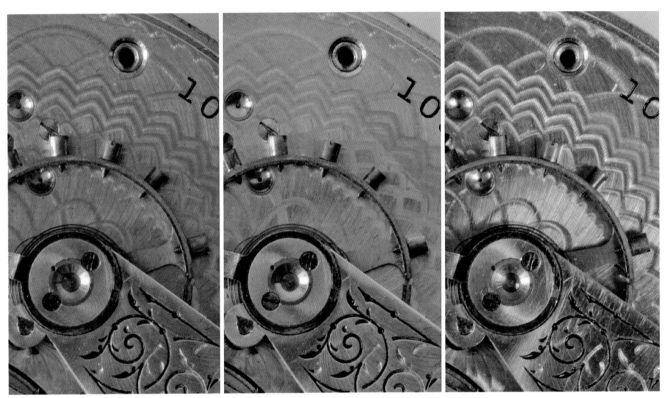

3.13d

SHADOWS

Where there is light, there is shadow – at least some of the time, especially if the light is strong and direct. Looking carefully, you will see how small changes in the positioning of the light, along with some other tricks of the trade, can alter the quality and positioning of shadows in images.

A powerful direct light source can produce a significant shadow, and that shadow becomes a very strong compositional element in these two images. **3.14, 3.15**

3.14

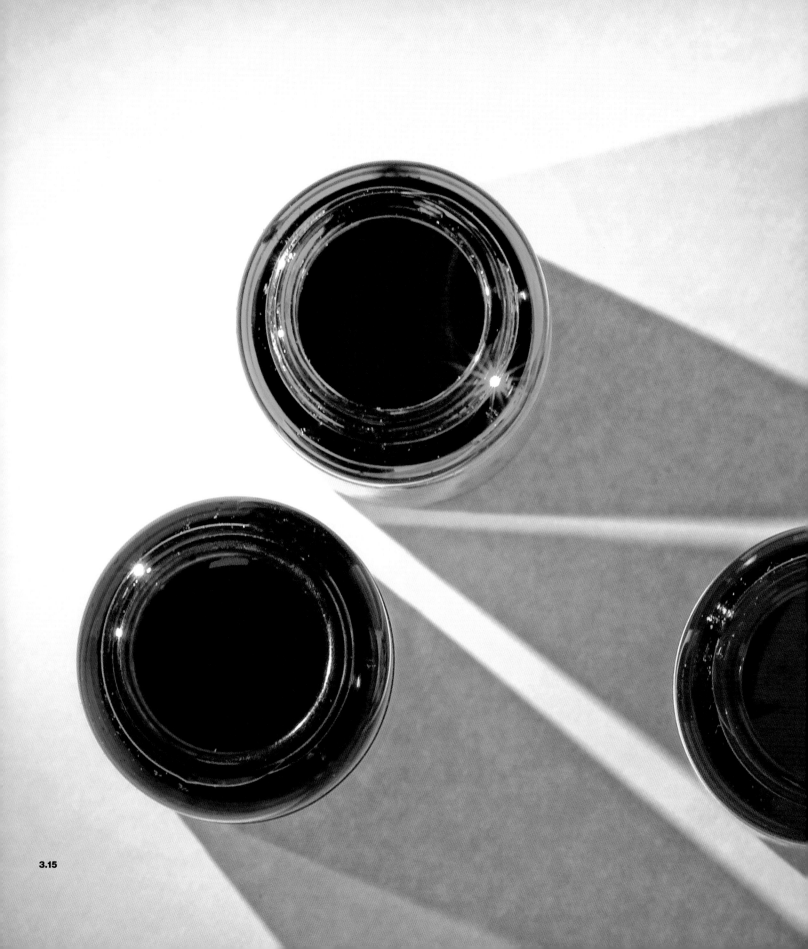

3.15

CHAPTER 3 / LIGHT

Here is a wafer with imprinted chips. In this particular image, I was playing around and decided to use just a slant of light that translated into a heavily shadowed area on the rest of the wafer. **3.16a**

With this next image, using a diffuse lighting setup, no shadows appeared. **3.16b**

I prefer the first image, but I introduce both to encourage you to think about the possibilities in using shadows as part of the composition.

3.16a

3.16b

In comparing the next two images, you can see that I added a shadow in the second image by placing a card in front of the light source. The point was to better communicate the presence of the grating on the surface of the triangular plastic. The dispersion of the various light wavelengths is better seen with the presence of the shadow. **3.17a,b**

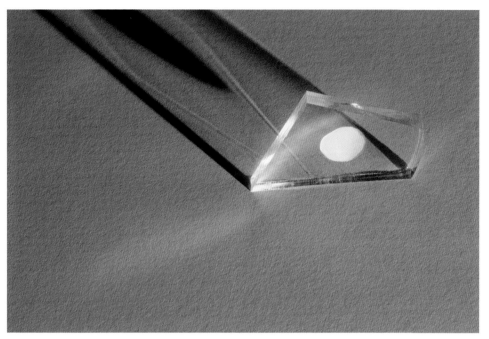
3.17a

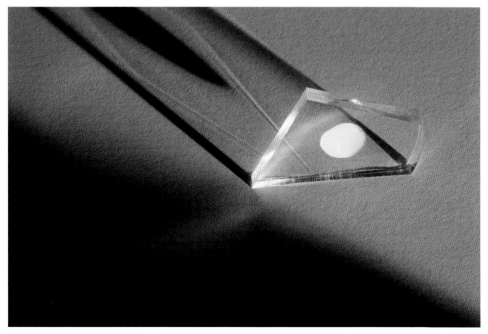
3.17b

Shadows alone can tell a story. In the next couple of images, I was trying to depict the Marangoni effect, a complicated surface phenomenon which occurs when a glass of wine is swirled. Some refer to it as "tears of wine." The first image is an unsuccessful attempt to capture the Marangoni effect. **3.18a**

Realizing that I should concentrate on the *shadow*, I simplified the image, which brought more attention to what was happening. **3.18b**

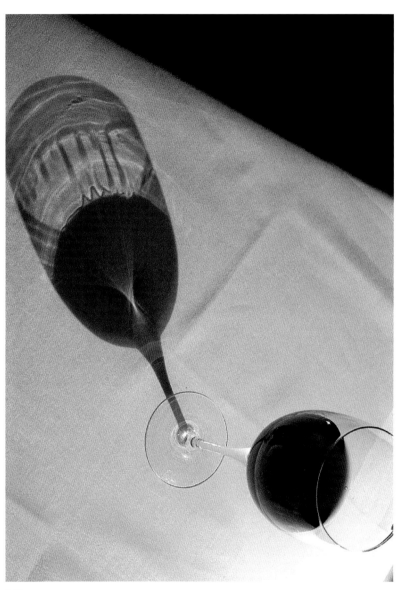

3.18a

3.18b

Here I encourage you to go to our online interactive tool, created by Ben Mandeberg, on the web resources page. Along with being fun to use, it helps you see how small adjustments in lighting change an image. In the image below, for example, you can surmise where the one light source is placed. **3.19a**

It is as simple as saying to yourself, "if the shadow is *here*, then the light has to come from *there*." I lit the setup for this device with a single light from the upper right.

In the next example, I lowered the light source. You can deduce that because of the longer shadow. **3.19b**

Next, I added a second light source to the previous setup. **3.19c**

Here's the device with simple window light. Although the quality of the light is diffuse, you can still tell where the window is. **3.19d**

Why bother looking at all of this? Once again, this is about learning to see. When you play with your own light sources and your own devices and material, you will pay greater attention, not only to the lighting of your device, but also to the shadows that your lighting will produce. With every small change, you are adding or changing components in your images. And as you add more components, you are either helping the viewer to *see* or hindering her from seeing what you want her to see.

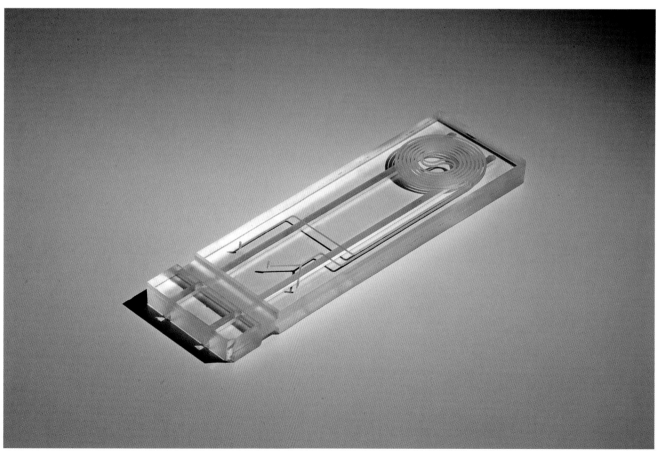

3.19a

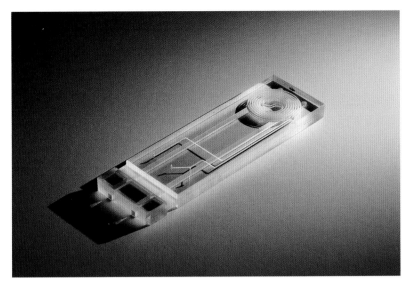

3.19b

3.19c

3.19d

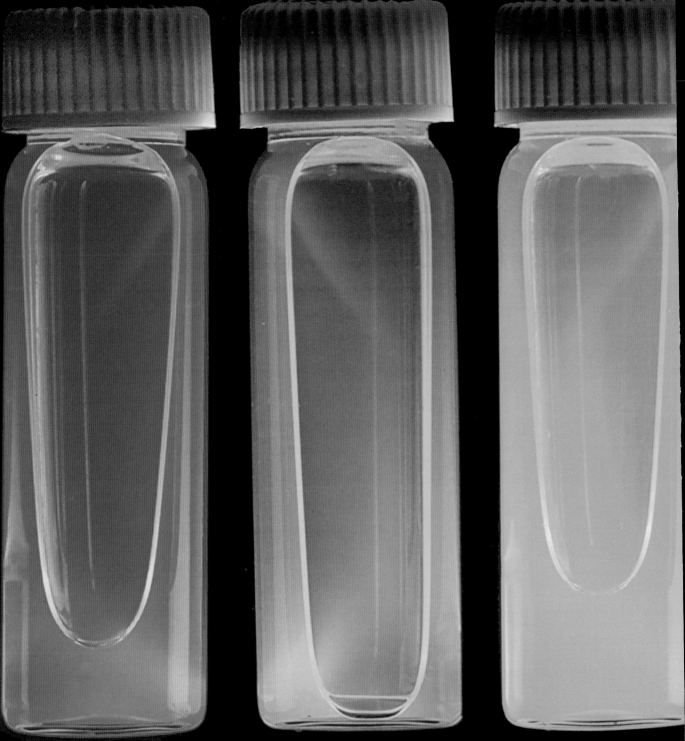

FLUORESCENCE

For the most part, photographing fluorescing material requires long exposures, which is possible here since the camera is attached to a tripod. The image on the preceding page is of a series of vials containing cadmium selenide nanocrystals (quantum dots) that have been excited with two ultraviolet lamps. **3.20**

The exposure was about four seconds, with the camera mounted on a tripod. I purposely set the camera above the vials, which were placed on black material. You can imagine the setup, in which the vials are lying on their sides and the camera is above, because of the presence of air bubbles.

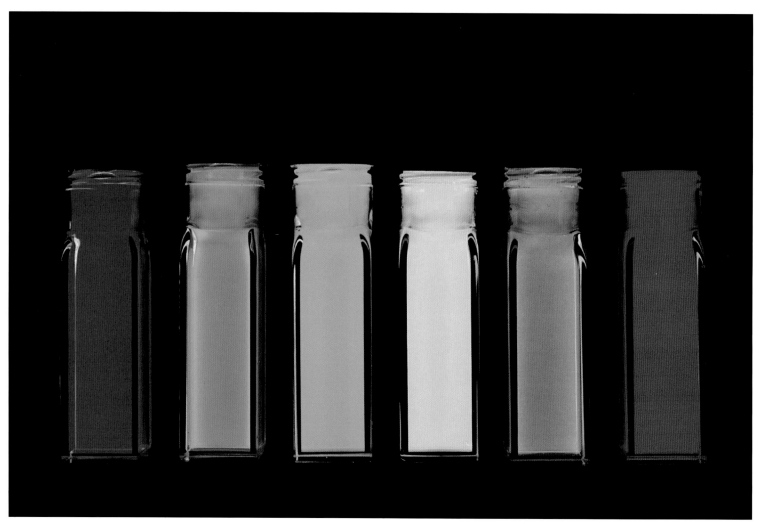

3.21a

Here is another image of the same material after a request from the researchers to make the image more "documentary." **3.21a**

The photograph was used on the cover of the journal that published the research article. Just for fun, later on I started playing around with the composition of the cuvettes containing the nanocrystals. First I placed them in this order. **3.21b**

And then I composed them more randomly. Eventually, this image, too, made the cover of another publication. **3.21c**

3.21b

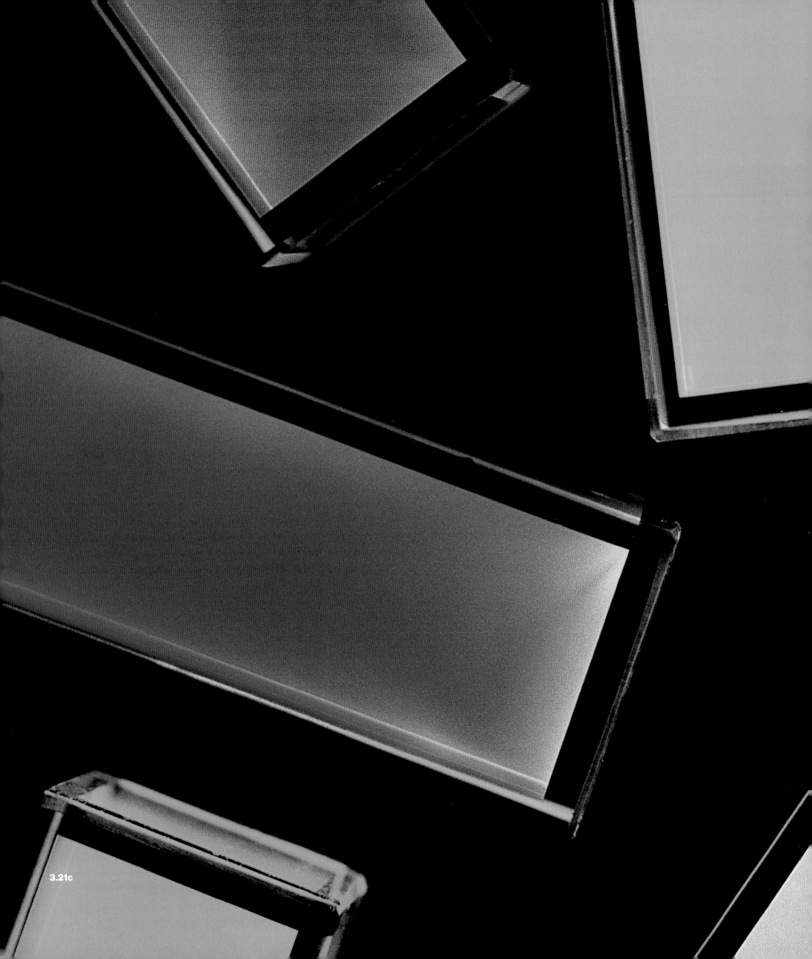

3.21c

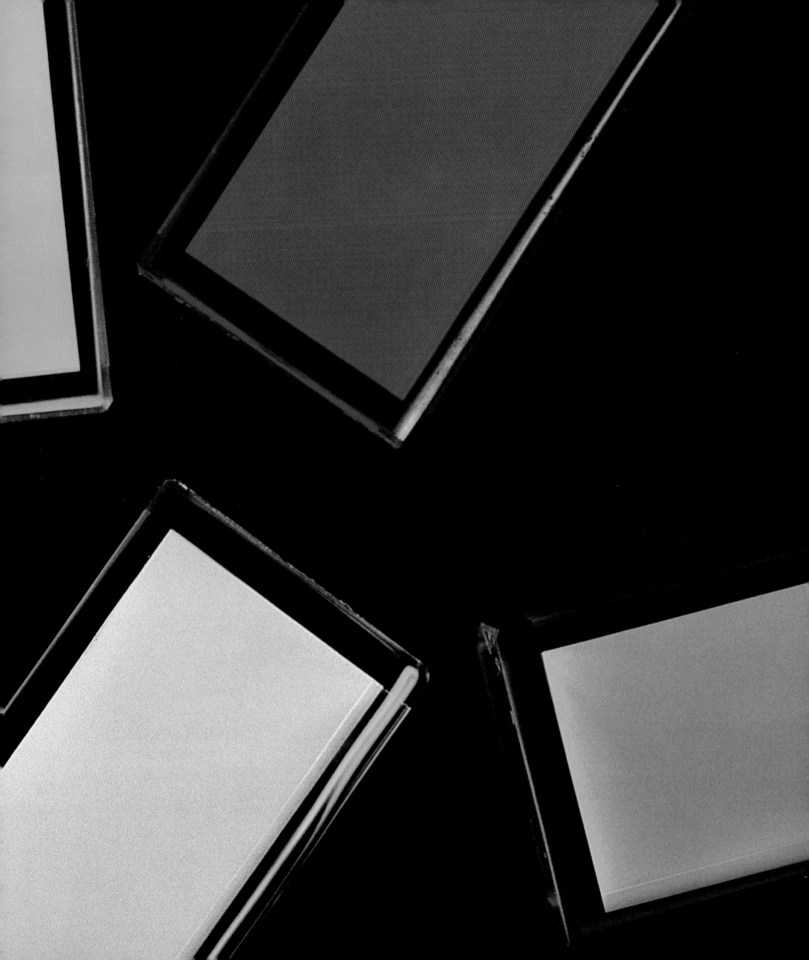

Here's another example – two images of fluorescing gels contained within two petri dishes. The first was taken under UV light alone. **3.22a** The second used a combination of UV light and room light. **3.22b**

And here is another example of the previously mentioned quantum dots. This time, they are infused into plastic rods. The first image was again taken under simple UV illumination. **3.23a** The next was taken with a combination of available light and UV. **3.23b**

3.22a

3.22b

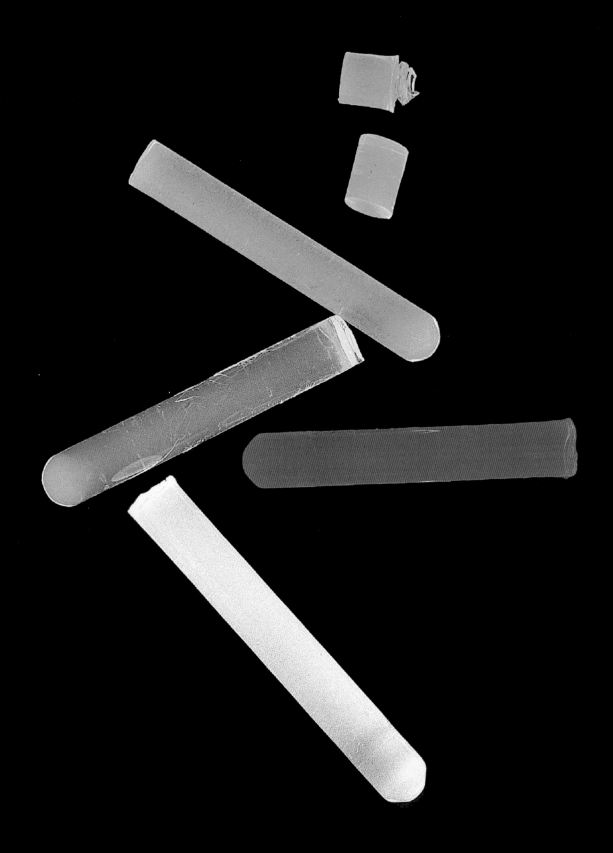

3.23a

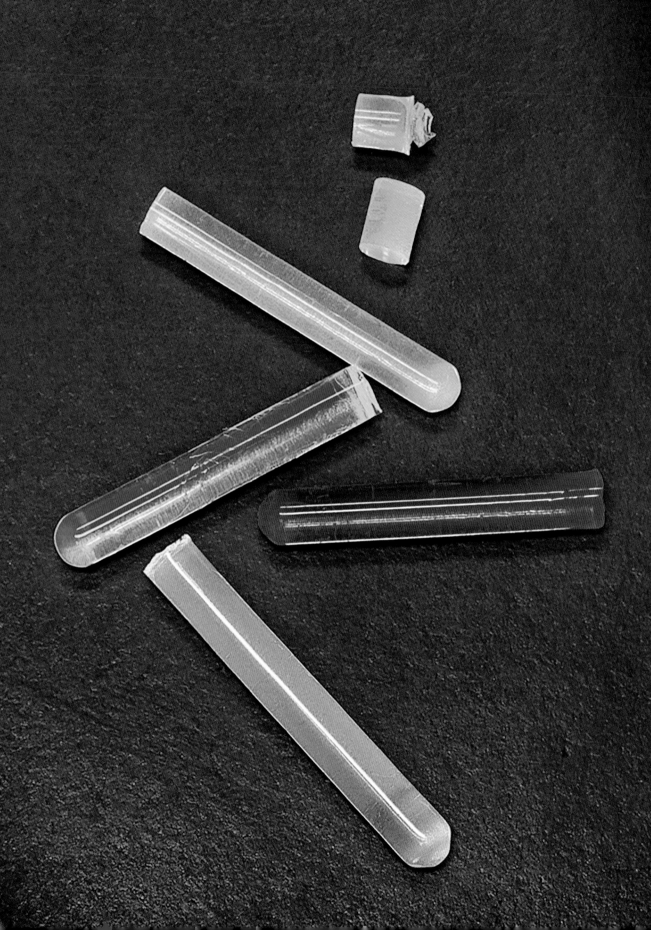

3.23b

FINDING YOUR LIGHT

I'd like to encourage you to dig deeply into your imagination, as you do with your research, to expand the way you think about this most important component of photography — light. Developing your own new approaches to lighting, in ways that go beyond what you will find in most photography textbooks, will not only be fun but will open your eyes to new ways of *seeing* your research.

Take, for example, this device we saw previously. **3.24** You might be surprised to learn that I used the lightbox we discussed at the beginning of the chapter, but I did not place the device *on* the lightbox. Instead, I used the lightbox as a light source on the side, as you see in the image below. The ease in alternating between setups with this light source is invaluable. **3.25**

3.24

3.25

Later, in a more playful mood, while walking around my studio with the device in hand, I noticed something interesting as I approached my scanner, which happened to be on with the lid opened. I placed the device on my flatbed scanner and was drawn to the quality of the scanner's light *on* the device. **3.26**

This next image is *not* a scanned image made by the scanner. It is a picture taken with a camera from above, using the light *from* the flatbed scanner. **3.27**

Another idea that you might not have considered, probably because it seems too simple, is using small LED flashlights. **3.28**

They work well when you want to image just a small area of a device. Here (continuing to use the same device as our subject), I photographed only the spiral area, measuring about 2.5 centimeters across. **3.29**

I just shined the LED flashlight onto that particular area. Notice that we see light "fall off" at the lower left, and for that reason I kept the framing close to the spiral.

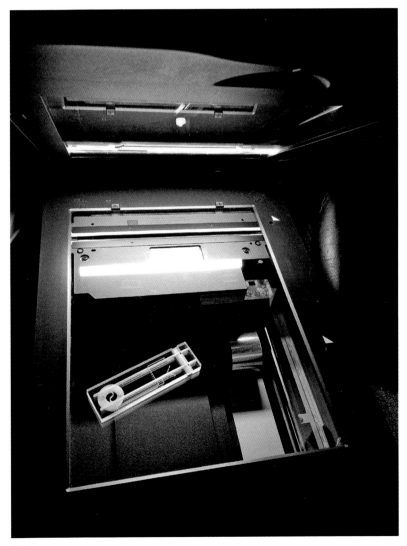

3.26

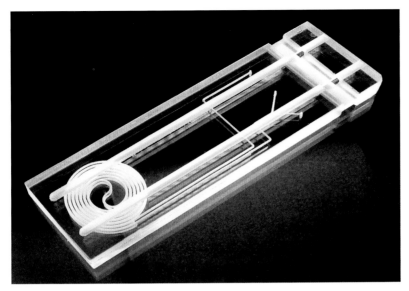

3.27

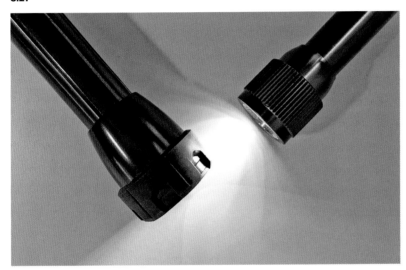

3.28

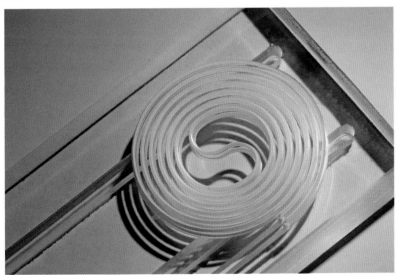

3.29

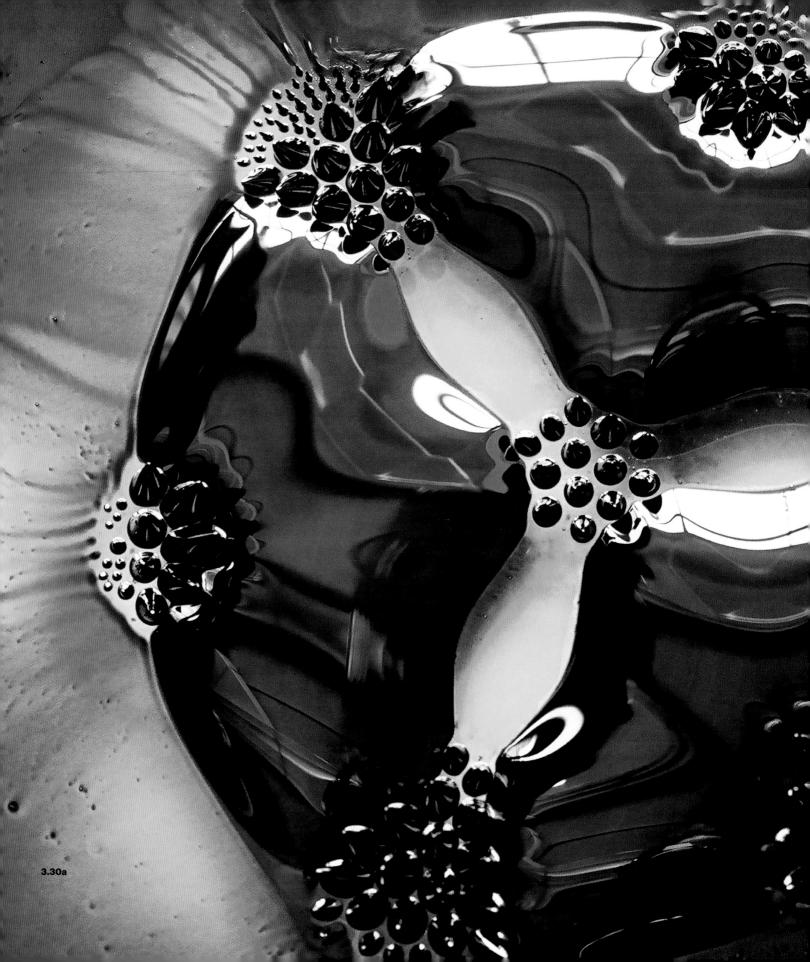
3.30a

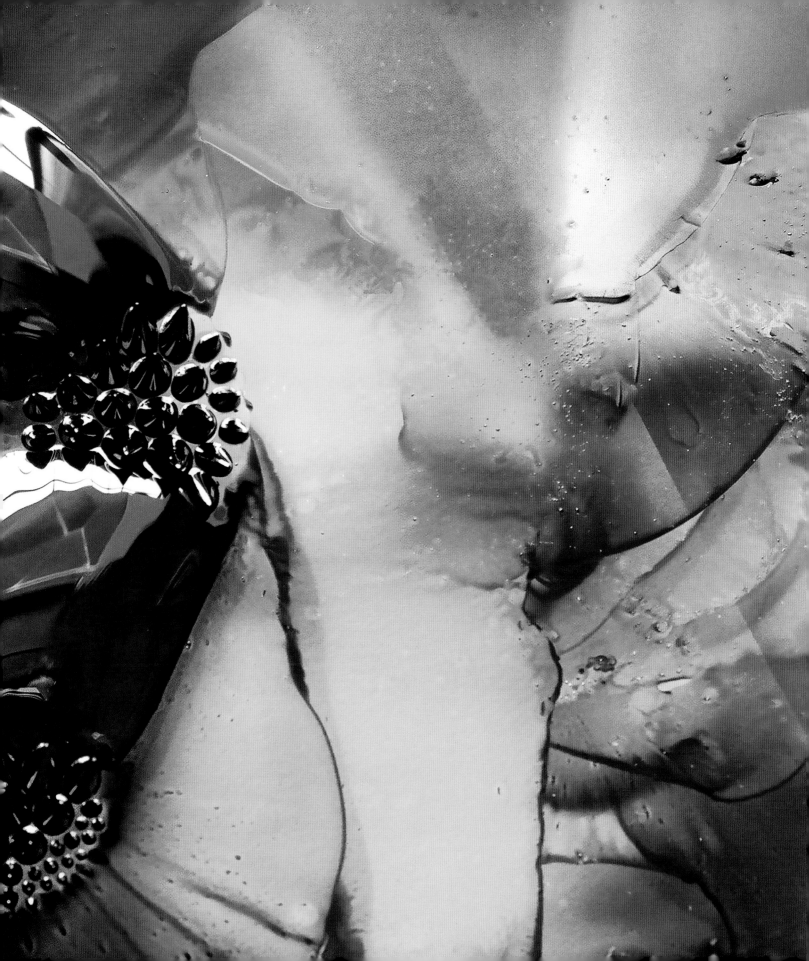

Some time ago, I made an image (see previous page) that seemed to get a great deal of attention. To this day, I am not sure why. But finding the right approach to lighting the material probably helped in its popularity. **3.30a**

Ferrofluid is a colloid of small iron filings suspended in oil. I placed a drop 2 centimeters across on a glass slide. Under the glass slide is a yellow Post-It, and under the Post-It are seven circular magnets. We are seeing the small iron particles responding to the magnets. I started with a close-up (below). Notice the light source – a reflection from a large window with its window panes. But the picture is too "tight" to see anything of value. **3.30b**

In this next attempt, I pulled the camera away, and now we see a little more of what is going on. **3.30c**

Then, noticing the reflective nature of the material, I decided to add another element to the photograph. I held a green card above and slightly to the side of the setup. **3.30d**

Now we see a little bit of that green card reflecting from the material. This addition is a purely aesthetic component – it is not necessarily clarifying any information about the material. However, the image became more interesting, which probably helped the viewer want to look. And after all, that's what we want when making science photographs. Wanting to look is the first step in understanding.

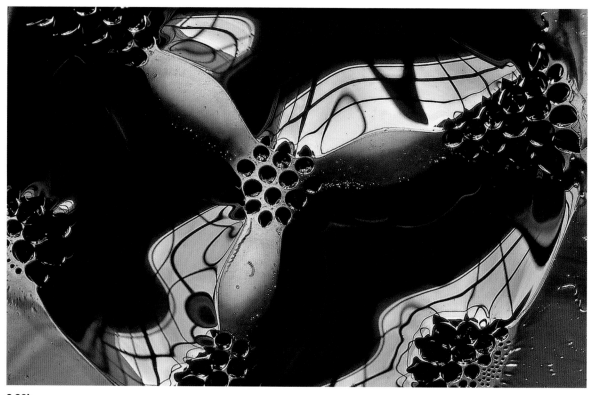

3.30b

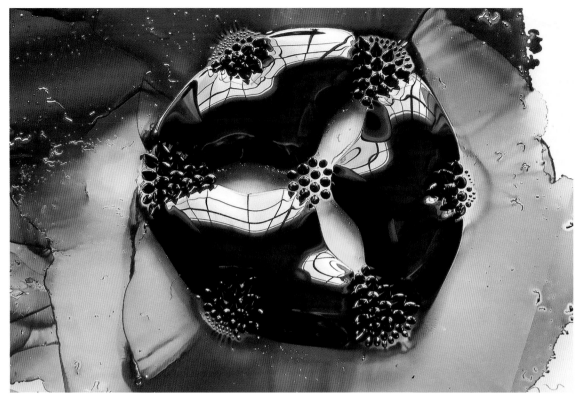

3.30c

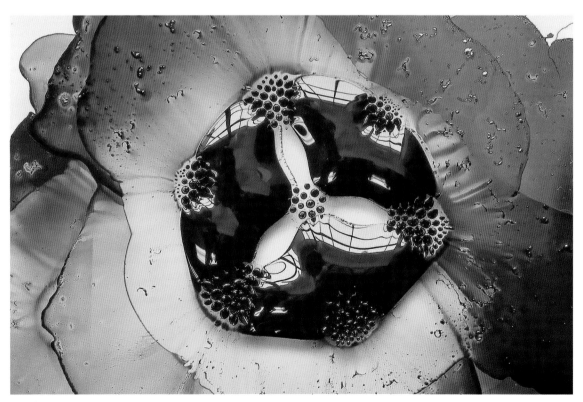

3.30d

SUMMING UP

Experiment with:

- Different sources of light – daylight, incandescent bulbs, fluorescent bulbs, UV lamps, LEDs.

- Location of light – distance from object, height and angle with respect to the object.

- Directed and diffused light – using lens, bounce card, container, mirror, flashlight, fiber optic monopoint, reflective background.

- Multiple light sources and locations.

- Lighting to impact composition – selective lighting of the object, slants and slices of light.

Let properties of your object guide lighting, composition, and exposure

- Fluorescent samples – UV light, long exposure times.

- Transparency.

- Reflectivity.

- A combination of the above.

Study published photographs yourself

- Where does light fall on the image and where are there shadows?

- How much light is there?

- From what direction is the light?

- Is the light direct? bounced?

- Can you guess at how the lighting was created? would you change it?

Keep a record

- of your process.

4

PHONE CAMERAS

When I first outlined the MITx online course on photographing science and engineering, around 2013, I decided to include merely a mention of photographing with phone cameras. At that point, I used my phone for what we used to call "quick and dirty" shots – those that couldn't really be taken seriously by one who considered herself a *serious* photographer.

That has changed.

Today, I am astounded by the quality of some of the phone cameras on the market. But at this point, I am not prepared to encourage you to ditch all the equipment discussed in the previous chapters. An important reason is that you will not have control over depth of field with the phone camera, although that's changing as I write this book. And as we saw in chapter 1, the file size of phone images, i.e., the amount of information or resolved detail, will not come close to a good scanner or a single-lens reflex (SLR) camera. But that, too, will change. I am sure the phone companies have the appropriate technology waiting backstage to be introduced to the market when they sell out the older technology.

Recall our comparison between two images of a petri dish, one made with my phone camera, the other an image I made on the flatbed scanner. **4.1**

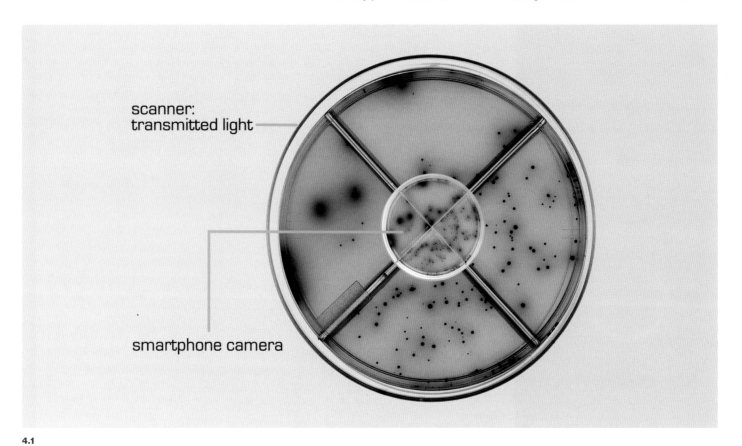

4.1

The phone camera's file size is just too small for most of our purposes. It's worth repeating how the difference in file size translates to resolution. In the following pair, the left image was taken with a phone camera. The right was taken with our standard equipment, a DSLR with a 105 mm lens. **4.2a**

Below are details from these images. **4.2b**

Another problem is that the built-in lenses in most of the phone cameras are too wide for our purposes, but once again that is changing. You'll see later that, at the time of this writing, I had to correct the wide-angle lens distortion in post-production. However, the most exciting and important characteristic of these phone cameras is that they give us the ability to *quickly* make fine images without the need of setups and all that entails.

In this chapter, I am including images that are not necessarily about research for a few reasons. First, I am convinced that the key to making high-quality and compelling images is not just a matter of learning the technical aspects (which you can find here, online, and in various other books). Making as many images as you can expands your ability to *see* in ways that you never before imagined. The phone cameras give you that opportunity. If you see something remarkable and know that you can capture it

at that moment, *instantly*, you will then continue *making* images. And with that you will begin to *look* and observe more than ever. Very simply, the more you make pictures and learn to critically edit those you have taken, the more you will be on track to becoming a fine photographer.

The critical component in this process is the need for careful critiquing and editing of your instant shots. It amazes me how many images people store on their phones. You have got to get into the habit of studying the images you've made and making decisions about which to delete, which to keep, and which can potentially be "fixed" afterward. This editing process will further help you become a more discerning photographer and inform your imaging in later attempts.

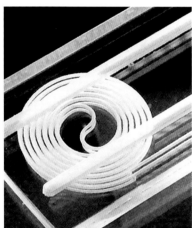
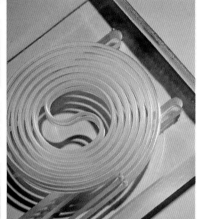

4.2a

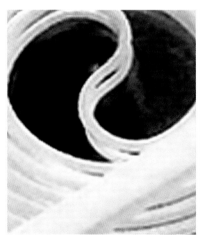

4.2b

PHENOMENAL MOMENTS

Let's start with what was my personal turning point – seeing the value of making images on my phone. **4.3**

At one particular moment, I saw something wonderful and quickly wanted to capture what was happening in my kitchen. I knew it would be a great deal of work and time to set up my usual gear. I also was aware that what I was observing would change quickly, losing the perfect moment. I was sautéing some multicolored peppers, and when I put the glass lid on the pan – there it was. What I saw was all about scientific phenomena: condensation, optics, and so much more. Study the image as I did. What do you see? What's going on? Making these careful observations is where the fun is, along with figuring out how to make the image better the next time the chance comes along. All it took was a good phone camera and the inclination to capture the moment.

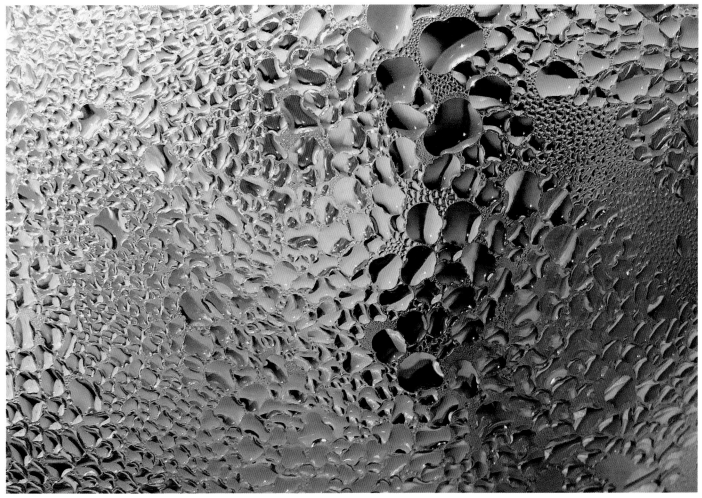

4.3

Here's another "phenomenal moment" (and a pretty amazing one at that). I knew, again, that I had to act quickly before the light changed. The final image was slightly enhanced with the Photoshop highlights/shadows adjustment tool, to bring out the details in the lower (underexposed) part of the frame. **4.4** But this is *really* the way the scene looked.

Or the image on the next page, captured while I was traveling on a small plane to Bristol, UK. It was my first attempt at making a movie with my phone. Once again, it was an opportunity to see and capture a phenomenon taking place at that particular moment in time. **4.5**

In the following photograph, note the way the tiny water drops on the right perfectly aligned themselves in one of the creases of the plastic wrap (enveloping a tree trunk). I was reminded of the process of self-assembly, and found this moment while walking to campus one beautiful sunlit morning. **4.6**

4.4

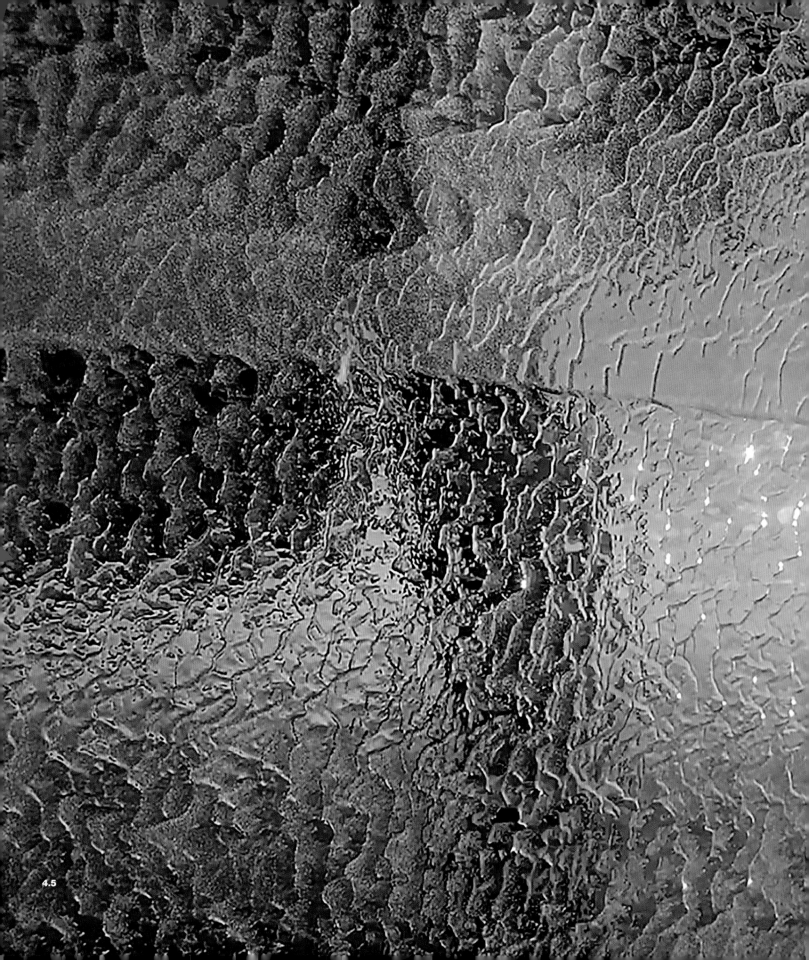
4.5

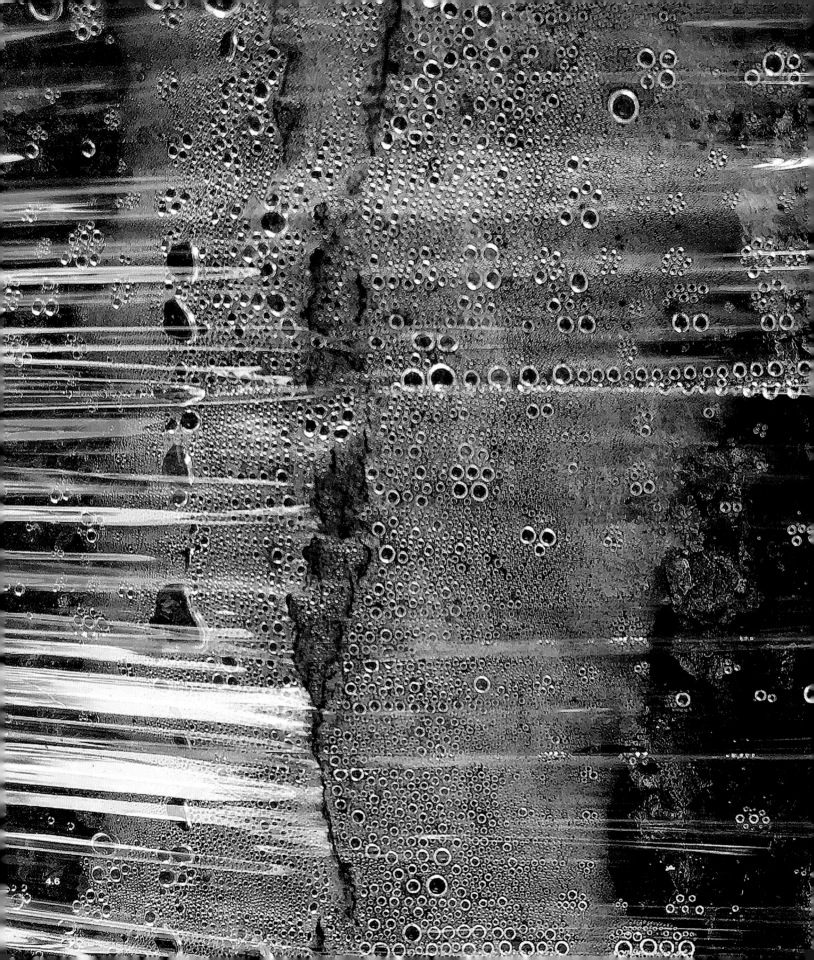

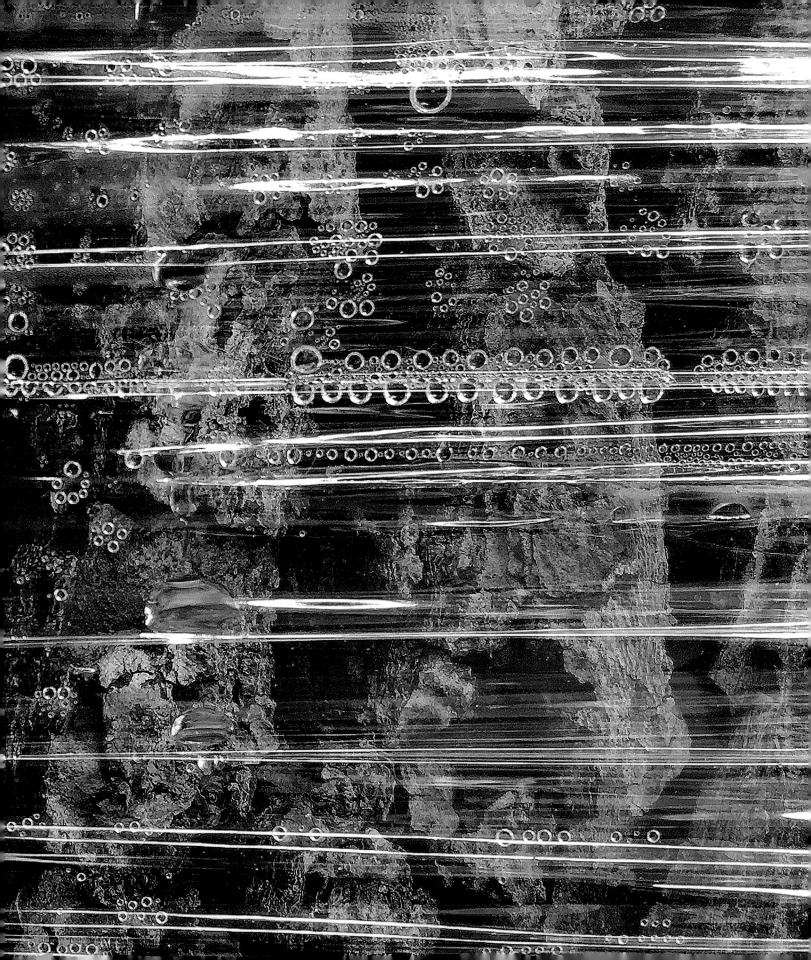

This image, rotated 90 degrees, is a detail of a small wire table I've lived with for many years. With my phone camera, the interesting reflections on the wired surface were easy to capture. This final image was cropped from a larger picture that included distracting elements in the room (the wide angle lens problem). While making the image, I anticipated the post-production cropping. I knew the image didn't have to be perfect while I was capturing it. **4.7**

4.7

4.8

And for this next moment, I was watching a redundancy happen before my eyes while walking on a country road in Maine. Looking for visual repetitions is a helpful (and fun) exercise that advances your ability to find interesting images. **4.8**

This glass apple has always been important to me. The "found" reflection pushed me to finally make this image quickly, before the light changed. **4.9**

I mentioned the problem with wide-angle lenses. We can correct the distortion after the image is made if need be. The easiest method is to simply crop out the distorted part of the image (or the part we don't want to include) around the perimeter. You should keep that in mind whenever you feel you are stuck with something or someone in your shot.

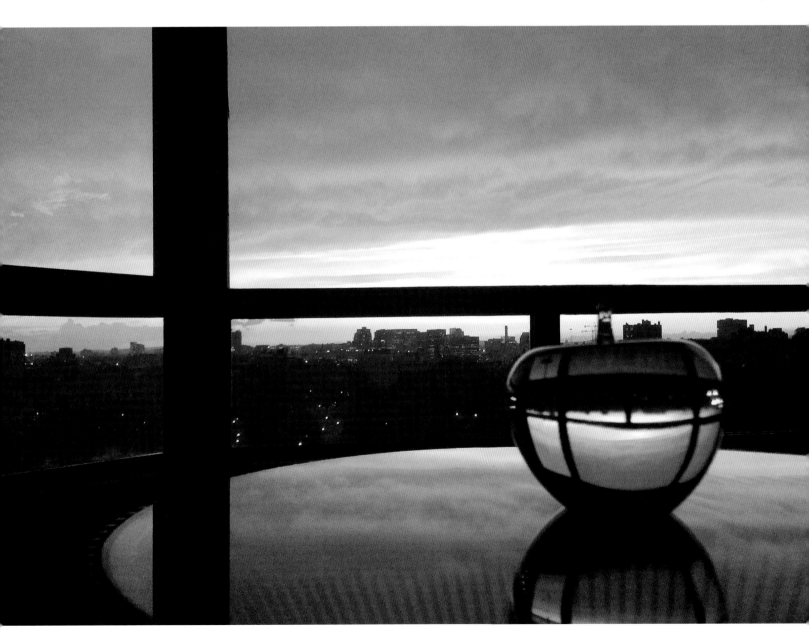

4.9

The ability to make quick images continues to be useful for me, and I patiently wait until the technology offers larger files. For now, anticipating ideas of how I can refine my phone pictures gives me the freedom of not having to make them perfect the first time around. You too should consider thoughtful potential corrections and not leave the work half-baked and, by the way, taking up precious digital space.

I made this first image very quickly, showing off two of my photographs in the Provost's office on campus. **4.10a** Note the perspective distortion. Fixing it in Photoshop was easy. It is a subtle fix, but one which you as a serious photographer will want to make. **4.10b**

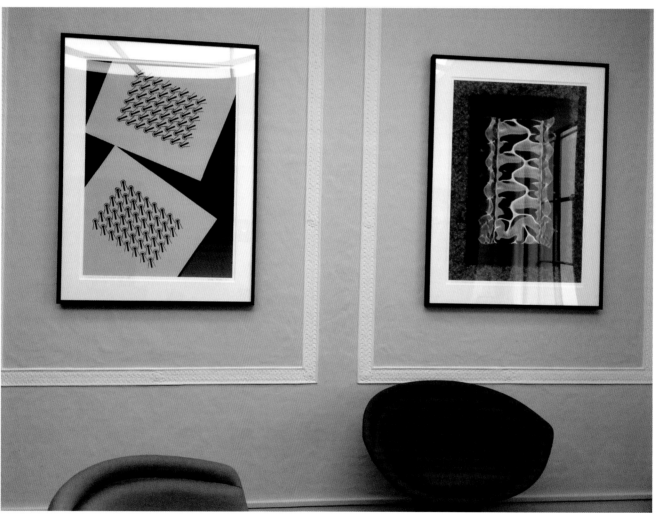

4.10a

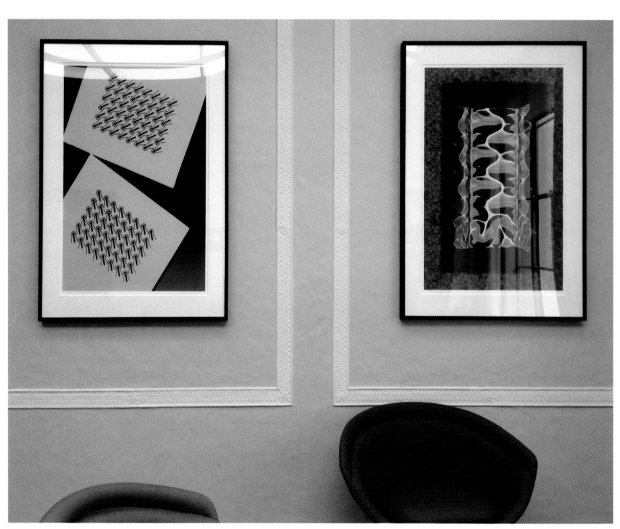

4.10b

Here's another fix I made for a phone image. I was not about to bring all my gear to Switzerland for a visit to CERN's first accelerator – the Synchrocyclotron. **4.11a**

Once again, because I knew that later on I would crop it, to refine the composition, it was worth making the shot. **4.11b**

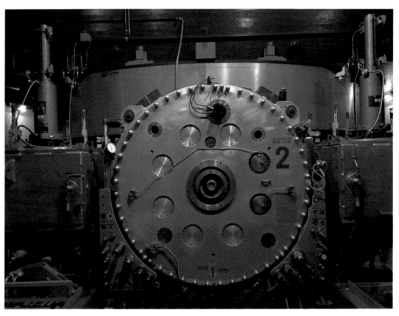

4.11a

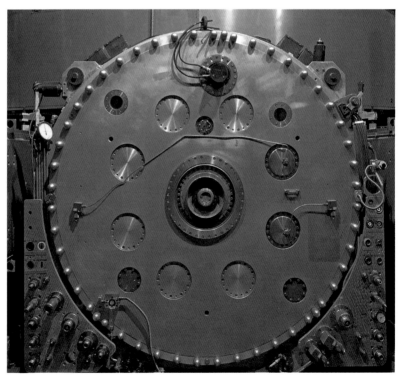

4.11b

Because I imagined I might use the image as a background, I deleted the distracting number 2 (although some would argue that the number is highly informational). Additionally, my phone's software exaggerates the color saturation under some light conditions. The color is a bit over-the-top and certainly artificial-looking. After researching older images of the accelerator, I discovered that the metallic finish is steel-like. And so I reduced its garishness by slightly desaturating the image, resulting in a grayer tone. This image now comes closer to the real thing. **4.11c**

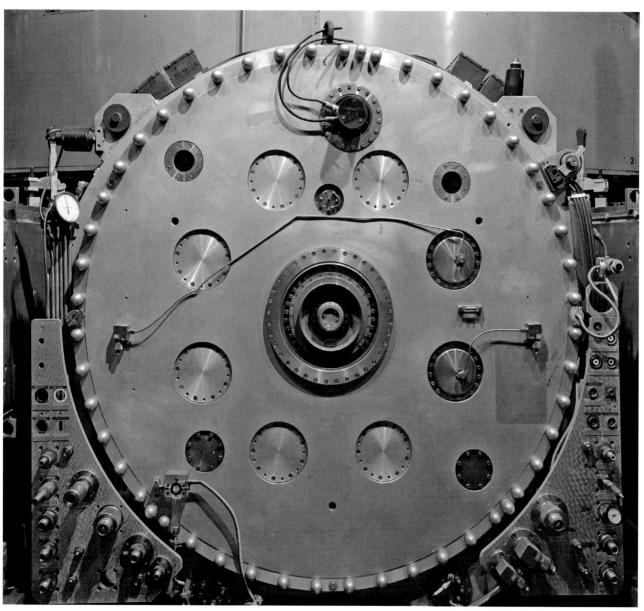

4.11c

For this next image, I was stunned by the beauty of Miquel Barceló's ceiling art in the United Nations Human Rights Council Palace of Nations in Geneva, Switzerland. I had been previously unaware of it and frankly was blown away when I walked into the conference room. Even later, after reading about the controversy surrounding its installation, I still marvel at its unique and suggestive references to social issues. **4.12a**

On the right is another of the same, from a slightly different point of view. **4.12b** Look carefully at the difference.

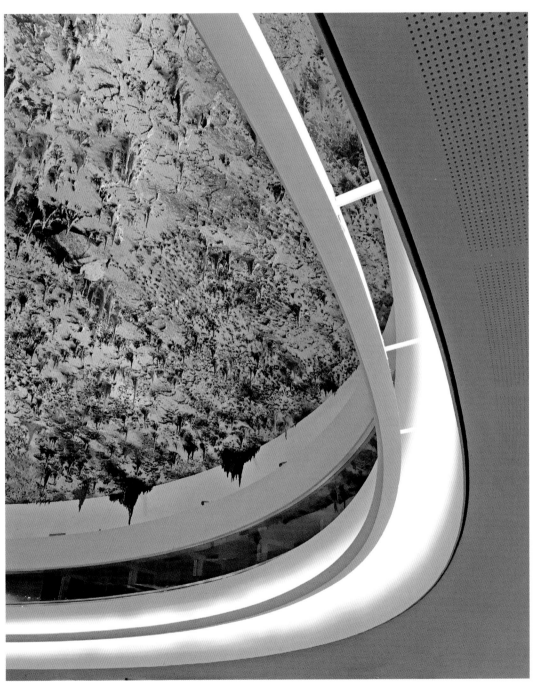

4.12a

Both of the images have been adjusted to bring the viewer's attention to the ceiling. On the next two pages are the originals. See if you can discern what my "fixes" were on these original images. **4.12c,d**

I include both of these examples to show how small changes (in this case, shifting the camera ever so slightly) impact final photographs, even on your phone.

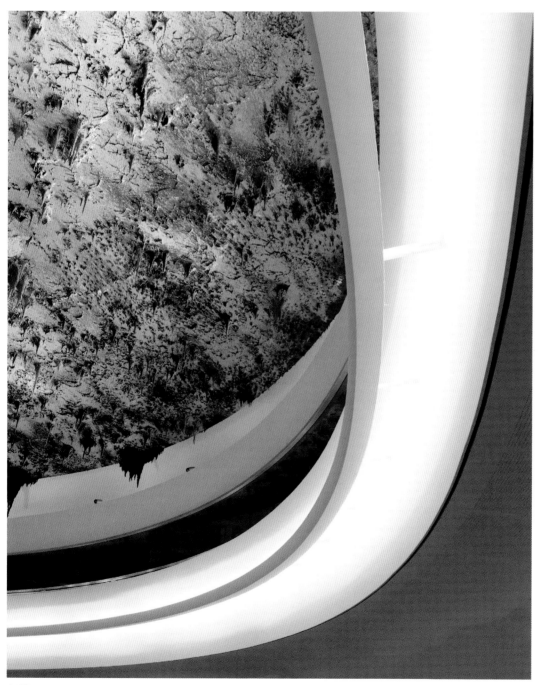

4.12b

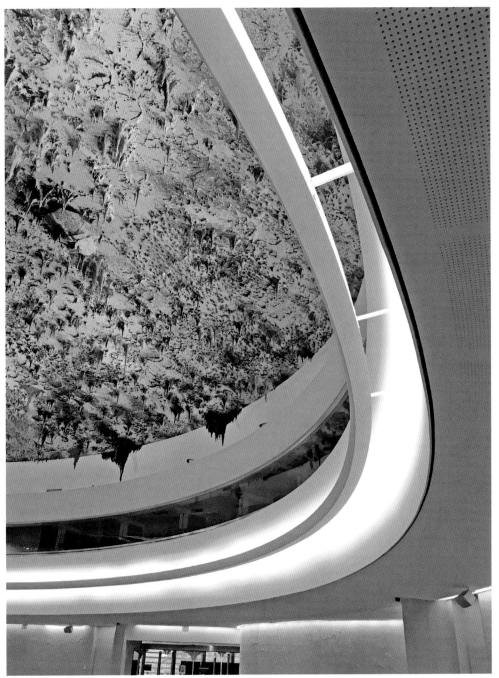

4.12c

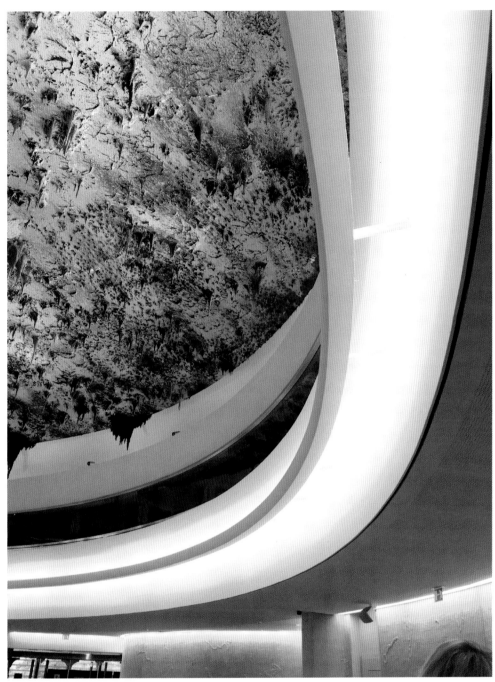

4.12d

One of the more powerful installations at Daniel Libeskind's Jewish Museum in Berlin is Menashe Kadishman's *Shalekhet* (*Fallen Leaves*). I knew in this first shot that the visitor was in the way, and I imagined cropping him out later on. **4.13a** But I also knew this fix would negatively affect the composition: that small black triangle in the upper right looks like a mistake. **4.13b** Luckily, he did leave, and in this final image I was able to incorporate more of the wonderful design of the space. **4.13c**

4.13a

4.13b

When I tell my friends that I no longer take a "serious" camera with me when I travel, they usually seem bewildered. It's difficult to explain that I am in a different mindset when using only my phone camera than my professional frame of mind in the lab. Knowing that I can make pretty wonderful pictures without the responsibility of getting them perfect is a gift. Here are three more from my travels. Take note of their composition. **4.14, 4.15, 4.16**

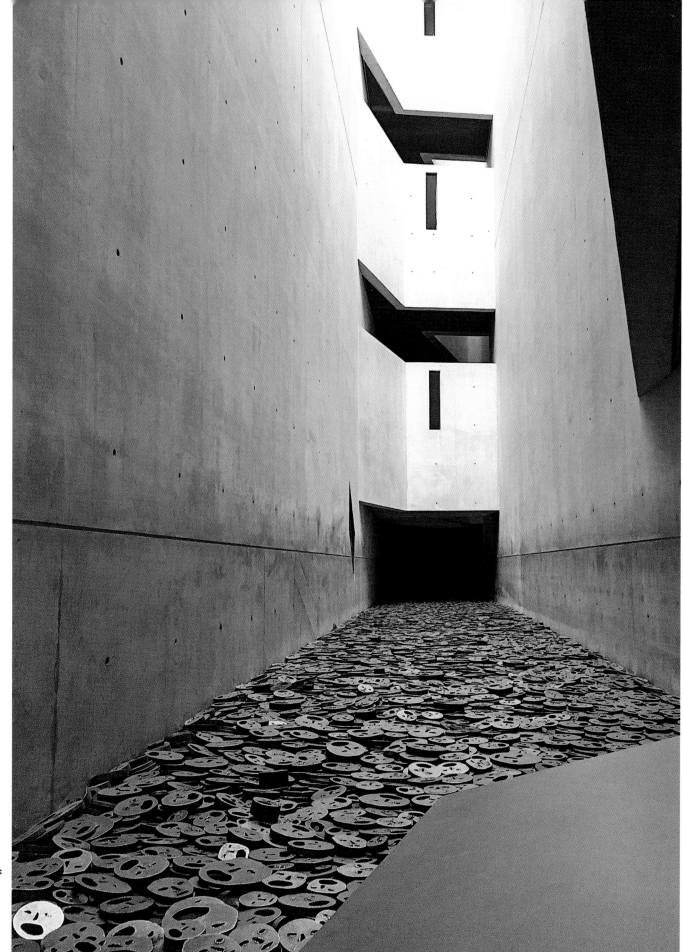
4.13c

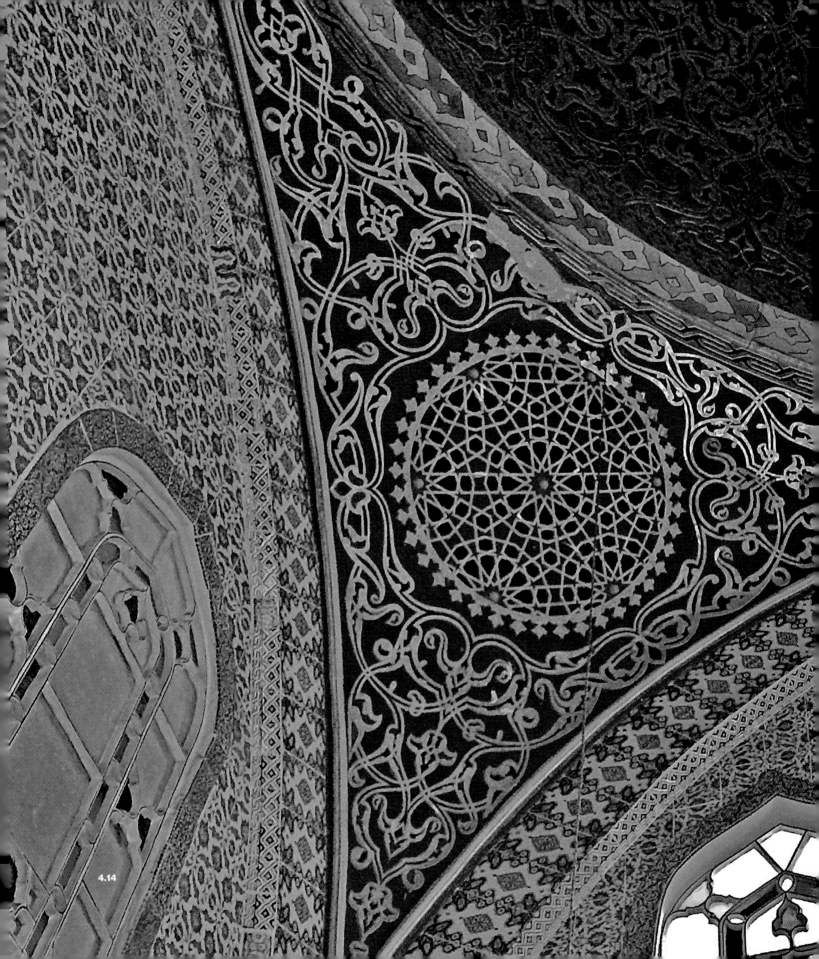

4.14

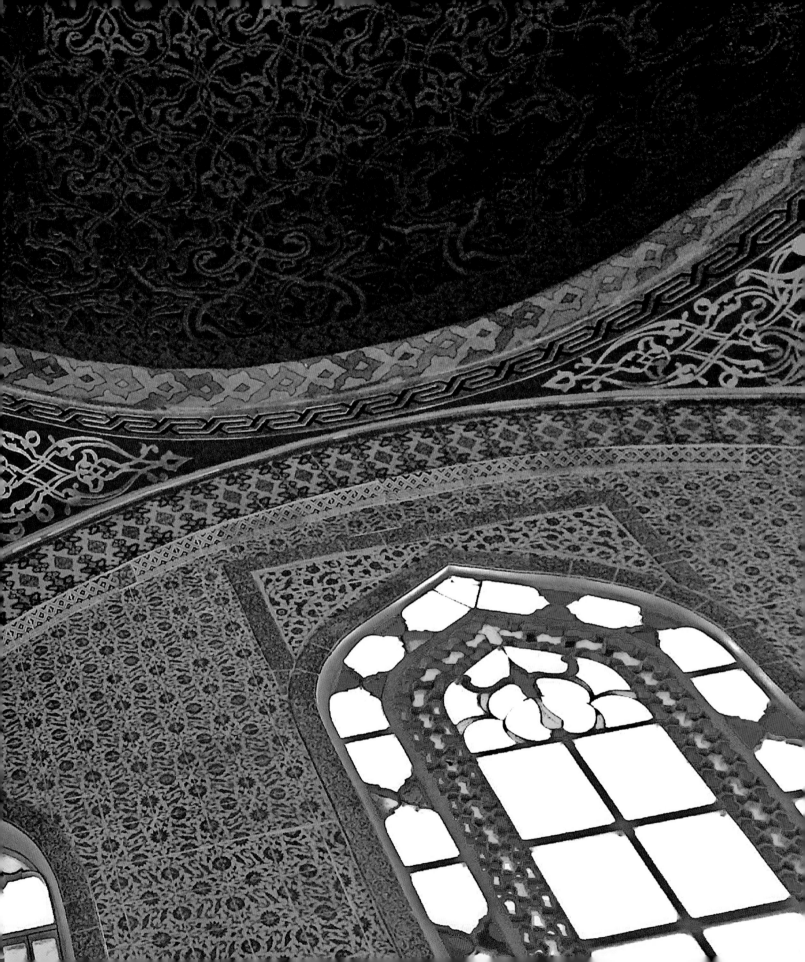

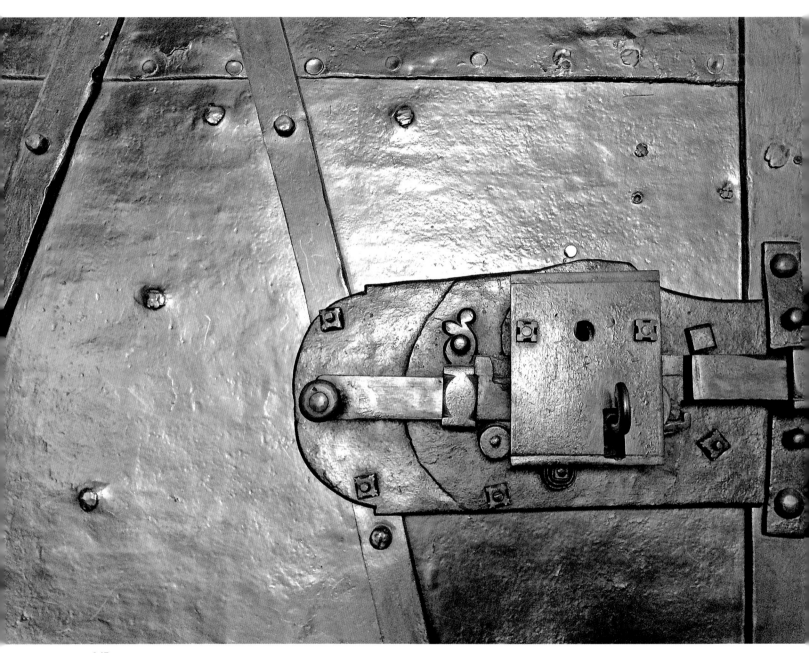
4.15

4.16

YOUR LAB

The phone camera works well for making quick images to document what you are seeing or some equipment you've designed for a slide presentation or to share with colleagues.

This next example shows how we can create some pretty good images of table apparatus. In this first attempt, I simplified the background by placing pieces of white paper which I knew I would be able to "fix" in Photoshop in post-production, resulting in the second image. **4.17a,b**

Here's a similar example **4.18a,b** created by MIT student Youzhi Liang. Youzhi is studying the mechanics of a particular hockey shot taken by players called the "slap shot."

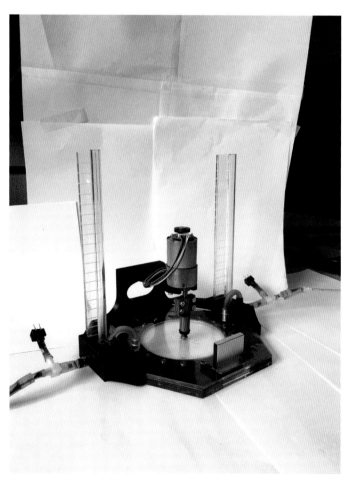

4.17a

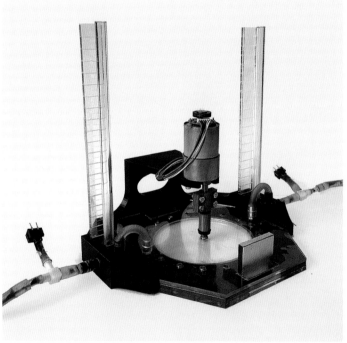

4.17b

4.18a

4.18b

If you need images for your lab's website, there is nothing better than your smartphone to create "hints" of what your lab looks like, along with your research images. Consider these as portraiture of a lab. In this case, I made photographs from Hadley Sikes's lab at MIT. Her group concentrates on finding new biomolecular systems to detect and treat disease. **4.19a,b,c**

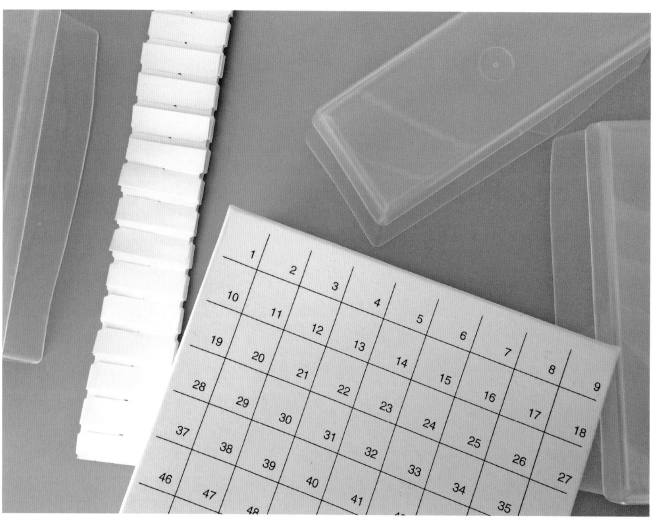

4.19a

4.19b

4.19c

BACKGROUNDS

In chapter 1, I mentioned I was a collector of backgrounds. I now also use my smartphone to add to my collection, the backgrounds here being digital. Here's a particular image that I made at the Franklin D. Roosevelt Presidential Library and Museum in Hyde Park. **4.20** You'll see in case study 15 how I used this image. At the time I shot this picture, I had no idea how I was going to use it, but knew I would someday. It is a portion of a large plastic orange circle, depicting Japan's "rising" sun. The dramatic solid circle is hanging on a wall with lighting behind it. The glowing orange "band" is the light's reflection on the stucco wall.

4.20

In this next image taken at CERN, I digitally deleted the detail on the left side, imagining the image as a background for text. **4.21a,b**

4.21a

4.21b

The same thinking was the reason for shooting the constantly changing ceiling in Google's Cambridge, Massachusetts atrium (next page). **4.22** The image doesn't work alone, but as a background for a slide, for example, it might. I haven't used this one yet, but I know I will.

4.22

Here's another background – all set for text insertion. **4.23**

SOMETHING ELSE

I want to introduce you to a particular tool that has added a new layer to my photography.

For years I've had a miserable time trying to position my phone at the right spot over the ocular in my microscopes. Finally, some folks have come out with this perfect adapter, to do the positioning for you. You simply attach it to the ocular while it holds the phone in the perfect spot. Incidentally, I made this image of the adapter with my phone camera. **4.24**

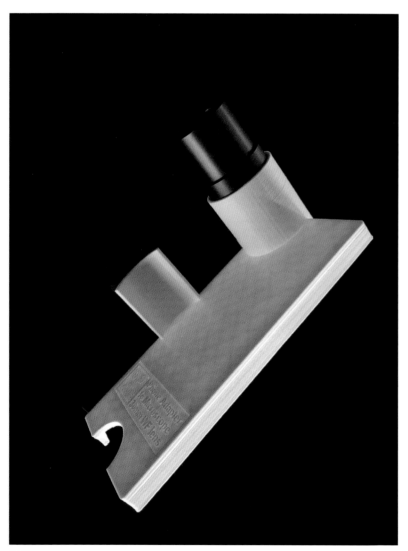

4.24

4.25a

4.25b

Here are a couple of images of water bubbles in diluted coffee made with the adapter and my phone. **4.25 a,b**

You'll find a video I also made of these bubbles in motion, using my phone camera on the microscope, on the book's web resources page.

Here's how an image looks with the adapter in place. **4.26a**

You will have to crop the image by zooming in with your camera, as if you were focusing into a scene, to get a full image. Keep in mind that you will lose resolution as you do so. **4.26b**

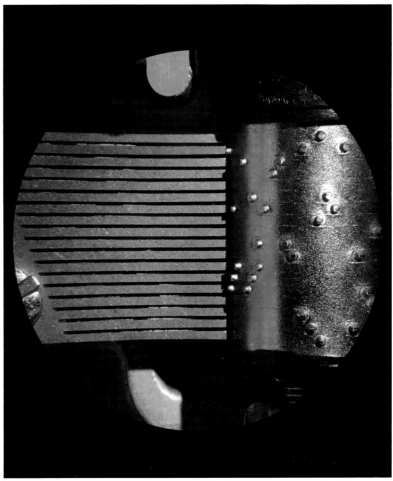

4.26a

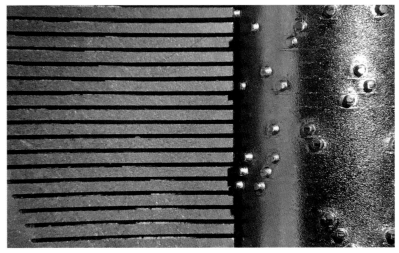

4.26b

PHOTOGRAPHING FOOD

You might ask why I am including this sort of photography in a book about photographing science. Once again, I return to the idea that the more images you make, and the more critical you become while studying your images after you make them, the more you will see and the more you will refine your photographs, no matter what you are capturing.

I love to cook and I love capturing beautifully presented plates. I am not alone, judging from the number of food images appearing on line. The question is whether these images are worth paying attention to. I, for one, am not interested in posting food pictures. I cannot imagine anyone is eager to discover what I had for dinner the other night. However, I am interested in capturing a wondrous experience for myself, and perhaps for a couple of my fellow foodies.

One memorable experience in Barcelona was with a group studying science and cooking. As I mentioned, I no longer take my "serious" gear when I travel — I rely on my phone camera. And in fact, I rarely make any pictures, only when something catches my attention. My attention on this trip was grabbed a number of times when the group was presented with various plates of gloriously prepared and composed food. You'll see a few of those images shortly. But first, I present just a few guidelines for making images of food with phone cameras:

1. First and foremost, pay attention to the restaurant's rules. Some may not permit taking pictures.

2. Make sure you are not annoying anyone while you are making the images. Clicking away throughout the whole meal can be highly disruptive to others, so plan to make only a very few pictures. Look carefully and make mental notes of the shot. Only after you are clear about what you are looking for should you set up your shot, moving the flatware and glasses out of the frame if they are a distraction. On this particular trip, because the group was invited to various Michelin-starred restaurants for the purpose of "studying" the plates, I believed my picture-making would be noninvasive to my fellow travelers.

3. Never use flash. Making images with a flash at a restaurant is disruptive to your fellow diners. Just don't, period. Most of the time flash is unnecessary, and it often produces an artificial light quality that detracts from the subject matter.

4. Remember that you can fix an image later if you cannot get it just right while making the image.

5. Pay attention to the shadows. Consider them as shapes in the composition.

6. Take one or two pictures, thoughtfully. If you look carefully at the image on the screen, you will figure out the best shot, without making a ton and clogging up your storage space. If there is something special about the plates and place setting, you might want to include them in the shot.

Here is an image of a spectacular dessert created by chef Jordi Herrera at his restaurant, Manairó, in Barcelona: goat cheese and pepper ice cream with strawberries from Modena. Note how I carefully captured the straight horizontal lines. The image was adjusted with the same enhancement adjustment tool I used before: "highlights/shadows." **4.27a**

Here's another shot I made at the same meal, this time purposely including the flatware and glasses in the image, placed arbitrarily to suggest informality. **4.27b**

The next few (pages 186–191) are from one of the most spectacular meals I've ever had. The lunch was prepared at Carme Ruscalleda's and Toni Balam's three-Michelin-starred restaurant Sant Pau, in Sant Pol de Mar. The 22-course meal was "Inspired by the Universe," as indicated on the menu. Each dish referenced something astronomical, either in the ingredients or the plate on which the food was presented. You'll find more information about the ingredients in the visual index.

4.27a

4.27b

4.28a

This first pair of images captures the initial presentation of one dish and then the "reveal" inside the delicate enclosure. **4.28a,b** Note how I decided to compose them differently, giving the viewer (me) a recollection of what was going on.

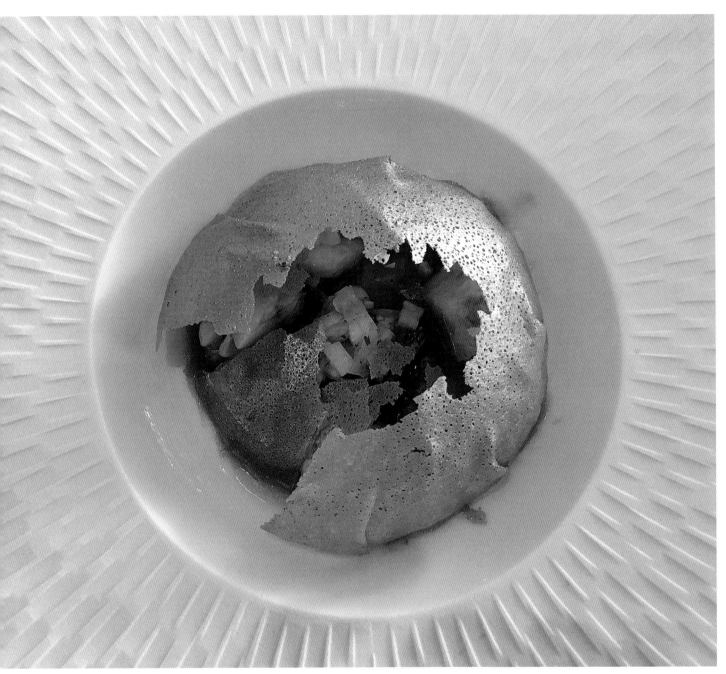

4.28b

For this pair, I studied the dish before I carefully moved some of the gel, again exposing the underlying ingredients. **4.29a,b**

4.29a

4.29b

Here's the last "reveal" of the meal – this one demonstrating the chef's playfulness and sense of humor. **4.30a,b** The dish was called "Krypton," and again I zoomed in a bit on the second image. The metallic-looking strip of paper with its image was inserted into a slot beneath the glass plate.

4.30a

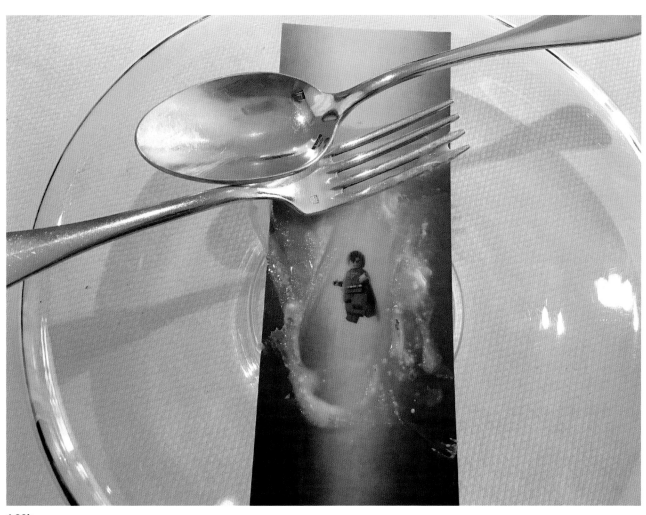

4.30b

Transferring these ideas to the main subject of the book, I am confident you can use this concept in your lab. Think of it as a "before and after" story, perhaps like this pair **4.31a,b** when I made the series of images on page 269. I captured a number of images showing changes in block-copolymer structure. Here I am only showing the starting image and final image, photographed 24 hours apart.

4.31a

4.31b

For the last dish in our meal, "Halley's Comet," the challenge was to figure out what to do with the annoying reflection from light above. Hiding it was one option, done by moving the camera. **4.32a**

But eventually, I decided to embrace the reflection, including it as a suggestion of all things astronomical. I think it works here. **4.32b**

4.32a

4.32b

4.33a

4.33b

I happily end this chapter with three phone images made by my 14-year-old friend Fiona McGill. She has a natural eye for photography, and it was difficult to choose which images I should use. Two food images would fit the pattern here, but I just had to include one other. **4.33a,b,c**

Put the phone camera in the hands of the young and they will teach us how to see the world.

4.33c

A phone camera is a good choice for:

- Quick portraits and videos of places, process, equipment, and documentation, and for use in grant submissions or correspondence.
- Images for use on the web.
- A placeholder until you can set up a high-resolution shot.
- Spontaneous situations when no other camera is available.

A phone camera is not a good choice for:

- Shots with fine detail or ones you plan to enlarge.
- Large images for journal covers.

Standard image guidelines apply to photographs from mobile devices

- Background, lighting, and composition are still key choices.
- A less-than-perfect quick shot can be improved with post-processing (straightening, cropping, brightness adjustment).
- Science informs the best composition — for example, a container edge or adjacent objects may highlight key points of information.

Keep a record

- of your process.

5

MICROSCOPY

Before I begin, it's important for you know to that I am not a microscopist. I am a photographer who often uses a microscope. Experts in the field who study and practice various forms of microscopy know much more than I about the important technical issues when using a microscope. Consider this chapter an overview of some of the images I've made with microscopes over the years. They are intended to communicate structure and information at a particular scale. My hope is that you will look carefully at them and perhaps be inspired to bring into your images a certain aesthetic. I also include a brief look at confocal microscopy from other labs, since many of you might be heading in that direction.

Once again, as I've emphasized before, the images in this chapter as in the others should be considered explanatory and not exploratory. They show various structures about which we (the image-makers) already have knowledge. I am not searching for where a certain fluorescent label has tagged a protein, for example. We already know where to look.

As you turn the pages in this chapter, think about all that we've discussed in the previous ones – many of the issues still apply. Composition and point of view are certainly still relevant and mostly under your control. However, you'll have less control than with previously discussed equipment since, for microscopy, your camera will be rigidly connected to a portal, losing the ability to move it around. I encourage you to use the same camera you will be using for the previous chapters. Most microscope vendors will try to sell you a camera along with the scope. Unless you are doing high-speed microscopy or fluorescence work, the high-quality digital

SLR that you will use for the other chapters – one that will give you a large file – makes more sense. A large file, remember, has more information than a small file.

Lighting will also be limited, depending on what your scope offers. If you are using a dissecting or stereo microscope, for low-magnification images, you will have the opportunity to use auxiliary lighting for epi-illumination (reflected light). I mostly use fiber-optic lighting when using my stereo scope. I can move the lighting around and see the same changes happening as I would for macrophotography. Your stereo microscope can also come with transmitted light – from beneath, traveling up through your material. For the compound microscope (higher magnification), your lighting choices will be even more limited. My microscope offers transmitted and reflected light. Although you might think you will only need one because of the nature of your work, I suggest you purchase a scope that offers both. If you are lucky and have funding for separate scopes, that would be the way to go. Once again, I urge you to look farther than your first glance and thinking. There might be something later on requiring transmitted light that you will have missed.

Play with your light. For example, note the differences, at right, between the microscopic darkfield image **5.1a** of an old computer memory core and the brightfield image. **5.1b** Both were taken under reflective (epi-illuminated) light.

The next two photographs show subtle differences between an image taken under reflected light **5.2a** and one taken with transmitted light. **5.2b** Both images capture the structure of packing foam with a stereo microscope.

The biggest challenge in microscopy is the loss of depth of field. It is not easy and sometimes impossible to get everything in focus. You can close down the microscope's aperture, which helps a bit, but it's not the same as closing down your camera lens. Experts explain that you are only adding contrast by adjusting the microscope's aperture, and it comes with a loss in resolution. Frankly, I don't see that loss, so I often close down the aperture for both my stereo and compound microscopes because the images appear better focused. Keep in mind when you close down the aperture lens that you will have to use a slower shutter speed to obtain the right exposure. (Remember?) Note how more and more of a sample of self-assembled colloids become focused as I change (close down) the aperture on the scope. **5.3**

5.1a

5.1b

5.2a

5.2b

5.3

Capturing sharp microscopic images is what we should aim toward, and this can be accomplished on optical microscopes if you work at it. However, I've made an observation over the years on this point. Often young researchers will show me images of their work made with a scanning electron microscope (SEM) even though the relevant structures are perhaps 50–200 microns in length (i.e., within the optical range). They could easily have used a compound optical microscope to capture larger files than the SEM offers. Researchers seem to be seduced by the SEM, probably since almost everything usually appears in focus (with the right settings) and generally the images look great. Just as a reminder, the SEM uses electrons, not photons, to capture structures smaller than the wavelength of light. For example, later in the chapter, in fig. 5.20, you will see an image I made with the SEM that would have been impossible to make optically (with photons). However, the file size for SEM images is usually much lower than for an image from a camera. I try to encourage researchers to go back to the SEM (if they insist on using it) and adjust the settings to capture a larger file and, more important, to question whether the SEM is the equipment to use in the first place. Try slowing down and think it over. Which instrumentation would be best? Just because you have access to certain equipment does not mean you must use it.

For context, let's go through a series of images made of the same object—an old computer memory core. For the first image, I used my camera and lens. **5.4a**

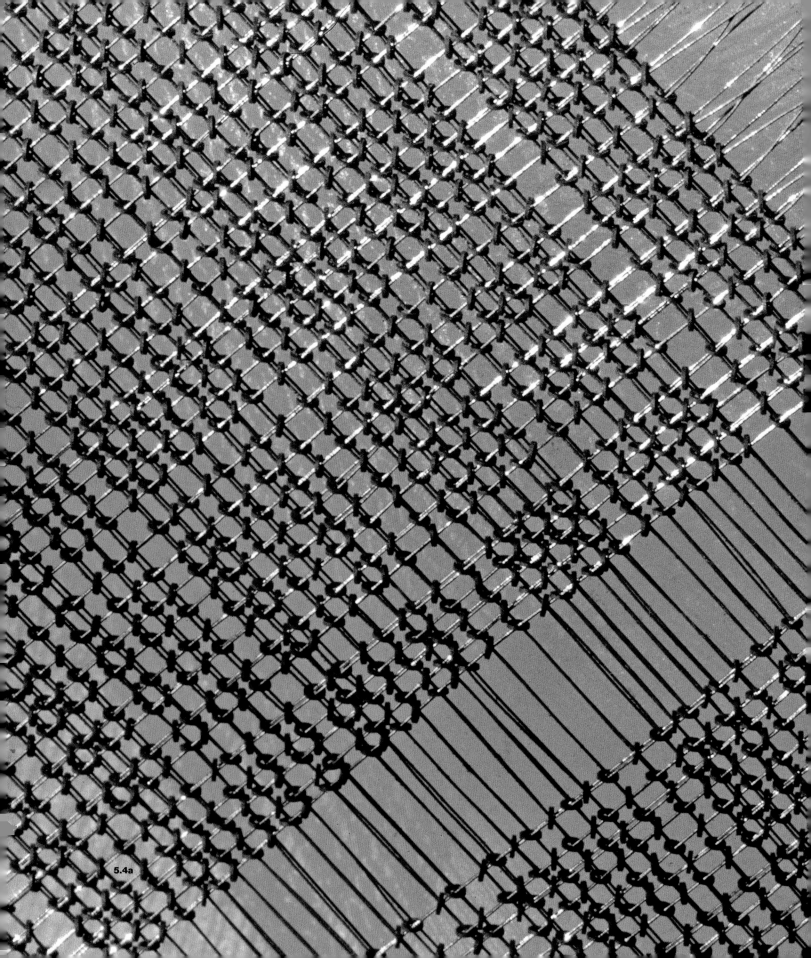
5.4a

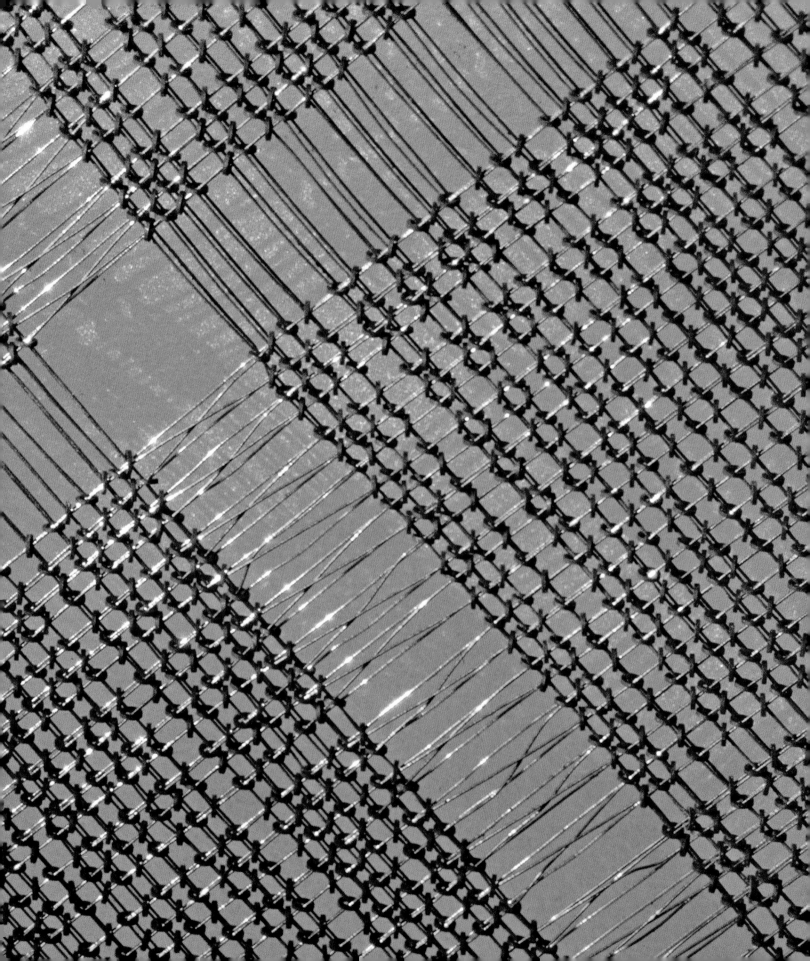

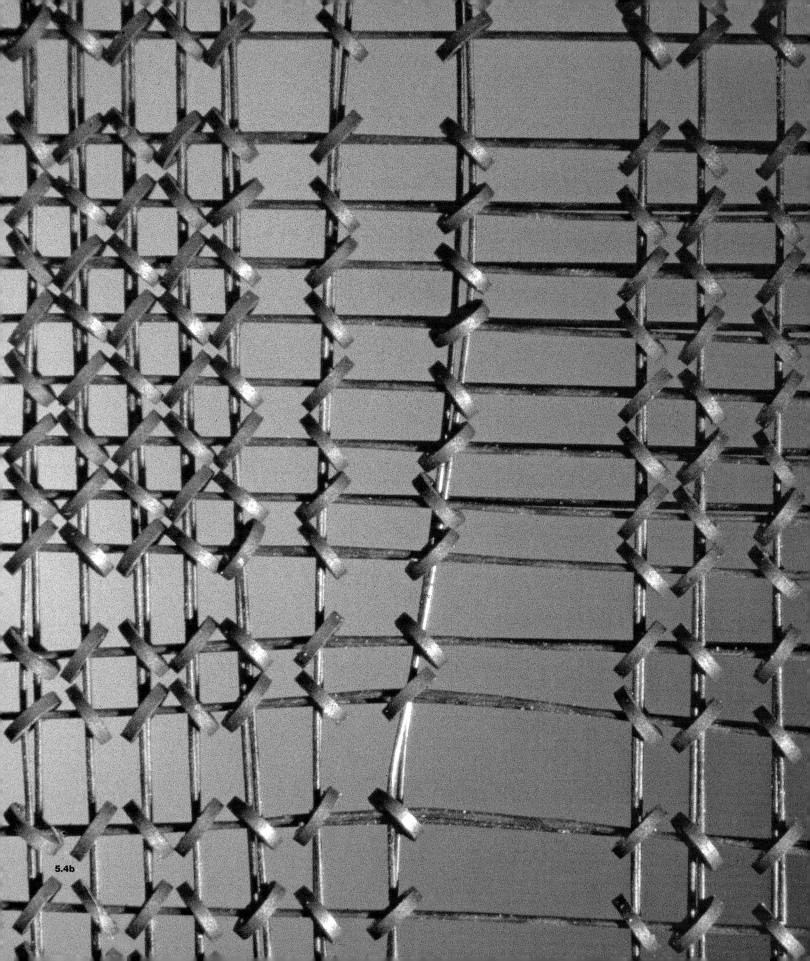
5.4b

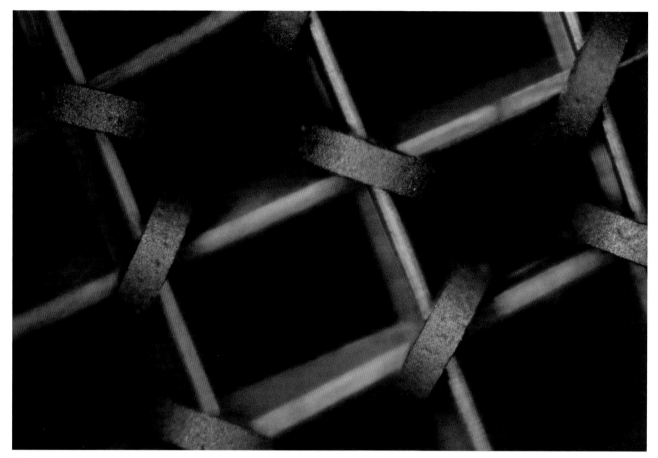

5.4c

The next image was taken with my stereo microscope with epi-illumination. **5.4b**

This next image was taken with my compound microscope. **5.4c** And just for fun, I made the image on the next page with an SEM and then colored it. **5.4d**

All of them can be used to give a sense of scale as we zoom in to the material. The lower-magnification images may not give the reader the information you are emphasizing (the ceramic circles); however, they all give context. Imagine only seeing one of these images: it would tell only part of the story.

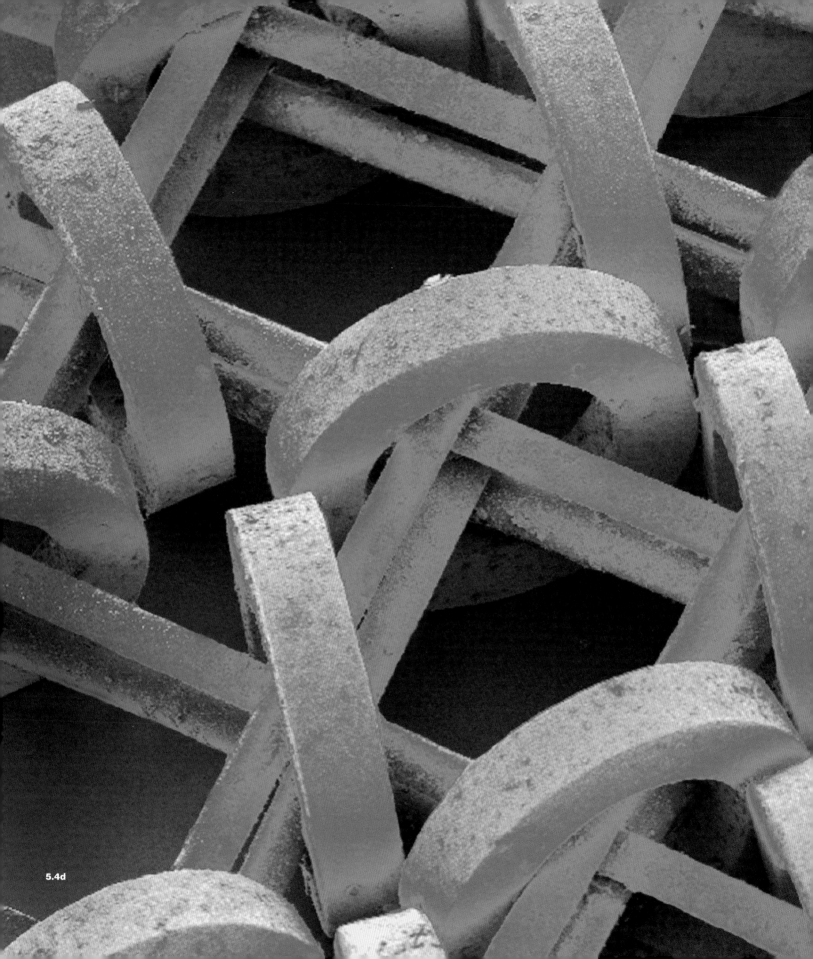
5.4d

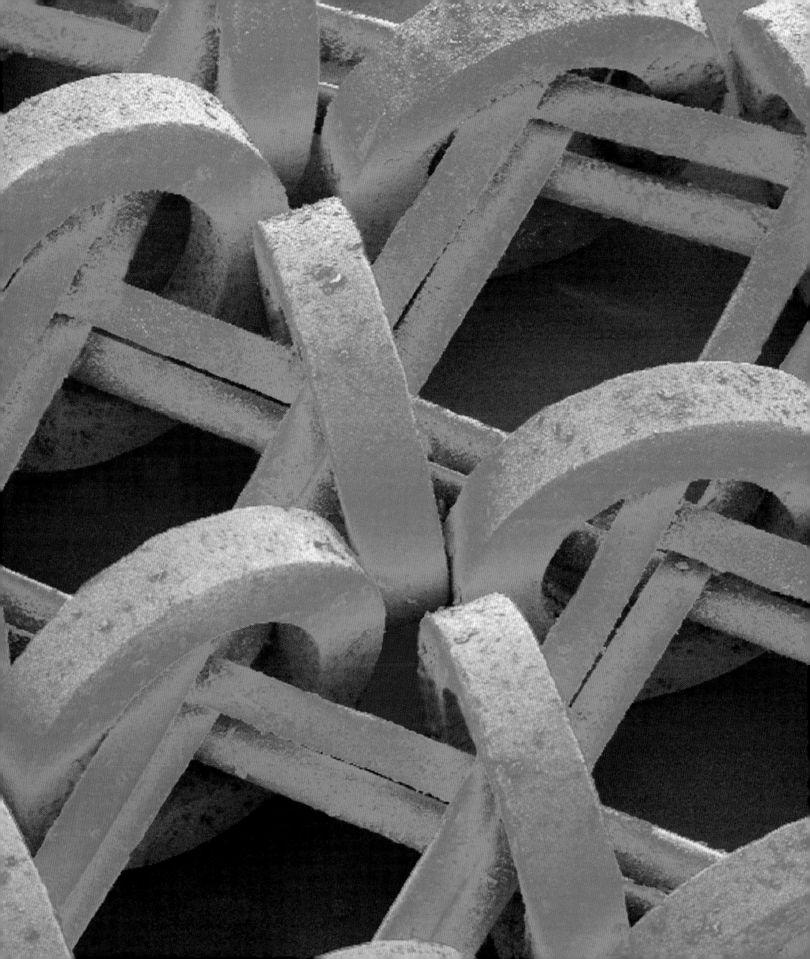

Here are some images from Nick Fang's lab at MIT. I made the first on a stereo microscope. **5.5a** The next two were made with a compound microscope using two magnifications. **5.5b,c** Note that the last image has a very narrow depth of field. In this case, the narrow depth of field is informational. The viewer understands the 3D structure because part of the image is not in focus.

5.5a

5.5b

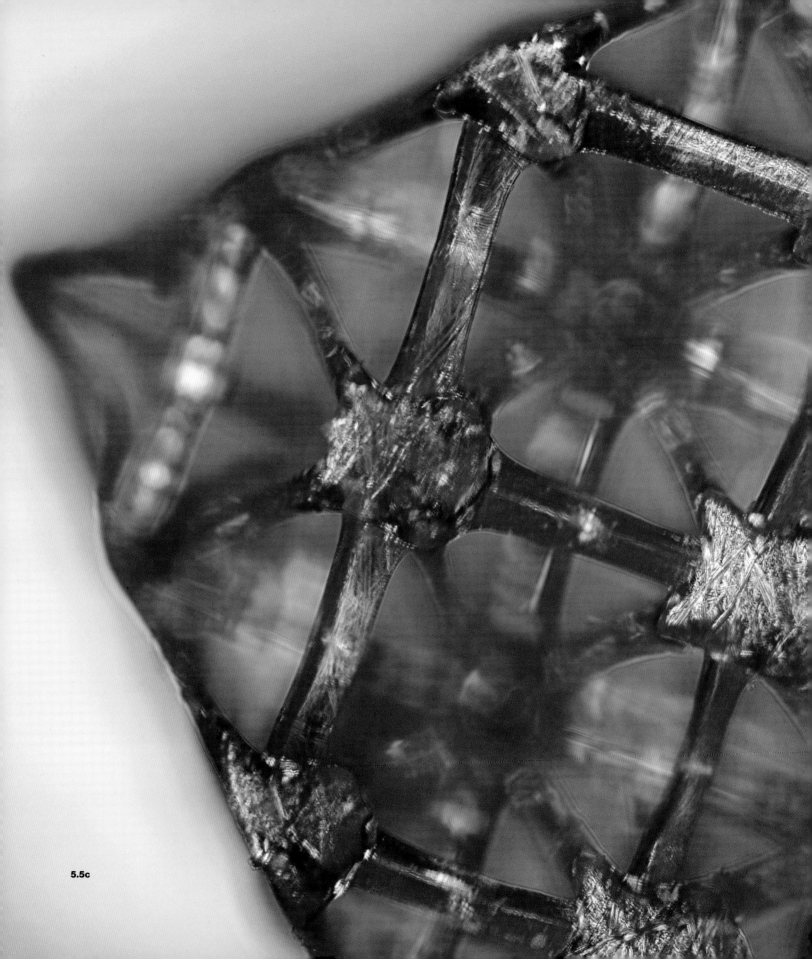
5.5c

5.6a

Choosing what magnification to use is another decision involving point of view. The decision is not always straightforward. Here are three images from Dean Anantha Chandrakasan's lab, with work done by Phillip Nadeau. Note how I zoom in to the device and have to recompose each shot. **5.6a,b,c**

5.6b

5.6c

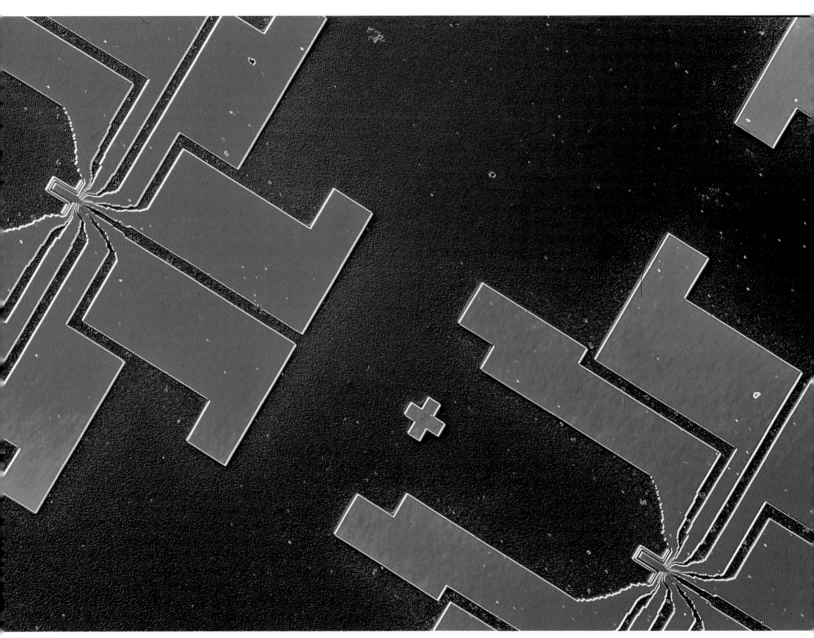

5.7a

Here too, from Mark Wrighton's lab, zooming in from one magnification to the next higher magnification **5.7a,b** offers completely different points of view. See if you can discern where the structures appearing in the second image also appear in the first.

These images and a number of others in this chapter were made using Nomarski, also known as differential interference contrast (DIC) technique. Consider purchasing a scope with that capability if your work involves surface structures or unstained biological material. It can be used in both transmitted and epi-illuminated light. The technique is based on changes in index of refraction and contributes to seeing forms. However, be aware of the following, according to Olympus' Microscopy Center (http://www.olympusmicro.com/primer/techniques/dic/dicintro.html): "Images produced in differential interference contrast microscopy have a distinctive shadow-cast appearance, as if they were illuminated from a highly oblique light source originating from a single azimuth. Unfortunately, this effect, which often renders specimens in a pseudo three-dimensional relief, is frequently assumed by uninformed microscopists to be an indicator of actual topographical structure."

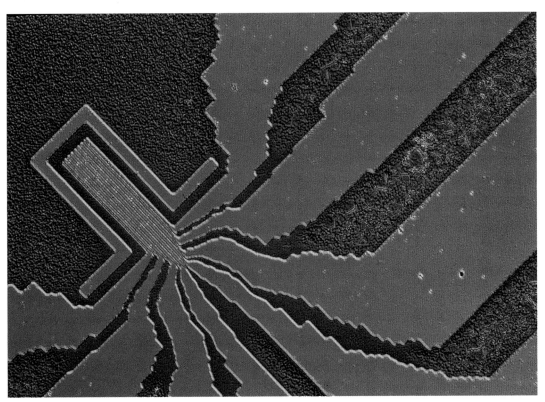

5.7b

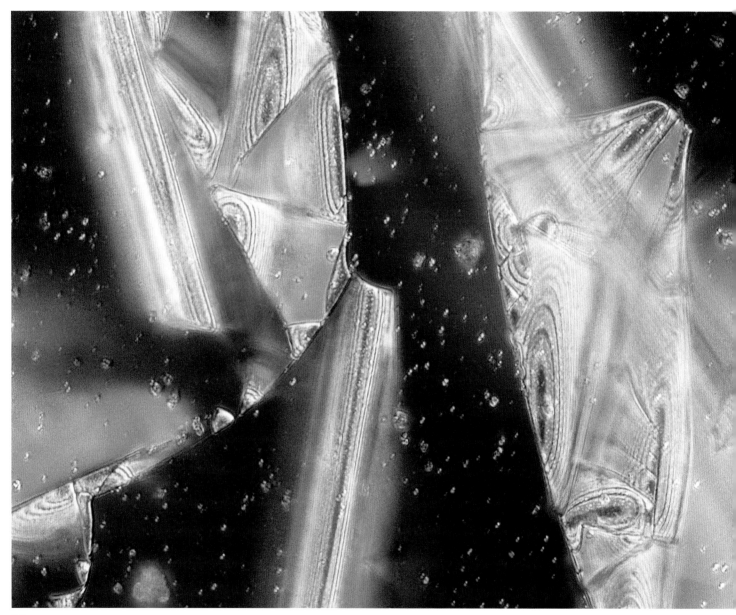

5.8a

For my purposes the technique works well and also adds color. In this image, for example, of plastic folding over on itself (an error made in the lab, by the way), we see interference patterns that could be a hint as to the thickness of the plastic. **5.8a** Since the colors are "dialed in" and not quantitative in this case, I inverted the image for fun and liked the result. **5.8b**

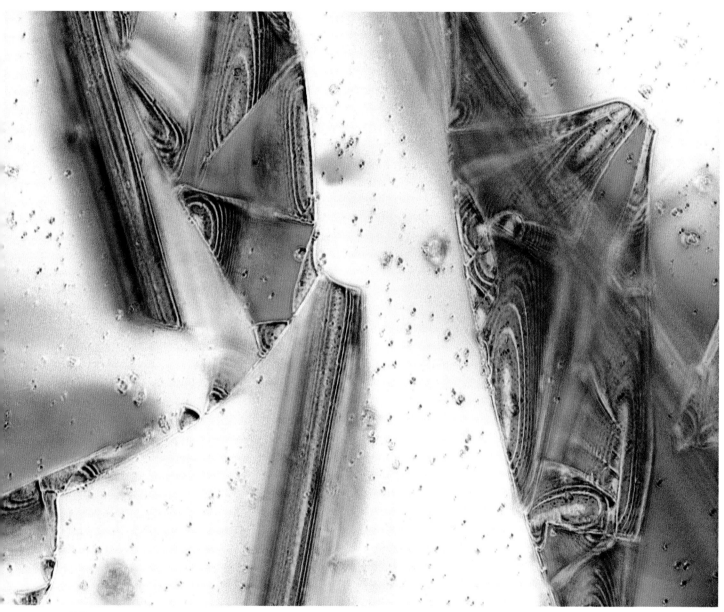
5.8b

Take care when deciding to use Nomarski. The possibilities are more than you need. Here you can see the various outcomes of Chris Love's device as I tried various wavelengths. **5.9a,b,c,d**

I prefer the first of these. Incidentally, on the following page is a more magnified version, also using Nomarski. **5.9e**

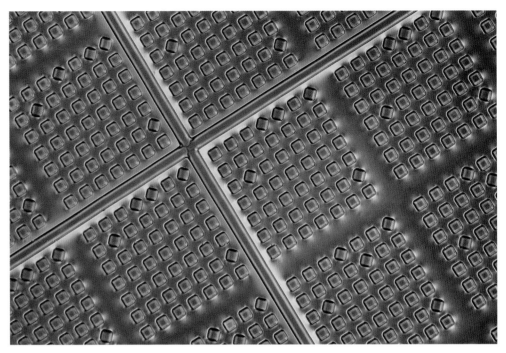
5.9a

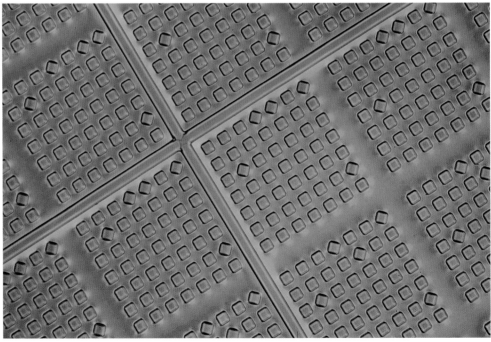
5.9b

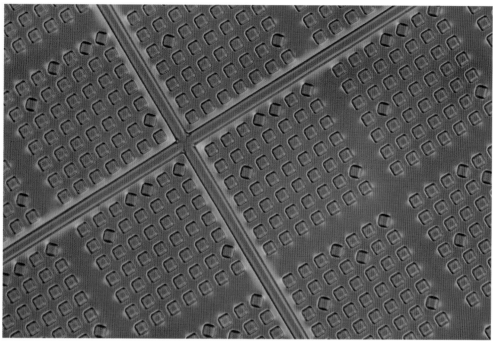

5.9c

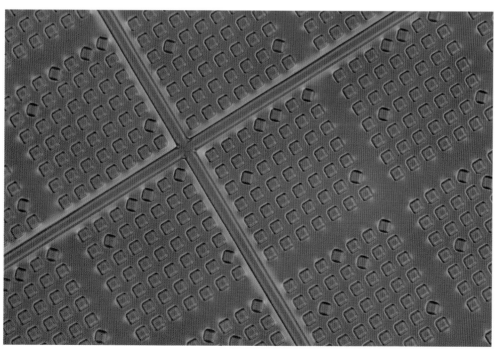

5.9d

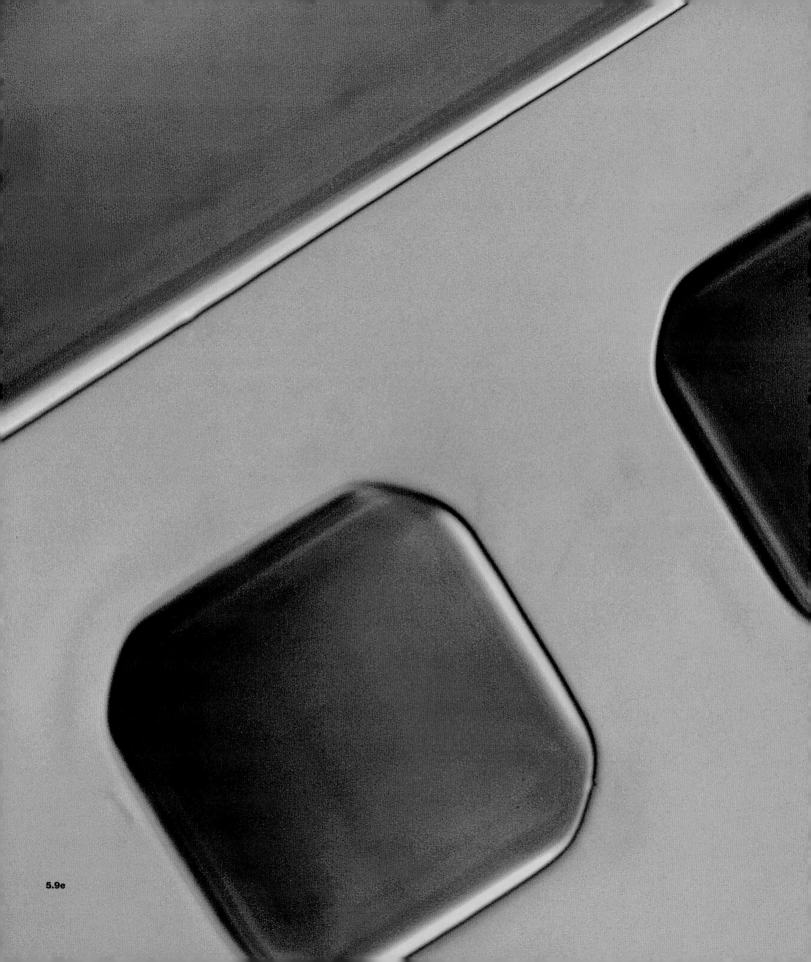

5.9e

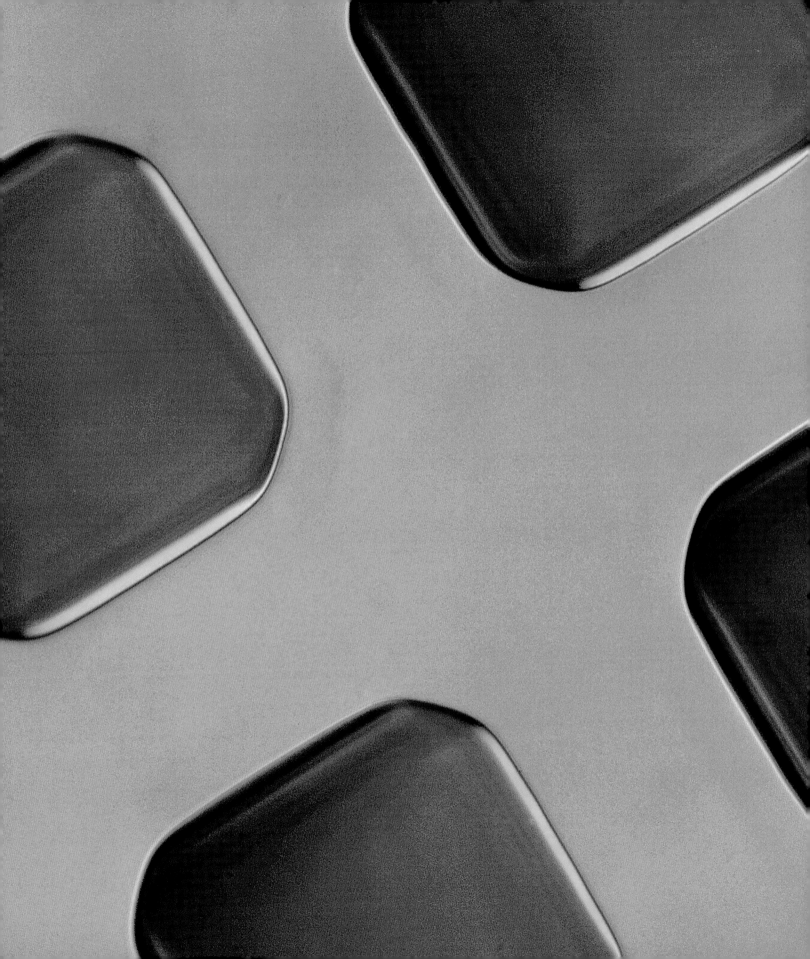

Continuing our discussion of point of view and composition, in this next image, showing the presence of two different forms of yeast colonies, the light source becomes a distraction. **5.10a** You are seeing my process, and I would rather you pay attention to the science in the image. Observing the colonies and the differences in their morphologies is the primary purpose of the image. And so I suggest that a second, more magnified image is more useful. **5.10b**

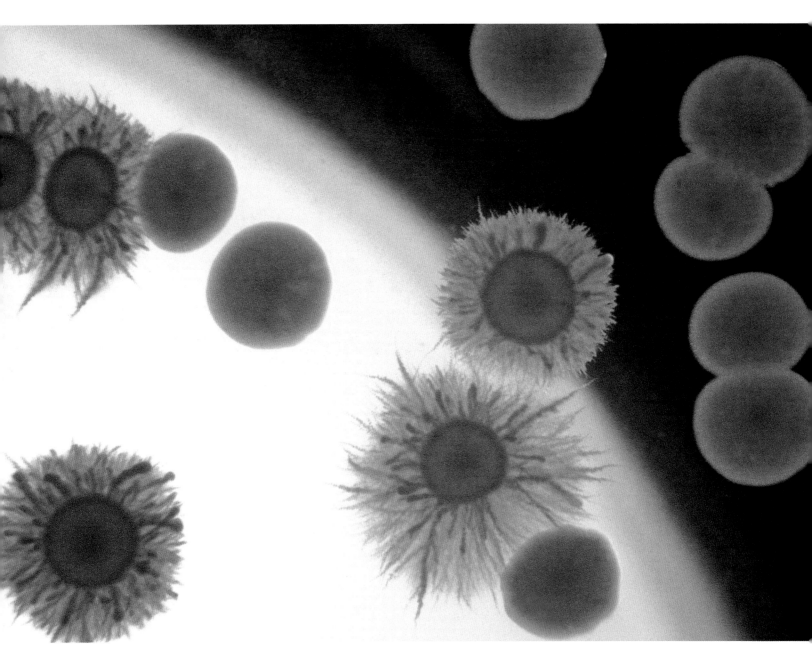

5.10a

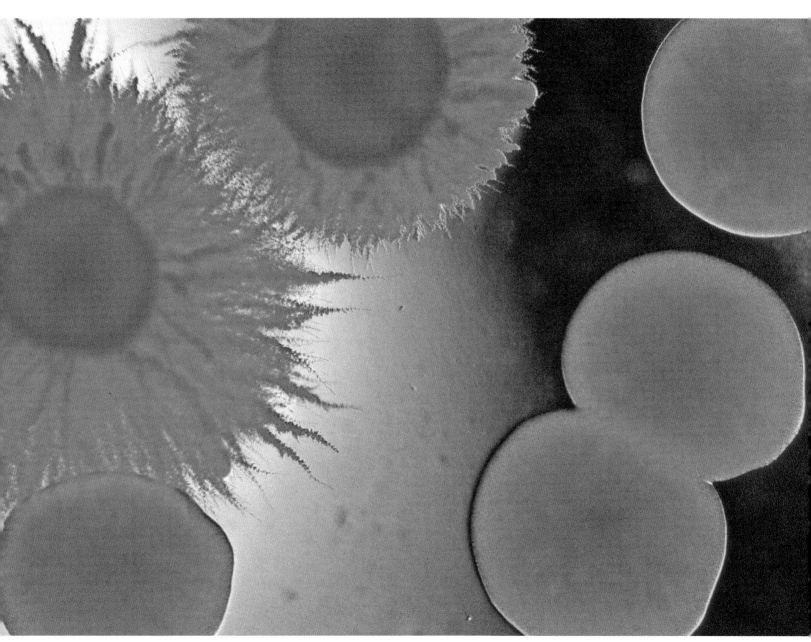

5.10b

There are times when deciding from what point to photograph is not very complicated. With this example from Klavs Jensen's lab, my decision was straightforward. **5.11**

Also from Klavs's lab, I composed these microchannels slightly off center. **5.12**

And from Mehmet Toner's lab, the composition of this image of another device with microchannels is also slightly unequal. **5.13** Try thinking this way for your own work.

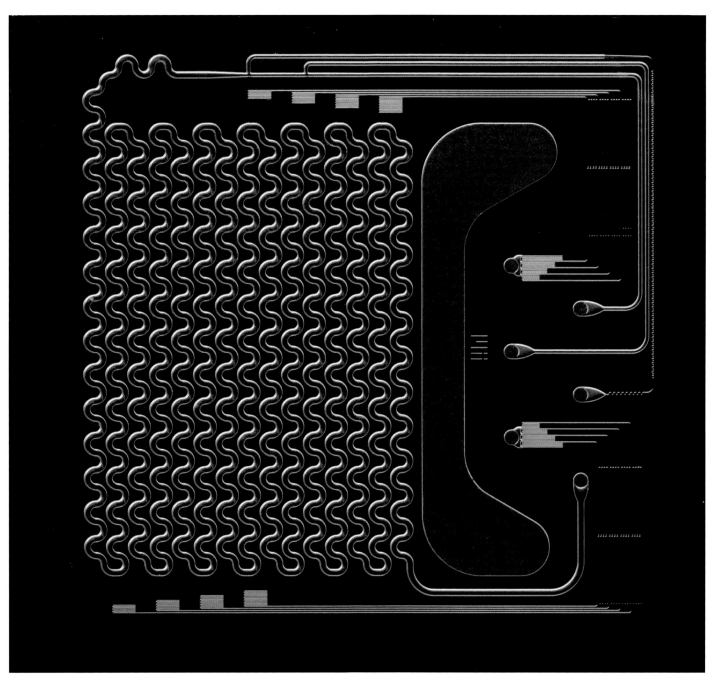

5.11

5.12

5.13

Then there are times when one has to work hard at finding the right composition. With this transmitted-light microscopic image of cadmium selenide nanocrystals from Moungi Bawendi's lab, it took me a while to make some sort of compositional sense of some completely disordered material. **5.14** I think it works.

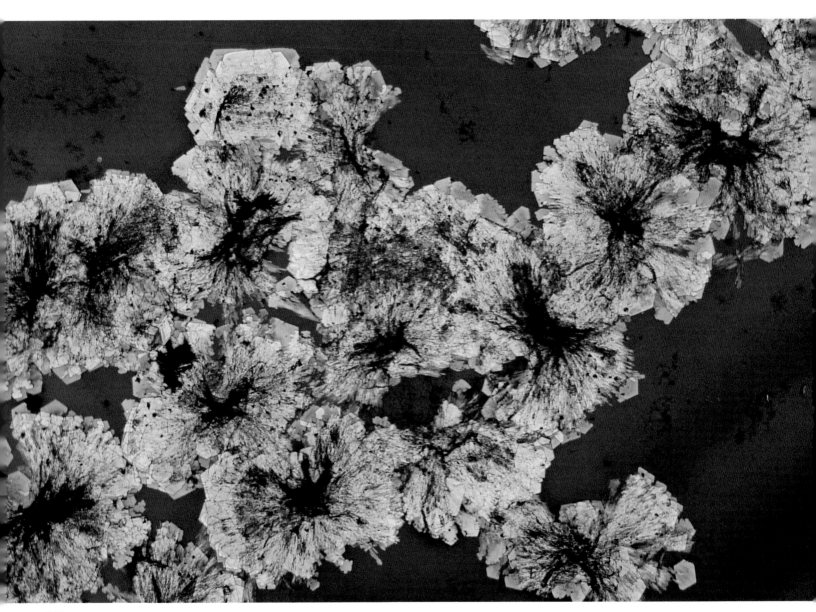

5.14

But finding the right composition for a vinyl record track of "Eleanor Ribgy" was not obvious (for George Whitesides's and my book *No Small Matter*). When in doubt, I slant the image. It works better than the less interesting repeated horizontal lines when nothing else is going on. **5.15** Compare this image to 5.12 and 5.13 where there are already interesting components besides just straight lines.

5.15

This next image is yet another attempt to get the right composition for the complex surface of a microrotor. **5.16a**

5.16a

Just for context, here is an image of the device taken with my camera and lens. **5.16b**

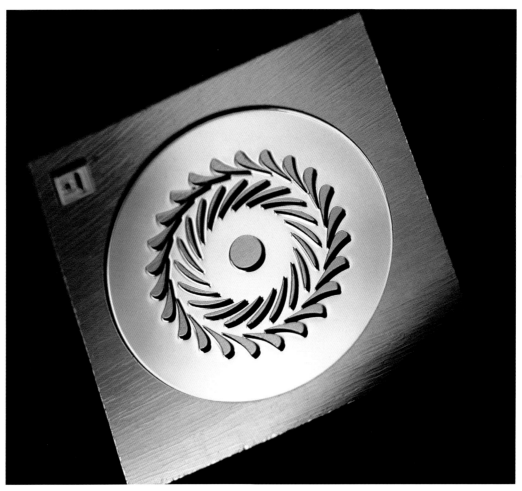

5.16b

Another note about microscopic composition. Remember my suggestion, in chapter 2, to image in twos? The same can be relevant if you are capturing at low magnification under a stereo microscope. **5.17** The devices at right are prototypes fabricated by students in Marty Schmidt's lab. You've seen this image before, here made a little less dramatic.

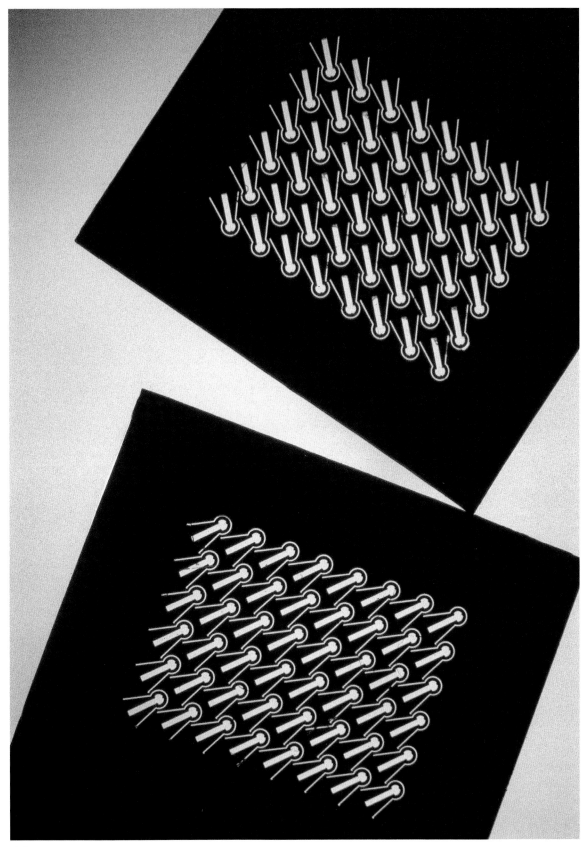

5.17

Here's another idea for composition that you might consider. To visually emphasize the point you are trying to communicate, it often works to include "the other" in the picture — that is, to make a comparison within one image. We saw it in 5.10a and 5.10b, but here the idea is slightly different. In this sample, we see only the patterned self-assembled colloids. **5.18a** By moving the sample slightly on the microscope stage, we see an area where the colloids did *not* self-assemble, giving the reader a way to think about and compare the two areas — making the comparison clearer and reinforcing the patterned self-assembled part of the story. **5.18b**

And further, as you also recall, I seem to be obsessed with backgrounds. You might find that at some point you will create a microscopic image, as I did with these microcapsules, and will wonder why you bothered. Here's some advice — hold on to that image. You never know when it will come in handy. **5.19** (See case study 3 in chapter 8.)

5.18a

5.18b

5.19

SEM AND CONFOCAL IMAGES

Covering all of microscopy would require a book in itself, and I certainly don't have the expertise to discuss this equipment, but I decided to include two more techniques used across a number of disciplines.

The scanning electron microscope, discussed earlier in this chapter, is a powerful way to capture a structure. Through the years I've made a number of images using it, always with the help of someone who knows more than I. I act as a sort of art director and ask for various points of view as we both look at the screen. Here's an SEM of an atomic force microscopy (AFM) tip made with Chris Love's help. **5.20**

I colored the image for a cover of *Scientific American* (see a brief discussion of SEM coloring enhancement in chapter 7).

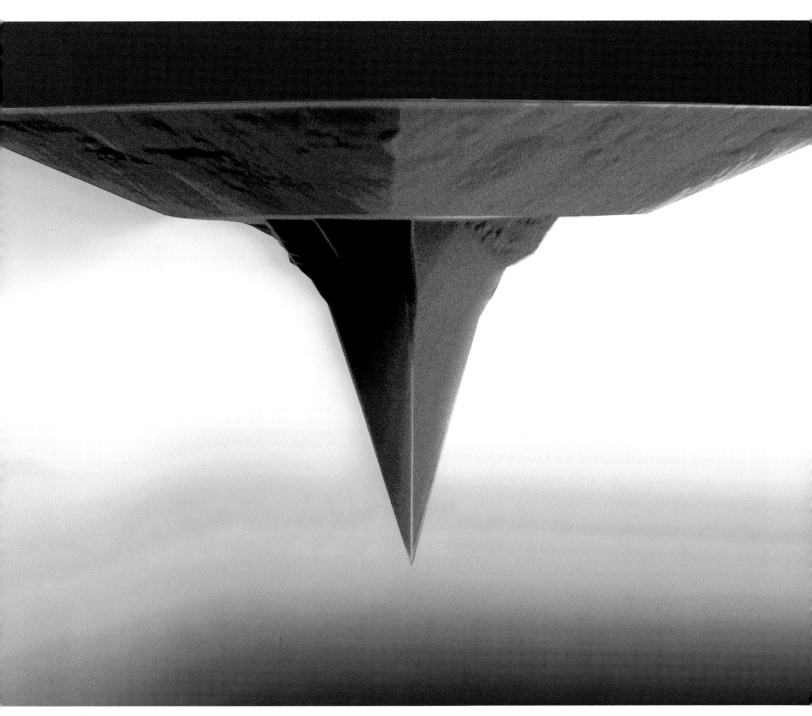

5.20

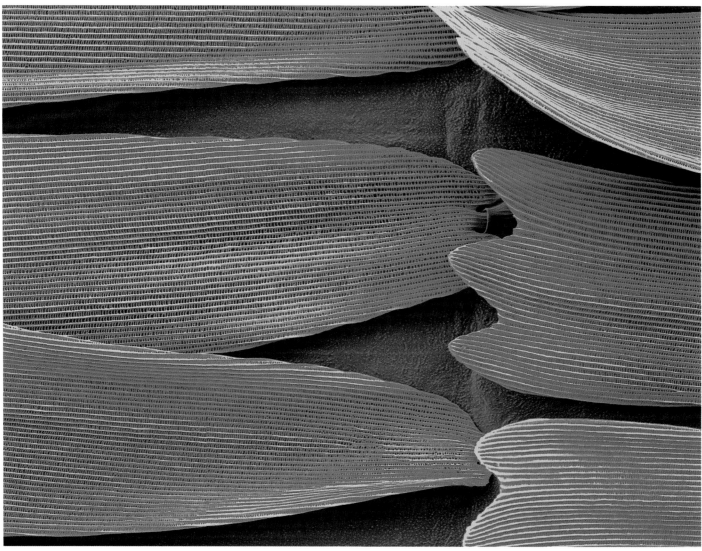

5.21a

These next two SEM images both capture details in a morpho butterfly wing. I colored these as well. **5.21a,b**

On the following page is an SEM image the researchers made; I colored it and added an illustrated "glowing LED" in the center—creating a photo-illustration. **5.22** You'll see more photo-illustrations in later chapters.

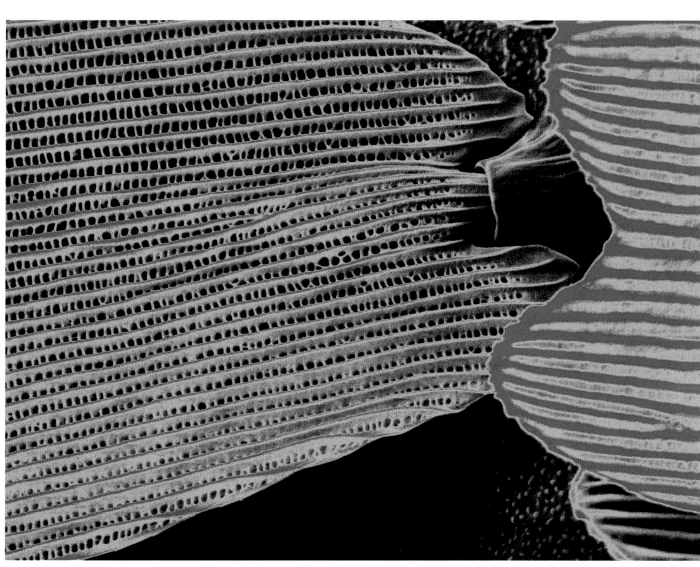

5.21b

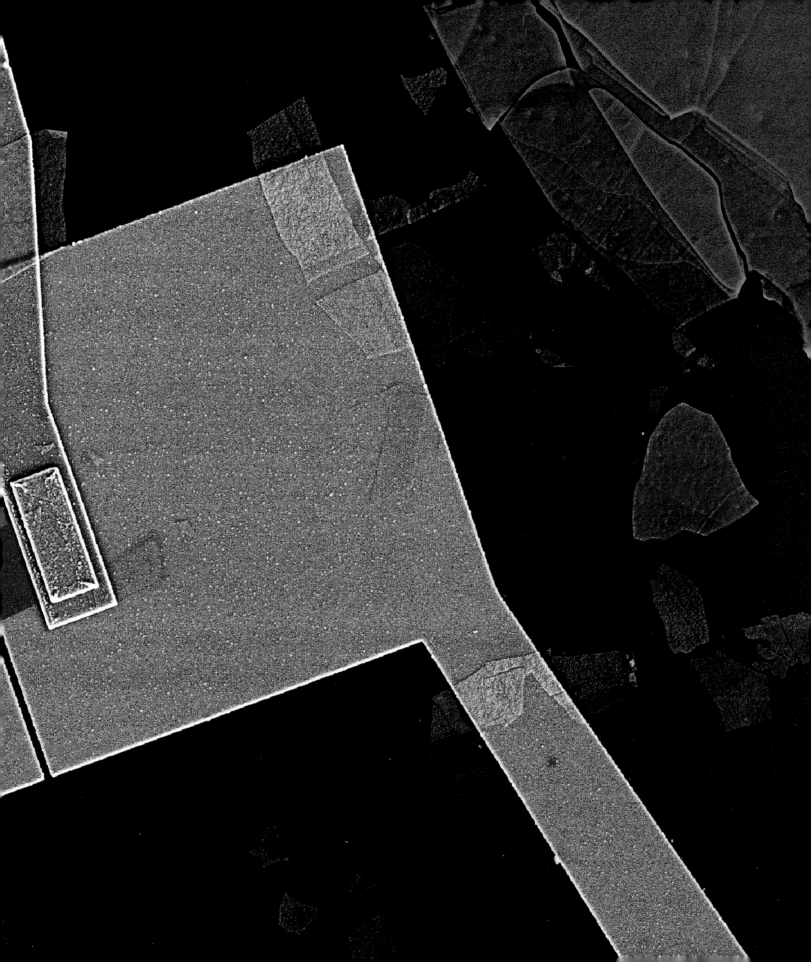

Confocal microscopy uses a technique similar to one discussed in chapter 2 – a form of stacking a series of images, but considerably more complicated, since the results offer both 2D and 3D constructions. I include here two stunning images made with confocal microscopes.

The first is of self-assembled brain cells grown on a synthetic hydrogel. The image was constructed by Collin Edington and Iris Lee from Linda Griffith's lab at MIT's Koch Institute for Integrative Cancer Research. Various fluorophores were used to tag components. Collin clarified to me: "Alexa Fluor 488 (green), 568 (red), and DAPI (blue, 405nm). Green is beta-3-tubulin, a structural protein in neurons, and red is GFAP (glial fibrillary acidic protein) which stains for other neural cells like astrocytes, and blue is nuclei. There is a lot of red/blue overlap in the center which makes it appear purple." **5.23**

I also asked him to describe any manipulations to the image, a subject we consider in chapter 7. He wrote: "Manipulations would be standard deviation z-projection to flatten the layers, and then just balancing the intensity of the color channels to make it pop visually. Since we were only looking for location of the stains and not relative intensity, we were not worried about editing the color channels." To emphasize his point, quantifying the saturation of each color was not the purpose of the image – just the location of the various tags in order to see the structure. This is critical. Again, you'll see a discussion about this and published guidelines from a few journals in chapter 7.

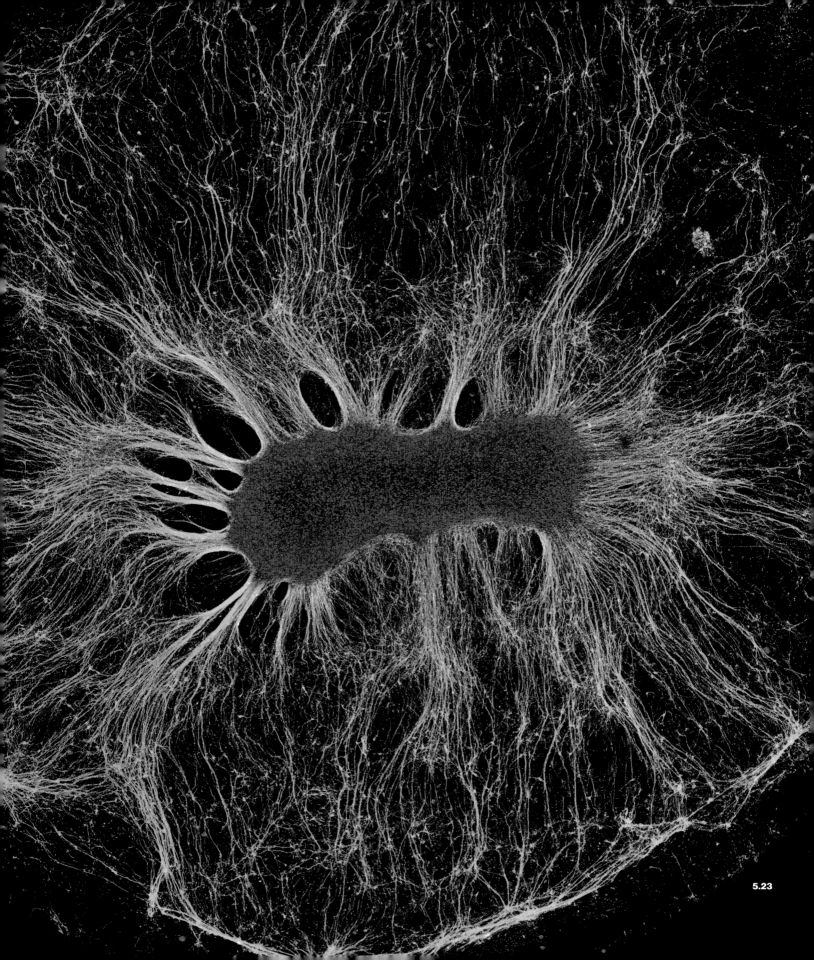

5.23

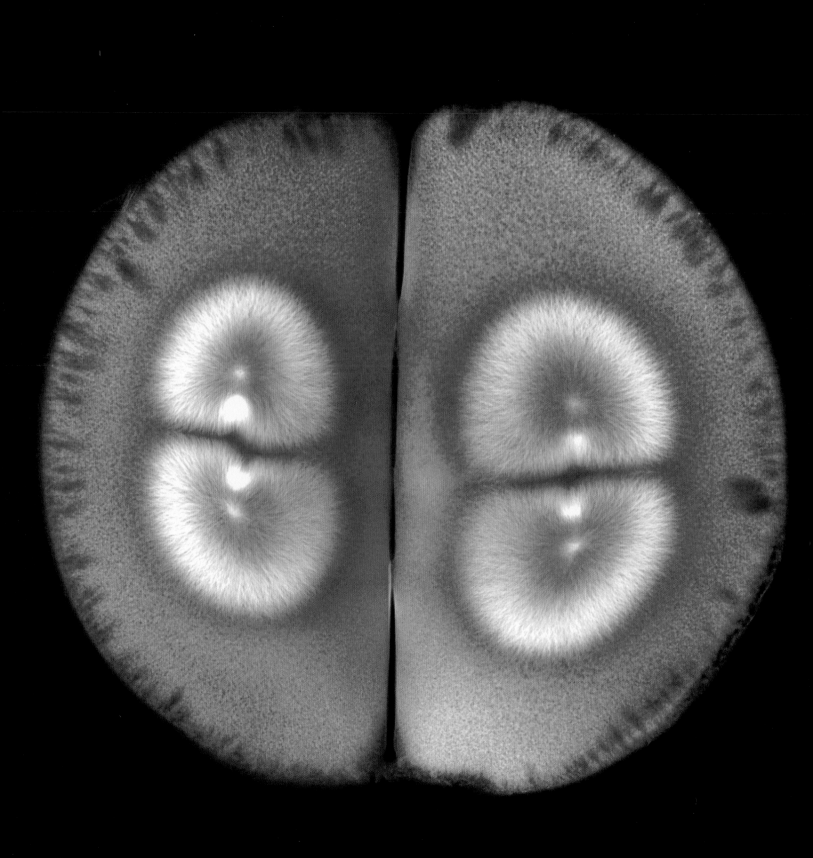
5.24

Here is another confocal example – a *Xenopus laevis* egg undergoing mitosis, imaged at 119 minutes post-fertilization. **5.24** The image was constructed by Martin Wuehr in Tim Mitchison's lab in Systems Biology at Harvard Medical School. The embryos are stained for alpha-tubulin (green) and gamma-tubulin (red). You can find more information about this image and a library of other magnificent images at http://www.cellimagelibrary.org/images/36441.

SUMMING UP

Optical

- Determine what kind of microscope to use.

- Along with a high-magnification compound scope, consider a second scope with lower magnification to produce images for communicating context.

- Consider differential interference contrast (DIC), or Nomarski.

Know your equipment

- Once you make a decision about which microscope to use, take the time to read the manual.

- If applicable, observe the differences between darkfield and brightfield.

- Test different aperture settings.

Your camera on the microscope

- Always compose and focus through the camera (via computer or in the camera viewfinder). Never use the ocular for those purposes.

Scanning electron microsopy (SEM)

- Set the instrument to give the largest file possible (dpi). Check with the expert to ensure this makes sense, to prevent damage to your material.

- Consider coloring the image, and *always* indicate that you have done so (if you do).

Confocal

- Set the instrument to give the largest file possible (dpi). Check with an expert to ensure this makes sense, to prevent damage to your material.

- Archive a workable number of the slices for referencing later on.

Keep a record

- of your process.

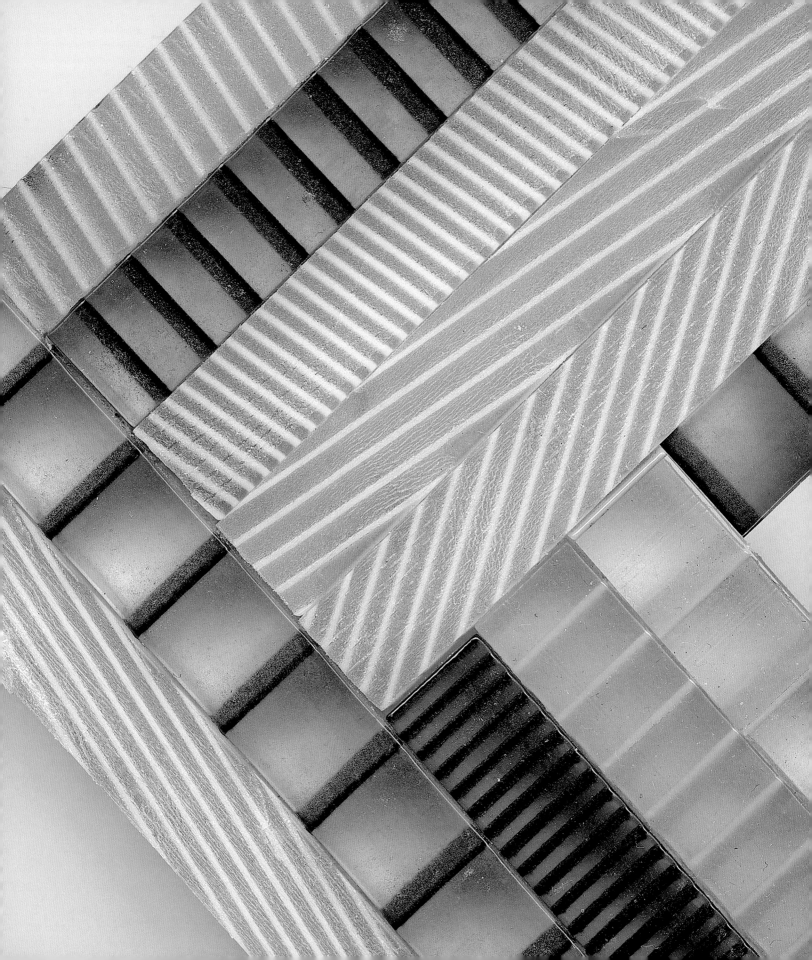

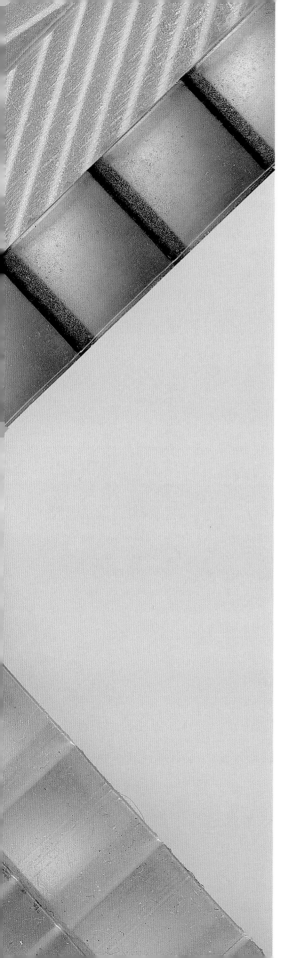

6

PRESENTING YOUR WORK

Now that you are familiar with the principles of making good photographs, in this chapter we'll take a look at what to *do* with your photographs — how to *present* them in various forms. We'll address the challenges of developing figures, journal cover designs, and showing scale and time in a still image. We'll also take a look at slide presentations.

FIGURING YOUR FIGURES

This section is intended to get you to think differently about creating figures that are readable and clear to someone viewing them *for the first time*. This is important. You cannot assume the first-time viewer will see exactly what you have in mind. You have been working on these images and numbers more than anyone, and you know exactly what to look at. But a viewer, when first presented with the material, sees it *all*, including the unnecessary components that don't add to the understanding of your research. If there is too much to look at, she might not even bother looking. And if you cannot visually present a clear hierarchy of information, then *you* are not clear about the purpose of the graphic. I'll show a few examples in this chapter, and you'll see in-depth descriptions of a few more in the case studies in chapter 8. The examples might, at first, appear too specific to their particular research, but give them more than a quick look. I am confident you will translate these specific ideas to your own work.

As always, I encourage you to view the online videos on the book's web resources page, since I'll not be including all of the video examples in this edition. For one thing, a few of the video discussions on graphics can already be found in print in Angela DePace's and my book, *Visual Strategies: A Practical Guide to Graphics for Scientists and Engineers* (Yale, 2012). And probably more important, I developed some more recent ones and wanted to offer you some newer perspectives.

From the get-go

I have always wondered why the design of various graphics and photographs from labs is usually left to the last minutes of submission deadlines. Often, for example, when I am given a sample of a device and asked to image its structure, I find that the material is a mess, with distracting dust and scratches (see the case studies). If you keep the photographic process in mind from the very beginning of your research, later you'll be happy to photograph a good clean sample.

And for those involved with representing massive amounts of data (evidence), I am going to suggest that you think about the following. The *representation* of your data should take a front-and-center role, so that the *readability* of the data becomes just as important as the algorithms designed to gather it. I am convinced that thinking about depiction, from the beginning, will not only advance the exploratory ease of the work but will advance your own understanding. Therefore, designing your visuals should be part of your methodological thinking.

For those representing evidence in graphics, relying on templates from PowerPoint, i.e., not coming up with your own design, will subvert your process. Why should you count on someone else to design your presentations when only you can decide on the expression of your information?

After running scores of visual communication workshops on the MIT campus and around the country, I've come up with three basic categories of science graphics—those that:

1. show evidence, i.e., images or numerical data,

2. are explanatory—depicting concepts, processes, visual models—or metaphoric, or

3. encourage discovery, as in interactive or exploratory graphics.

Attempts to combine these categories into one graphic often result in overcrowded information and are difficult to read, especially for the first-time viewer. The following is a good list of questions that you, the researcher, should ask yourself when beginning to develop a graphical figure.

Who is the audience?

The way you approach creating your visual depictions should depend upon whether they are going to be presented to an expert audience or to the general public. In fact, even when you are presenting to fellow scientists, if their discipline is different from yours, their knowledge of your material is almost that of a general audience. So watch your language — the visual one, that is — whether you are presenting a public talk or are publishing in a journal or magazine. Don't assume you have to "dumb down" your material for the public. But your selection of metaphors to express a complicated point (a good exercise to consider) can be one of your most creative endeavors and should be taken seriously, by you and your audience.

What is the first thing you want the viewer to see and understand?

Have you clearly visually "defined" your figure? Will your viewer understand that you are showing evidence, or a process? Where do her eyes first land?

In the draft figure on the next page, from Vera Steinmann, it's not obvious whether the intent is to show process or structure. **6.1a**

We first see a pile of tin sulfide powder, which yields some information displayed in a graph. An SEM then shows that the tin becomes deposited in layers, with a final image of a device. This particular figure is intended to be mostly about *process*.

When the researchers and I met, I first questioned whether the graph really had to be included. Perhaps it could be placed elsewhere in the article or in the supplement. Happily they agreed that the graph would be deleted from the final figure. We then discussed whether it was important to show the powder. They first asked that I come up with another way of depicting the tin sulfide, and so I tried a series of vials containing the tin sulfide. Eventually that, too, was deemed unnecessary. We then agreed that inserting their SEM *within an illustration*, showing all of the various layers, was a more concise and clean approach. And then finally, after I made a better photograph of the solar cell, we all agreed on the final figure with the caption explaining each component. Compare the first attempt to the "redo," **6.1b** and see if you agree.

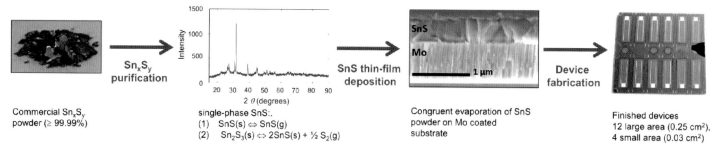

6.1a

Commercial Sn_xS_y powder (≥ 99.99%)

single-phase SnS:
(1) $SnS(s) \Leftrightarrow SnS(g)$
(2) $Sn_2S_3(s) \Leftrightarrow 2SnS(s) + \frac{1}{2} S_2(g)$

Congruent evaporation of SnS powder on Mo coated substrate

Finished devices
12 large area (0.25 cm²),
4 small area (0.03 cm²)

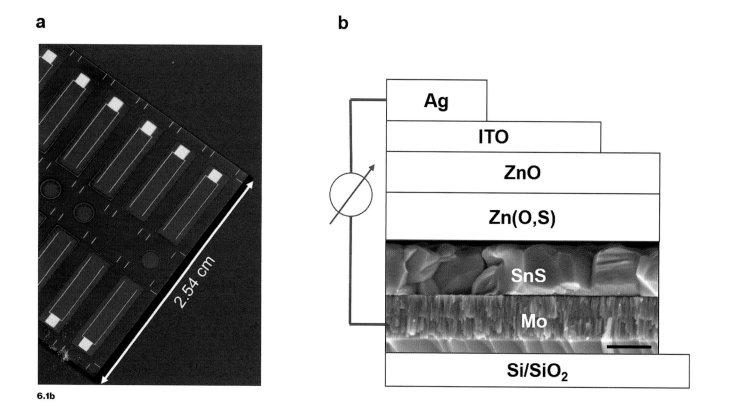

6.1b

Is your information redundant?

Often I see figures containing a repetition of information. Most of these redundancies are attempts to show that you've done the work (i.e., you've made a picture or two), but the more material you put in your figure, the more the viewer has to discover what to look for. Ask yourself: is this particular piece of the figure contributing? If a figure is to *inform* the reader about the structure of a device, for example, or the process of fabrication, then consider how many pieces within the figure will suffice. Is it really important to show all the photographs you've made?

In another draft figure (next page, above), from Cullen Buie's lab, we see two photographs at the top that are redundant – the second is not saying anything different from the first. **6.2a** We don't need both, especially given a journal's limited graphical space.

This tendency to include more images than necessary doesn't work. It can in a slide presentation, where the speaker can layer the information from slide to slide, over time. (See the discussion on slide presentations later in the chapter.) However, when the information is gathered within the one graphic permitted by the journal, the figure should be composed in a way that nudges the reader to see *exactly* what you want her to see. Once again, the key is to decide what to include and what to either leave out or move to a supplemental section. This draft figure finally evolved into the one below it. **6.2b** First, I made a clearer image of the device. We inserted an inverted fluorescent image at the bottom right, clearly connected to the image at the upper right. In addition, note how we resized each image to make a cleaner composition with equal space between the images.

An added note: I am convinced that most journals will eventually embrace the idea of interactive graphics – those that permit the reader to interactively choose which component of data in the figure to read. By clicking, the reader will be able to reveal various layers of information. The researcher (not the software!) will ultimately be responsible for designing the hierarchy of information. Frankly, I am a bit surprised that very few journals are implementing the idea. I suggest going to our book *Visual Strategies* for more discussion and examples of this subject. Also see case study 5 in chapter 8.

254

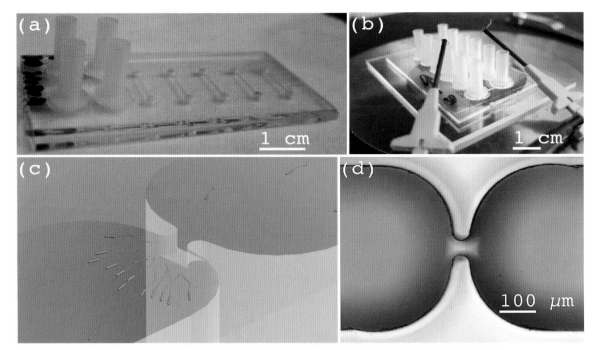

6.2a

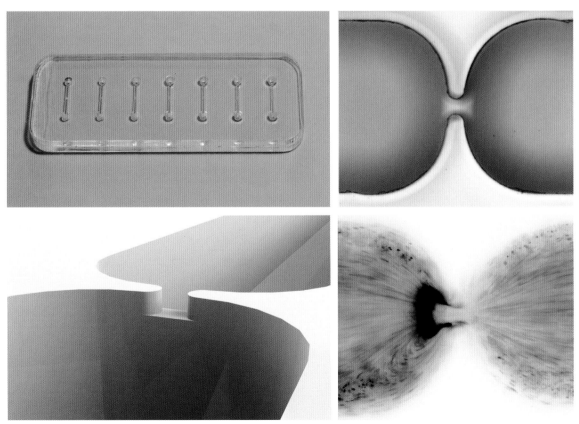

6.2b

Can you delete or change any graphical components?

Colors, labels, fonts, graph ticks, arrows, and similar components all contribute to how your figure works graphically. Dependence on your software's default choices for your graphics can often crowd your figures. For example, do you need *all* those ticks and labels in your plots? The image at left below uses the default setting. **6.3a** The one on the right is the suggested redo with fewer ticks and labels, made by Kun-Hua Tu who agreed that this small change made a difference. **6.3b** Also, note the deletion of the parentheses in the redone version. A less crowded figure is easier to read. Any graphical element that is not necessary should be edited out. Your goal is to create clean, spare, and readable graphics with plenty of white space.

6.3a

6.3b

Watch your arrows – they are strong graphical elements that take on a host of meanings: "measure from here to there," "this is called that," "go from here to there," "this becomes that," "this reaction takes place in the presence of that," etc. We use them in all corners of science, but be careful. Make sure your arrows for processes are all in the same style, and are distinguished from, let's say, a "labeling" arrow. And most important, question their use. In this example, the labeling arrows are not necessary. **6.4a** Take a look at Lauren Chai's redo during a workshop – deleting the arrows and simplifying the text to only one line beneath each illustration. **6.4b**

6.4a

6.4b

Are your color choices intuitive and helping to make a point?

Color is a powerful tool and should be carefully considered. I am always surprised at how often color is overused in figures. The fact is that too many researchers depend on the default color palette in the software. Why give that decision over to a software engineer?

In this draft figure (above on facing page), the illustration at the top left with colored layers misses an opportunity. **6.5a**

In the redo, to help the reader better understand the most important part of the structure (the buffer layer), we used only red in two places to bring attention to this critical component of the structure. **6.5b** Using color helps the reader see the connection between two parts of a figure. Make sure you want her to make that connection. As an aside, we also simplified the figure by deleting an unnecessary SEM. We made an even smaller edit, deleting the parentheses, and placed the letter labels outside the images, resulting in a more organized figure. These changes may all seem trivial, but when added up, they can make a graphic considerably easier to read.

6.5a

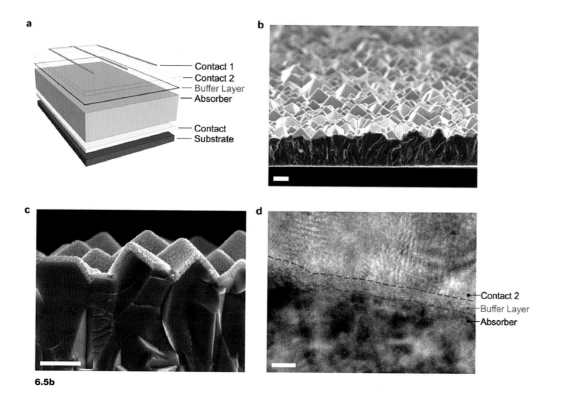

6.5b

Here's another before and after. For this example, I questioned the use of black. Allison Yost started with this first draft. **6.6a** (This is how we conduct our workshops, starting with first ideas.) She understood that some of the images were hardly readable and a few were unnecessary.

After some serious editing, her redo was considerably clearer, and it appeared in the journal. **6.6b**

Later, I encouraged a further change—inverting the black backgrounds to white/gray for the top and bottom left images. **6.6c** The figure now has a visual uniformity that the others didn't have.

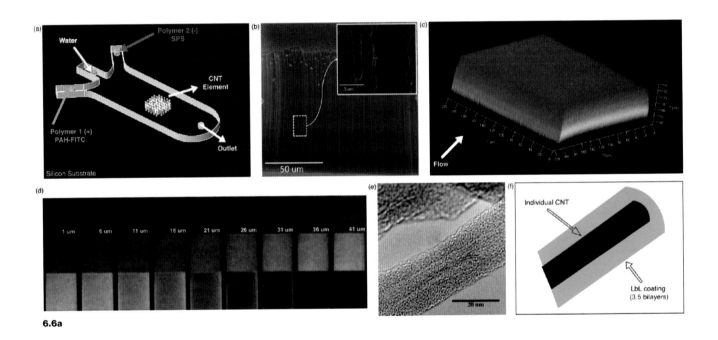

6.6a

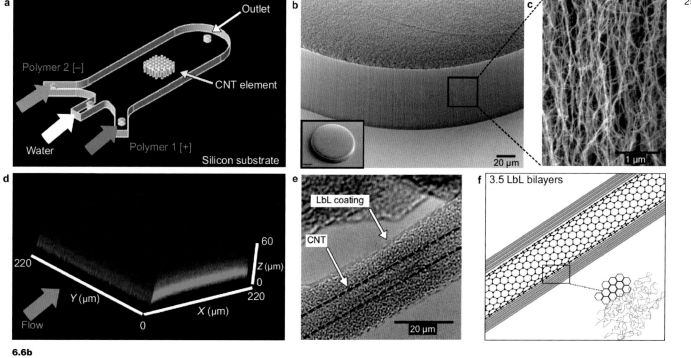

6.6b

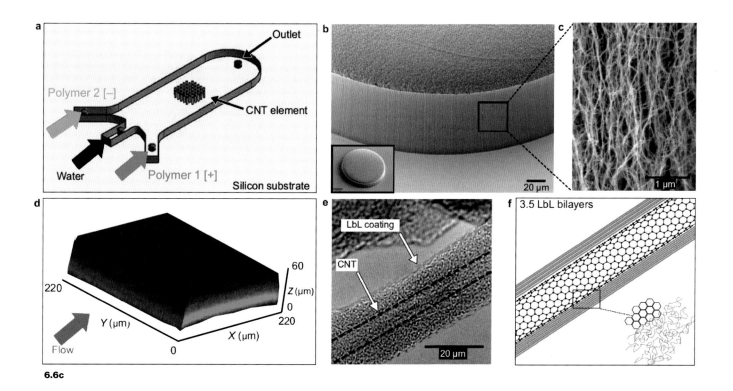

6.6c

Keep in mind that figures screaming with primary colors (which I too often see) are not necessarily easier to read than those colored more subtly. Take a look at this first draft, **6.7a** and note a number of other changes Jessica Swallow and I made in the redo. **6.7b**

In the matter of software color defaults, I often question why researchers who image with atomic force microscopy (AFM) insist on using the unattractive rust palette that comes with the software. **6.8a** If you think about it, the AFM image is basically in grayscale, which then is automatically tinted. Aesthetically, the rust tint limits other color choices in the rest of the figure. When I try to persuade my research colleagues to keep the AFM image in grayscale, **6.8b** the usual response is that the published rust-colored images will quickly be identified as AFMs by readers working with that instrument. It's a point well taken, but in the end I still question whether this particular point of view should be perpetuated.

6.7a

6.7b

6.8a

6.8b

Journals are now asking researchers to come up with their own designs in the table of contents (TOC) to attract readers' attention to their article. Keep in mind that these designs will appear *very* small, and so your attempt has to translate well at that scale. The simpler the better.

Here's a quick example of Qiyang Lu's original idea for a TOC. **6.9a** After our discussion, he transformed it to a simpler version. **6.9b** Deleting most of the unnecessary color, using mostly gray and emphasizing what was important, worked well.

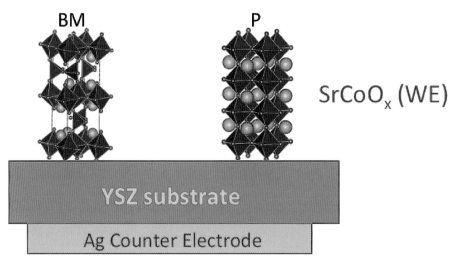

6.9a

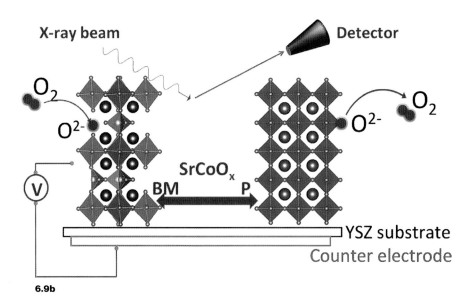

6.9b

Are your images more than good enough?

If you are going to include a photograph in the figure, why not insert the very best image possible? Viewers are drawn to photographs, perhaps because they are easy to "read," or perhaps because everyone is a photographer these days. But why settle for the not-so-terrific image if you can create one that shines? Joe Davidson started with this image. **6.10a**

After our workshop, he came up with this one. **6.10b** Quite a difference, wouldn't you say?

6.10a

6.10b

CHANGE OVER TIME

Most of the time, when researchers want to present what happens over time, they create videos, which makes perfect sense. Indeed, watching dynamic phenomena is quite compelling, and if you think about it, all of science is ultimately dynamic. We generally assume that we must watch moving images (i.e., a video) in order to observe change. But there is a place for the still image that suggests change. Here we'll take a look at just a few possibilities.

I open this discussion with a stunningly beautiful and highly informative image by Mark Klett and Byron Wolfe, created in 2002, entitled *Four views from four times and one shoreline, Lake Tenaya*. **6.11** I include it here to inspire you. Look at how informative and at the same time how aesthetically wonderful is this collage of various images.

6.11

They worked with a large-format view camera, copy prints of historic images, and Polaroid film and used the instant image to compare with the historic ones. When great accuracy was required, they made measurements of the distance between various objects in the pictures, then compared and changed their camera position as needed. It's a method they learned back in the days of film; it is now significantly easier to do and more accurate with digital cameras and laptops and the use of transparent overlays (in Photoshop). Once they made their own images and a mockup of the idea, they went back to their studios, scanned the film, obtained copy scans of the historic imagery, then assembled it all in Photoshop.

6.12

In this next example, I created a grid of photographs of the Belousov-Zhabotinsky reaction. **6.12**

It is a complicated, oscillating reaction taking place within a petri dish. I was privileged to create the images in Professor Zhabotinsky's lab at Brandeis. I took the entire series of images 11 seconds apart over a period of five minutes. By the way, I made the images on slide film, all those years ago. Here we are seeing a sampling of the digital scans of those individual frames, which allows us to observe the characteristic spiral waves forming, in the presence of a color indicator.

In fact, we could create an animation with these photographs by rapidly cycling through the series of *still* images, one right after the other. (See the web resources page.) This allows us to create what is, in fact, a movie. And, naturally, that could be highly visually interesting. But in my opinion, it is just as interesting to see the individual images lined up in a grid, giving us the ability to compare one moment to the next and to make detailed observations of the changes occurring over time. One can argue that this allows us to see far more detail than in a quickly moving video.

6.13a

Here is another example. **6.13a**

We are looking at a one-centimeter-diameter circular "sandwich" of two pieces of glass. This glass sandwich contains material called block copolymers in a solvent. When the solvent evaporates around the edges, over time, the block copolymers self-assemble, visually translating into color changes.

Again I created a series of stills and combined them into one grid. **6.13b**

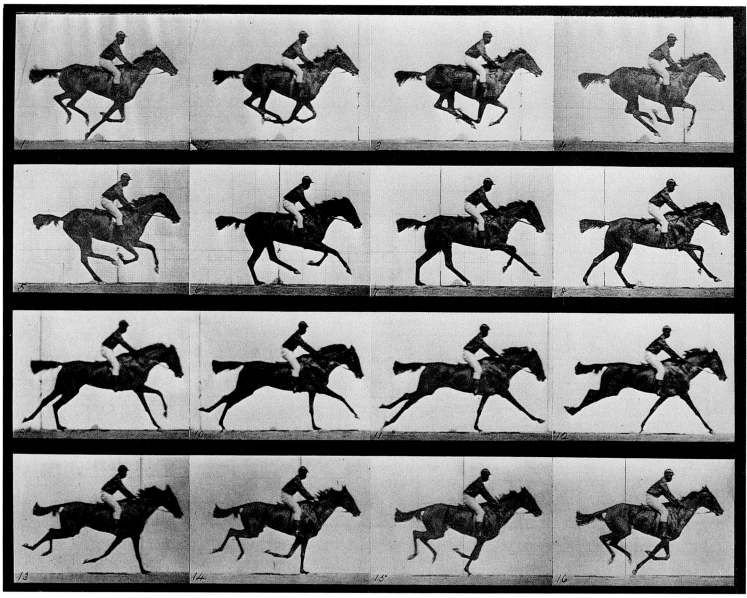

6.14

We could computer-animate the series by displaying them, one right after the other, as a moving image (see the web resources page). But observing each static image side by side can greatly clarify exactly what is going on. This approach is hardly new. The famous *Horse in Motion* created by Eadweard Muybridge in 1878 met the challenge of visually proving whether a galloping horse ever becomes fully "airborne." **6.14** Observing each individual frame gave the answer.

Here's an idea that can work only if *part* of your device moves. I made four images of this 3D-printed device from the company Desktop Metal and Chris Schuh's work. Its unique property is that it moves. **6.15a**

The first image was of the device alone without my hands moving any parts. For the next three, I held the lever at different levels. **6.15b**

6.15a

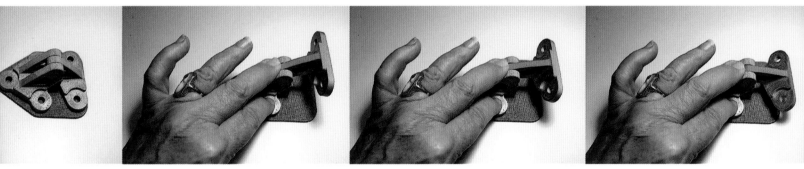

6.15b

Then, with careful cropping, cutting, and pasting of all the layers, I made the gif that you can see on our web resources page. For the still image, however, I layered only one of the cropped images over the base and made that overlaid layer slightly transparent. It got too busy using more than one image.

Take a good look at the still image on the next page and note the movement in one particular area. **6.16** Again, this works because the rest of the image is still.

6.16

SCALE

The purpose here is to encourage you to think differently from the standard approach to showing scale within an image. For starters, instead of showing the coin in the overused side-by-side layout, **6.17a** a slightly altered composition and a little cropping can make a more focused and interesting image. **6.17b**

6.17a

6.17b

Showing a device with something recognizable that echoes a particular property can also work well. In this case (next page), I used a compact disk, suggesting the size of this luminescing glass slide (although CDs might soon become as exotic as film). **6.18**

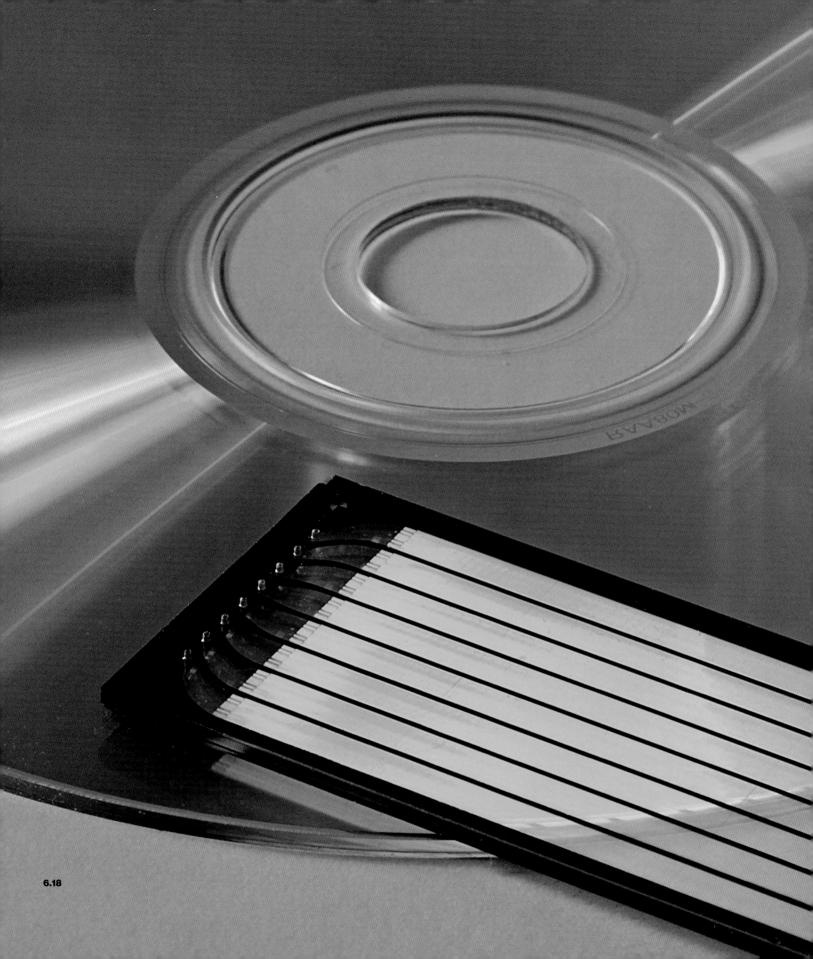

6.18

And here we see an engineered structure imaged with coins to suggest scale and also the important property of the material – its ability to collapse and bounce back. **6.19**

Another way to present an idea of scale is to show various points of view while zooming in with various levels of magnification. **6.20** You've seen two examples of this idea in chapter 5.

Keep in mind that I am not showing the exact size of the material; but I am giving the viewer more of a *sense* of scale, or of something missing from so many of our images – *context*.

Here is something else to think about. Instead of always placing a scale bar either in the lower right or lower left corner of an image, try placing the scale bar *within* the image while respecting the design of the image. **6.21**

6.19

6.20

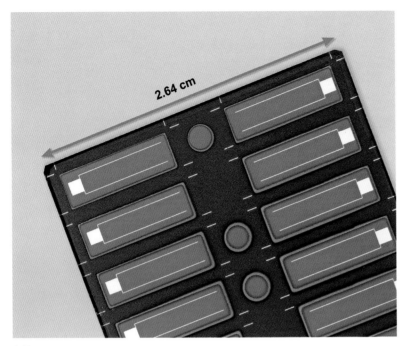

6.21

Here's another example of placing and labeling the scale bar *within* the image. **6.22**

The full design of the image works better. The information is there but doesn't compromise the aesthetics. Once again, I urge you to reconsider perpetuated notions of how to represent science. The scale bar doesn't always have to be on the bottom right or left, unless the journal insists on it.

6.22

TELLING A STORY

Visually suggesting the process of fabrication and the use of your material can inform your composition. This image has three compositional components. **6.23**

The green form on the left is the underside of a circular wafer (note the square "holes"). The fuchsia patterning is the top side of a similar wafer. The two small chips show the final elements in the process. The chips are intended for drug delivery via those holes. Keep in mind that none of these ideas work without the text describing the process. With the combination of text and image, viewers can grasp the story of how the chips are fabricated.

6.23

Here's another example. These fibers have various optical qualities. **6.24** My attempt here was to weave them into somewhat of a fabric – the researchers' intention for future use of the material. **6.25** In this case, the visual "story" is suggesting the use of the material.

6.24

6.25

The next image is of variously treated corn, each batch within its separate packet. I decided to include the plastic packets in which they arrived as part of the composition. **6.26**

6.26

Here's an image of several devices. **6.27** By showing various design iterations we can suggest the researchers' thinking. Note how I composed the image. The added upper left corner – the edge of the table – is intentional.

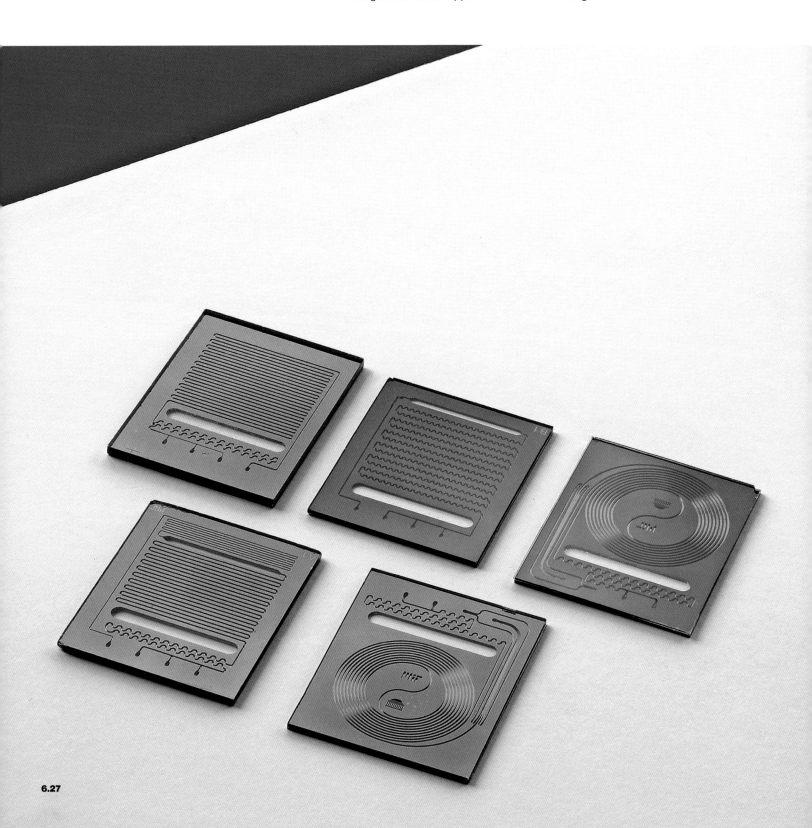

6.27

SEEKING COVER

If you are thinking about submitting your photographs as potential cover art for a journal, it is essential for you to study the layout of that particular journal — specifically, how the image is likely to be placed in their particular cover format. In the case studies, you'll see a few more examples of cover submissions, going into detail about my process.

Most covers these days are *full bleeds*, i.e., the image takes up the whole cover and is therefore vertical, **6.28a** although some still use rectangular boxes within the larger vertical format. **6.28b**

In addition, you will have to think about where the journal's logo is placed and where additional text might be dropped. **6.28c**

All of the above have to be considered to help the art director and editors decide whether your image is good enough for a cover. I do not suggest submitting a cover idea that includes the journal's logo. Let the folks at the journal use their imaginations.

6.28a

6.28b

6.28c

Here's an example of a cover attempt. Stephan Rudykh brought me these various pieces of material, with varying physical properties, that he had fabricated in his lab. **6.29a**

Using my flatbed scanner, I started playing around with some of these shapes **6.29b** and finally wound up with this composition, **6.29c** which I thought had the potential to be considered for a journal cover. In the end, I digitally added a color gradient to the background. **6.29d**

I have to admit that getting covers is always rewarding.

But keep in mind that it is not just the image that will get your cover. The importance of the *science* in your article is what ultimately informs the journal's selection process.

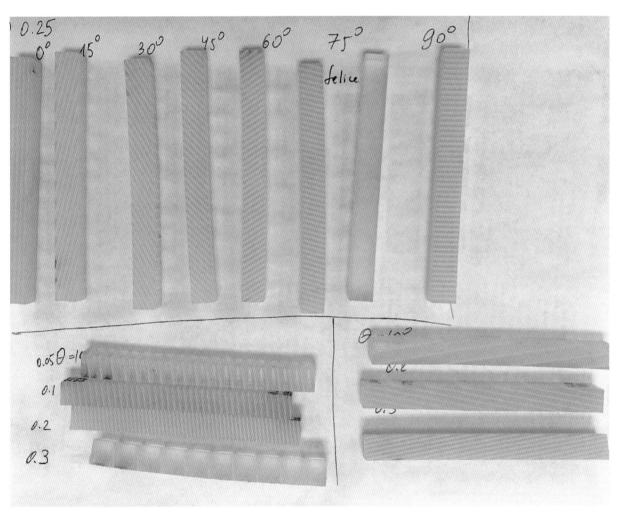

6.29a

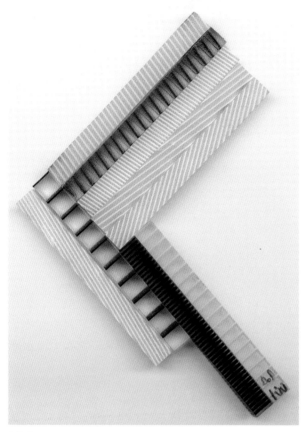

6.29b

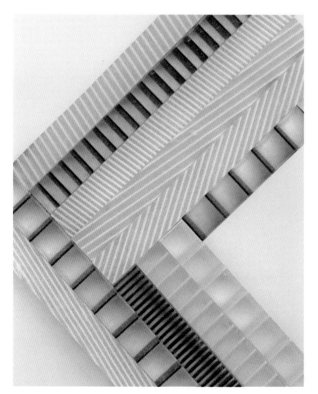

6.29c

6.29d

Here's a horizontal image **6.30a** that ultimately appeared on the cover of a chemistry textbook. **6.30b** Notice how they cropped the image to fit the format (with my permission).

6.30a

CHEMISTRY
& Chemical Reactivity

KOTZ | TREICHEL | TOWNSEND

6.30b

In this next image, while working to produce print material for the DuPont MIT Alliance, a research collaborative funding bio-inspired material, I created this picture of a sea urchin. First, I shot it straight on. **6.31a**

I then tried it with the flatbed scanner. **6.31b**

In the end, our talented graphic designer, Stuart McKee, who created a stunning brochure, placed the scanned image on the cover. **6.31c** It worked well in terms of the whole design of the brochure.

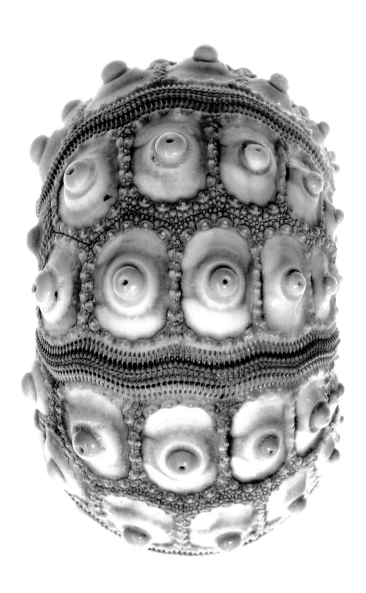

6.31a

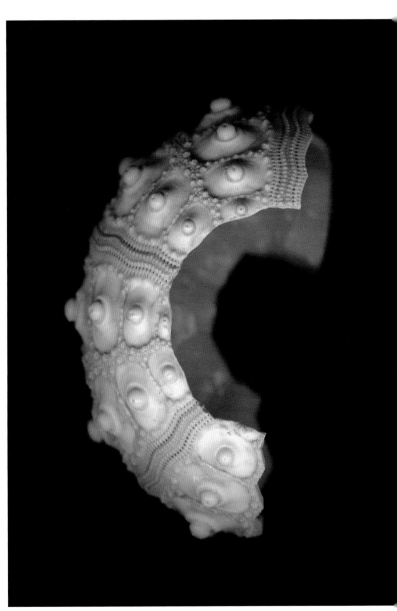

6.31b

6.31c

I have always been delighted to see how a simple image can become something more when text is inserted. Take this example. I made a detail shot of some important equipment at MIT's Microsystems Technology Laboratories. **6.32a**

The photograph became so much more interesting when used on the cover of an annual report. **6.32b**

6.32a

6.32b

For our book *No Small Matter*, I photographed beer within a rectangular container. The idea was to consider the molecular or nanostructure of bubbles as part of the nanoscience story. Notice how I included the wall of the rectangular container on the far right of the image. **6.33a**

The finished book cover wrapped the image around the full book and put the container area on the front book flap, which I think worked well. **6.33b**

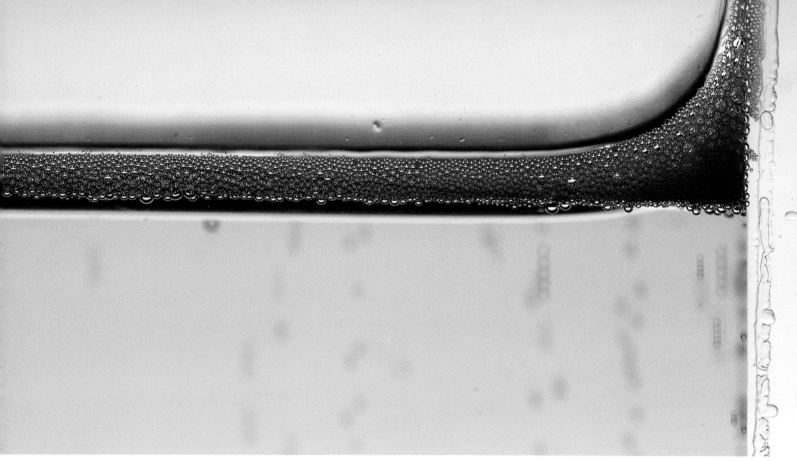

6.33a

6.33b

6.34a

Dropping text within an "OK" image – like the one on the facing page – **6.34a** can also make a successful cover image (below). **6.34b** The dark blue rectangle is the back cover of a booklet. I think it works.

6.34b

And finally, here's another image you've seen before, used both as a front and back cover for an MIT publication. **6.35**

I was quite pleased that an image I made 16 years ago still had a life. This was mostly because of the importance of the research in nanocrystal (or quantum dot) science. If you are lucky to work with researchers like Moungi Bawendi, whose work is timeless, then your photographs might become timeless as well.

The point of showing these covers is to encourage you to wrap your head around graphic design in your thinking. If you have created a wonderful high-resolution image of your research, you should alert the communications or design/art director of your department or university initiative. No matter how virtual we become, I am convinced there will always be a place for stunning printed material. The challenge for designers is that researchers simply don't think in terms of high-resolution images. The technical thread, weaving through all of these cover designs, is that each of the images was captured at 300 dpi in the final dimension for the publications. You should be doing the same.

6.35

A QUICK LOOK AT YOUR SLIDE PRESENTATIONS

For the most part, the errors I observe in many slide presentations are similar to those described earlier in preparing photographs and graphics for print publication, with these additional thoughts more relevant for slide presentations.

1. **Who is the audience?** Once again, you have to decide how much technical detail to include. But be careful not to include too much. Even those you consider "expert" might not see what you want them to see.

2. **What is the first thing you want the viewer to see and understand?** If you cannot quickly answer that, then you need to go back to the drawing board and consider how clear your slide is, in terms of how your audience grasps the purpose of each slide.

3. **Have you viewed your presentation from the audience's point of view?** I will bet your answer is no. If you had done so, you would most likely see how busy your slides are. Generally, there is just too much information to show on one slide for the first-time viewer. You might also see that some pieces on the slides are just plain unreadable. You've perhaps plopped in a map with all sorts of labels that began as a large file, but ended in your slide as one-eighth of the page. Why include a component if it gives unreadable information to the viewer in the audience?

4. **"Layering" or "animating" your slides.** If you absolutely insist on including all that you choose to include, then try taking your audience through your thinking by layering information on each slide as you click from slide to slide. On the next page is a series of slides describing how many different uses we give to arrows. **6.36** I didn't want to bombard the viewer with a long list and decided to add to the list gradually as I moved from slide to slide.

5. **Are your color choices intuitive and helping to make a point?** As you know, I see this is a continuing problem for many researchers. Color is powerful. It's where our eyes go first, and if you are using every primary color you can get your hands on, and then some, your slides will dizzy your audience. Pay attention to how you use color. Ask yourself, does it really make sense to use it as you are? You'll see a wonderful example of smart rethinking at the end of this section.

6. **What about the composition of the slide?** If you decide to layer your slides, you'll find it helps in composing the elements within the slides. The process will force you to make room for this and that, and probably you will then edit out what you discover is unnecessary.

6.36

7. **Do you really need all that text?** I can never figure out why so many presenters cram in long sentences on the slide while they are speaking different sentences. It's quite frustrating, at least for me, to read one sentence while hearing another. For the slide, think in terms of bullets, or magazine callouts. Help the audience follow your story by using slide text to emphasize the points you are *speaking*.

8. **Are your titles clear?** Edit your slide's title down to fewer words. Texts on slides are not meant to be read as a journal article nor should they be a narrative. Titles should help the viewer understand the overarching point you are expanding on in your verbal explanation of what we are seeing.

9. **Can you find your own "voice"?** Don't get used to using someone else's template. Consider coming up with your own style for your slide presentations. I was delighted to see Audrey Bosquet's hand-drawn slide as part of her team's midterm progress report for her MIT course "Sports Technology: Engineering and Innovation." **6.37** Incidentally, the choice of fuchsia for labeling the parts echoes previous slides in the presentation where that color was significant.

6.37

The following is a wonderful example of rethinking a slide by students Michael Nawrot, Ferran Vidal-Codina, and Patrick McClure in the same course just mentioned. MIT instructors Anette Hosoi and Christina Chase encouraged the students to pay close attention to each slide.

Above is their original slide. **6.38a**

Below is the redo developed by the students. **6.38b** Their audience was expert in the sports arena and could grasp the meaning of the slide.

The team's thinking and "fixes" were spot-on:

a. the original color was overwhelming and not clear,

b. the title was too long and difficult to read,

c. there was too much information and text.

10. **Finding the abstraction.** Visually explaining concepts, forms, and processes relies heavily on editing down all of these components of an explanation to the bare essentials, deciding on what needs to be included. We can call this pared-down entity an abstraction or a visual metaphor. We all try to develop them in our attempts to communicate.

Breaking down first-quarter game activity by event type shows that running has highest impact on total load.

6.38a

Running contributes the most to first-quarter external load

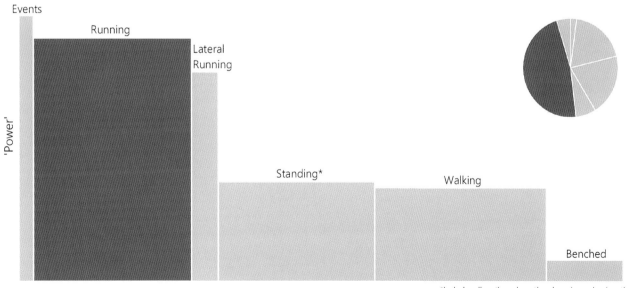

6.38b

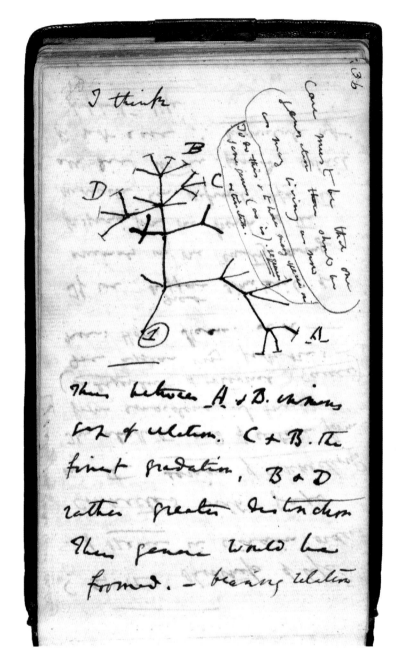

6.39a

But not only does the process help to communicate to others. I have always believed that finding a successful abstract depiction is a powerful means of clarifying ideas for *you*, the researcher.

When Darwin minimally abstracted his observations in 1827, the depiction was, in fact, a *concept*. **6.39a** I suggest you take a look at the evolution from this initial idea to a more final representation in 1859. **6.39b** In the process, he created a hierarchy of information, editing out what was not necessary to comprehend the whole.

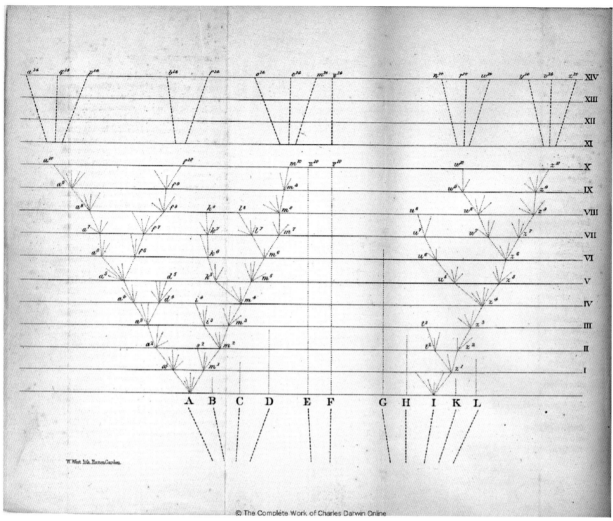

6.39b

And the same abstractive process was utilized by architect Fay Jones when he designed his wondrous chapel at the Crosby Arboretum in Picayune, Mississippi. **6.40a**

However, this abstraction relates to *form*. The design of the chapel is such that one doesn't immediately see the boundaries between the architecture and the landscape. They magnificently blend together. **6.40b**

And the most relevant point is that he didn't *copy* the surface of the pine trees to represent their surface in the columns. He abstracted the essen-tial *form* of their surfaces. Look carefully at his brilliant design and compare the columns to the surrounding trees. **6.40c**

6.40a

6.40b

6.40c

Don Ingber, founding director of the Wyss Institute for Biologically Inspired Engineering at Harvard University, has always grasped the power of abstraction. His remarkable insight connecting Buckminster Fuller's notion of tensegrity to the structure of cells has informed his work and others' for many years. Here is his abstraction of the concept. Note how pared down is his representation of the cellular material, giving us only the information we need for this particular idea. **6.41**

Dominique Brodbeck is an expert in visualizing data. For fun, he came up with an easy-to-read yet complicated timeline of his life, up to 2004. Study this remarkable abstraction and note how cleverly and clearly he combined all the information. The original had a black background, which we changed for easier reading on the printed page. **6.42**

6.41

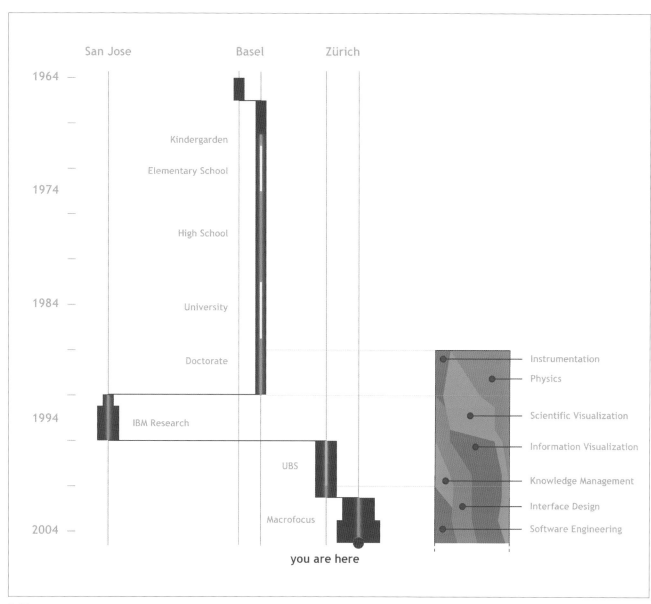

6.42

And finally, Ben Fry is another expert in visualizing data. He is one of the very few who bring a stunning aesthetic to intelligent and communicative information design. His decisions, when visually abstracting complex systems, are deeply considered and wonderfully successful. Here is part of a representation he made some time ago of all of the genes on chromosome 14 (about 107 million letters long) and their descriptions. **6.43a** 347 genes were identified (according to the most recent data when he designed the piece). There could have been as many as three times as many genes that had not yet been identified. His brilliant thinking includes the following information, edited from his website http://benfry.com/chr14/, where you will see more information. On this book's web resources page, you can also find an interview I was privileged to have with Ben for my "Sightings" column.

1. The boxes are proportional to the size of the letters that code for the gene relative to its adjacent and intermingled letters.

2. The yellow wireframe boxes signify a gap between genes, an area where the letters are considered "junk dna."

3. The blue areas are parts where genes exist.

4. The dotted line denotes a gene that is predicted but not known for certain.

At lower left is a detail of a particular area. **6.43b**

Note Ben's use of dotted lines to indicate uncertainty—we don't yet know of what base pairs these particular areas consist. Darwin's 1859 representation also included lines of uncertainty. Conjuring up depictions of uncertainty and probability are challenging exercises, and unfortunately very little attention is paid to that process.

6.43a

6.43b

6.44

When the iconic 2D model of the atom gained worldwide attention as the Atomic Energy Commission's logo, very little was discussed concerning its incompleteness, perhaps because a logo is not a teaching tool. **6.44**

However, representations are powerful and stay with us. I have always wondered if this particular representation caused confusion in the science classrooms when Roger Hayward's stunning pastel for Linus Pauling's *The Architecture of Molecules* indicated a more probabilistic nature of the atom's electron clouds. **6.45**

All of nature is probabilistic, and having a grasp of this difficult concept could potentially benefit society's decision-making capabilities. Perhaps if we taught the notion of probability to the young, beyond the coin toss exercise, we would have less of a challenge arguing the effects of global warming.

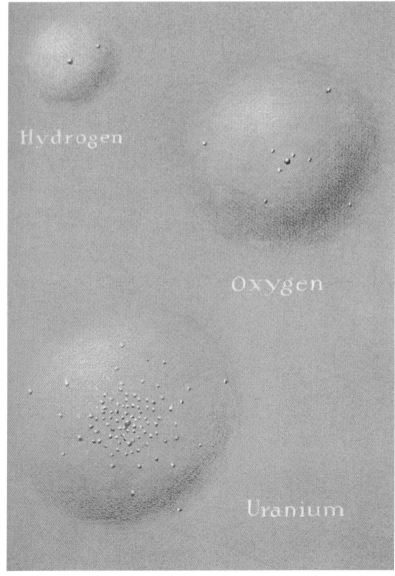

6.45

SUMMING UP

Designing graphics

- Simplify, clarify. Create empty space. Remove arrowheads. Stick to lower-case text.

- Align labels horizontally and vertically. In composite figures, align images to a grid.

- Stop perpetuating bad graphic design.

Time and scale

- To show change over time, use serial images along with or instead of animation.

- Fresh, familiar objects can convey scale. Position scale bars as part of the composition.

Telling a visual story

- is a means of simultaneously incorporating documentation and application.

Cover submissions

- Note a publication's design and layout — orientation, framing, logo placement. Your image should complement the look.

- Consider the design roles of text and line art. Use them to enhance photographic work.

- Is the science important? Create great images to support great science.

Keep a record

- of your process.

7

IMAGE ADJUSTMENT AND ENHANCEMENT

The question of how far one can go to enhance, adjust, or "touch up" an image is a critical one in science, and for that reason I've given it a full chapter. Unfortunately, the subject is hardly discussed during most scientists' training. *Nature* published an editorial ("Image Doctoring Must Be Halted," 29 June 2017, vol. 546, 575) stating that "the primary responsibility for image integrity lies with principal investigators." I suggest going further and placing this responsibility at the *university* level, and here's why. I have the privilege of working with some of the most remarkable and respected researchers in the world, and yet I have been surprised that some have given little thought to the issue of image integrity. Perhaps that's because many principal investigators no longer *make* the images themselves — a task often assigned to a graduate student (you?). The relative ease of revising/improving the image may prevail over rigorously questioning any such changes. And although university ethics guidelines consider plagiarism to be unacceptable, they rarely if ever indicate whether image manipulation is a form of potentially dishonest scholarship.

Most of you have been left to assume that certain adjustments are permitted in your pictures, but that is not always the case. Fortunately, guidelines addressing image manipulation are finally showing up on various journals' websites. I have included the posted guidelines from *Nature*, *Science*, and *Cell* at the end of this chapter. At the time of this writing, you will see that only *Nature* has given this important subject the attention it deserves, going into considerable detail about what is permitted.

On these next pages, I'll address a few examples so that you can begin thinking about the issue of image manipulation when submitting for publication—or better still, when you start documenting the work as evidence of your research from the beginning of your thinking. I encourage you to consider each of these examples and question the integrity of the adjustments.

If you think about it, the very nature of *making* an image involves a subjective decision (manipulation?) from the start of recording evidence. It takes the form of deciding *what* and *when* to photograph. Thus it is a mistake to get bogged down with the idea that no enhancement whatsoever should be permitted. You already have edited the evidence by not including this or that within the frame. If we can agree that the purpose of your visuals is not only to show evidence but also to *communicate* that evidence, then we can permit some enhancement to help the viewer read the information, *as long as we specify exactly how the image was enhanced*. How many times, while photographing a sample, have I left out an imperfection? Is that decision unethical? Am I manipulating the evidence? Or is it good enough to indicate in the caption that "a clean section was chosen for clarity"?

In general, a good starting point (see *Cell*) is "to reduce the amount of post-acquisition processing." The one important thread throughout the journals' guidelines is that researchers must *always* indicate when any "enhancement" is applied to a photograph. Increasing contrast, for example, is permitted, as long as you indicate that you have done so *and* that the process was applied to the *entire image*—not just one piece (although there are rare exceptions—see guidelines at end of chapter).

COLOR ENHANCEMENT

Let's start with this stunningly beautiful Hubble image of the Eagle Nebula. **7.1** The image is completely color-enhanced. I wonder how many nonexperts who have seen this image online and in magazines are aware of the process. You can read a conversation about how the image was made in an interview I published for my column "Sightings" in *American Scientist* (see the book's web resources page). It is about the decisions the researchers made about coloring the details of nebulae. In essence, the coloring, or enhancement, was done mostly for the purpose of communicating structure and properties. Here is part of that account by Jeff Hester of NASA.

> The image is constructed out of 32 separate images made using four different filters. Each of the four quadrants of the image is a physically separate camera. Making the final image involved:
>
> (1) calibrating each frame and removing various "instrumental signatures" such as bias levels, pixel-to-pixel sensitivity variations, errors in digitization and dark currents, etc.;

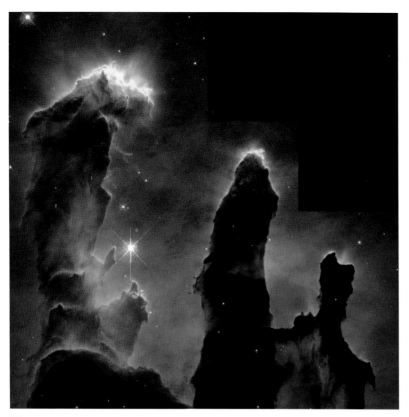

7.1

(2) identifying and rejecting various artifacts such as the streaks left by cosmic rays as they passed through the detectors;

(3) combining all of the images taken through a given filter into a single frame (which entailed alignment, correction of geometrical distortions and stitching individual images together into a four-chip mosaic); and

(4) combination of the different single-filter mosaics into a color image.

In the final image, blue represents light in an emission line (a distinct emission wavelength) from doubly ionized oxygen. Green represents light in the distinct wavelength emitted when a proton and electron combine to make a hydrogen atom. Red represents light in a line emitted by singly ionized sulfur atoms. So the colors show variations in the level of ionization and excitation from place to place. It is a map of the physical properties of the gas.

He continues, "It turns out that it is also closer to what you might see through a telescope with your eye than is a picture taken with color film."

Jeff is telling us that we can see these colors (perhaps not as saturated) with our telescopes, but that *capturing* the images (on film in this case) loses the color information. I had a similar experience, many years ago when I was still shooting on film.

Here is the image I captured on Fuji film under UV light. **7.2a** We see rods, measuring about two centimeters long, all of which have absorbed fluorescing material.

My eye, however, saw some of the rods fluoresce in the orange wavelength of the spectrum. It turns out the film did not capture that wavelength, and so I digitally adjusted those rods that were supposed to appear orange. **7.2b**

7.2a

7.2b

Just as in the Eagle Nebula, the adjusted image is more "honest" than what the unadjusted film image captured. Interestingly, when I discussed this example with the editors at *Nature*, they seemed firm that my "enhancement" would *not* be permitted. The inability of the film to capture a particular wavelength was considered an artifact of the tool (film). My question was whether we should be permitted to "fix" that artifact. At the time, I didn't push my point of view in the conversation, and I wish I had.

The astronomers' process of selecting colors in the image of the Eagle Nebula is similar to my process when I started with this uncolored SEM **7.3a** and then colored it. **7.3b** My purpose was to show the nanowires more clearly.

The difference between my adjustment and the astronomers' is that the color choices in their case were informed by chemical characteristics of the various areas of the image. My choices in this particular case were purely aesthetic.

7.3a

7.3b

For a figure showing particular deformations in a material when force is applied, the researchers made this image. **7.4a** In my colored version, I am bringing attention to the important area of the material. **7.4b** I also deleted the background and cropped the image at the bottom. In my opinion, I have not changed the pertinent data. Researchers Mary Boyce and Stephan Rudykh decided not to use it, but I am convinced the manipulation helps the reader see the salient point.

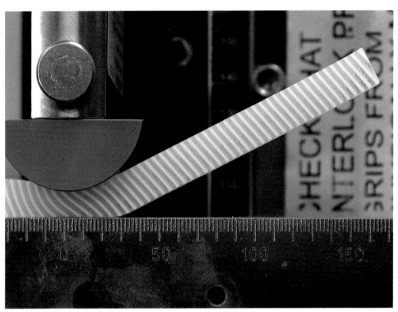

7.4a

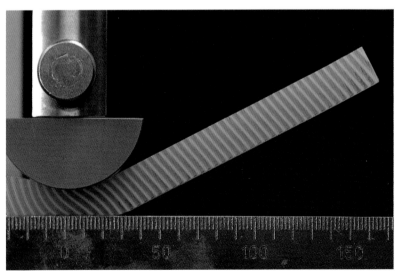

7.4b

Here are two fluorescent images excited with UV light supplied by the researchers. **7.5a** The colored areas show specific quantum dots that have attached to specific structures—giving highly detailed morphological information about the cell being pictured. As you see, in standard views of fluorescently labeled material, the colored areas are set against a black background.

I thought it would be clever—and perhaps more communicative—to see the information differently, as long as I maintained the integrity of the science. I "inverted" the two images in Photoshop, making the black background white. **7.5b** You'll see another example of inversion later.

7.5a

7.5b

But because it was important to keep the original colors, I changed the colors back to red and green. **7.5c**

I then layered both of these images over a third image made with standard microscopy, again supplied by the laboratory. **7.5d**

The result is this three-layered image **7.5e** which shows the same information as the original separate images, but with the added benefit of a sense of the whole. From a scientific point of view, I am maintaining the integrity of the essential data here – showing where the structures are *but not quantifying* the amount of quantum dots present.

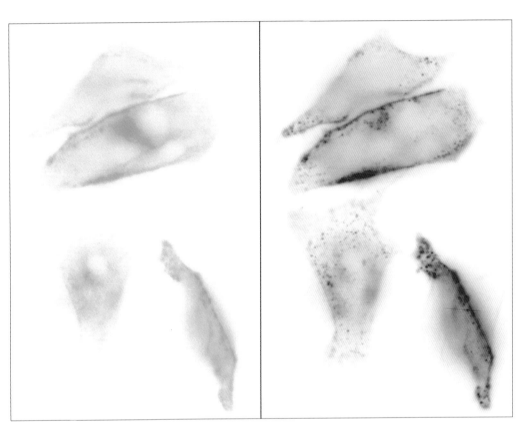

7.5c

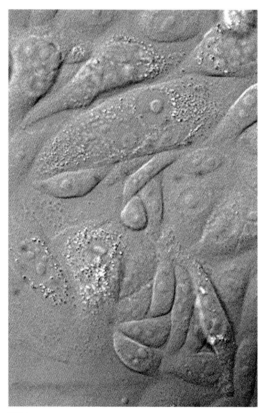 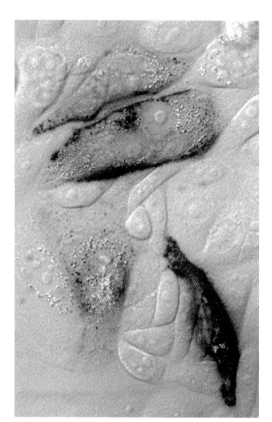

7.5d　　　　　　　　　　　　　　**7.5e**

Here's an image of a device I made on film a number of years ago. **7.6a**

The fluorescent lighting in the lab added a green cast to the image. After the film was scanned, my digital adjustment altered the color to what my eyes saw (or more specifically how my brain was compensating for the green cast). **7.6b**

If I had made this image with my digital camera and first performed a manual "white balance," the color adjustment would probably not have been needed. In any event, no matter what the intent, first and foremost whenever an image is colored or color-adjusted, that information must *always* be indicated – somewhere near the image – not on another page where the reader has to dig deeply to find out what's going on.

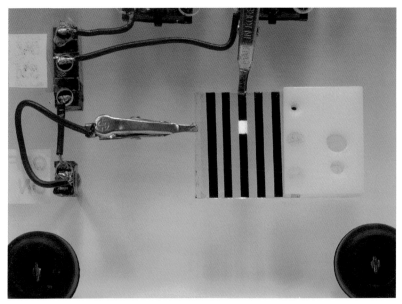

7.6a

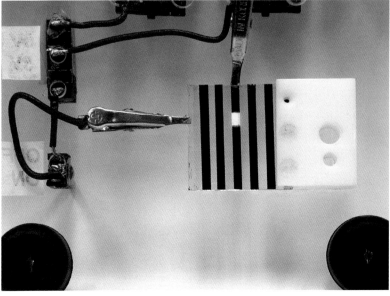

7.6b

INVERSION

One adjustment I often suggest for a grayscale image is to "invert" the image. Sometimes the image becomes more readable, as I believe is the case for this before-and-after example of inversion showing *E. coli*. **7.7** The bacteria are flowing between microscopic chambers from right to left. The fluorescence is a tagging technique, showing evidence of the presence of the *E. coli*. We are not measuring or quantifying the fluorescence. We simply want to show in what direction the bacteria are moving.

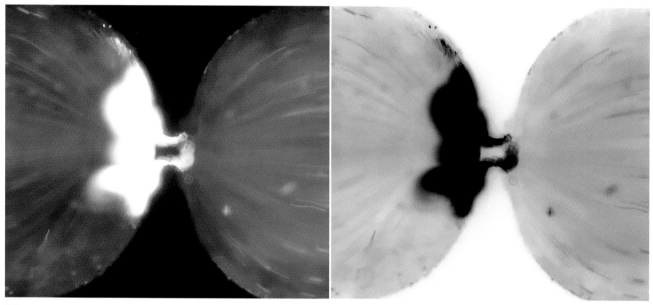

7.7

DELETING "DISTRACTIONS"

Here is a picture I originally made of a yeast colony growing in a petri dish. **7.8a** Because I wanted the viewer to see the stunning morphology of the colony, I digitally deleted the petri dish. **7.8b** The data in this image — the information we must keep intact — is the morphology of the colony. By deleting the dish, I am not adjusting that data. I am simply removing the part of the image that, in my opinion, is unnecessary or distracting. *Science* did permit this adjustment for the cover.

7.8a

7.8b

In this next image, taken under a stereomicroscope, we see an artifact of the process: a reflection of the lens on the wafer. **7.9a** I digitally removed that reflection, again always indicating what I've done. **7.9b**

Or take this image of some fascinating *Proteus* colonies growing in a petri dish, an image I made for our book *On the Surface of Things*. In this original image, the agar was cracking in a few places. **7.10a**

Because the purpose of the image was to show how the colonies grow, in a book for the public, I digitally deleted the distracting cracks. **7.10b** This would never be permitted for a journal submission, but perhaps it might for a cover shot.

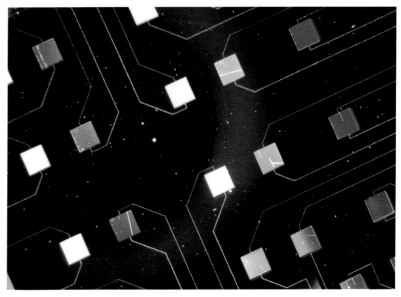

7.9a

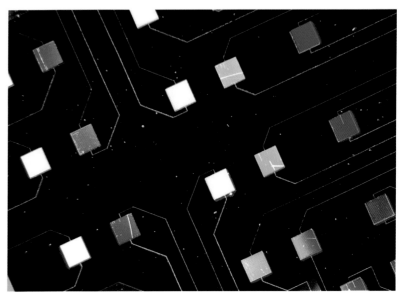

7.9b

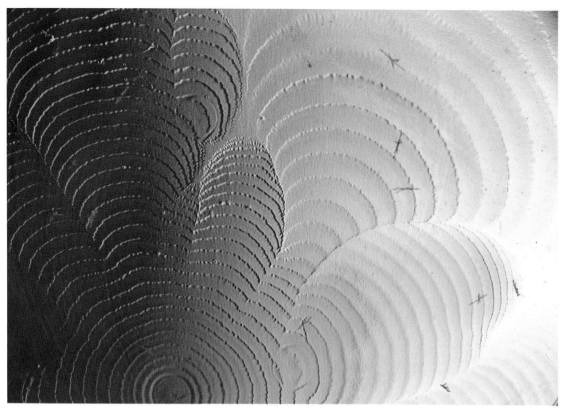
7.10a

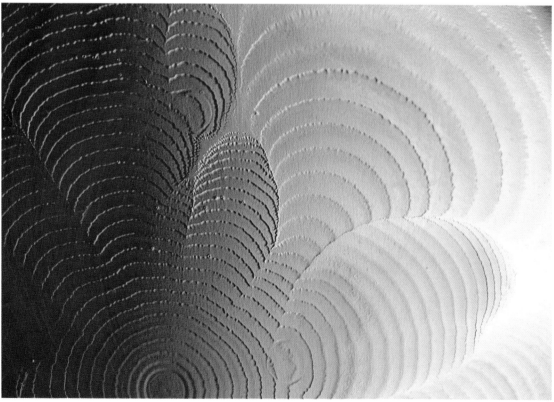
7.10b

330 ADJUSTING HISTOGRAMS

Changing the histogram of an image with image software, like Photoshop, increases contrast, helping to communicate the data. Here is an old gel run created a while ago, when the runs were still captured on film. **7.11a**

And here is the histogram read-out for that image. **7.11b**

I then changed the histogram (increased contrast). See where I moved the arrows along the *x*-axis. **7.11c**

At right, below, is the resulting image **7.11d** along with its histogram. **7.11e**

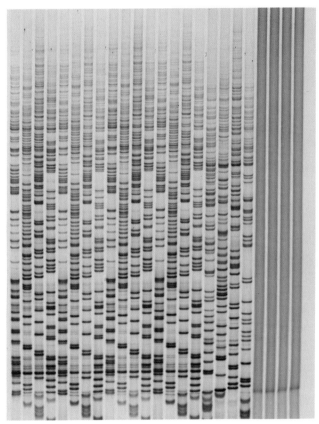

7.11a

7.11b

7.11c

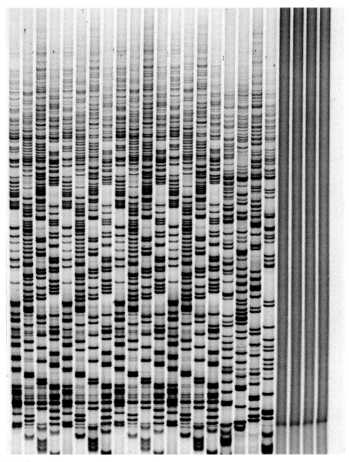

7.11d

7.11e

For clarity, here are details taken from both images. **7.11f**

I have to admit, I never quite understood exactly why changing the histogram resulted in more contrast. Bill Freeman at MIT's CSAIL was kind enough to explain it:

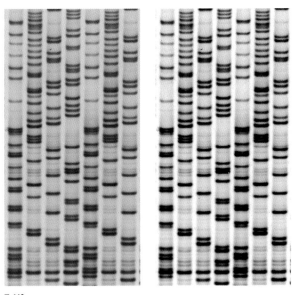

7.11f

> The contrast of an image relates to the differences between the intensity values of the image. If all the intensity values of the image were very similar – all near grey, for example – then the contrast of the image would be low. If you have lots of bright pixel values and lots of dark ones, then the image will look high-contrast.
>
> The histogram of the image tells how many pixels have each intensity value. If the histogram shows the image intensities all bunched inside some narrow range of intensity values, then the image will have low contrast because all the pixel intensities are just within that narrow range. If the histogram is spread out over a big range, then that shows that the pixel intensities will take on values from the very dark to the very bright, giving a higher-contrast image.
>
> A "global equalization of the histogram" is shorthand for: move around the pixel intensities so that (a) the histogram ranges over all possible values, from the very dark to the very bright and (b) the histogram is flat over that range (that's "equalization"). The histogram being flat means there are as many dark pixels as there are bright pixels as there medium gray pixels, etc. Having as many dark pixels as bright pixels as gray pixels will, in general, make the image contrast high, because there will be pixel values ranging from the very dark to the very bright.

Think carefully about these gel adjustments. In a conversation with the editors at *Nature*, all were comfortable with the enhancements, since the adjustment was made globally to *the entire image*. (See journal guidelines at the end of this chapter. All journals emphasized the need to clearly indicate how an image was "enhanced.")

PUTTING IT TOGETHER

The Eagle Nebula image near the beginning of the chapter is, in fact, a mosaic of many images (in that case made with different cameras). The following example might be easier to think about. **7.12**

This huge tank was used to study sediment rates of sand. It was too large for me to photograph in one image, so I made two images and superimposed them for a journal article. You will notice that I visibly overlaid the two images showing that there are, in fact, two images.

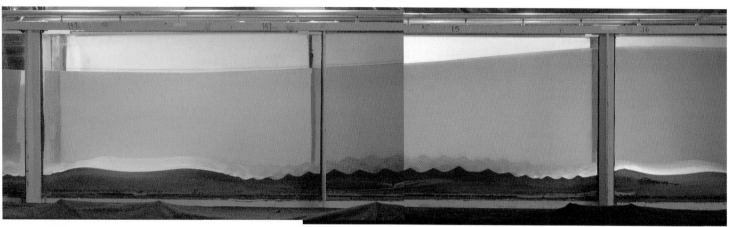

7.12

I did the same for this microscopic image of a device. It wasn't possible to show the whole device in one image. **7.13**

Look carefully and note how I allowed the boundaries for each image to remain visible, informing the viewer that the full image is a collage of pieces put together. I did this all by hand.

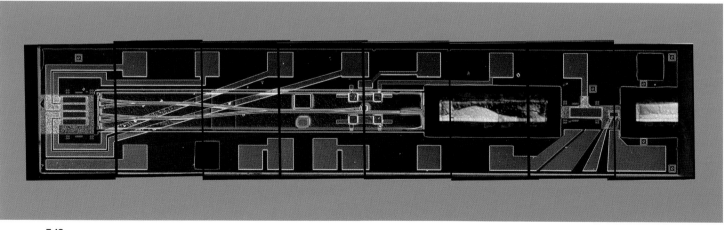

7.13

For this next collage, John Hart first created a series of single SEMs. **7.14a**

For an interview in my column in *American Scientist*, we discussed how he then used software to "stitch" the pieces together. **7.14b** You can find the article on the book's web resources page.

The final image was then digitally "cleaned." **7.14c**

7.14a

7.14b

7.14c

IMAGE SHARPENING

An almost standard practice for many photographers involves image sharpening. Sharpening often helps an image "read" better in printed material. In fact, as I mentioned in the introduction, most of the images in this book have been minimally sharpened. You can learn how to sharpen in the "How-to-do-it" section of the web resources page.

OVER THE TOP

These last three examples are intended to encourage you to seriously consider when an adjustment is simply not permissible. In the first image, the setup was mishandled and the gel run became slanted. **7.15a** A suggestion was made to digitally "unslant" the image and to include the control in the right in the process. **7.15b** I think we will all agree that this is an over-the-top adjustment and would never be permitted – or would it?

7.15a

7.15b

Here is an image from another of my interviews in *American Scientist*. **7.16a** This one was with MIT mathematician John Bush. (Look for the thumbnail on the web resources page to see a detailed explanation of the image.)

I deleted a small speck in the middle of the glowing circle here **7.16b** — a big mistake, as it turned out.

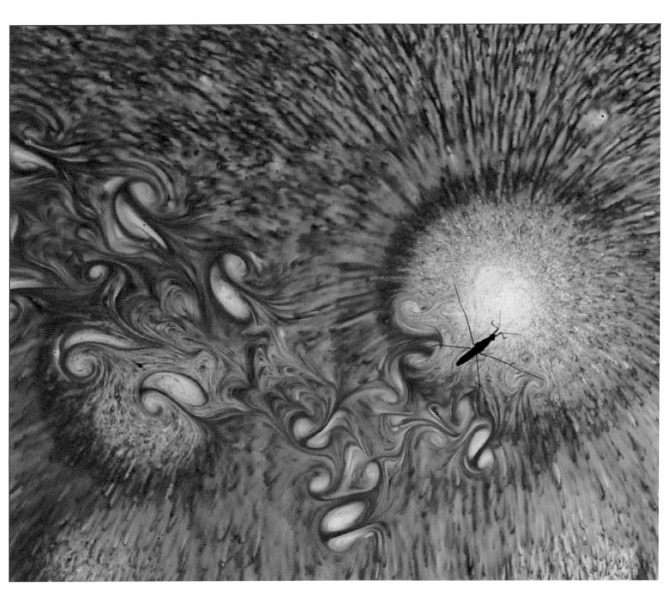

7.16a

I asked John if it would be OK and he politely said it was fine. But years later, when we discussed the article, I realized that this deletion was highly improper. It turned out that the small speck had an important effect on the final outcome of the image. In hindsight, we both agreed the mistake was clearly mine. I had no right to adjust that image, not even with his permission.

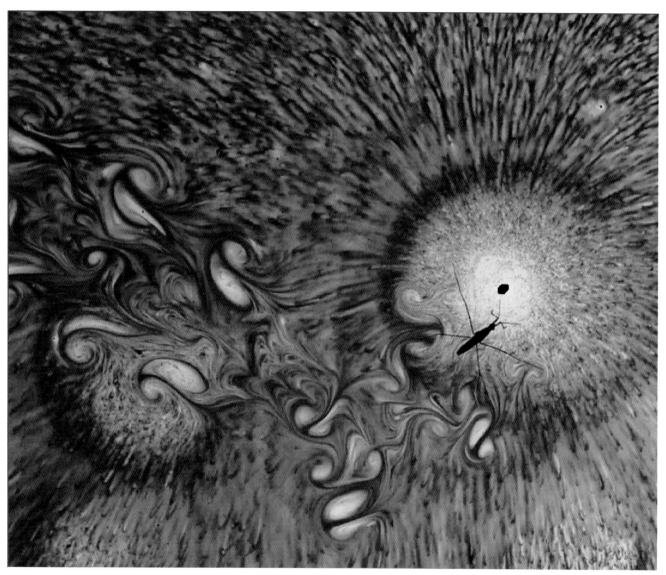

7.16b

Here's one last theoretical example, to get you thinking. Let's say, for a cover submission, I wanted to show an experimental hydrophobic surface where water beads up to a perfectly round ball. However, the particular hydrophobic sample given to me wasn't prepared properly—when I dropped water on this particular surface, the contact angle was not as large as the researcher would have wanted, which translated to a flattened water drop. **7.17a** Let's say my colleague suggested the following. Because the other samples in the experiment *did* show the appropriate hydrophobicity, I was permitted to manipulate the drop, as you see here, digitally rounding the drop to depict how it would ordinarily look. **7.17b** The idea was to submit this "fixed" image for a cover but not within the article.

Think about whether this specific manipulation would be permitted for a cover.

It is critical to keep all of these questions in mind when we talk to each other, and certainly when we start thinking about communicating our work.

I mentioned previously that I had digitally cleaned some of the images in this book. I did this so that you would not be distracted by extraneous imperfections. That was a decision I made for the particular purposes of this book, to teach about and illustrate the process. Most important is the fact that I informed you of my adjustments. It's a different story, however, if you are submitting an image to be published as a figure in a journal. In that case, you need to read the journal's guidelines. Although journals are developing software to discover post-production processing which may reveal a history of manipulations, it will be of greater benefit to scientific scholarship if the issue is made part of a scientist's education from the beginning.

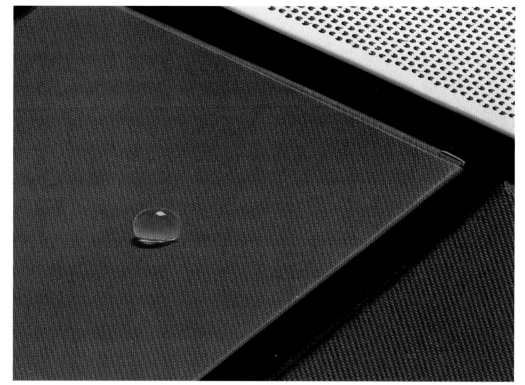

7.17a

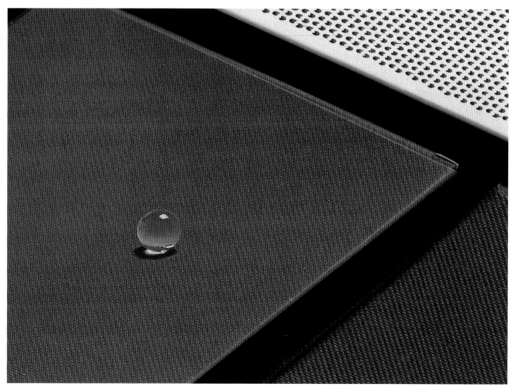

7.17b

Nature, "Digital Image Integrity and Standards" (lightly edited for this book):

A certain degree of image processing is acceptable for publication (and for some experiments, fields and techniques is unavoidable), but the final image must correctly represent the original data and conform to community standards. The guidelines below will aid in accurate data presentation at the image processing level; authors must also take care to exercise prudence during data acquisition, where misrepresentation must equally be avoided. Manuscripts should include an "equipment and settings" section with their methods that describes for each figure the pertinent instrument settings, acquisition conditions and processing changes, as described in this guide.

• Authors should list all image acquisition tools and image processing software packages used. Authors should document key image-gathering settings and processing manipulations in the methods.

• Images gathered at different times or from different locations should not be combined into a single image, unless it is stated that the resultant image is a product of time-averaged data or a time-lapse sequence. If juxtaposing images is essential, the borders should be clearly demarcated in the figure and described in the legend.

• The use of touch-up tools, such as cloning and healing tools in Photoshop, or any feature that deliberately obscures manipulations, is to be avoided.

• Processing (such as changing brightness and contrast) is appropriate only when it is applied equally across the entire image and is applied equally to controls. Contrast should not be adjusted so that data disappear. Excessive manipulations, such as processing to emphasize one region in the image at the expense of others (e.g., through the use of a biased choice of threshold settings), is inappropriate, as is emphasizing experimental data relative to the control.

When submitting revised final figures upon conditional acceptance, authors may be asked to submit original, unprocessed images.

Electrophoretic Gels and Blots

Positive and negative controls, as well as molecular size markers, should be included on each gel and blot — either in the main figure or an expanded data supplementary figure. For previously characterized antibodies, a citation must be provided. For antibodies less well characterized in the system under study, a detailed characterization that demonstrates not only the specificity of the antibody, but also the

range of reactivity of the reagent in the assay, should be published as Supplementary Information.

The display of cropped gels and blots in the main paper is encouraged if it improves the clarity and conciseness of the presentation. In such cases, the cropping must be mentioned in the figure legend and the supplementary information should include full-length gels and blots wherever possible. These uncropped images should be labeled as in the main text and placed in a single supplementary figure. The manuscript's figure legends should state that "full-length blots/gels are presented in Supplementary Figure X."

• Quantitative comparisons between samples on different gels/blots are discouraged; if this is unavoidable, the figure legend must state that the samples derive from the same experiment and that gels/blots were processed in parallel. Vertically sliced images that juxtapose lanes that were nonadjacent in the gel must have a clear separation or a black line delineating the boundary between the gels. Loading controls must be run on the same blot.

• Cropped gels in the paper must retain important bands.

• Cropped blots in the body of the paper should retain at least six band widths above and below the band.

• High-contrast gels and blots are discouraged, as overexposure may mask additional bands. Authors should strive for exposures with gray backgrounds. Multiple exposures should be presented in Supplementary Information if high contrast is unavoidable. Immunoblots should be surrounded by a black line to indicate the borders of the blot, if the background is faint.

• For quantitative comparisons, appropriate reagents, controls and imaging methods with linear signal ranges should be used.

Microscopy

Authors should be prepared to supply *Scientific Reports* with original data on request, at the resolution collected, from which their images were generated. Cells from multiple fields should not be juxtaposed in a single field; instead multiple supporting fields of cells should be shown as Supplementary Information.

Adjustments should be applied to the entire image. Threshold manipulation, expansion or contraction of signal ranges and the altering of high signals should be avoided. If "pseudo-coloring" and nonlinear adjustment (e.g., "gamma changes") are used, this must be disclosed. Adjustments of individual color channels are sometimes necessary on "merged" images, but this should be noted in the figure legend.

We encourage inclusion of the following with the final revised version of the manuscript for publication:

• In the methods, specify the type of equipment (microscopes/objective lenses, cameras, detectors, filter model and batch number) and acquisition software used. Although we appreciate that there is some variation between instruments, equipment settings for critical measurements should also be listed.

• An "equipment and settings" section within the methods should list for each image: acquisition information, including time and space resolution data (xyzt and pixel dimensions); image bit depth; experimental conditions such as temperature and imaging medium; and fluorochromes (excitation and emission wavelengths or ranges, filters, dichroic beamsplitters, if any).

• The display lookup table (LUT) and the quantitative map between the LUT and the bitmap should be provided, especially when rainbow pseudocolor is used. If the LUT is linear and covers the full range of the data, that should be stated.

• Processing software should be named and manipulations indicated (such as type of deconvolution, three-dimensional reconstructions, surface and volume rendering, "gamma changes," filtering, thresholding and projection).

• Authors should state the measured resolution at which an image was acquired and any downstream processing or averaging that enhances the resolution of the image.

Science magazine, "Modification of Figures":

Science does not allow certain electronic enhancements or manipulations of micrographs, gels, or other digital images. Figures assembled from multiple photographs or images, or nonconcurrent portions of the same image, must indicate the separate parts with lines between them. Linear adjustment of contrast, brightness, or color must be applied to an entire image or plate equally. Nonlinear adjustments must be specified in the figure legend. Selective enhancement or alteration of one part of an image is not acceptable. In addition, *Science* may ask authors of papers returned for revision to provide additional documentation of their primary data.

Cell, "Data Processing Policy":

Authors should make every attempt to reduce the amount of post-acquisition processing of data. Some degree of processing may be unavoidable in certain instances and is permitted provided that the

final data accurately reflect that of the original. In the case of image processing, alterations must be applied to the entire image (e.g., brightness, contrast, color balance). In rare instances for which this is not possible (e.g., alterations to a single color channel on a microscopy image), any alterations must be clearly stated in the figure legend and in the Experimental Procedures section. Groupings and consolidation of data (e.g., cropping of images or removal of lanes from gels and blots) must be made apparent and should be explicitly indicated in the appropriate figure legends. Data comparisons should only be made from comparative experiments, and individual data should not be utilized across multiple figures. In cases in which data are used multiple times (e.g., multiple experiments were performed simultaneously with a single control experiment), this must be clearly stated within each figure legend. In the event that it is deemed necessary for proper evaluation of the manuscript, authors will be required to make the original unprocessed data available to the editors of the journal. All accepted manuscripts will be taken through a data presentation image screening process before publication.

SUMMING UP

Always ask yourself:

- How far can I go to enhance this image?
- What are the rules?
- Have I changed the data?
- Have I clearly described what I did to enhance or alter an image?

Read the journals' guidelines

- Individual journals and publications will have their own guidelines.
- Cover images used as illustration or art may be subject to more flexible enhancement permissions.
- Figure images are strictly reviewed concerning retouching and even removing visual artifacts like cracks and dust.

Keep a record

- of your process.

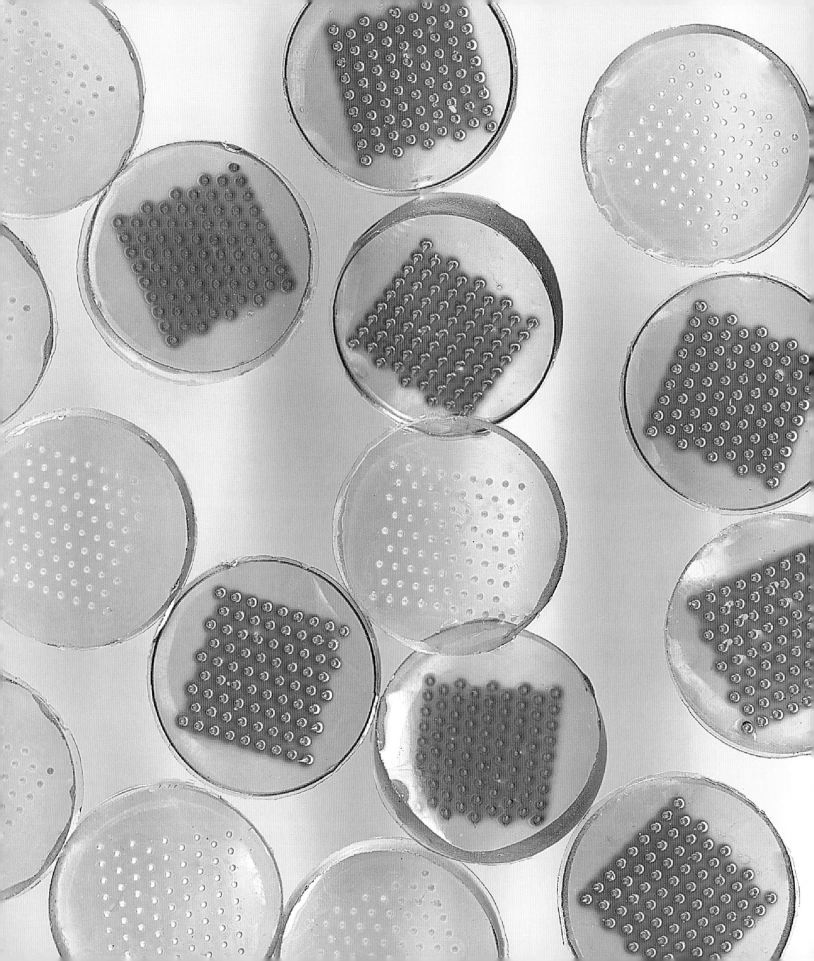

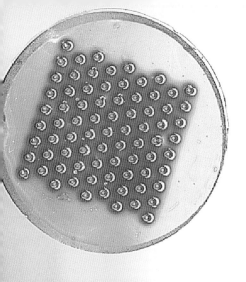
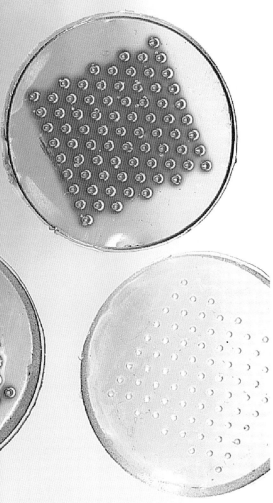

8

CASE STUDIES

I have always believed that showing detailed descriptions of any process is a powerful tool to engage any reader in the sort of thinking that lies behind the creative process, whether it's a complicated recipe or a journal figure or cover submission. This chapter gets us down into the weeds, with examples of my errors in choices and some of my successes. I also include two guest essays from my colleagues.

For the first four case studies, we'll see various attempts to visualize things that are impossible to photograph.

nature

THE INTERNATIONAL WEEKLY JOURNAL OF SCIENCE

OUTLINE
Corneal repair

FILM PRODUCER

Remote epitaxy with graphene turns substrate into copy machine **PAGES 301 & 340**

GENOMICS

RINGS OF POWER
The circular proteins that may tie DNA in loops
PAGE 284

ECOLOGY

SALAMANDERS AT RISK
Virulent power of fatal fungal infection revealed
PAGES 300 & 353

CAREERS

BALANCING THE BOOKS
Financial planning for postdocs and beyond
PAGE 381

NATUREASIA.COM
20 April 2017
Vol. 544, No. 7650

CASE STUDY 1:
GRAPHENE-ENABLED REMOTE EPITAXY

We'll start with a cover submission for *Nature*. This particular example was very much a joint effort. When Jeehwan Kim at MIT got his paper accepted, he contacted me to discuss a potential cover submission. The work was very exciting and potentially important. He and colleagues had developed a way to repeatedly produce flexible film by *remote* epitaxy. Because the system was not photographable, the challenge was to come up with a visual metaphor to depict the technique. The *Nature* cover caption explains it best: "Although epitaxy is widely used in the semiconductor industry, cost still restricts the technique to only certain materials. In this issue, Jeehwan Kim and his team suggest a possible way to overcome that limitation. They place a monolayer of graphene between the substrate and the 'epilayer' grown on top. The graphene layer does not interfere with epitaxial growth but, crucially, it allows the film produced to be released from the substrate easily, thereby allowing the substrate to be reused. The ability to 'copy and paste' semiconductor films from underlying substrates and transfer them to a substrate of interest could have implications for heterointegration in photonics and flexible electronics."

I first sent an idea to Kelly Krause, creative director at *Nature*. I quickly made an image on my phone, of a Plexiglas object I had wanted to use for some time. I imagined it could make a perfect metaphor for a substrate. **8.1.1**

I overlaid the hexagonal pattern for graphene, colored the pattern, and sent it off to Kelly. **8.1.2**

She responded positively and then sent me the next go-round of her thinking, which fit the concept Jeehwan had explained to me. **8.1.3**

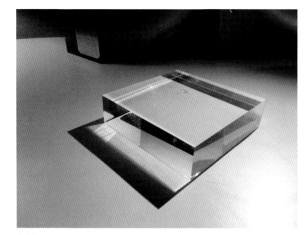

8.1.1

8.1.2

8.1.3

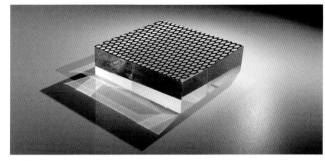

8.1.4

8.1.5

I knew I had to reshoot the Plexiglas, since the file size of the phone image was not large enough for a cover. I sent her this new image made with my DSLR. **8.1.4**

She responded with this next idea, emphasizing the "copying machine" aspect of the technique. Note her notes. **8.1.5**

I then started making new photographic pieces, first deciding that the "electronics" Kelly had in mind looked like one of the images from my files. You've seen it before. **8.1.6**

I inverted the color to make it feel a bit more "electronic." **8.1.7**

For another piece, I photographed a plastic surface, anticipating placing it on the substrate along with the graphene overlay. **8.1.8**

Here's how I put the pieces together in my first attempt, starting with the high-resolution Plexiglas, **8.1.9** to which I added the graphene layer **8.1.10** that I colored in the suggested gray tone. **8.1.11**

Next I manipulated the plastic shape and attached it where I thought it would work. I liked the highlights, thinking they helped the reader to "believe" the image. **8.1.12**

8.1.6

8.1.7

8.1.8

8.1.9

8.1.10

8.1.11

8.1.12

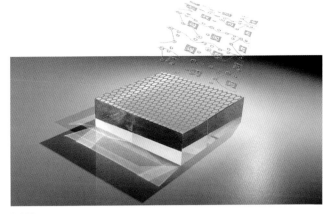

8.1.13

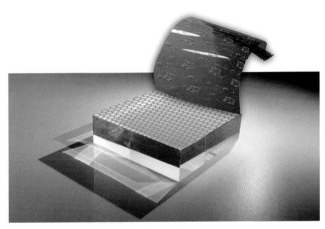

8.1.14

Then I overlaid the "electronics," which I modified to appear different from the original. Here is that electronic layer without the plastic. **8.1.13**

The next image shows all the layers, with the addition of a drop shadow and use of an "emboss" filter. **8.1.14**

In the end, Nik Spencer at *Nature* brought the image to another level using all my photographic pieces. **8.1.15**

I was thrilled. I asked him a number of questions about his process, eager to learn something from a truly great graphic artist. Here is Nik's response:

I actually found placing the graphene quite hard (I drew one with thinner strokes and little circles for the carbons), getting the molecules to line up with the edge of the glass exactly whilst getting the correct perspective distortion was pretty fiddly.

The sheen on top of the material was a combination of a couple of things—I added a subtle highlight and texture with a basic filter, and then duplicated and overlaid a couple of copies, adjusting the hue and brightness of the underlying layer, then setting the overlay to vivid light, I think, and adjusted the transparency to give that metallic-like plastic effect, coming from the different shades of blue showing through.

No, I didn't think to change any of the side of the block, I took out some of the highlights and lines that were running through it on top, as these were interfering with the overlays, but I left the imperfections in the glass as they didn't bother me!

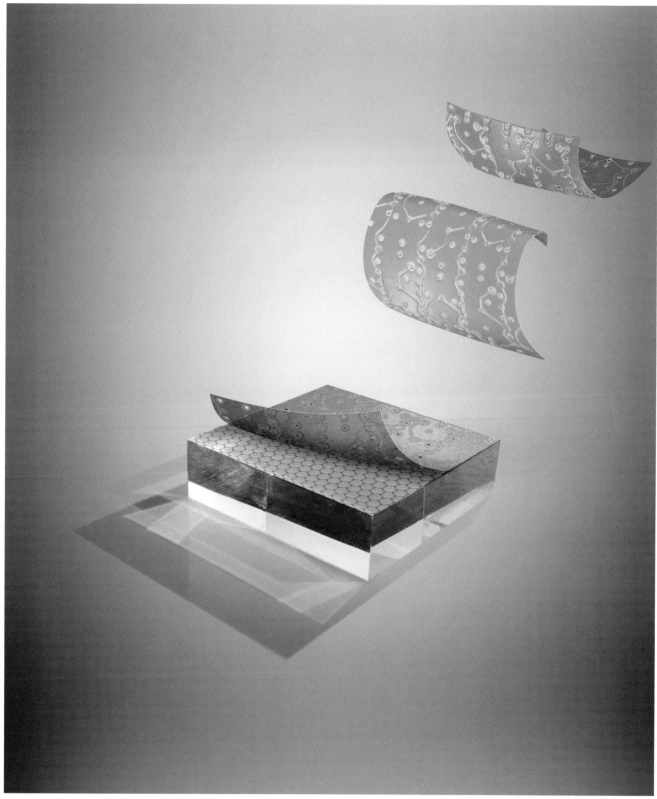

8.1.15

PNAS

Lubrication with crumpled graphene balls

Cell–cell communication and gradient sensing

Gene repression by juvenile hormone

Bipolar disorder and sleep disruption

Viral infection and lung biofilm formation

CASE STUDY 2:
"CRUMPLED" GRAPHENE

In the summer of 2016, I was privileged to be invited to Northwestern University by Dean Julio Ottino to conduct a series of workshops. Gathering students to discuss their graphics is something that should happen on every campus. Jiaxing Huang in the Department of Materials Science and Engineering was instrumental in organizing the week, and we also struck up a conversation about a potential cover submission for his just-accepted article in *Proceedings of the National Academy of Sciences*.

Jiaxing first suggested we create some sort of metaphor, visually describing how his work with "crumpled" graphene might be represented. I started with this practice image to see if there was a hint of something worthwhile.
8.2.1

Not particularly excited with the image, I tried inverting it.
8.2.2

8.2.1

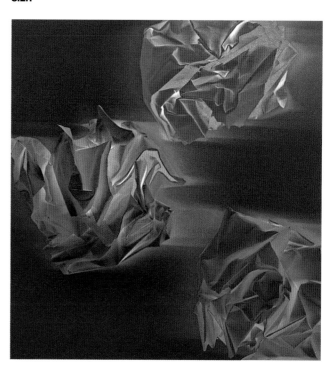

8.2.2

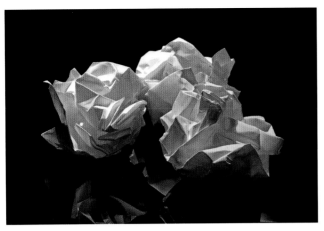

8.2.3

Still not happy, I went back to reshooting, this time on a highly reflective black table at night. **8.2.3**

The reflection made the image too busy, so I then placed the crumpled paper on simple foam core, including the "blackness" of the table at night as a background. **8.2.4**

I eventually decided to use the shiny side of the foam core and shot the setup during the day, with the highly reflective table reflecting the blue sky. **8.2.5** Note the resulting differences in almost identical setups.

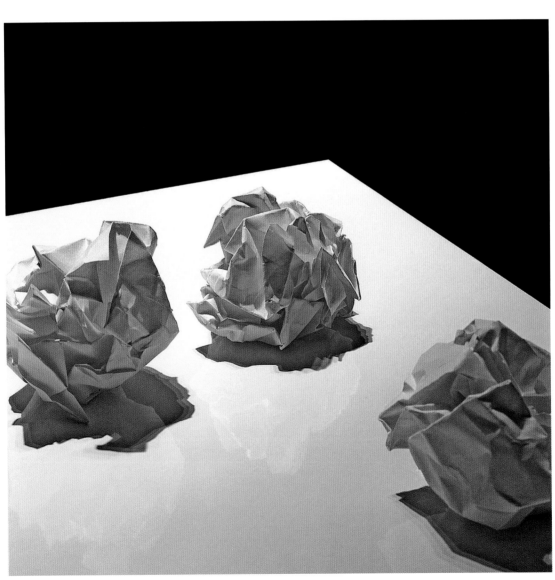

8.2.4

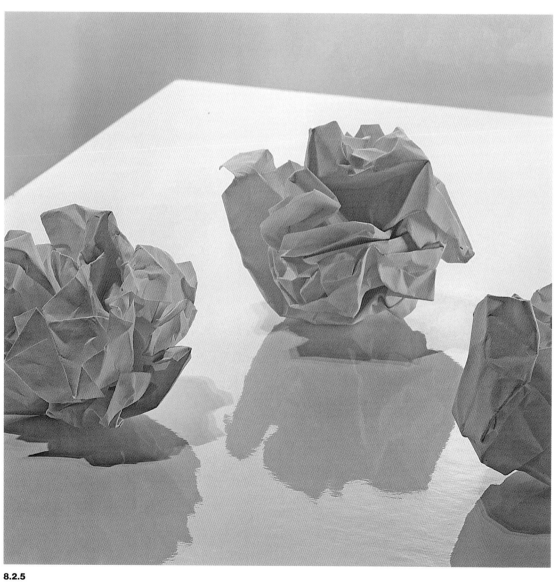

8.2.5

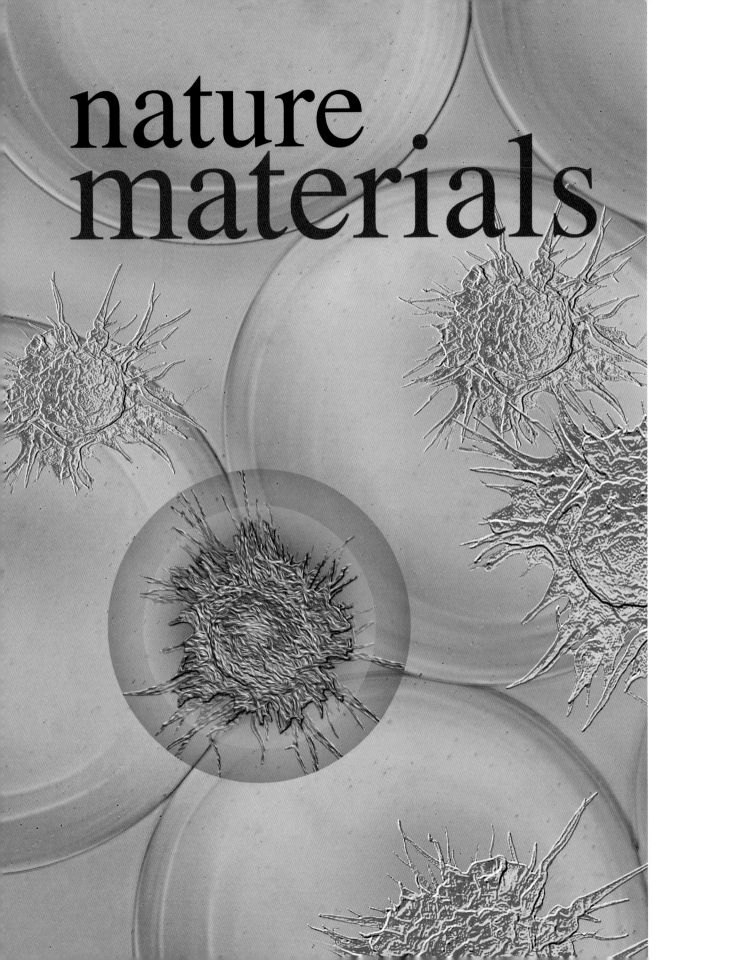

CASE STUDY 3:
MACROPHAGE INHIBITION

Here's another example of bringing various photographic pieces together to create an image that is more a visual explanation than a documenting of visual data. Again, sitting down with one of the researchers, Josh Doloff at MIT, to discuss the possibilities was an integral part of the process.

The thought was to show how a particular chemical alteration could help scientists extend the lifespan of many types of implantable medical devices by blocking the formation of scar tissue around the devices.

I first decided to use as a background an image I had previously made from the lab suggesting the presence of capsules, which was both a design decision and a reference to the process. **8.3.1**

Next, I knew I had to include the important macrophage shapes in the image, but didn't have any in my files. Science Photo library in the UK has a terrific archive and I found this colored SEM created by Dennis Kunkel. **8.3.2**

8.3.1

8.3.2

8.3.3

I decided to digitally change that image to create a different "feel" in order to work with what I had in mind, using a series of filters in Photoshop. The resulting altered macrophage image was overlaid on the background capsules. **8.3.3** Now remember, we are creating a metaphor here. None of this can actually be visually documented.

The next bit was the hard part. How to show that at least one of the macrophages was changed, metaphorically suggesting that it no longer was able to do its work of attacking the foreign body (the medical device)? Here was the result. **8.3.4**

Note that I added a few more macrophages and composed the final photograph so that the journal's logo could be easily placed at the top.

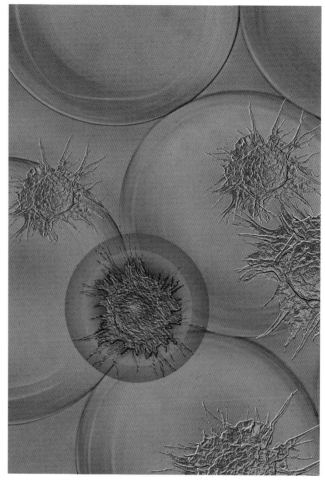

8.3.4

nature medicine

VOLUME 22 NUMBER 3 MARCH 2016
www.nature.com/naturemedicine

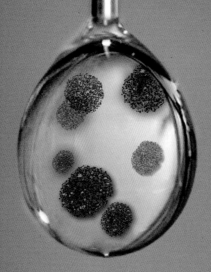

Glycemic correction without immunosuppression
Restoring the microbiota after C-section
Tracing paths for acquired resistance to EGFR inhibitors

CASE STUDY 4:
STEM CELL ENCAPSULATION

Here's yet another example of combining photographic pieces to create an image that is visually explanatory. Meeting with researchers Arturo Vegas and Omid Veiseh at MIT and discussing the possibilities was an integral part of the process.

The concept we decided to depict was how a droplet of alginate hydrogels encapsulated human embryonic stem cell–derived beta cells. The idea would later suggest the basis for a new treatment for diabetes. We all agreed to keep it simple – the best approach for a cover submission.

Surprisingly, the researchers remembered an image I made for George Whitesides's and my book *No Small Matter* whose background seemed to be memorable for them. (We saw this image in chapter 2.) Frankly, I was delighted they remembered it. **8.4.1**

I then cropped the image to the size of the journal cover (8.5 by 11 inches, at 300 dpi), and digitally elongated the water drop and manipulated it a bit to look more "real." **8.4.2**

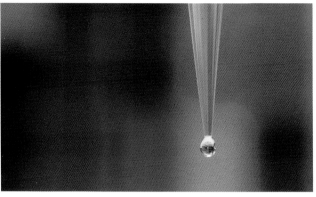

8.4.1

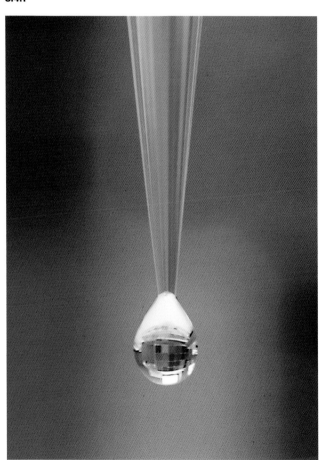

8.4.2

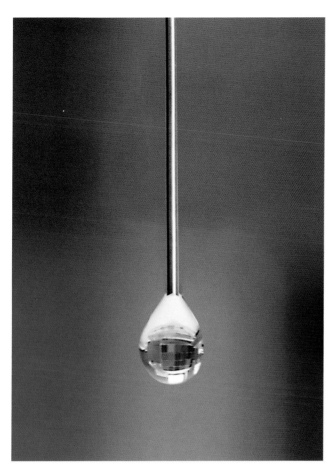

8.4.3

I scanned a metal syringe on the flatbed scanner and digitally replaced the plastic syringe with the metal one. **8.4.3**

I then filled part of the interior of the drop with white, to prepare for the insertion of fluorescent images of cell clusters, made by the researchers in the lab. **8.6.4**

I digitally played with the drop to make it more "drop-like" and then added some drop shadows to the clusters for the final submission. **8.4.5**

8.4.4

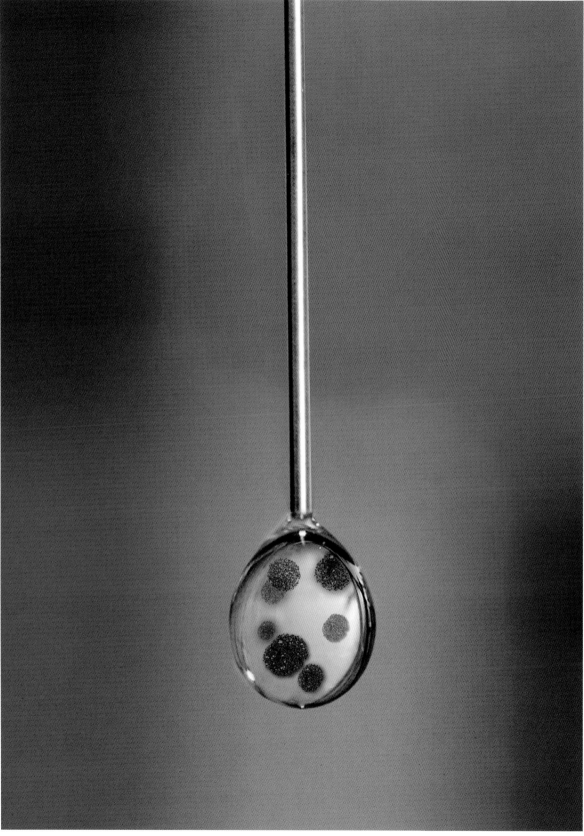

8.4.5

GUEST CASE STUDY 5:
A NEURONAL CIRCUIT WIDGET

In this case study, my friend and colleague Gaël McGill addresses his process for the design and production of scientific multimedia. Gaël well appreciates how the process of making representations informs better understanding, and we have spent hours in conversation strategizing how this idea could be incorporated into the science curriculum. This story describes interactive thinking and the additional options to consider when designing educational materials that involve motion and/or interactivity – not a trivial exercise.

This case study is drawn from the design of an interactive "widget" from the iBook series E. O. Wilson's *Life on Earth*, a high school biology digital textbook created by Digizyme in partnership with Apple and the E. O. Wilson Biodiversity Foundation. The project resulted in a series of seven iBooks covering 40-plus chapters from molecules to ecosystems. A hallmark of the project was the incredible design freedom to brainstorm and decide what might be the best possible way to teach a particular biological concept: would it be a diagram, photograph, movie, simulation, or perhaps an interactive? As with all widgets in the project (this was one among over 500), the planning of the "Neuronal Circuits" widget (book 4 "Animal Physiology," chapter 15 "Nervous Systems") started with a clear definition of learning objectives: (1) for students to understand that neurons work in networks and (2) that the contraction of a muscle is the result of a coordinated activity of both positive and inhibitory inputs from a number of different neurons. To achieve these objectives, we considered a number of different options, including a static graphic or a narrated animation, for example. However, the former did not give us the opportunity to show the dynamic nature of signaling and muscle contraction, while the latter was a linear narrative format that would not give students the ability to select and experiment with various neuronal inputs. It was decided that an interactive experience (in this case a Keynote widget in iBooks Author) would give us the most flexibility to combine different kinds of imagery and media, and therefore would better serve the learning objectives of the piece. In the end, the widget combined the planning, art direction, and production skills of several scientist-artists, including Geoffrey Cheung, Eric Keller, Jeannie Park, and Gaël McGill at Digizyme, working with input from teams at Apple and the E. O. Wilson Biodiversity Foundation.

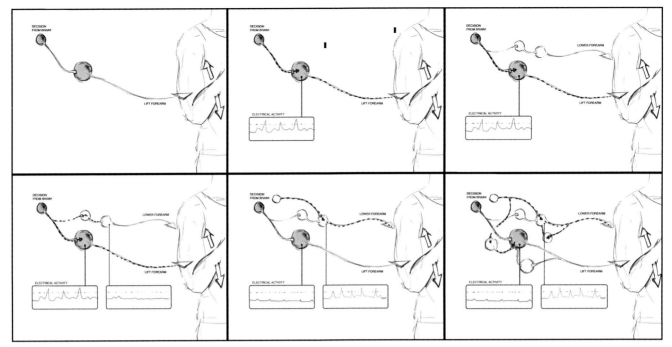

8.5.1

8.5.2

8.5.3

As a first step, a series of visual brainstorms were created—sketching proved to be the easiest way to mock up such progressions. **8.5.1** The goal at this stage was to map out the layout of the imagery in the widget (i.e., the position of the various neurons in the network) as well as how these would interface with the muscle contraction. We also needed to plan for screen real estate to display animated recordings of action potentials. Since these would only appear upon clicking a navigation button to select a specific type of signaling pathway, we decided that they could temporarily replace the main navigation buttons in the lower left of the screen—these buttons would simply reappear once the animation was finished. **8.5.2**

We then considered what types of visual media would work best to show neuronal signaling and muscle contraction, but with an eye toward budget and technical difficulty (since we were always on a *very* aggressive timeline for this project!). A digital painting of the neuronal network was deemed easier than a 3D model and also allowed us to easily animate signals traveling along the axons of the neurons in Adobe After Effects. **8.5.3** In the final interactive widget, we reduced the opacity of neurons that are not firing to help focus the students' attention on only the relevant neurons in the network for a particular type of signaling.

8.5.4

For the muscle and skeleton system, however (and in keeping with the style of some of the other widgets in this and neighboring chapters of the iBook), we opted for a full 3D model and photorealistic animation. Our primary production tool for 3D modeling, animation, and rendering during this project was Autodesk Maya, and we used the embedded Muscle simulation system to create believable biceps and triceps deformations during cycles of contraction. **8.5.4**

The final widget used Keynote to import the neuronal network digital paintings, the animations of the action potential traces and axonal overlays, and photorealistic movies of muscle contraction. All text for titles, navigation, and commentary/labels was created natively in Keynote and therefore kept as vector. The two panels in this last figure are snapshots of the widget "in action." **8.5.5**

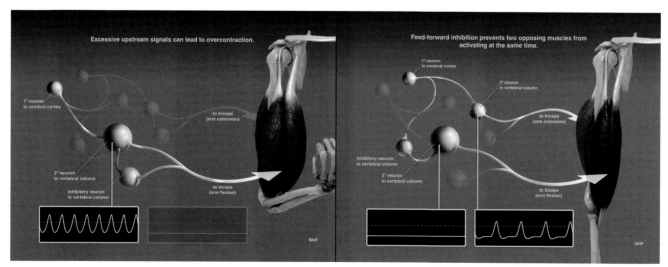

8.5.5

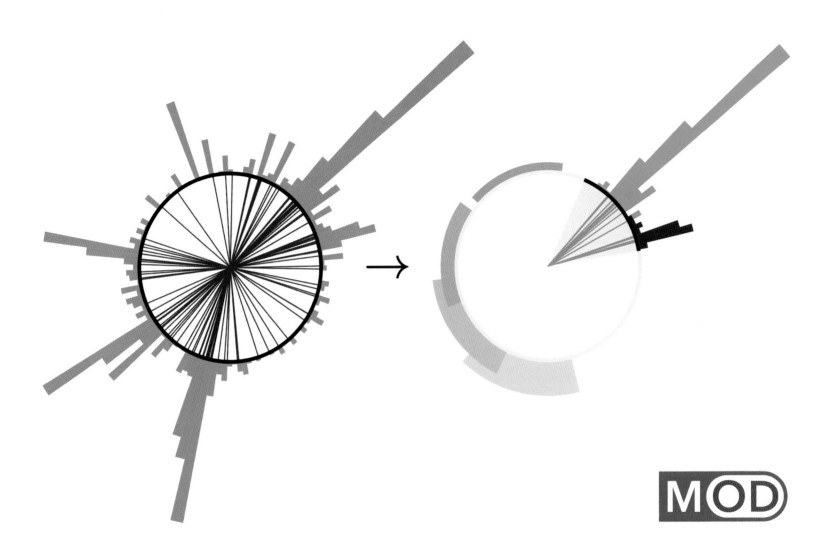

GUEST CASE STUDY 6:
PARTICLE COLLISIONS

Here's an account from another colleague, Jesse Thaler. As he writes, "I am a theoretical particle physicist, which means that I smash together particles ... in my mind."

He is also a rarity – a brilliant physicist at MIT who is also keenly aware of the power of visual communication and works hard at those challenges. Try following his process even if you are not a particle physicist. His thinking is fascinating, and I am grateful that he took the time to write for this book.

One of the challenges in visualizing data in particle physics is that any individual collision has relatively little information, and the science is better captured by histograms that involve many collisions stacked together. Here is a histogram that was involved in discovering the Higgs boson at the Large Hadron Collider (LHC) at CERN in 2012. **8.6.1**

While histograms are the primary data representation we use in particle physics, it is often helpful to visualize one collision event in order to get a sense of the processes at play. To do so, we need to cherry pick a single event that highlights the physics we want to show, while also being visually interesting. Here is one event display from CMS that contains a candidate Higgs boson. **8.6.2**

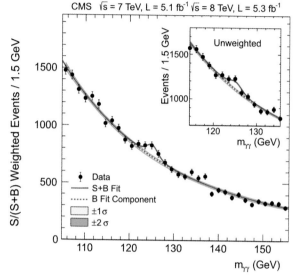

8.6.1

8.6.2

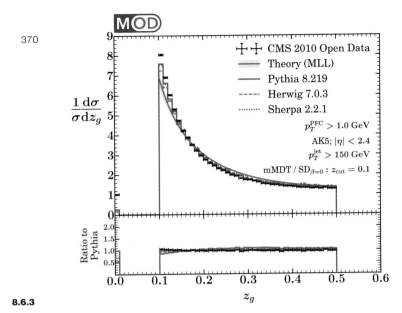

8.6.3

Recently, I had the opportunity to work directly with data from the LHC through the CMS Open Data project. This is the first time in the history of particle physics that data from a collider experiment was made public for use outside of the official experimental collaborations. So while I am a theoretical physicist, my collaborators and I had the unique experience of working directly with experimental data. Not surprisingly, the primary outcome of this research was ... a histogram. **8.6.3**

Or, more accurately, seventy histograms split across two papers.

Because of the historic nature of the CMS Open Data release, and because our work was the very first analysis based on it, our paper was flagged as an "Editors' Suggestion" by *Physical Review Letters* (PRL). As such, we needed to provide an image to use on the PRL website to communicate our work. A histogram simply wasn't going to have the visual impact we wanted. What we needed was an event display.

Where to start? First, I knew that it had to be simple. Some event displays contain multiple views of the same collision along with extra explanatory information, but that would not work for a (relatively small) image on a website. So I definitely wanted to avoid having an event display with multiple panels and extensive text, as in this ATLAS depiction. **8.6.4**

Second, I had to decide on whether to make the event display two dimensional or three dimensional. Collisions happen in 3D, and some of the coolest event displays use 3D representations. **8.6.5**

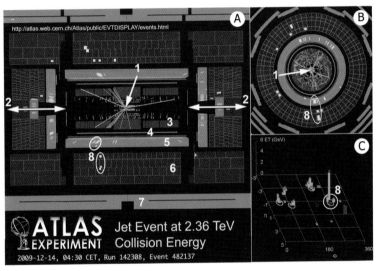

8.6.4

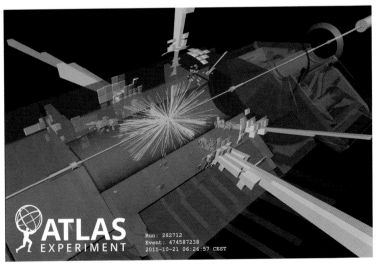

8.6.5

But I had very little time and no experience using 3D software, so I settled on using a 2D visualization where the colliding beams are perpendicular to the plane of the image and the collision debris sprays out over the page in projection. Here is an example of a CMS event display in this 2D style. **8.6.6**

Since I did not have access to the CMS software to make event displays, I wrote my own simple event display tool using Mathematica. I asked one of my collaborators to get me the information for the most extreme collision event in our sample, and it turned out to be a complete dud visually. **8.6.7**

But you can already see the style I chose: white background, red lines representing the trajectories of (charged) particles, gray radial bars representing the energies of (charged and neutral) particles, and just a thin black circle to hint at the CMS detector.

In any case, I needed an event with more pop. I tried six more events, randomly selected from our sample, but none of them had the pizzaz I wanted.

Then, on the next event I tried, I hit the jackpot. I slapped our "MIT Open Data" logo on it, turned the red and gray into the official MIT colors (Pantone 201 and Pantone 423) and sent it off to my collaborators for their approval. **8.6.8**

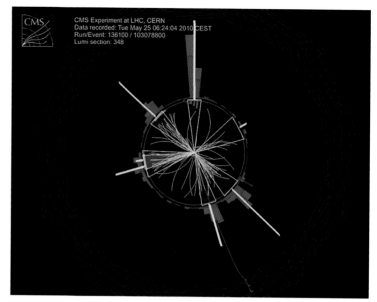

8.6.6

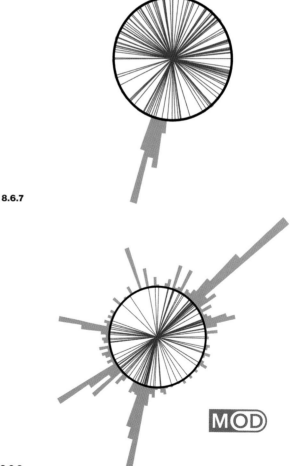

8.6.7

8.6.8

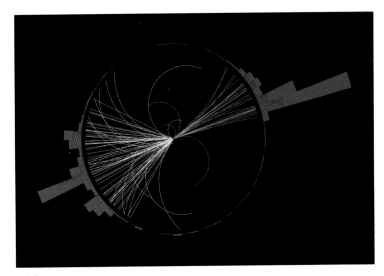

8.6.9

8.6.10

8.6.11

The next day, though, I realized that the event I had selected was not really showing the physics in our paper. This event consisted of five "jets" of collimated particles. But our study was not about multijet events; rather, our study was about the internal structure of a single jet. So no matter how interesting this event display was, it was not capturing the actual science.

In pondering my dilemma, I was reminded of this elegant event display from CMS, which shows a pair of jets, each with three-prong substructure. **8.6.9**

You can see the similarities to my visualization, though I made a number of simplifications. Instead of using two colors (blue and red) to represent the energy deposits, I used just one color (gray) since I thought the distinction would be distracting. Instead of using curved particle trajectories (which is more accurate from the experimental perspective), I straightened the trajectories (which is more accurate from the theoretical perspective).

But what jumped out at me from this CMS display was that, because it uses two different colors for the particle trajectories (yellow and green), the viewer immediately sees that there are two jets. What the viewer does not immediately see, however, is that each jet consists of three subjets, but that could easily be fixed just by color coding the subjets of interest.

Here is the single jet of interest from my five-jet event, with its subjets highlighted in green and blue. **8.6.10**

I kept the particle trajectories within the jet, but made them dark gray to draw attention away from them. So now I had the correct physics, but it seemed strange to have a jet floating on the page without any context. I therefore decided to summarize the four other jets in the event as simple gray arcs, which restored some balance to the event display. **8.6.11**

Jet aficionados might be interested to know that the opening angles of the arcs match the clustered jet size (overlapping since this is really happening in 3D) and the areas of the arcs are proportional to the jet energies.

This last image captures the physics better than I could have ever hoped. The event is really happening in 3D, but I got lucky that the green and blue subjets can still be seen clearly in this 2D projection. Moreover, the fact that the blue subjet has significantly less energy than the green one is actually a key finding of our study, shown scientifically in the above histogram but captured viscerally in a single event display.

So now I had two event displays. One of a dynamic collision event with five jets, four of which were irrelevant to the science. One with a single jet isolated to show its two-prong substructure, but lacking a bit in visual interest. What to do? Use them both, of course, with a rightward arrow to indicate that by processing the left image, one could arrive at the right one. [See opening image of this case study.]

My collaborators approved wholeheartedly.

There is one last feature that I should point out. These jets arise from the dynamics of the strong force, otherwise known as quantum chromodynamics. Here, "chromo" does not refer to actual color, but to a mathematical structure involving three labels, typically given as "red," "green," and "blue." So yes, I admit that my color scheme involves a gratuitous visual pun, but hopefully that is the only gratuitous feature of the final image.

In the next five case studies, we'll be looking at examples of how I photographed objects *as they are*, without the need to create an explanatory metaphor. There's a hidden agenda here. The best thing I can accomplish in these pages is to encourage you to look at your work in new ways and to learn to see the world from new points of view. You'll see in this first case study how small changes result in different perspectives.

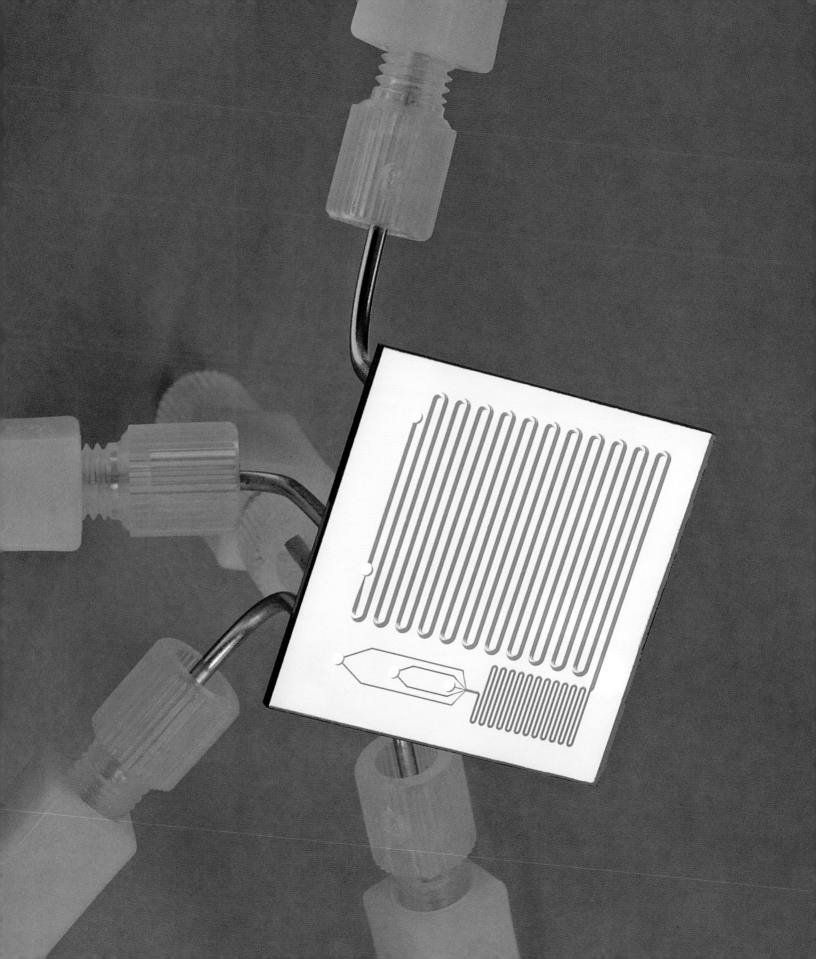

CASE STUDY 7:
AN ANALYTIC MICROREACTOR

Most of the time we don't have the luxury of showing a variety of points of view in a journal submission, so we have to find that one "right" perspective when submitting materials for a cover or a figure.

Here is the first image that I made of a microreactor developed in Klavs Jensen's lab at MIT. **8.7.1**

The researchers and I then agreed that it was important to somehow show the back of the reactor, how the microreactor was connected to the analytic components, so here it is from that perspective. **8.7.2**

However, the image didn't work alone, so I continued looking for a way to include the front of the device along with the back pieces. **8.7.3**

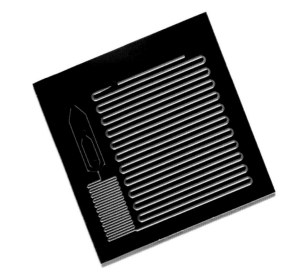

8.7.1

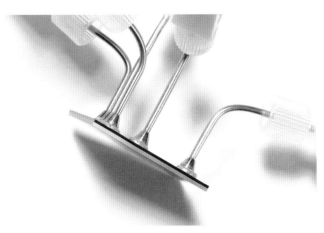

8.7.2

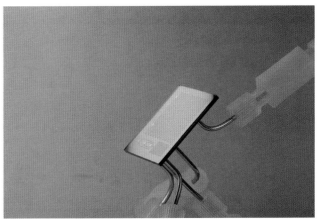

8.7.3

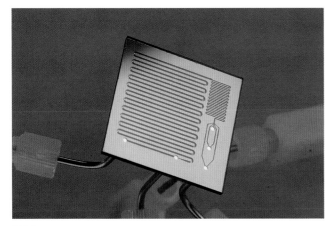

8.7.4

The result was OK but not well-composed – I wanted to see just a little more of the front, and so I photographed it from this perspective. **8.7.4**

Notice that something isn't quite right. By now, I hope that you are getting more particular with your own images and can see the problem – the upper left corner. Take another look.

By moving the camera ever so slightly to a different angle, we get a cleaner image without the distracting dark reflection. **8.7.5**

For fun, I decided I wanted to play around with just the straight-on shot of the microreactor by duplicating a single image into an array **8.7.6** and then digitally colored the background. **8.7.7**

I thought it would be interesting cover material, or perhaps could be used for an introduction slide for a presentation. I guess the researchers didn't agree. They never used it.

As to the more documentary image that shows the complete story of the device, we did get it published as a cover. **8.7.8**

The image was also used in this figure. **8.7.9**

As it turned out, this was the best point of view for this particular device. Note that I adjusted the background color for an image used in a *Nature* news feature. **8.7.10**

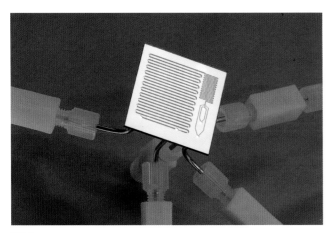

8.7.5

8.7.6

8.7.7

8.7.8

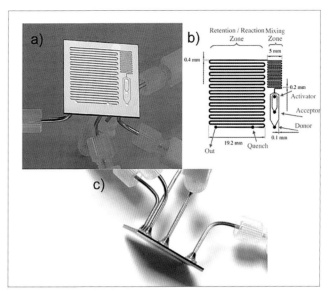

8.7.9

8.7.10

Joule

Volume 1 Number 1 January 1, 2017

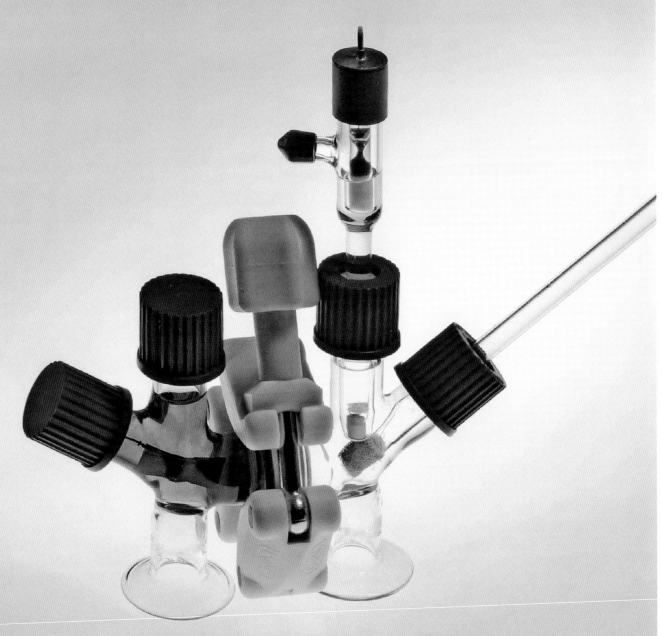

www.cell.com

CASE STUDY 8:

AN "AIR-BREATHING" BATTERY

This laboratory cell is used to test an "air-breathing" aqueous sulfur rechargeable battery concept for ultra-low-cost grid storage

Getting this particular image on a cover was satisfying for a number of reasons. First, at the time of this writing, *Joule* was a new journal, and it's always nice to be there from the inception. Moreover, Andrew Tang, the art director at *Cell*, was helping them out for their first few issues, and I knew Andrew from my previous book with Angela DePace, *Visual Strategies: A Practical Guide to Presenting Your Work*.

Liang Su, from Yet-Ming Chiang's lab at MIT, met with me and handed over the apparatus. My first thought was to place it on a high-gloss table. **8.8.1** I immediately realized the reflection was too distracting and nixed that idea.

Moving over to my light table made more sense, and there it was. **8.8.2**

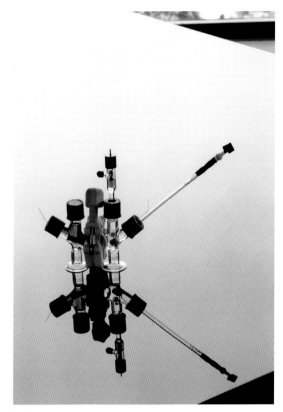

8.8.1

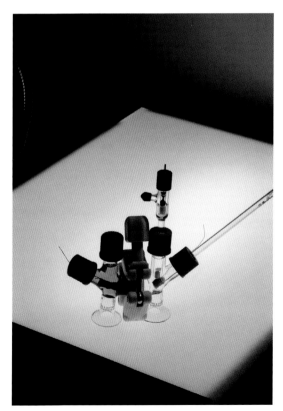

8.8.2

It was getting there – simple and elegant. But the image needed just a little more warm "fill" light from the front. **8.8.3**

I then cropped the image and digitally stretched the background to give Andrew the size he requested. **8.8.4**

Just one more refinement was necessary. The red cap in the lower left was a bit dented, so I copied and pasted the very top from another red cap to finish it off. **8.8.5**

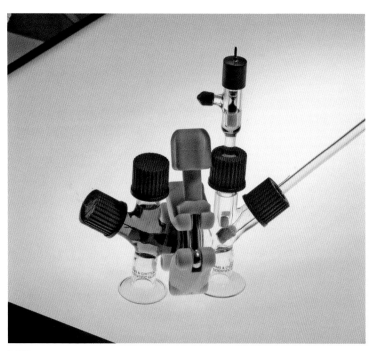

8.8.3

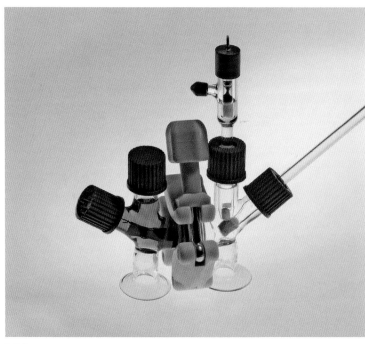

8.8.4

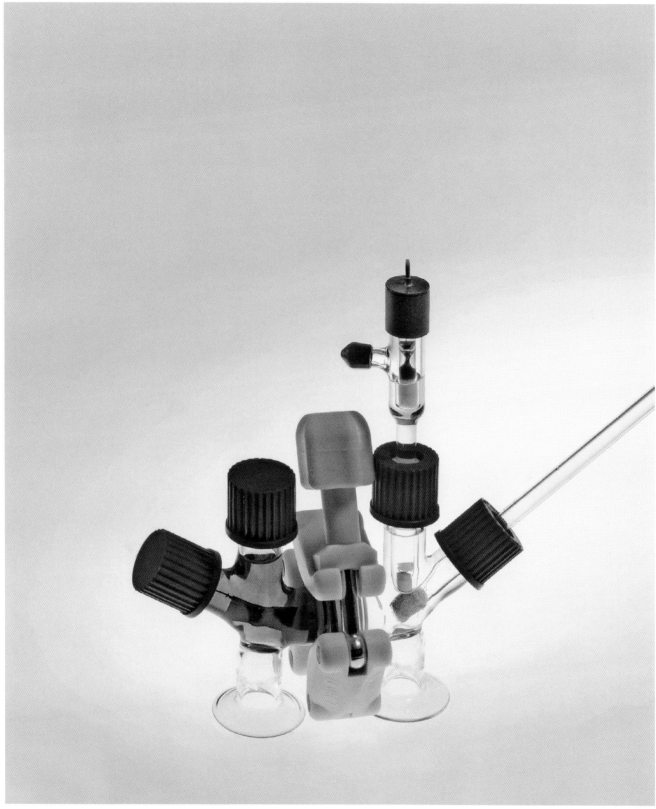

8.8.5

CASE STUDY 9:
MICRONEEDLES

In this case study, documenting Peter DeMuth's microneedles, I'll be going into possibly excruciating detail, showing that I am not always sure from which point of view I should make a photograph.

For starters, I placed the 1 cm disks containing the needles on a table to take a quick look – just to get a sense of what they look like. **8.9.1** I also tried putting them on top of the petri dish in which they came to my office. **8.9.2** I was surprised that I liked this accidental image. The fact that the background was out of focus probably helped.

This next successful image, which we have seen before, was made on the flatbed scanner. It's simply a different way of viewing and communicating the microneedles. **8.9.3**

8.9.1

8.9.2

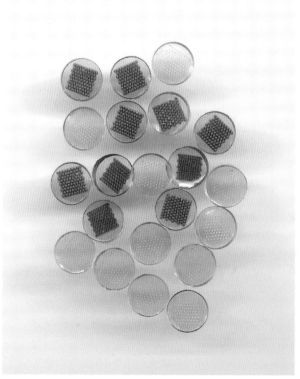

8.9.3

8.9.4

I then decided to go back and refine the previous arrangement. Note that the material came in two colors. **8.9.4**

Taking a more serious look by now, I kept in mind the issue of depth of field and started to compose for a cover shot, leaving room for the journal logo. **8.9.5**

I thought that the pink was distracting. So next I tried including just one color of the disks. **8.9.6**

8.9.5

8.9.6

I continued playing and shifted my point of view. **8.9.7**

Look carefully, here, as I *slightly* change the positioning of the disk in the lower left. **8.9.8**

See how this changes the alignment of the needles so that they do not become redundant with arrangements on the other disks. These are very minute changes, and you might consider them unnecessary. It's these small changes that make a photograph better.

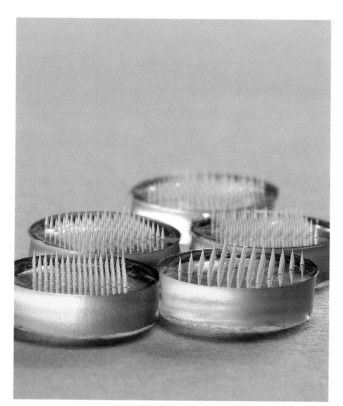

8.9.7

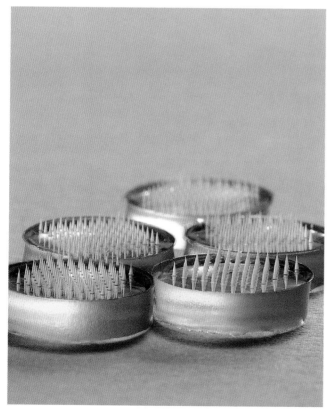

8.9.8

In the end, however, Peter sent me a wonderful microscopic picture of these microneedles, and he wanted to try to get a cover with his image. **8.9.9**

The challenge was that the image was horizontal and the cover was a vertical bleed, so I first cropped the image, anticipating that I would digitally stretch the background to get the cover. Go to the how-to-do-it videos on the web resources page for more on this. **8.9.10**

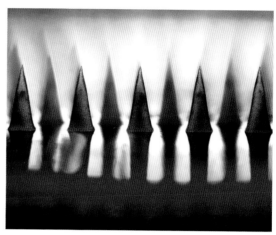

8.9.9

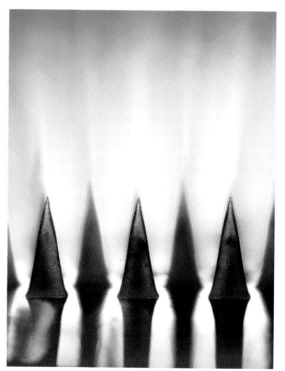

8.9.10

CASE STUDY 10:
A SOLAR THERMOPHOTOVOLTAIC (STPV) DEVICE

Here's a case in which I brought a little artistic license into my documentation.

There are times, when I'm asked to help with an image, that I have no idea what is in store for me. When Andrej Lenert from Evelyn Wang's lab first walked me through this lab at MIT, the amount of sophisticated equipment made my head spin. And even when I was shown the relevant chamber in which the solar thermophotovoltaic (STPV) device was situated, I still had no clue of how to think about making a picture. **8.10.1**

The chamber was covered with aluminum foil (as are many chambers in labs, I've noticed). In particular, my eye focused on the window of the chamber. **8.10.2**

It had the potential to appear beautiful, but there was a little too much going on in this first quick image. I decided to simplify it — as I continually urge you to do. I digitally deleted all that foil and concentrated on the circular window, showing the device inside. **8.10.3**

8.10.1

8.10.2

8.10.3

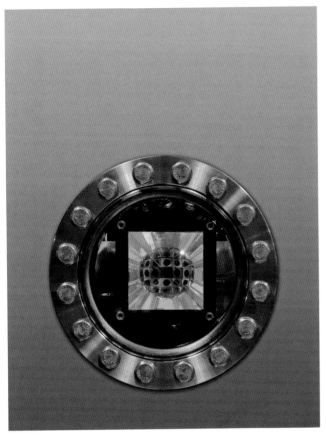

8.10.4

I then digitally added a background for a potential cover submission. **8.10.4**

When I returned to the lab a few days later, there was a similar but different device in the chamber. I decided to shoot this one as well. Taking advantage of the reflective quality of the surfaces, I laid an orange cloth (which I found hidden away on a table) over the lens, so that some orange was reflected off the surface. **8.10.5**

In addition, I moved the camera closer to the window, focusing in on the device inside the chamber and shooting at around f/32. Note the orange reflections. **8.10.6** You can see how very little is in focus.

I then imagined what I might do, like cropping in to the focused section. **8.10.7**

Then I decided to try something else. Using the single image of just the device, I digitally stretched part of it to make it more vertical (anticipating using it as a background) and then overlaid a copy of the original image on the vertically stretched image so that the device became proportionately right, as you see in the opening image of this case study.

It didn't make the journal cover, but happily it got the MIT homepage highlight. **8.10.8**

8.10.5

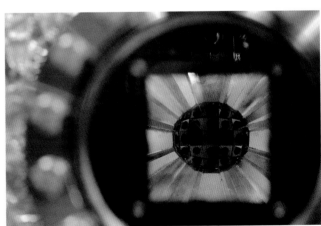

8.10.6

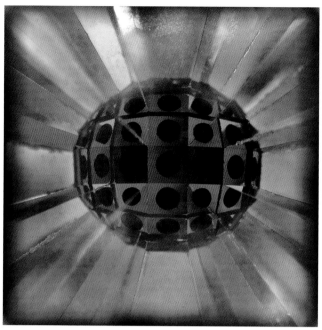

8.10.7

8.10.8

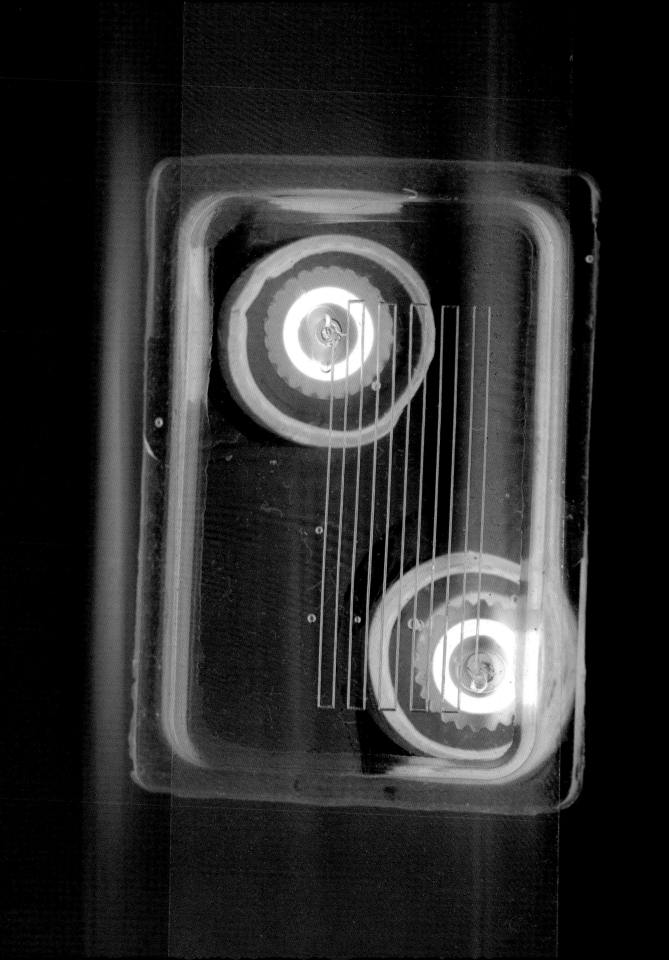

CASE STUDY 11:
MATERIALS EXTRACTION AND MANUFACTURING

I mentioned the challenge of capturing quality images when the sample is not in the best condition — particularly in the presence of large amounts of dust and dirt. With my first scan of this device (with the scanner cover open), from Antoine Allanore's lab, I knew I was going to have a challenge ahead. **8.11.1** Frankly, spending hours digitally cleaning the image was not something I was looking forward to. To be fair, when the researchers fabricated the device, they had no idea I was going to photograph it for publication. I am quite sure this particular device was used for experimental purposes only.

In any event, I decided to try the lazy way out and imagined doing the following. I knew the black background was emphasizing the specks of dust, so I made the scan with the cover closed, as I normally would do. **8.11.2**

OK, better, I thought. I then decided to see what transmitted light would give me. **8.11.3**

It was an interesting image that didn't work alone, but overlaying the two might give me something more readable than either one separately. **8.11.4**

Using the layers window in Photoshop, I adjusted the opacity of the overlaid transmitted image to 39% with the "normal" setting for the layer. Experimenting further, I set the overlaid image to "overlay" in the layers window, with this result. **8.11.5** See if you can see the subtle change for the better.

Taking it even one step further, I inverted the normal layered image, resulting in the opening image for this case study.

In the last four case studies, we'll see my further attempts to depict concepts that are not photographable. I find the exercise to be extraordinarily instructive for a number of reasons. First, it's a fascinating challenge to create a depiction that will engage a reader in a particular concept though they may not have the expert background for deep understanding. The *Nature* cover case study, at the beginning of this chapter, is a good example of this. In addition, if the concept is not directly photographable, the need to find a visual metaphor for it can bring clarification.

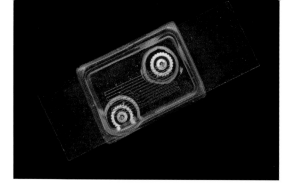

8.11.1

8.11.2

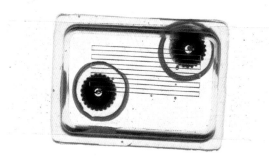

8.11.3

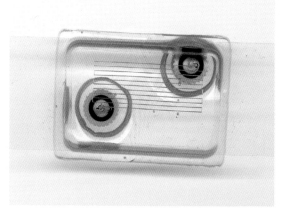

8.11.4

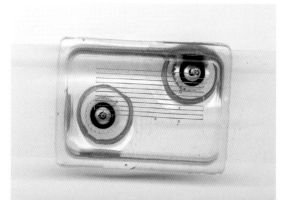

8.11.5

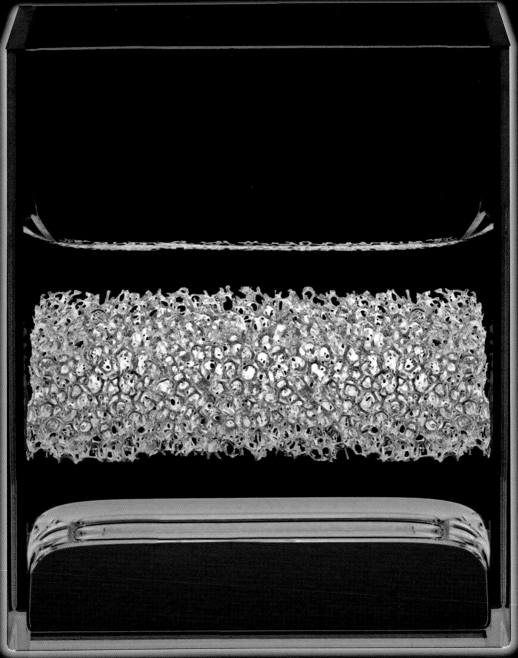

CASE STUDY 12:
LIQUID BATTERY MODEL

In this case, my intention was to submit a journal cover by first creating various photographic bits and pieces and then combining them into one final photo-illustration—similar to what I described in case study 1. It's as if I drew all the various components, as most graphic artists do, but because I cannot draw (or have never really tried), I used the only skills that I know—making photographs.

First I met with researcher Don Sadoway and his colleagues Brice Chung and Takanari Ouchi at MIT for a brainstorming session. Together we discussed what materials were needed, along with a sketch of my thinking of how to begin. **8.12.1, 8.12.2**

The "lab instructions" included in my package were critical and, frankly, a little unnerving. Although I have worked in various labs over the years, I was not delighted with handling liquid mercury. In fact, my hesitancy later informed the process of making the final image. The number of "pours" and the need to save the discarded material according to environmental regulations changed my approach. I decided, instead, to incorporate a few digital steps in the process.

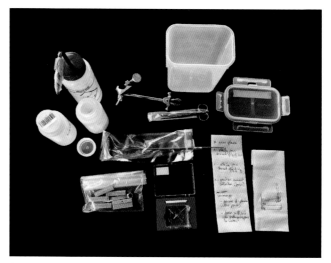

8.12.1

8.12.2

8.12.3

First, I took the supplied optical-quality cuvette, put it on my light table, and then *very* carefully poured in the mercury and water, just to see what I was dealing with. **8.12.3**

It was at this point that I got nervous, realizing I would have to discard and restart a number of times to determine the order of things.

So instead, I decided to use this image as the primary "canvas" for the final image, and planned to *digitally* insert the rest of the necessary components. After I tried a number of water levels along with different placements of the foam, the following image gave me the best one with which to work. **8.12.4**

I decided to add a little tungsten light from the front to give the metal foam a warmer hue. **8.12.5**

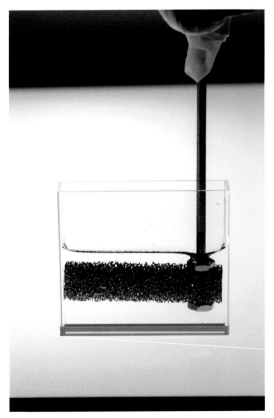

8.12.4

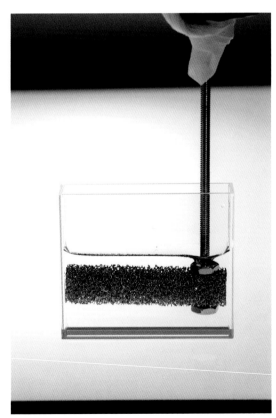

8.12.5

I then copied and inserted the foam and water level **8.12.6a** into the previously determined "canvas" image. **8.12.6b**

This resulted in the next image. **8.12.6c** I had to move it around a little bit to match the various lines, and then flattened the layers.

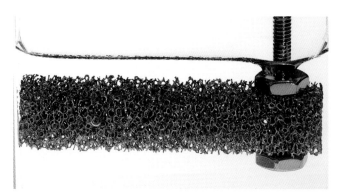

8.12.6a

8.12.6b

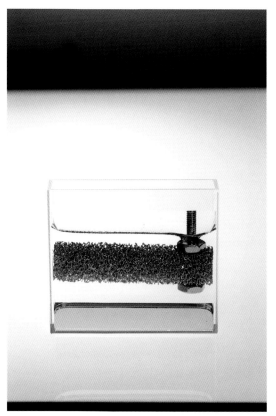

8.12.6c

8.12.7

I then copied the left side of the cuvette and moved that copied piece to the right (to cover the folder holder). **8.12.7**

I "flipped" the piece horizontally and placed it so that the cuvette appeared "finished." I also added a drop shadow. **8.12.8**

For a little drama, I digitally color-inverted the whole picture. **8.12.9**

And then, to get the now blue metal foam back to having an orange tint, I changed the hue just in the foam area, resulting in the final image (see the opening image of this case study).

Unfortunately, we did not get the cover, but *Nature* liked the photograph so much that they used it on the journal's home page. The research received a great deal of attention in other news outlets — primarily, of course, because the science was important. But I believe that drawing attention with a dramatic image helped.

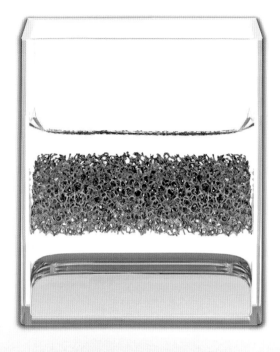

8.12.8

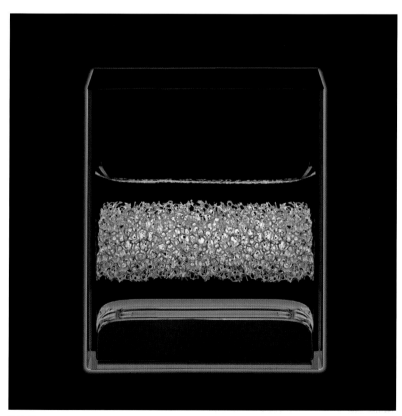

8.12.9

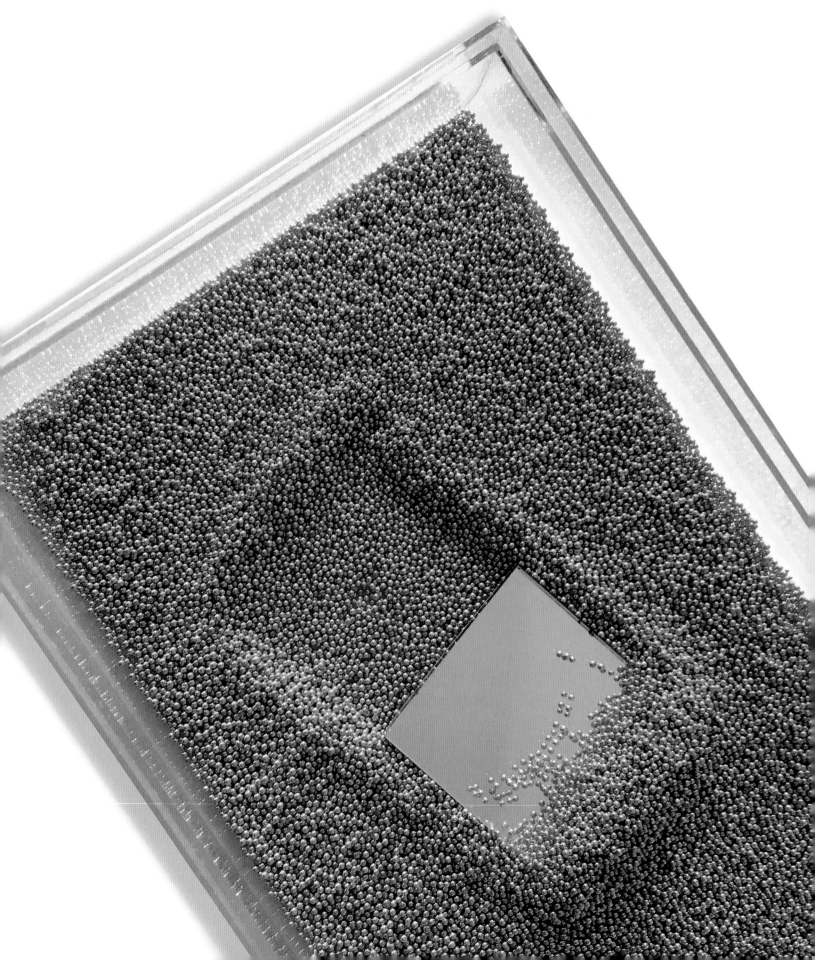

CASE STUDY 13:
A MATHEMATICAL "INTRUDER"

MIT researcher Ken Kamrin was looking for an interesting way to depict his new and simple equation to calculate the force required to push a shovel — or any other "intruder" — through sand. He had some nice images of his son pushing sand with his shovel, but I persuaded him to reconsider. Without even seeing that image, I could imagine what it looked like. That was a point I was trying to make — that the clichéd image is not necessarily compelling.

I started playing around with various media resembling sand and some visual ideas for "intruders." Ken also made the point that his equations would work with other sorts of media. Here's one image I first liked. **8.13.1** But after second thoughts, I found the image to be interesting — frankly, too interesting. There was so much going on that it was difficult to see the point of the photograph, even with a caption.

I knew I had to simplify the idea and did a little searching on line to find some great-looking sandlike material. These beads could work, I thought. **8.13.2**

I also tried toothpaste, denture adhesive, and baby diaper rash cream for other possible "media" metaphors. We'll stick with the beads for this discussion.

Simplifying the idea further, for the final image, shown at the beginning of this case study, I tried to address Ken's suggestion to create an image "so it looks like someone tried to jab it in, kinda like a chip scooping guacamole."

We did get the image on the MIT homepage. **8.13.3**

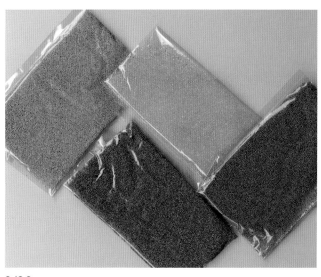

8.13.2

8.13.3

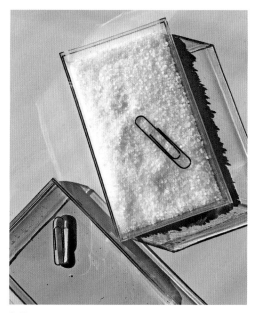

8.13.1

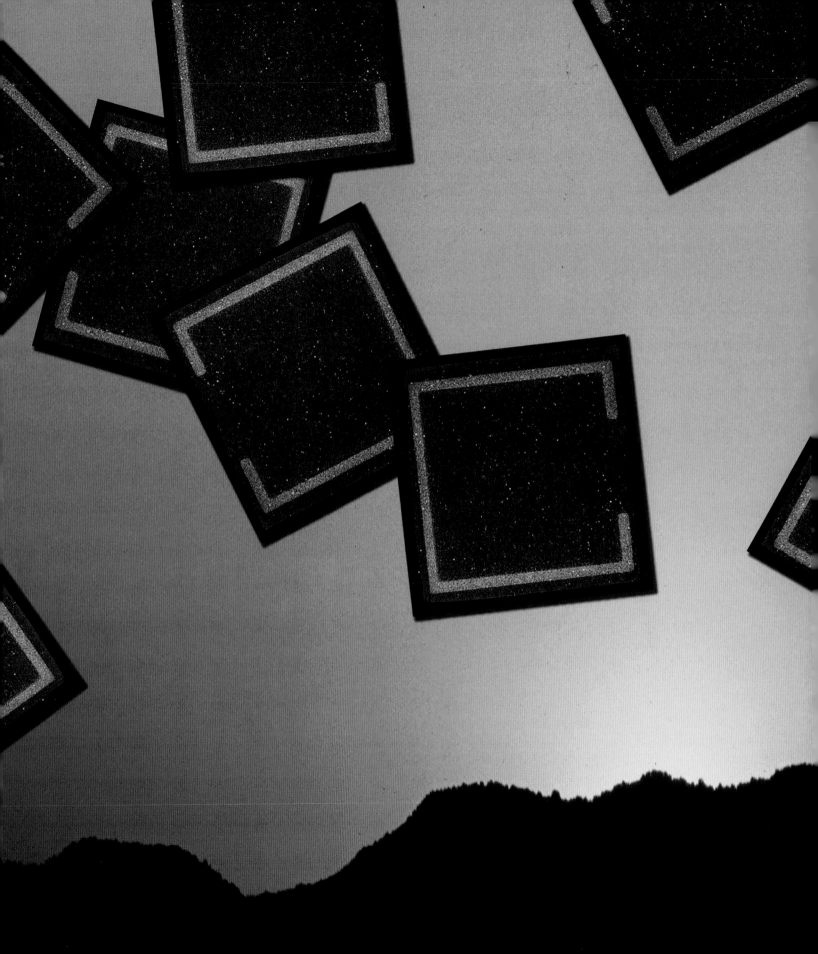

CASE STUDY 14:
SOLAR CELL

In this next example, my idea was to include a visual nod to the application of a particular solar cell.

Here is an image of one of the cells. **8.14.1** The image was made by Rongrong Cheacharoen at Stanford University.

But there is a problem—one that I see often coming from labs. The subject of the image (the solar cell) is hardly readable. In fact, if you think of it in terms of "real estate," the subject of the image takes up about 1% of the full image. The reader has to work too hard to figure out that the photograph is not about a purple glove.

For my attempt at MIT, I began by making an image of just one device using a stereomicroscope. **8.14.2**

I could just as well have used a camera and a 105 lens, but it was easy to quickly place the device under the scope.

I was in a lavender mood at the time and overlaid the one image on a background and then duplicated the cell a number of times, randomly placing them on the background. **8.14.3**

The MIT News Office used the image for one of their news stories. **8.14.4**

8.14.2

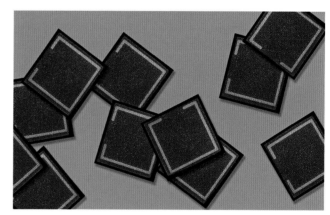

8.14.3

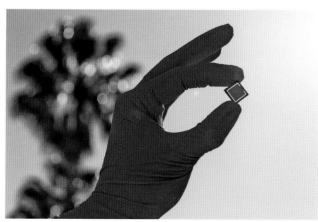

8.14.1

8.14.4

However, I was still hoping to get on the homepage and considered making an image that would suggest something "solar-like," suggesting a connection to the sun, so I tried using a red-yellow gradient for the background. **8.14.5**

That didn't work.

I then remembered an image I had made 20 years ago from my thousands of landscape slides – a sunset in California. **8.14.6**

Using that image for the background, I again overlaid a number of the duplicated solar cells, resulting in the opening image of this case study.

I was happy to see the image appear on MIT's homepage. **8.14.7**

8.14.5

8.14.6

8.14.7

CASE STUDY 15:

OXYGEN VACANCIES

When Bilge Yildiz at MIT contacted me to come up with an image that somehow represented how a new surface treatment could improve the efficiency of a particular material, perovskite, for fuel cell electrodes, I thought I was in over my head. Once again, the important part of my process was to sit down and have the science explained. And as she was doing so, I began to visualize how we could represent something impossible to capture with a camera or microscope. The phrase "oxygen vacancy" became an integral part our conversation, and I began to grasp, at least for myself, that a vacancy felt like a "hole." But selling Bilge on using a hole to visualize vacancy was not easy. I knew I had to show her what I meant.

I started with a photographic background discussed in chapter 4 in the section on Backgrounds, **8.15.1** and then did some searching for various ways scientists were representing perovskite oxides. Many of the representations were so complex that they were difficult to read. **8.15.2**

I landed on a two-dimensional graphic — much easier to read. **8.15.3**

Imagining that I would float a couple of these on the background I selected, I started altering the shape **8.15.4** and added the questionable "holes" that I had to talk Bilge into. These metaphors for vacancies are, in fact, photographs! **8.15.5**

Combing all the pieces resulted in the opening image. Note that I colored some areas in red on the upper part of this graphic. The purpose was to suggest that once some of the oxygen vacancies were filled with particular atoms (in red), the material became more durable and efficient. MIT used the image on its homepage. **8.15.6**

8.15.1

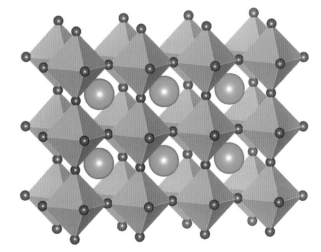

8.15.2

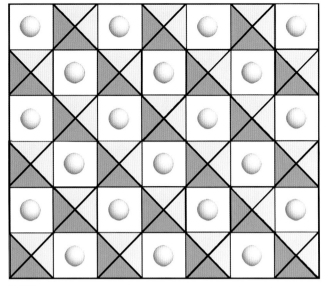

8.15.3

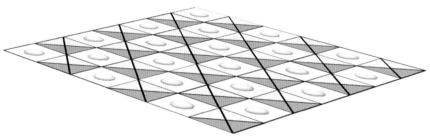

8.15.4

8.15.5

8.15.6

VISUAL INDEX

The purpose of this visual index is to provide you with relevant scientific information about each image. You can also use this as a quick tool to find your way back to the images in the book.

With a few exceptions, the images are mine and are copyrighted and may not be used without my permission. The few that are not mine are indicated as such.

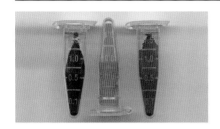

1.1
analytical chemicals

G. M. Whitesides, Whitesides Group, Department of Chemistry and Chemical Biology, Harvard University

Martinez, A. W., S. T. Phillips, G. M. Whitesides, et al. "Diagnostics for the Developing World: Microfluidic Paper-Based Analytical Devices." *Analytical Chemistry* 82, no. 1 (January 1, 2010).

1.2
human physiome chip

L. Griffith, Charles Stark Draper Laboratory; Department of Biological Engineering, Massachusetts Institute of Technology

1.3
mother-of-pearl

Frankel, F., and G. M. Whitesides. *On the Surface of Things: Images of the Extraordinary in Science*. San Francisco: Chronicle Books, 1997.

1.4
E. coli

S. Bhatia, Laboratory for Multiscale Regenerative Technologies, Massachusetts Institute of Technology

Danino, T., J. Lo, A. Prindle, et al. "In Vivo Gene Expression Dynamics of Tumor-Targeted Bacteria." *ACS Synthetic Biology* 1, no. 10 (October 2012).

1.5
microneedles

P. DeMuth, Department of Biological Engineering; Irvine lab, Koch Institute for Integrative Cancer Research; Hammond lab, Koch Institute for Integrative Cancer Research, Massachusetts Institute of Technology

DeMuth, P. C., Y. Min, D. J. Irvine, et al. "Implantable Silk Composite Microneedles for Programmable Vaccine Release Kinetics and Enhanced Immunogenicity in Transcutaneous Immunization." *Advanced Healthcare Materials* 3, no. 1 (January 2014).

1.6
pears

author's personal exploration

1.7
raw egg

author's personal exploration

1.8
heirloom tomatoes

author's personal exploration

1.9
lung on a chip

D. Ingber, Wyss Institute for Biologically Inspired Engineering, Harvard University

Huh, D., B. D. Matthews, A. Mammoto, et al. "Reconstituting Organ-Level Lung Functions on a Chip." *Science* 328, no. 5986 (June 25, 2010).

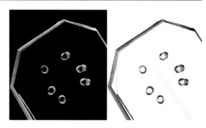

1.10
dried flower

author's personal exploration

1.11
electronic camera

J. Rogers, Rogers Research Group, School of Engineering, Northwestern University

Ko, H. C., M. P. Stoykovich, J. Song, et al. "A Hemispherical Electronic Eye Camera Based on Compressible Silicon Optoelectronics." *Nature* 454, no. 7205 (August 7, 2008).

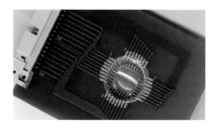

1.12
agate

Frankel, F., and G. M. Whitesides. *On the Surface of Things: Images of the Extraordinary in Science*. San Francisco: Chronicle Books, 1997.

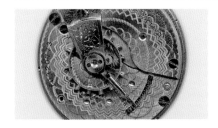

1.13
watch gears

author's personal exploration

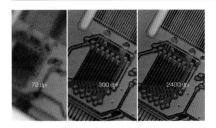

1.14
e-ink apparatus detail

www.eink.com/

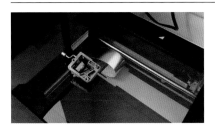

1.15
Epson scanner

image inserted for clarification

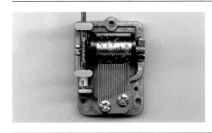

1.16–1.23
music box

author's personal exploration

1.24
Euplectella

J. Aizenberg, Aizenberg Biomineralization and Biomimetics Lab, Harvard University

Aizenberg, J., A. C. Weaver, M. S. Thanawala, et al. "Skeleton of *Euplectella* sp.: Structural Hierarchy from the Nanoscale to the Macroscale." *Science* 309, no. 5732 (July 8, 2005).

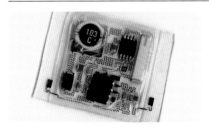

1.25
soft microfluidic sensor

J. Rogers, Rogers Research Group, School of Engineering, Northwestern University

Xu, S., Y. Zhang, L. Jia, et al. "Soft Microfluidic Assemblies of Sensors, Circuits, and Radios for the Skin." *Science* 344, no. 6179 (April 4, 2014).

1.26–1.32
microarrays

D. Walt, Illumina

http://www.illumina.com

1.33, 1.34
human physiome on a chip

L. Griffith, C. Edington, D. Trumper, M. Cirit, Massachusetts Institute of Technology and Charles Stark Draper Laboratory

Chen, W. L. K., C. Edington, E. Suter, et al. "Integrated Gut/Liver Microphysiological Systems Platform Elucidates Inflammatory Cytokine/Chemokine Inter-Tissue Crosstalk." *Biotechnology and Bioengineering* 114, no. 11 (November 2017).

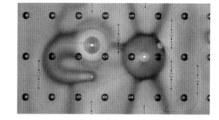

1.35–1.39
E. coli

S. Bhatia, Laboratory for Multiscale Regenerative Technologies, Massachusetts Institute of Technology

Danino, T., J. Lo, A. Prindle, et al. "In Vivo Gene Expression Dynamics of Tumor-Targeted Bacteria." *ACS Synthetic Biology* 1, no. 10 (October 2012).

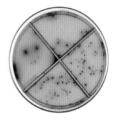

1.40, 1.41
selected backgrounds

1.42
diagnostic device

D. Duffy Laboratory, Quanterix Corporation

Kan, C. W., A. J. Rivnak, T. G. Campbell, et al. "Isolation and Detection of Single Molecules on Paramagnetic Beads Using Sequential Fluid Flows in Microfabricated Polymer Array Assemblies." *Lab on a Chip* 12, no. 5 (March 2012).

2.1
quick-release device

image inserted for clarification

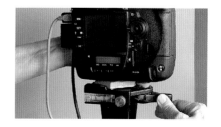

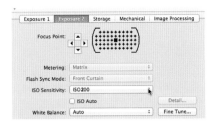

2.2
screen shot for exposure

image inserted for clarification

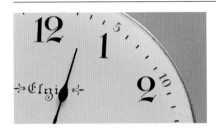

2.3
ISO settings

image inserted for clarification

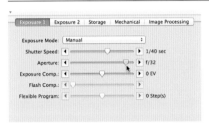

2.4, 2.5
screen shots for exposure

image inserted for clarification

2.6
acrylamide gels

T. Tanaka, Tanaka Laboratory, Department of Physics, Center for Materials Science and Engineering, Massachusetts Institute of Technology

Alvarez-Lorenzo, C., O. Guney, T. Oya, et al. "Polymer Gels That Memorize Elements of Molecular Conformation." *Macromolecules* 33, no. 23 (November 14, 2000).

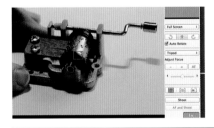

2.7–2.9
screen shots for exposure and composition

images inserted for clarification

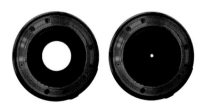

2.10–2.12
depth-of-field discussion

images inserted for clarification

2.13
engineered hairs

A. Hosoi lab, Department of Mechanical Engineering, Massachusetts Institute of Technology

Nasto, A., M. Regli, P. T. Brun, J. Alvarado, C. Clanet, and A. E. Hosoi. "Air Entrainment in Hairy Surfaces." *Physical Review Fluids* 1, no. 3 (July 2016).

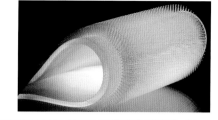

2.14
autumn leaves

Frankel, F. *Envisioning Science: The Design and Craft of the Science Image*. Cambridge, MA: MIT Press, 2002.

2.15
laboratory-made crystals

R. Birgeneau Laboratory, Department of Physics, Massachusetts Institute of Technology

"Laboratory-Made Calcium Fluoride and Manganese Fluoride Crystals." In *The Art and Science of Growing Crystals*, ed. J. J. Gilman. New York: Wiley, 1963.

2.16
microreactor

S. Ajmera, Jensen Research Group, Department of Chemical Engineering, Massachusetts Institute of Technology

Ajmera, S. K., C. Delattre, A. Martin, et al. "A Novel Cross-Flow Microreactor for Kinetic Studies of Catalytic Processes." In *Microreaction Technology: IMRET 5: Proceedings of the Fifth International Conference on Microreaction Technology*, ed. M. Matlosz, W. Ehrfeld, and J. P. Baselt. Berlin: Springer-Verlag, 2001.

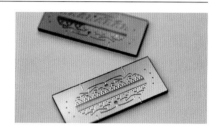

2.17
lung on a chip

D. Ingber, Wyss Institute for Biologically Inspired Engineering, Harvard University

Huh, D., B. D. Matthews, A. Mammoto, et al. "Reconstituting Organ-Level Lung Functions on a Chip." *Science* 328, no. 5986 (June 25, 2010).

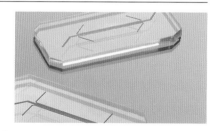

2.18
patterned spheres

G. M. Whitesides, Whitesides Group, Department of Chemistry and Chemical Biology, Harvard University

Paul, K. E., M. Prentiss, and G. M. Whitesides. "Patterning Spherical Surfaces at the Two-Hundred-Nanometer Scale Using Soft Lithography." *Advanced Functional Materials* 13, no. 4 (April 2003).

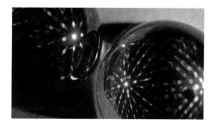

2.19
plasmonic crystals

J. Rogers, Rogers Research Group, School of Engineering, Northwestern University

Stewart, M. E., N. H. Mack, V. Malyarchuk, et al. "Quantitative Multispectral Biosensing and 1D Imaging Using Quasi-3D Plasmonic Crystals." *Proceedings of the National Academy of Sciences* 103, no. 46 (November 14, 2006).

2.20
***E. coli* patterns**

E. Budrene, Budrene Laboratory, Department of Cellular and Developmental Biology, Harvard University

Budrene, E. O., and H. C. Berg. "Complex Patterns Formed by Motile Cells of *Escherichia coli*." *Nature* 349, no. 6310 (February 14, 1991).

2.21
self-assembled spheres

Frankel, F., and G. M. Whitesides. *No Small Matter: Science on the Nanoscale*. Cambridge, MA: Belknap Press of Harvard University Press, 2009.

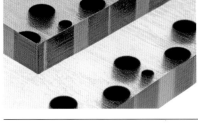

2.22
fabricated material

M. Boyce, M. Guttag, Massachusetts Institute of Technology

Guttag, M., and M. C. Boyce. "Surface Engineering: Locally and Dynamically Controllable Surface Topography through the Use of Particle-Enhanced Soft Composites." *Advanced Functional Materials* 25, no. 24 (June 2015).

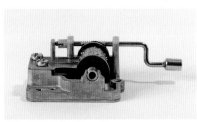

2.23
music box

background discussion

2.24
light-emitting device

M. Rubner lab, Department of Materials Science and Engineering, Massachusetts Institute of Technology

Handy, E. S., A. J. Pal, and M. F. Rubner. "Solid-State Light-Emitting Devices Based on the Tris-Chelated Ruthenium(II) Complex. 2. Tris(bipyridyl)ruthenium (II) as a High-Brightness Emitter." *Journal of the American Chemical Society* 121, no. 14 (April 14, 1999).

2.25
copper

G. M. Whitesides, Whitesides Group, Department of Chemistry and Chemical Biology, Harvard University

Whitesides, G. M. "Copper." *Chemical and Engineering News* (2003). http://pubs.acs.org/cen/80th/copper.html.

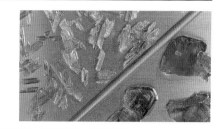

2.26
soft sensors

J. Rogers, Rogers Research Group, School of Engineering, Northwestern University

www.mc10inc.com

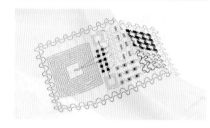

2.27
water drop

Frankel, F., and G. M. Whitesides. *No Small Matter: Science on the Nanoscale*. Cambridge, MA: Belknap Press of Harvard University Press, 2009.

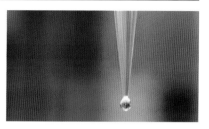

2.28
Bacillus subtilis

Roberto Kolter Lab, Harvard Medical School

Frankel, F., and G. M. Whitesides. *No Small Matter: Science on the Nanoscale*. Cambridge, MA: Belknap Press of Harvard University Press, 2009.

2.29, 2.30
high-pressure microreactor

K. Jensen, Jensen Research Group, Department of Chemical Engineering, Massachusetts Institute of Technology

Marre, S., A. Adamo, S. Basak, et al. "Design and Packaging of Microreactors for High Pressure and High Temperature Applications." *Industrial Engineering and Chemistry Research* 49, no. 22 (November 2010).

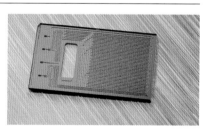

2.31
origami robots

R. Wood, School of Engineering and Applied Sciences; Wyss Institute for Biologically Inspired Engineering, Harvard University

ttp://news.harvard.edu/gazette/story/2010/06/a-marriage-of-origami-and-robotics/

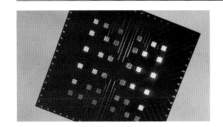

2.32
all-electronic DNA array sensor

D. Ehrlich and P. Matsudaira, Whitehead Institute for Biomedical Research, Massachusetts Institute of Technology

2.33
laboratory-made crystals

R. Birgeneau lab, Massachusetts Institute of Technology

"Laboratory-Made Calcium Fluoride and Manganese Fluoride Crystals." In *The Art and Science of Growing Crystals*, ed. J. J. Gilman. New York: Wiley, 1963.

2.34
microparticles

R. Langer lab, Department of Chemical Engineering, Massachusetts Institute of Technology

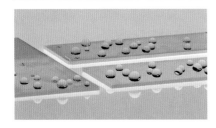

2.35
superhydrophobic surface

M. Rubner, Center for Materials Science and Engineering, Massachusetts Institute of Technology

Lee, H., M. L. Alcaraz, M. R. Rubner, et al. "Zwitter-Wettability and Antifogging Coatings with Frost-Resisting Capabilities." *ACS Nano* 7, no. 3 (March 2013).

2.36
nickel-tungsten alloy sandwiched between gold and brass layers

C. Schuh, Department of Materials Science and Engineering, Massachusetts Institute of Technology

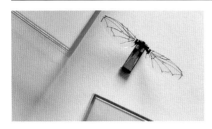

2.37
robotic insect (robobees)

R. Wood, School of Engineering and Applied Sciences; Wyss Institute for Biologically Inspired Engineering, Harvard University

Wood, R. "The First Take-off of a Biologically Inspired At-Scale Robotic Insect." *IEEE Transactions in Robotics* 24, no. 2 (April 2008).

2.38

microneedles

P. DeMuth, Department of Biological Engineering; Irvine Lab, Koch Institute for Integrative Cancer Research; Hammond Lab, Koch Institute for Integrative Cancer Research, Massachusetts Institute of Technology

DeMuth, P. C., Y. Min, D. J. Irvine, et al. "Implantable Silk Composite Microneedles for Programmable Vaccine Release Kinetics and Enhanced Immunogenicity in Transcutaneous Immunization." *Advanced Healthcare Materials* 3, no. 1 (January 2014).

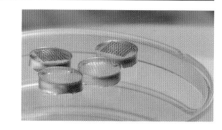

2.39

discretely assembled capacitor

W. Langford, Electronic Digital Materials, Media Lab, Massachusetts Institute of Technology

Langford, W., A. Ghassaei, and N. Gershenfeld. "Automated Assembly of Electronic Digital Materials." *ASME 2016 11th International Manufacturing Science and Engineering Conference* 2 (2016).

2.40

microrotor blades

A. Epstein, Gas Turbine Laboratory, and M. Schmidt, Microsystems Technology Laboratories, Massachusetts Institute of Technology

Gabriel, K. J. "Engineering Microscopic Machines." *Scientific American* 273, no. 3 (September 1995).

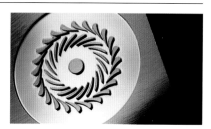

2.41

etched-glass wafer

D. Ehrlich, Whitehead Institute for Biomedical Research, Massachusetts Institute of Technology

2.42

flexible electronic circuit

J. Rogers, Rogers Research Group, School of Engineering, Northwestern University

Rogers, J. A., Z. Bao, K. Baldwin, et al. "Paper-like Electronic Displays: Large-Area Rubber-Stamped Plastic Sheets of Electronics and Microencapsulated Electrophoretic Inks." *Proceedings of the National Academy of Sciences* 98, no. 9 (April 24, 2001).

2.43
3D-printed multiply-wound Scherk-Collins toroid

Séquin, C. "Sculpture Generator." http://people.eecs.berkeley.edu/%7Esequin/SCULPTS/collins.html

2.44
micro-fermenter

Jensen Research Group, Department of Chemical Engineering, Massachusetts Institute of Technology

Zhang, Z., N. Szita, et al. "A Well-Mixed, Polymer-Based Microbioreactor with Integrated Optical Measurements." *Biotechnology and Bioengineering* 93, no. 2 (February 2006).

2.45
bioreactor

L. Griffith, Griffith Laboratory, Massachusetts Institute of Technology

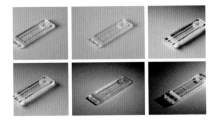

3.1
microreactor photographed under different light conditions

compiled from the interactive tool by B. Mandeberg on the book's web resources page, https://mitpress.mit.edu/frankel

microreactor setup by W.-H. Lee (see figure 3.19)

3.2
light table

image inserted for clarification

3.3
apparatus discussion

image inserted for clarification

3.4
***E. coli* patterns**

E. Budrene, Budrene Laboratory, Department of Cellular and Developmental Biology, Harvard University

Budrene, E. O., and H. C. Berg. "Complex Patterns Formed by Motile Cells of *Escherichia coli*." *Nature* 349, no. 6310 (February 14, 1991).

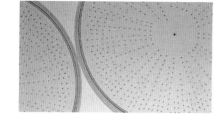

3.5
cross-shaped self-assembled structures

G. M. Whitesides, Whitesides Group, Department of Chemistry and Chemical Biology, Harvard University

Bowden, N., A. Terfort, J. Carbeck, et al. "Self-Assembly of Mesoscale Objects into Ordered Two-Dimensional Arrays." *Science* 276, no. 5310 (April 11, 1997).

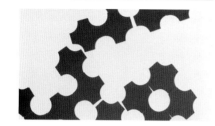

3.6
sugar crystals

author's personal exploration

3.7
music box

author's personal exploration

3.8
lighting setup

image inserted for clarification

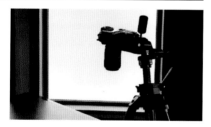

3.9
fishing reel

author's personal exploration

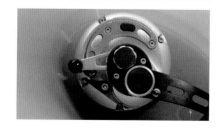

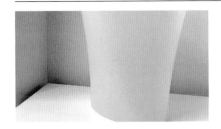

3.10
translucent plastic garbage can

author's personal exploration

3.11
water chamber

M. Schmidt, Microsystems Technology Laboratories, Massachusetts Institute of Technology

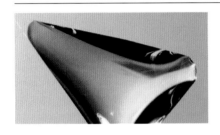

3.12
patterned drops of water

G. M. Whitesides, Whitesides Group, Department of Chemistry and Chemical Biology, Harvard University

Abbott, N. L., J. P. Folkers, and G. M. Whitesides. "Manipulation of the Wettability of Surfaces on the 0.1 to 1-Micrometer Scale through Micromachining and Molecular Self-Assembly." *Science* 257, no. 5075 (September 4, 1992).

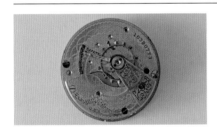

3.13
watch under various lighting

image inserted for clarification

3.14
three-dimensional metallic tetrahedron microstructure

G. M. Whitesides, Whitesides Group, Department of Chemistry and Chemical Biology, Harvard University

Jackman, R. J., S. T. Brittain, and A. Adams. "Three-Dimensional Metallic Microstructures Fabricated by Soft Lithography and Microelectrodeposition." *Langmuir* 15, no. 3 (February 2, 1999).

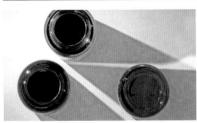

3.15
lighting discussion

image inserted for clarification

3.16
microchemical systems

K. Jensen, Jensen Research Group, Department of Chemical Engineering, Massachusetts Institute of Technology

Jensen, K. F. "Microchemical Systems: Status, Challenges, and Opportunities." *AIChE Journal* 45, no. 10 (October 1999).

3.17
optical grating

G. M. Whitesides, Whitesides Group, Department of Chemistry and Chemical Biology, Harvard University

Wilber, J. L., R. J. Jackman, G. M. Whitesides, et al. "Elastomeric Optics." *Chemistry of Materials* 8, no. 7 (1996).

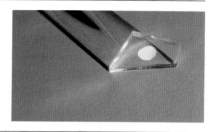

3.18
tears of wine (the Marangoni effect)

A. Adamson, Department of Chemistry, University of California, Los Angeles; A. Gast, Department of Chemical Engineering, Stanford University

Adamson, A. W., and A. P. Gast. *Physical Chemistry of Surfaces*. 6th ed. New York: Wiley, 1997.

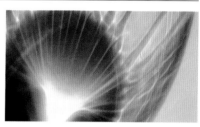

3.19
microreactor

Lee, W.-H. "Development of Microreactor Setups for Microwave Organic Synthesis." PhD diss., Massachusetts Institute of Technology, February 2014.

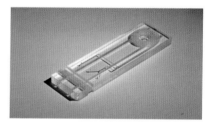

3.20, 3.21
vials of CdSe nanocrystals

M. Bawendi, M. Bawendi lab, Department of Chemistry, Massachusetts Institute of Technology

Dabbousi, B. O., J. Rodriguez-Viejo, F. V. Mikulec, et al. "(CdSe)ZnS Core-Shell Quantum Dots: Synthesis and Characterization of a Size Series of Highly Luminescent Nanocrystallites." *Journal of Physical Chemistry B* 101, no. 46 (November 13, 1997).

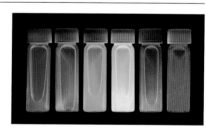

3.22
fluorescing adsorbing gels

T. Tanaka, Department of Physics; Tanaka Laboratory, Center for Materials Science and Engineering, Massachusetts Institute of Technology

Oya, T., T. Enoki, A. Y. Grosberg, et al. "Reversible Molecular Adsorption Based on Multiple-Point Interaction by Shrinkable Gels." *Science* 286, no. 5444 (November 19, 1999).

3.23

nanocrystal-embedded fluorescing rods

M. Bawendi, M. Bawendi lab, Department of Chemistry, Massachusetts Institute of Technology

Lee, J., V. C. Sundar, J. R. Heine, et al. "Full Color Emission from II-VI Semiconductor Quantum Dot-Polymer Composites." *Advanced Materials* 12, no. 15 (August 2, 2000).

3.24–3.29

microreactor

K. Jensen, Jensen Research Group, Department of Chemical Engineering, Massachusetts Institute of Technology

Lee, W.-H. "Development of Microreactor Setups for Microwave Organic Synthesis." PhD diss., Massachusetts Institute of Technology, February 2014.

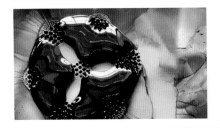

3.30

ferrofluid

Ferrofluidics Corporation

Raj, K., and R. Moskowitz. "Commercial Applications of Ferrofluids." *Journal of Magnetism and Magnetic Materials* 85, nos. 1–3 (April 1990).

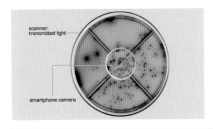

4.1

E. coli

S. Bhatia, Laboratory for Multiscale Regenerative Technologies, Massachusetts Institute of Technology

Danino, T., J. Lo, A. Prindle, et al. "In Vivo Gene Expression Dynamics of Tumor-Targeted Bacteria." *ACS Synthetic Biology* 1, no. 10 (October 2012).

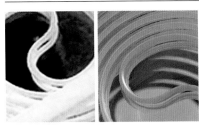

4.2

microreactor detail

K. Jensen Research Group, Department of Chemical Engineering, Massachusetts Institute of Technology

Lee, W.-H. "Development of Microreactor Setups for Microwave Organic Synthesis." PhD diss., Massachusetts Institute of Technology, February 2014.

4.3

sauteeing peppers under a pan cover

author's personal exploration

4.4
Boston in the winter

author's personal exploration

4.5
looking out a prop jet window

author's personal exploration

4.6
cellophane-wrapped tree trunk

author's personal exploration

4.7
wire table detail

author's personal exploration

4.8
found squigglies

author's personal exploration

4.9
Boston sunset

author's personal exploration

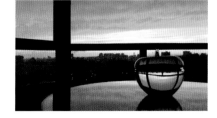

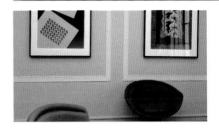

4.10
Provost's office

author's personal exploration

4.11
synchrocyclotron, CERN, Geneva

author's personal exploration

4.12
ceiling in the United Nations Human Rights Council, Palace of Nations, Geneva

artist: Menashe Kadishman

4.13
***Shalekhet (Fallen Leaves)* installation, Jewish Museum, Berlin**

artist: Menashe Kadishman

4.14
ceiling detail, Topkapi Palace, Istanbul

author's personal exploration

4.15
castle door detail, Prague

author's personal exploration

4.16
Holocaust Memorial, Prague

author's personal exploration

4.17
apparatus

image by Y. Liang, Massachusetts Institute of Technology

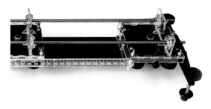

4.18
studying slap shot mechanics

Y. Liang, Massachusetts Institute of Technology

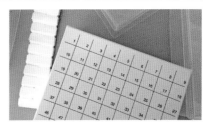

4.19
lab materials

H. Sikes lab, Department of Chemical Engineering, Massachusetts Institute of Technology

4.20
detail of a plastic frame, Franklin D. Roosevelt Presidential Library

author's personal exploration

4.21
floor detail, CERN, Geneva

author's personal exploration

4.22
ceiling, Google Atrium, Cambridge, Massachusetts

author's personal exploration

4.23
wallpaper detail

author's personal exploration

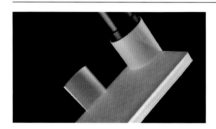

4.24
mobile device holder for microscope

https://www.ilabcam.com/

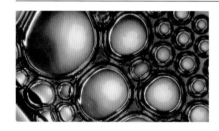

4.25
coffee bubbles

author's personal exploration

4.26
music box

author's personal exploration

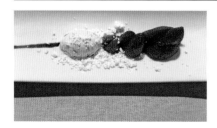

4.27
goat cheese and pepper ice cream with strawberries

Chef Jordi Herrera; restaurant Manairó

4.28
almodroc, jurvert, cantuccini, anchovy

Carme Ruscalleda, Toni Balam; restaurant Sant Pau

4.29
tomato and strawberry velvet

Chefs Carme Ruscalleda, Toni Balam; restaurant Sant Pau

4.30
cucumber, ginger, lime

Chefs Carme Ruscalleda, Toni Balam; restaurant Sant Pau

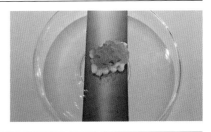

4.31
block copolymers

N. Thomas lab, Department of Materials Science and Engineering, Massachusetts Institute of Technology

Lee, W., J. Yoon, and H. Lee. "Dynamic Changes in Structural Color of a Lamellar Block Copolymer Photonic Gel during Solvent Evaporation." *Macromolecules* 46, no. 16 (2013).

4.32
cod, spicy chop

Chefs Carme Ruscalleda, Toni Balam; restaurant Sant Pau

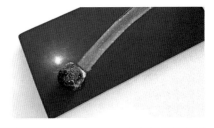

4.33
Fiona's personal explorations

images by Fiona McGill

5.1

magnetic core memory

from an IBM 7094 computer of the mid-1960s: each donut-shaped magnet remembered 1 bit; the computer had 32K of memory arranged in 36-bit words

Frankel, F. *Envisioning Science: The Design and Craft of the Science Image*. Cambridge, MA: MIT Press, 2002.

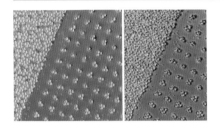

5.2

Styrofoam sheets

G. Holt lab, Boston University

Ouellette, J. "The Physics of … Foam Bubble, Bubble: The Toil and Trouble of Foam Research Reveals Some Magical Results." *Discover* 23, no. 6 (June 2002).

5.3

self-assembled colloids

Hammond lab, Koch Institute for Integrative Cancer Research, and M. Rubner lab, Department of Materials Science and Engineering, Massachusetts Institute of Technology

Lee, I., H. Zheng, M. F. Rubner, and P. T. Hammond. "Controlled Cluster Size in Patterned Particle Arrays via Directed Adsorption on Confined Surfaces." *Advanced Materials* 14, no. 8 (2002).

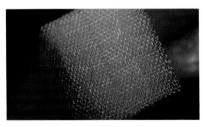

5.4

magnetic core memory

from an IBM 7094 computer of the mid-1960s: each donut-shaped magnet remembered 1 bit; the computer had 32K of memory arranged in 36-bit words

Frankel, F. *Envisioning Science: The Design and Craft of the Science Image*. Cambridge, MA: MIT Press, 2002.

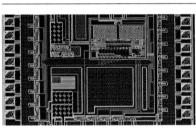

5.5

metamaterial

N. Fang lab, Department of Mechanical Engineering, Massachusetts Institute of Technology

Zheng, X., H. Lee, N. X. Fang, et al. "Ultralight, Ultrastiff Mechanical Metamaterials." *Science* 344, no. 1373 (2014).

5.6

SAR ADC using the LSB-first search algorithm

A. Chandrakasan lab, Department of Electrical Engineering and Computer Science, Massachusetts Institute of Technology

Yaul, F. M., and A. P. Chandrakasan. "A 10 Bit SAR ADC with Data-Dependent Energy Reduction Using LSB-First Successive Approximation." *IEEE Journal of Solid-State Circuits* 49, no. 12 (December 2014).

5.7

patterned polymer "wires"

M. Wrighton, Department of Chemistry, Massachusetts Institute of Technology

Wrighton, M., et al. "Patterned Polymer Layer Formed by Oxidation of the Monomer on a SAM Substrate." *Langmuir* 11 (1995).

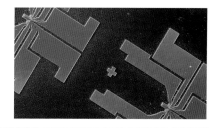

5.8

overlapping plastic interference patterns

author's personal exploration

5.9

arrays of subnanoliter wells for single-cell analysis

J. C. Love lab, Department of Chemical Engineering, Massachusetts Institute of Technology

Ogunniyi, A. O., C. M. Story, E. Papa, E. Guillen, and J. C. Love. "Screening Individual Hybridomas by Microengraving to Discover Monoclonal Antibodies." *Nature Protocols* 4, nos. 767–782 (2009).

5.10

Candida albicans

G. Fink lab, Whitehead Institute for Biomedical Research, Massachusetts Institute of Technology

Liu, H., et al. "Suppression of Hyphal Formation in *Candida albicans* by Mutation of a STE 12 Homolog." *Science* 266 (1994).

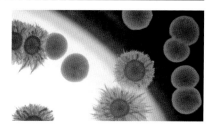

5.11

microreactor

K. Jensen Research Group, Department of Chemical Engineering, Massachusetts Institute of Technology

Yen, B. K. H. "Microfluidic Reactors for the Synthesis of Nanocrystals." Ph.D. dissertation, Department of Chemistry, Massachusetts Institute of Technology, 2007.

5.12

nuclear delivery of plasmid DNA in microfluidic channels

K. Jensen, R. Langer labs, Department of Chemical Engineering, Massachusetts Institute of Technology

Ding, X., et al. "High-Throughput Nuclear Delivery and Rapid Expression of DNA via Mechanical and Electrical Cell-Membrane Disruption." *Nature Biomedical Engineering* 1, no. 39 (March 2017).

5.13

microchannels

M. Toner lab, Harvard Medical School

Stott, S. L., C.-H. Hsu, D. I. Tsukrov, et al. "Isolation of Circulating Tumor Cells Using a Microvortex-Generating Herringbone-Chip." *Proceedings of the National Academy of Sciences* 107, no. 43 (October 26, 2010).

5.14

nanocrystals

M. Bawendi lab, Department of Chemistry, Massachusetts Institute of Technology

Murray, C. B., et al. "Self-Organization of CdSe Nanocrystals into Three-Dimensional Quantum Dot Superlattices." *Science* 270 (1995).

5.15

"Eleanor Rigby" vinyl track

Frankel, F., and G. M. Whitesides. *No Small Matter: Science on the Nanoscale.* Cambridge, MA: Belknap Press of Harvard University Press, 2009.

5.16

microrotor blades

A. Epstein, Gas Turbine Laboratory, and M. Schmidt, Microsystems Technology Laboratories, Massachusetts Institute of Technology

Gabriel, K. J. "Engineering Microscopic Machines." *Scientific American* 273, no. 3 (September 1995).

5.17

silicon microcantilevers

Microsystems Technology Lab, faculty and students, and M. Schmidt, Massachusetts Institute of Technology

5.18

self-assembled colloids

Hammond lab, Koch Institute for Integrative Cancer Research, and M. Rubner lab, Department of Materials Science and Engineering, Massachusetts Institute of Technology

Lee, I., H. Zheng, M. F. Rubner, and P. T. Hammond. "Controlled Cluster Size in Patterned Particle Arrays via Directed Adsorption on Confined Surfaces." *Advanced Materials* 14, no. 8 (2002).

5.19

microcapsules

Anderson lab, Koch Institute for Integrative Cancer Research; Department of Chemical Engineering, Massachusetts Institute of Technology

Vegas, A., et al. "Long-Term Glycemic Control Using Polymer-Encapsulated Human Stem Cell-Derived Beta Cells in Immune-Competent Mice." *Nature Medicine* 22, no. 3 (2016).

5.20

atomic force microscopy tip

scanning electron microscope image taken with the help of C. Love

"Nanotech: Science of the Small Gets Down to Business." *Scientific American*, special issue (2001).

5.21

scanning electron microscope image of a morpho butterfly wing

Whitehead Institute for Biomedical Research, Massachusetts Institute of Technology

5.22

optoelectronic device, layered scanning electron microscope image

Jarillo-Herrero lab, Massachusetts Institute of Technology; original SEM by H. Churchill

Baugher, B. W. H., H. O. H. Churchill, Y. Yang, and P. Jarillo-Herrero. "Optoelectronic Devices Based on Electrically Tunable pn Diodes in a Monolayer Dichalcogenide." *Nature Nanotechnology* 9, no. 262 (2014).

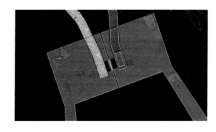

5.23

self-assembled brain cells on a chip

image by C. Edington and I. Lee, Koch Institute Image Awards, Massachusetts Institute of Technology

https://ki-galleries.mit.edu/2017/edington-lee

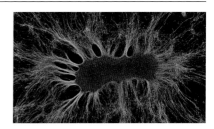

5.24

***Xenopus laevis* egg undergoing mitosis**

T. Mitchison lab, Department of Systems Biology, Harvard Medical School; image by M. Wuehr and T. Mitchison

http://www.cellimagelibrary.org/images/36441

6.1
solar cell

T. Buonassisi, Photovoltaic Research Laboratory, Department of Mechanical Engineering, Massachusetts Institute of Technology

Steinmann, V., R. Jaramillo, K. Hartman, et al. "3.88% Efficient Tin Sulfide Solar Cells Using Congruent Thermal Evaporation." *Advanced Materials* 26, no. 44 (August 20, 2014).

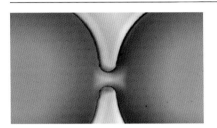

6.2
bacterial analysis

C. Buie lab, Department of Chemical Engineering, Massachusetts Institute of Technology

Braff, W. A., D. Willner, P. Hugenholtz, et al. "Dielectrophoresis-Based Discrimination of Bacteria at the Strain Level Based on Their Surface Properties." *PLoS One* (October 2013).

6.3

C. Ross lab, Department of Materials Science and Engineering, Massachusetts Institute of Technology

Tu, K.-H., and C. Ross. "Domain Wall Structure and Interactions in 40 nm Wide Cobalt Nanowires." Under review.

6.4
"filler" material properties

Computational Instrumentation Group, Department of Mechanical Engineering, Massachusetts Institute of Technology

Chai, L. "Organization and Compaction of Composite Filler Material Using Acoustic Focusing." International Mechanical Engineering Congress and Exposition (IMECE2017), November 3–9, 2017.

6.5
solar cell

T. Buonassisi, Photovoltaic Research Laboratory, Department of Mechanical Engineering, Massachusetts Institute of Technology

Steinmann, V., R. Jaramillo, K. Hartman, et al. "3.88% Efficient Tin Sulfide Solar Cells Using Congruent Thermal Evaporation." *Advanced Materials* 26, no. 44 (August 20, 2014).

6.6
layer-by-layer (LbL) assembly of polyelectrolyte multilayers

Departments of Mechanical Engineering and Chemical Engineering, Massachusetts Institute of Technology

Yost, A. L., et al. "Layer-by-Layer Functionalized Nanotube Arrays: A Versatile Microfluidic Platform for Biodetection." *Microsystems and Nanoengineering* 1 (2015).

6.7

film expansion

J. Swallow, K. J. Van Vliet lab, Department of Materials Science and Engineering, Massachusetts Institute of Technology

Swallow, J., K. J. Van Vliet, et al. "Dynamic Chemical Expansion of Thin-Film Non-Stoichiometric Oxides at Extreme Temperatures." *Nature Materials* 16 (May 8, 2017). https://www.nature.com/articles/nmat4898

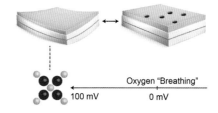

6.8

AFM of block-containing polymers

C. Ross lab, Department of Materials Science and Engineering, Massachusetts Institute of Technology

Kathrein, C., C. Ross, et al. "Electric Field Manipulated Nanopatterns in Thin Films of Metalorganic 3-Miktoarm Star Terpolymers." *Soft Matter* 12 (2016).

6.9

table of contents design

B. Yildiz lab, Department of Materials Science and Engineering, Massachusetts Institute of Technology

Lu, Q., and B. Yildiz. "Voltage-Controlled Topotactic Phase Transition in Thin-Film SrCoOx Monitored by In Situ X-ray Diffraction." *acs.nanolett* (December 21, 2015).

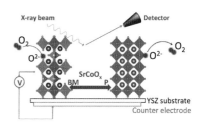

6.10

robotic apparatus

photo by Joe Davidson, Newman Lab for Biomechanics and Human Rehabilitation, Department of Mechanical Engineering, Massachusetts Institute of Technology

Davidson, J. R., and H. I. Krebs. "Characterization of an Electrorheological Fluid for Rehabilitation Robotics Applications." ASME Conference on Smart Materials, Adaptive Structures, and Intelligent Systems (SMASIS), Snowbird, Utah, September 18–20, 2017.

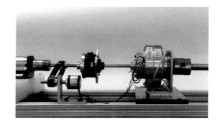

6.11

composite image by Mark Klett and Byron Wolfe, *Four Views from Four Times and One Shoreline, Lake Tenaya*

Digital inkjet print, 24 × 66 inches. Left to right: Eadweard Muybridge, 1872; Ansel Adams, c. 1942; Edward Weston, 1937. Back panels: Swatting high-country mosquitoes, 2002. Muybridge's picture courtesy of the George Eastman House, Rochester, New York. Adams's picture, Collection Center for Creative Photography, University of Arizona, © Trustees of the Ansel Adams Publishing Rights Trust. Weston's picture, Collection Center for Creative Photography, University of Arizona, © 1981 Arizona Board of Regents.

6.12
Belousov-Zhabotinsky reaction

A. Zhabotinsky Laboratory, Brandeis University

Fife, P. C. "Understanding the Patterns in the BZ Reagent." *Journal of Statistical Physics* 39, nos. 5–6 (June 1985).

6.13
block copolymers, time-lapse

N. Thomas lab, Department of Materials Science and Engineering, Massachusetts Institute of Technology

Lee, W., et al. "Dynamic Changes in Structural Color of a Lamellar Block Copolymer Photonic Gel during Solvent Evaporation." *Macromolecules* 46 (2013).

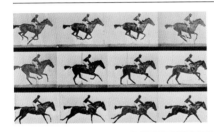

6.14
horse in motion

Eadweard Muybridge, *Horse in Motion*, 1878

https://en.wikipedia.org/wiki/Eadweard_Muybridge

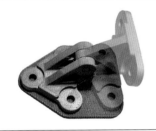

6.15
3D movable metal printing

Desktop Metal; C. Schuh, Department of Materials Science and Engineering, Massachusetts Institute of Technology

https://www.desktopmetal.com/company/about/

6.16
soap bubbles

bubble machine fabricated by J. Ossi, Massachusetts Institute of Technology

Isenberg, C. *The Science of Soap Films and Soap Bubbles*. New York: Dover, 1978.

6.17
16-bit 16-MS/s SAR ADC

A. Chandrakasan lab, Department of Electrical Engineering and Computer Science, Massachusetts Institute of Technology

Yaul, F. M., and A. P. Chandrakasan. "A 10 Bit SAR ADC with Data-Dependent Energy Reduction Using LSB-First Successive Approximation." *IEEE Journal of Solid-State Circuits* 49, no. 12 (December 2014).

6.18
microarray

D. Walt, Illumina

http://www.illumina.com

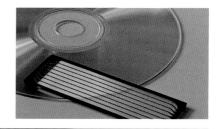

6.19
reversible collapse

A. Hosoi lab, Department of Mechanical Engineering, Massachusetts Institute of Technology

6.20
magnetic memory core

from an IBM 7094 computer of the mid-1960s: each donut-shaped magnet remembered 1 bit; the computer had 32K of memory arranged in 36-bit words

Frankel, F. *Envisioning Science: The Design and Craft of the Science Image.* Cambridge, MA: MIT Press, 2002.

6.21
solar cell

T. Buonassisi, Photovoltaic Research Laboratory, Department of Mechanical Engineering, Massachusetts Institute of Technology

Steinmann, V., R. Jaramillo, K. Hartman, et al. "3.88% Efficient Tin Sulfide Solar Cells Using Congruent Thermal Evaporation." *Advanced Materials* 26, no. 44 (August 20, 2014).

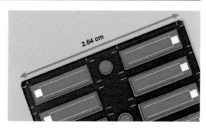

6.22
prism

Frankel, F., and G. M. Whitesides. *No Small Matter: Science on the Nanoscale.* Cambridge, MA: Belknap Press of Harvard University Press, 2009.

6.23
controlled-release microchip

R. Langer lab, Department of Chemical Engineering, Massachusetts Institute of Technology

Santini, J. T., Jr., A. C. Richards, R. Scheidt, et al. "Microchips as Controlled Drug-Delivery Devices." *Angewandte Chemie, International Edition* 39, no. 14 (July 17, 2000).

6.24
optical fibers

Y. Fink, Research Laboratory of Electronics, Department of Materials Science and Engineering, Massachusetts Institute of Technology

6.25
optical fibers

Y. Fink, Research Laboratory of Electronics, Department of Materials Science and Engineering, Massachusetts Institute of Technology

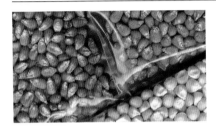

6.26
corn

author's personal exploration

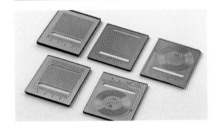

6.27
high-pressure microreactor

K. Jensen, Jensen Research Group, Department of Chemical Engineering, Massachusetts Institute of Technology

Marre, S., A. Adamo, S. Basak, et al. "Design and Packaging of Microreactors for High Pressure and High Temperature Applications." *Industrial Engineering and Chemistry Research* 49, no. 22 (November 2010).

6.28
generic journal cover

image inserted for clarification

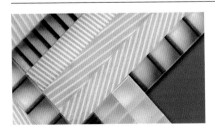

6.29
3D-printed layered composites with varying microstructure parameters

M. Boyce lab, Department of Mechanical Engineering, Massachusetts Institute of Technology

Rudykh, S., and M. C. Boyce. "Transforming Small Localized Loading into Large Rotational Motion in Soft Anisotropically Structured Materials." *Advanced Engineering Materials* 16, no. 11 (November 2014).

6.30
lotus effect

Kotz, J. C., P. M. Treichel, and J. R. Townsend. *Chemistry and Chemical Reactivity*. 7th ed. Belmont, CA: Thomson Brooks/Cole, 2008.

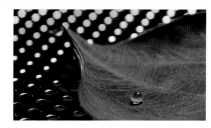

6.31
sea urchin

DuPont MIT Alliance, Massachusetts Institute of Technology

author's personal exploration

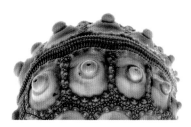

6.32
instrument detail

Microsystems Technology Laboratories, Massachusetts Institute of Technology

author's personal exploration

6.33
beer

Frankel, F., and G. M. Whitesides. *No Small Matter: Science on the Nanoscale*. Cambridge, MA: Belknap Press of Harvard University Press, 2009.

6.34
bubbles

Polli, R., and G. Faliva. *Bilancio sociale 2005*. Versione executive. Milan, Italy: Assolombarda, 2005.

6.35
quantum dots

M. Bawendi lab, Department of Chemistry, Massachusetts Institute of Technology

"MIT.nano, The Future of Innovation," 2014

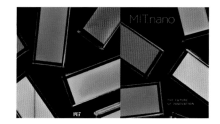

6.36
uses of arrows in graphics

image inserted for clarification

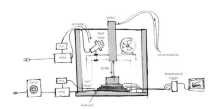

6.37
apparatus drawing

A. Hosoi and C. Chase, MIT 3-Sigma Sports program, School of Engineering, Massachusetts Institute of Technology

A. Bosquet, hand-drawn art for sponsor presentation

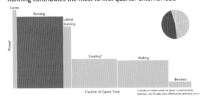

6.38
redo graphic

A. Hosoi and C. Chase, MIT 3-Sigma Sports program, School of Engineering, Massachusetts Institute of Technology

M. Nawrot, F. Vidal-Codina, and P. McClure, hand-drawn art for sponsor presentation

6.39
Darwin drawing

page from Darwin's notebooks, around July 1837, showing his first sketch of an evolutionary tree

6.40
Crosby Arboretum, Picayune, MS

F. Jones, architect

Frankel, F., and J. Johnson. *Modern Landscape Architecture: Redesigning the Garden*. New York: Abbeville Press, 1991.

6.41
tensegrity sculpture

D. Ingber, Wyss Institute for Biologically Inspired Engineering, Harvard University

Ingber, D. "Tensegrity: The Architectural Basis of Cellular Mechanotransduction." *Annual Review of Physiology* 59 (1997).

6.42

personal timeline

D. Brodbeck

https://www.macrofocus.com/

6.43

gene data visualization

B. Fry

http://benfry.com/chr14/

6.44

conventional atom

original logo of the United States Atomic Energy Commission

6.45

probabilistic atom

R. Hayward

Pauling, L., and R. Hayward. *The Architecture of Molecules.* San Francisco: W. H. Freeman, 1964.

7.1

gas pillars in the Eagle Nebula

J. Hester and P. Scowen, NASA

http://hubblesite.org/gallery/album/entire/pr1995044a/

7.2

acrylamide monomers

T. Tanaka lab, Department of Physics, Massachusetts Institute of Technology

Oya, T., et al. "Reversible Molecular Adsorption Based on Multiple-Point Interaction by Shrinkable Gels." *Science* 286 (1999).

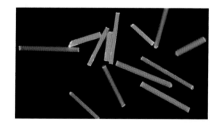

442

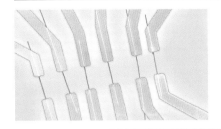

7.3
nanowires

C. Lieber lab, Department of Chemistry and Chemical Biology, Harvard University

Lieber, C. M. "The Incredible Shrinking Circuit." *Scientific American* 285 (2001).

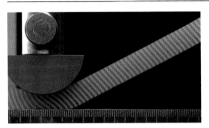

7.4
structured materials

M. Boyce lab, Department of Mechanical Engineering, Massachusetts Institute of Technology

Rudykh, S., and M. C. Boyce. "Transforming Small Localized Loading into Large Rotational Motion in Soft Anisotropically Structured Materials." *Advanced Engineering Materials* 16, no. 11 (2014).

7.5
quantum dots

P. Zou and A. Ting, Department of Chemistry, Massachusetts Institute of Technology

Howarth, M., et al. "Monovalent Reduced-Size Quantum Dots for Imaging Receptors on Living Cells." *Nature Methods* 5 (2008).

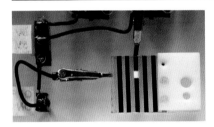

7.6
light-emitting device

M. Rubner lab, Department of Materials Science and Engineering, Massachusetts Institute of Technology

Handy, E. S., A. J. Pal, and M. F. Rubner. "Solid-State Light-Emitting Devices Based on the Tris-Chelated Ruthenium (II) Complex. 2. Tris(bipyridyl)ruthenium (II) as a High-Brightness Emitter." *Journal of the American Chemical Society* 121, no. 14 (April 14, 1999).

7.7
bacterial analysis

C. Buie lab, Department of Mechanical Engineering, Massachusetts Institute of Technology

Braff, W. A., D. Wilner, and P. Hugenholtz. "Dielectrophoresis-Based Discrimination of Bacteria at the Strain Level Based on Their Surface Properties." *PLoS One* (October 2013).

7.8
yeast colony

G. Fink lab, Whitehead Institute for Biomedical Research, Massachusetts Institute of Technology

Reynolds, T. B., and G. R. Fink. "Bakers' Yeast, a Model for Fungal Biofilm Formation." *Science* 291, no. 5505 (February 2, 2001).

7.9
all-electronic DNA array sensor

D. Ehrlich and P. Matsudaira, Whitehead Institute for Biomedical Research, Massachusetts Institute of Technology

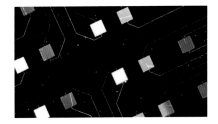

7.10
proteus colonies

J. Shapiro lab, Department of Biochemistry and Molecular Biology, University of Chicago

Shapiro, J. A., et al. "Sequential Events in Bacterial Colony Morphogenesis." *Physica* D 49 (1991).

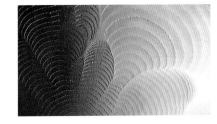

7.11
DNA analysis

P. A. Sharp lab, Department of Biology, Massachusetts Institute of Technology

Zhou, Q. A., and P. A. Sharp. "Tat-SF1: Cofactor for Stimulation of Transcriptional Elongation by HIV-1 Tat." *Science* 274 (October 25, 1996).

7.12
ocean wave analysis

Department of Civil and Environmental Engineering, Massachusetts Institute of Technology

Landry, B., M. Hancock, et al. "Note on Sediment Sorting in a Sandy Bed under Standing Water Waves." *Coastal Engineering* 54 (2007).

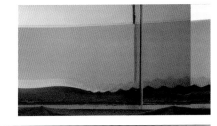

7.13
planar lightguide circuit

A. White, Bell Laboratories

Gates, J., D. Muehlner, et al. "Hybrid Integrated Silicon Optical Bench Planar Lightguide Circuits." Proceedings of the 48th Electronic Computers and Technology Conference, Seattle, Washington, S15P1 (1998).

7.14
aligned carbon nanotubes

image by J. Hart, Department of Mechanical Engineering, Massachusetts Institute of Technology

Frankel, F. "Needlework." *American Scientist* 94 (2006).

7.15
"enhanced" gel run

anonymous

7.16
vortices left by strider

image by J. Bush, Department of Applied Mathematics, Massachusetts Institute of Technology

Frankel, F. "Walk on Water." *American Scientist* 92 (July-August 2004).

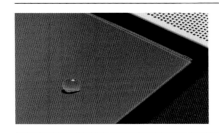

7.17
hydrophobic surface

author's personal exploration

8.1.0
remote epitaxy

J. Kim, Department of Materials Science and Engineering, Massachusetts Institute of Technology

Kim, J., et al. "Remote Epitaxy through Graphene Enables Two-Dimensional Material-Based Layer Transfer." *Nature* 544 (2017).

8.2.0
crumpled graphene balls

J. Huang, Department of Materials Science and Engineering, Northwestern University

Dou, X., and J. Huang. "Self-Dispersed Crumpled Graphene Balls in Oil for Friction and Wear Reduction." *Proceedings of the National Academy of Sciences* 113, no. 6 (2016).

8.3.0
extending lifespan of medical devices

J. Doloff, R. Langer lab, Department of Chemical Engineering, and Koch Institute for Integrative Cancer Research, Massachusetts Institute of Technology

Doloff, J. C., O. Veiseh, A. J. Vegas, et al. "Colony Stimulating Factor-1 Receptor Is a Central Component of the Foreign Body Response to Biomaterial Implants in Rodents and Non-human Primates." *Nature Materials* 16, no. 6 (2017).

8.4.0
encapsulation of stem cell–derived beta cells

A. J. Vegas, O. Veiseh, et al., Koch Institute for Integrative Cancer Research, Massachusetts Institute of Technology

Vegas, A., et al. "Long-Term Glycemic Control Using Polymer-Encapsulated Human Stem Cell-Derived Beta Cells in Immune-Competent Mice." *Nature Medicine* 22, no. 3 (2016).

8.5.3
nerve animation

Gaël McGill, Digizyme

https://www.digizyme.com/

8.6.0
particle physics

J. Thaler, Department of Physics, Massachusetts Institute of Technology

Tripathee, A., W. Xue, A. Larkoski, et al. "Jet Substructure Studies with CMS Open Data." *Physical Review D* 96, 074003 (October 3, 2017).

8.7.0
silicon microfluidic microreactor

K. Jensen, Jensen Research Group, Department of Chemical Engineering, Massachusetts Institute of Technology

Ratner, D. M., E. R. Murphy, M. Jhunjhunwala, et al. "Microreactor-Based Reaction Optimization in Organic Chemistry – Glycosylation as a Challenge." *Chemical Communications* 5 (2005).

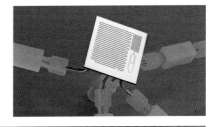

8.8.0
sulfur flow battery

L. Su, Y.-M. Chiang lab, Department of Materials Science and Engineering, Massachusetts Institute of Technology

Su, L., Y.-M. Chiang, et al. "Air-Breathing Aqueous Sulfur Flow Battery for Ultralow-Cost Long-Duration Electrical Storage." *Joule* 1, no. 2 (2017).

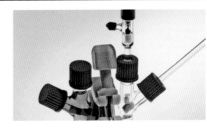

8.9.3
microneedles

P. DeMuth, Department of Biological Engineering; Irvine lab, Koch Institute for Integrative Cancer Research; Hammond lab, Koch Institute for Integrative Cancer Research, Massachusetts Institute of Technology

DeMuth, P. C., Y. Min, D. J. Irvine, et al. "Implantable Silk Composite Microneedles for Programmable Vaccine Release Kinetics and Enhanced Immunogenicity in Transcutaneous Immunization." *Advanced Healthcare Materials* 3, no. 1 (January 2014).

8.10.0

nanophotonic solar thermophotovoltaic device

E. Wang, Department of Mechanical Engineering, Massachusetts Institute of Technology

Lenert, A., D. M. Bierman, Y. Nam, et al. "A Nanophotonic Solar Thermophotovoltaic Device." *Nature Nanotechnology* 9, no. 2 (February 2014).

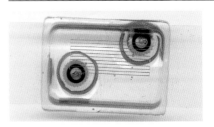

8.11.4

microfluidic device for determination of mineral dissolution rates

A. Allanore lab, Department of Materials Science and Engineering, Massachusetts Institute of Technology

Ciceri, D., and A. Allanore. "Microfluidic Leaching of Soil Minerals: Release of K+ from K Feldspar." *PLoS One* 10, no. 10 (2015).

8.12.0

liquid metal battery

D. Sadoway, Sadoway Group, Department of Materials Science and Engineering, Massachusetts Institute of Technology

Wang, K., K. Jiang, B. Chung, et al. "Lithium-Antimony-Lead Liquid Metal Battery for Grid-Level Energy Storage." *Nature* 514, no. 7522 (October 16, 2014).

8.13.0

resistive force theory metaphor

K. Kamrin Group, Department of Mechanical Engineering, Massachusetts Institute of Technology

Karmin, K., and H. Askari. "Intrusion Rheology in Grains and Other Flowable Materials." *Nature Materials* 15, nos. 1274–1279 (2016).

8.14.0

solar cells

T. Buonassisi, Photovoltaic Research Laboratory, Department of Mechanical Engineering, Massachusetts Institute of Technology, and M. McGehee, Stanford McGehee Group, Massachusetts Institute of Technology and Stanford University

Chandler, D. L. "New Kind of 'Tandem' Solar Cell Developed: Researchers Combine Two Types of Photovoltaic Material to Make a Cell That Harnesses More Sunlight." *MIT News* (March 25, 2015). fhttp://mitei.mit.edu/news/new-kind-tandem-solar-cell-developed

8.15.0
perovskite and fuel cells

B. Yildiz et al., Department of Nuclear Science and Engineering and Department of Materials Science and Engineering, Massachusetts Institute of Technology

Tsvetkov, N., Lu, Q., Sun, L., et al. "Improved Chemical and Electrochemical Stability of Perovskite Oxides with Less Reducible Cations at the Surface." *Nature Materials* 15, nos. 1010–1016 (2016).

index opener (page 448)
patterned drops of water

G. M. Whitesides, Whitesides Group, Department of Chemistry and Chemical Biology, Harvard University

Abbott, N. L., J. P. Folkers, and G. M. Whitesides. "Manipulation of the Wettability of Surfaces on the 0.1 to 1-Micrometer Scale through Micromachining and Molecular Self-Assembly." *Science* 257, no. 5075 (September 4, 1992).

INDEX

Abbott, Nicholas L., xii
Adobe After Effects, 366
Allanore, Antoine, 391
American Scientist, 316, 334, 336
aperture, 46, 50–52, 54–57, 62, 99, 204, 247
apparatus, laboratory, 170–171, 379, 427, 435, 440
Apple, 365
ATLAS, 370
Autodesk Maya, 367

backgrounds, 22, 36–38, 60–61, 68–70, 74–89, 99, 142, 159, 170, 174–178, 200, 236, 258, 286, 308, 320–321, 341, 354, 357, 361, 371, 376, 380, 383, 385, 388, 391, 401–402, 405
Balam, Toni, 184
Barceló, Miquel, 160
Bawendi, Moungi, 230, 296
Belousov-Zhabotinsky reaction, 267, 436
Berry, Michael, xiii
block copolymers, 192, 268, 429, 436
Bosquet, Audrey, 299
Boyce, Mary, 320
Brodbeck, Dominique, 308
Buie, Cullen, 253
Bush, John, 336–337

Cell, 316, 342–343, 379
CERN (European Organization for Nuclear Research), 158, 175, 369
Chai, Lauren, 256
Chandrakasan, Anantha, 216
Chase, Christina, 300
Cheacharoen, Rongrong, 401
Cheung, Geoffrey, 365
Chiang, Yet-Ming, 379
Chung, Brice, 393
circuits, 412, 419, 442, 443. *See also* neuronal circuits
CMS Open Data, 370
Collette, Natasha, xv
composition, 17–20, 26, 38, 52, 60–67, 70, 76, 81, 88, 92, 99, 117, 120, 129, 142, 158, 164, 183, 200, 203, 226–236, 253, 274, 280–281, 286, 297, 313
confocal microscopy, 244–247

Darwin, Charles, 302, 310
Davidson, Joseph, 263
DeMuth, Peter, 383, 385
DePace, Angela, 250, 379
depth of field, 12, 42, 54–57, 62, 74, 88, 99, 145, 204, 214, 384
Digizyme, 365
Doloff, Joshua, 357

Edington, Collin, 244
edX, xi
epitaxy, 347
Escherichia coli, 33, 65, 103, 325, 410, 413, 416, 421, 424

Fang, Nicholas, 214
ferrofluids, 140, 424

fluorescence, 128–134, 203, 253, 318–321, 324, 325, 362, 423, 424
food, photographing, 183–197
Franzetta, Gina, xv
Freeman, Bill, 332
Fry, Ben, 310
f-stop. *See* aperture
Fuller, Buckminster, 308

gels, 132, 188, 244, 330–332, 335, 340–341, 342, 343, 361, 414, 423, 444
graphene, 347–350, 353
graphics, scientific, xiv, 250–261, 297, 313, 353
Griffith, Linda, 244

Hart, John, 334
Hau, Lene, xiii
Hayward, Roger, 312
Herrera, Jordi, 184
Hester, Jeff, 316–317
Heyden, Robin, xv
Higgs boson, 369
Hosoi, Anette, 300
Huang, Jiaxing, 353

Ingber, Don, 308
ISO, 46–48, 52

Jensen, Klavs, 228, 375
Jones, Fay, 303
Joule, 378–379
journal covers, xi, xii, 25, 66, 96, 129, 285–287, 359, 361, 384, 388, 393, 396
journals, scientific, xii, 5, 46, 244, 251, 253, 258, 262, 279, 299, 315–316, 328, 332, 333, 338, 340–343, 375, 379–380, 396. *See also* graphics, scientific; journal covers; table of contents, journal

Kadishman, Menashe, 164
Kamrin, Ken, 399
Keller, Eric, 365
Keynote, 367
Kim, Jeehwan, 347
Klett, Mark, 264
Krause, Kelly, 347–348
Kunkel, Dennis, 357

Large Hadron Collider (LHC), 369–370
Larrabee, Joanne, xv
Lee, Iris, 244
Lenert, Andrej, 387
Liang, Youzhi, 170
Libeskind, Daniel, 164
lighting, 17–22, 60–61, 101–125, 135–140, 142, 200, 204, 324
light table (light box), 60–61, 103, 106, 135, 379, 394, 420
Love, J. Christopher, 222, 238
Lu, Qiyang, 262